SCAVULLO ON BEAUTY

Francesco Scavullo

PROJECT EDITOR: SEAN BYRNES

With Katherine Erskine and Brigid Berlin Polk

Random House 🏠

New York

**My thanks to
Connie Clausen and
Sean Byrnes**

Copyright © 1976
by Francesco Scavullo

All rights reserved under International and Pan-American Copyright Conventions. Published in the United States by Random House, Inc., New York, and simultaneously in Canada by Random House of Canada Limited, Toronto.

Library of Congress Cataloging in Publication Data

Scavullo, Francesco, 1929—
 Scavullo on beauty.

 1. Beauty culture. 2. Beauty, Personal.
I. Byrnes, Sean. II. Erskine, Katherine.
III. Title. IV. Title: Beauty.
TT957.S3 646.7'2'024042 76—14158
ISBN 0—394—40728—8

Manufactured in the United States of America
9 8 7 6 5 4 3 2
First Edition
Design by Rochelle Udell
Production by Jan Tigner
Mechanical art by Sandy Blough

MAKE-UP CREDITS

Way Bandy:
Princess Aga Khan
Marisa Berenson
Jacqueline Bisset
Karen Bjornson
Helen Gurley Brown
Irene Cara
Diahann Carroll
Geraldine Chaplin
Ellen Coughlin
Dalila di Lazzaro
Patti d'Arbanville
Agnetta Daren von Rosen
LouLou de la Falaise
Angie Dickinson
Christina Ferrare
Jerry Hall
Joan Hemingway
Margaux Hemingway
Lauren Hutton
Iman
Anna Levine
Hilda Lindley
Ali MacGraw
China Machado
Maxime McKendry
Dina Merrill
Caterine Milinaire
Mary Tyler Moore
Tatum O'Neal
Elsa Peretti
Brigid Berlin Polk
Andrea Portago
Marquesa de Portago
Lee Radziwill
Helen Reddy
Rene Russo
Blair Sabol
Geraldine Smith
Maria Smith
Barbra Streisand
Cicely Tyson
Gloria Vanderbilt
Tuesday Weld

Sandy Linter:
Karen Bjornson (straight-hair picture)
Iman (laughing picture)

John Richardson:
Faye Dunaway
Editta Sherman
Joan Sutherland
Viva
Barbara Walters

Rick Gillette (Hair and Make-up):
Lauren Hutton (straight-hair picture)

HAIR CREDITS

Harry King:
Princess Aga Khan
Marisa Berenson
Jacqueline Bisset
Irene Cara
Diahann Carroll
Geraldine Chaplin
Ellen Coughlin
Patti d'Arbanville
Agnetta Daren von Rosen
LouLou de la Falaise
Jerry Hall
Joan Hemingway
Iman
Anna Levine
Ali MacGraw

China Machado
Maxime McKendry
Dina Merrill
Caterine Milinaire
Elsa Peretti
Andrea Portago
Marquesa de Portago
Lee Radziwill
Helen Reddy
Rene Russo
Blair Sabol
Geraldine Smith
Maria Smith
Viva
Barbara Walters

Alexandre:
Rene Russo (chignon)

Eugene:
Helen Gurley Brown

Francois:
Karen Bjornson
Christina Ferrare
Andrea Portago
Chris Royer

Ara Gallant:
Faye Dunaway

Maury Hopson:
Jerry Hall
Margaux Hemingway
Hilda Lindley
Mary Tyler Moore
Barbra Streisand
Angie Dickinson

James Reda:
Brigid Polk

Suga:
Rene Russo
Maria Smith

HAIR COLOR CREDITS

Robert Renn:
Ellen Coughlin
Lauren Hutton
Marquesa de Portago
Rene Russo

Contents

SCAVULLO ON BEAUTY

I love beautiful women. Every woman who steps in front of my camera is the most glamorous and desirable woman on earth. I think every woman is glamorous and desirable—if she would only believe it. I am a photographer of people because people are all I care about. I take only beautiful pictures because I'm only interested in showing people at their best. I believe that people who care about themselves and who do the most to look their best are among the happiest in the world. I know that every woman wants to, and every woman can, look better than she does today. I am writing this book to show you how you can start to bring out the best in yourself.

This book is the story of fifty-nine of my favorite women, some of whom are famous, all of whom are interesting—how they look at themselves and how I look at them. I have selected some of these women because their careers and success depend on their looks. To them, beauty is a serious business. It is for you too. You can make more of your life by making more of yourself.

I have selected all of these women to be in the book because famous or not, beautiful or not, rich or poor, young or old, they are human beings with a sense of themselves. I've interviewed all of them because I like to know what they think—about themselves, about anything—because what you think shapes what you are. And if you think you're the best . . . you are. These women have problems that every woman has, and they must deal honestly with their looks as everyone must. I think you can learn a great deal by just hearing them talk. You'll meet many different types of people in this book—from various professions, with their own special intelligence, peculiarities and charm. You won't see any flawless face in this book, but you won't see any ugly ones either—for the simple reason that there aren't any such things.

With beauty comes power—and you can have it if you know yourself well enough to trust your own instincts. You are the one that picks and chooses among your strengths and weaknesses, deciding what to play up and what to ignore. Everyone has self-doubts. The women in the book have learned how to deal with theirs. You can too. Start searching from top to bottom, inside and out for a better, more beautiful you.

I have always been fascinated by the power of beauty. But my ideas of exactly what beauty is have not always been so well defined as they are now.

When I was a young boy, the beauty and glamour possessed by my two older sisters stood in direct proportion to the number of hours they were allowed to stay up after I had to go to bed. My ideas about beauty changed when, at the age of ten, I was exposed to the movies and Dorothy Lamour. Wild-haired and saronged, she was more than a match for my sisters no matter how late they stayed up.

Nonetheless, the way I saw it, the only difference between Dorothy Lamour and my sisters was a little bit of make-up, wilder hair, more exotic clothes, and a thoughtful eye behind a camera. Nothing was easier than convincing my sisters to allow me to put some panchromatic make-up on their faces, run my hands through their hair, and dress them up in sexy gowns, and with the help of a floodlight attached to the standing lamp in the living room, take their pictures with my father's camera.

Pretty soon I had all my sisters' girl friends lined up in front of my house, prom dresses over their arms, begging me to "make them over." I did and I loved every minute of it. Although my sisters never quite became mirror images of the movie star I adored, I think they discovered something far more important. With their pictures as proof, they saw that somewhere inside them was a more beautiful, more glamorous person than they had ever thought possible. They became aware of a new energy, a new potential, and they haven't stopped trying to improve on themselves since.

After years of being a photographer, specializing in fashion, beauty and personality photography, I am convinced that I can make women look better, and show them how to see and realize that better, more beautiful person in themselves.

It starts with...

LIKING YOURSELF . . .
Beauty must begin with self-confidence that builds up to an attitude of total self-respect. What good can you really do or feel for others if you aren't aware of the best possible feelings you can have about yourself? It's a matter of taking pride in your appearance and achievements. It's not letting any of your strengths go to waste. It's getting in touch with all the positive power within you and using it to create a sense of yourself that allows you to care for yourself and others in the most affirmative way.

If the face, the body, the physical being go uncared for, a person has gone to waste.

MAKING A COMMITMENT TO YOURSELF . . .
to find a better you. Building beauty takes time and energy. Time . . . to define what your problems are in terms of your face, body, diet, dress. Time . . . to map out an intelligent set of solutions, a system that works within your lifestyle and your abilities that will provide maximum results. And energy . . . to carry out your plan, because beauty takes work.

STRIPPING OFF EVERYTHING . . .
your clothes, your make-up, even your preconceptions of what beauty has meant to you up until now. Stand, washed and naked, in front of a full-length mirror, in a room lit only by candlelight. Concentrate on forgetting whatever anyone has told you about beauty, what anyone has said you look like. Get rid of all the ideal images of beauty: the movie stars, the television personalities, the magazine models who have been set before you as something to strive for, something to wish for. Just deal with what you've got. Decide to develop something that is your own.

ANALYZING YOURSELF . . .
feature by feature, strength by strength, fault by fault. Get to know yourself intimately by going back to the mirror again and again, revising, improving the reflection you see. Put a name to your looks, your build, your kind of life and work within those boundaries. Work only with the elements that make up the *real* you.

HAVING YOURSELF PHOTOGRAPHED . . .
Have pictures taken of yourself constantly in every situation: working, eating, gardening, cooking, waking up, undressed, dressed up, made up, un-made up. Photograph parts of your body, photograph yourself in different outfits, with your hair different ways, and keep a record of how you are doing. See how you can become more aware of yourself—progress through photographs. Cameras and film are inexpensive enough to be readily available to everyone. You don't need "portraits"; you just need snapshots. You'll find that photographs provide a legitimate criticism of you—they provide the "other eye." It's not the eye that sees you in the mirror, subjectively. It's the eye that sees you enter a room, walk down the street, sit, stand, gesture . . . the eye that sees the way you move, the way you look in life.

Getting used to being photographed and getting used to using a photograph to look at yourself, to pick out points about your looks, posture, presence, will give you a brand new perspective. Don't pose. Work to become completely unaware of the camera. You can't race for a comb and the bathroom mirror every time you're about to speak to someone, so don't do it before a picture is taken. What you're looking for is a sense of how you look to other people all the time. Photographs will show you, quite candidly, some of what others see that you don't. You can learn what parts of your body to minimize, what parts to maximize. Realize that everyone has problems, and work to overcome your own.

Finally, understand that a still photograph, because it catches you and freezes you in time, exaggerates certain things that ordinary motion conceals. I retouch my photographs only to take away what I never saw in the first place, a stray hair, a line . . . things that are only apparent when you stop motion. Remember, people are alive . . . they move. When you're dead, you don't get away with much.

DECIDING TO GET HEALTHY . . .
Think seriously about what you eat, when you eat and whether you need to gain or lose weight. Do you smoke? Drink? How much do you really know about nutrition? Do you know how much of the energy you need to lead your life comes from eating the right foods? Consult with your doctor to plan a diet—if not to lose or gain weight, then simply to include foods that are going to make you healthier, that your body needs to function.

I came to an awareness of how important health is in an extremely dramatic way. Twenty years ago I developed arthritis and was completely paralyzed. I had to be dressed every morning. I was shot full of chemicals, cortisone, the works, and I suddenly thought, All right, that's it. I'd had it with the chemicals and the shots, and I just started eating organic foods. I never went to a dinner party without taking my own little care package with me. I went to shop at a health store twice weekly and loaded up my station wagon with food so I

would never be tempted to dash out for a snack that might kill me. I went into periods of eating only rice, water, and Moo tea to purify my system. But I work and have to use my head, so I can't get away without eating some substantial food. Chicken raised without chemicals and hormones and fish from unpolluted streams became part of my diet. I don't eat meat unless it is organic "health food" meat because I'm not sure what it does to my body and my arthritis problem. Every morning I have the same breakfast of two soft-boiled eggs, a slice of toast, whole wheat or any kind that has no chemicals and preservatives in it. I eat only organic grain, unbleached flour, honey, raw milk, a special drink of two teaspoons each of honey and apple cider vinegar in a glass of mineral water. I steam my vegetables for fifteen minutes; then I squeeze lemon juice and add a little bit of sesame seed oil and pepper. That's what I do, and it works for me. Now I'm jumping around like a cricket.

But back to you ... If you want to lose weight, get on the scale, same time every day. If you need to get in shape, plan an exercise program now. If you lead a sedentary life, maybe you should take up jazz dancing, fencing, tennis or gymnastics. If you're generally active, running around at top speed all the time, you may need a quieter form of exercise. Investigate Yoga, simple stretch exercises, isometrics.

Plan a hair and skin care system and stick to it. It's cleanliness and health first when it comes to skin and hair. Visit a skin specialist and work together to find a way to get your skin in peak condition. Check with your haircutter to find out how best to take care of the kind of hair you have. Make a year's worth of appointments with someone you trust to cut your hair right. And keep to it.

STICKING TO IT ...
Just a word about discipline. Remember when our parents said, "Eat your vegetables, brush your teeth, wash again behind your ears"? I think they were trying to tell us something. You have to do these things for your own good. And if you didn't grow up inspired by the kind of discipline your parents imposed on you, then you have to come to discipline on your own. Every time you catch yourself saying, "Oh, it can wait, I'm too tired," or simply *"mañana,"* you're chipping away at your own stone. Stop yourself, push yourself to do it.

**CONTROLLING
YOUR ENVIRONMENT ...**
You love yourself, right? So if you're doing all this work to make yourself a happier, more attractive person, show yourself off to your best advantage ... always. Start in your own home with lighting that sets you (and others) off to perfection. Eliminate overhead lighting entirely, or put overhead fixtures and chandeliers on dimmers. And keep them low. Overhead light casts strange shadows, elongating noses, deepening and darkening circles under the eyes. Make as much use as possible of table lamps. But be aware that they too bounce light off the ceiling, causing the same effect as overhead lighting. Line the top opening of the lampshade with aluminum foil. Invest in opaque lampshades (they act as the kind of filters that the best—and most beloved—cameramen and photographers use) or translucent lampshades, but put in soft, low-wattage bulbs or drape scarves over them to cast the softest,

Self Analysis Chart

To help you think analytically about yourself, go through this chart and jot down your observations about yourself.

Body

Weight	
Height & proportions	
Condition	
Good features	
Bad Features	

Face

Shape	
Skin condition	
Strong features	
Weak features	
Bone structure	

Hair

Condition	
Shape & haircut	
Length	
Color	

Style & Attitude

Do you feel good about yourself?	
Do your clothes fit your life-style?	
Do they make you feel good?	
Do you want to look better?	

most flattering and diffused light. Have un-dreamed-of success as a hostess by placing candles wherever there's a surface, including the bath. It's seductive. If you're not already convinced that modern technology is working against a more beautiful you, flip open a compact in a modern elevator, or glance at yourself in the mirror in a supermarket or drugstore. Fluorescent lighting makes people look dead. If you have fluorescent lighting in your office, buy a table lamp and turn off the overheads forever. I also find modern hotel and motel lighting grotesque, so I pack along a bag of scarves to drape over the lamps in my room. You have no idea of the power of positive lighting.

KEEPING YOUR CLOTHES AND MAKE-UP SIMPLE ...
Before you put on a thing—lipstick, eye shadow, an accessory—think "Do I really need this to make myself look good?" I think the mistake that women make most often when they're unsure about how they look is to try to cover up and conceal—piling on color after color, bracelet after bracelet, curl after curl until they have made clear beyond doubt that they don't know what they're doing.

With the experts that I work with in my studio I have worked out very simple procedures for skin care, make-up, hair and dress that will help you start from scratch and build up, bit by bit, a look that is sensible for you.

Beauty Index

Each of the women in this book talks about her body, her face and hair, her style, but you'll see that each of these women—just like you—thinks most particularly about one or two features or problems or assets. To help you find out what these women say about things that may be of special interest to you, use this checklist—the numbers refer to pages in the book.

	10	12	16	20	22	24	28	30	33	34	36	38	40	43	47	50	55	56	58	61	65	68	69	72	76
Body																									
Weight #												✓		✓											
Height #																				✓	✓			✓	
Diet #	✓	✓	✓		✓			✓	✓		✓	✓	✓	✓					✓				✓	✓	✓
Condition & exercise #	✓		✓		✓						✓			✓								✓		✓	
Large features #					✓																	✓			
Small features #					✓																				
Face																									
Shape #				✓											✓										
Skin #	✓		✓	✓									✓												
Condition #	✓		✓								✓														
Care #	✓		✓								✓					✓			✓			✓			
Bone structure #					✓	✓		✓																	
Strong features #														✓								✓			
Weak features #			✓																						
Make-up #		✓	✓		✓	✓		✓	✓	✓		✓				✓			✓		✓				✓
Eyeglasses #																									
Hair																									
Condition #			✓	✓		✓		✓													✓				
Haircut #			✓						✓							✓	✓	✓			✓				
Length #			✓	✓			✓			✓	✓								✓		✓				
Color #																					✓				
Care #		✓	✓	✓		✓			✓										✓				✓		
Wardrobe	✓	✓	✓	✓		✓	✓											✓		✓	✓			✓	✓
Perfume			✓													✓			✓						✓
Accessories																									
Lifestyle			✓	✓									✓								✓	✓			✓
Attitude		✓	✓			✓					✓	✓	✓	✓							✓	✓			✓

81	86	90	93	97	98	102	104	108	110	112	114	117	120	124	126	128	130	132	138	142	144	148	154	155	161	166	168	170	172	176	180	187	190	
					✓								✓						✓					✓			✓	✓						
																					✓		✓	✓		✓								
			✓	✓						✓				✓				✓	✓				✓	✓	✓	✓	✓	✓	✓	✓	✓	✓	✓	
✓		✓	✓		✓					✓									✓				✓		✓		✓				✓	✓		
	✓		✓				✓												✓															
	✓		✓			✓																										✓		
				✓																														
														✓																		✓		
														✓																				
✓		✓	✓	✓	✓	✓	✓			✓			✓	✓					✓				✓	✓	✓				✓		✓	✓		
																		✓											✓					
			✓							✓							✓		✓															
					✓											✓		✓		✓														
	✓				✓	✓		✓				✓		✓	✓		✓	✓					✓	✓			✓			✓		✓		
												✓																						
✓																								✓	✓					✓				
							✓			✓												✓								✓				
		✓							✓			✓		✓		✓																		
				✓										✓							✓		✓					✓		✓				
				✓									✓														✓		✓	✓	✓	✓		
✓		✓	✓				✓											✓	✓	✓				✓		✓	✓					✓		
✓				✓		✓	✓		✓	✓	✓							✓			✓		✓		✓				✓					
✓				✓	✓	✓	✓																					✓				✓		
✓		✓				✓	✓	✓						✓					✓		✓		✓		✓					✓	✓	✓		
✓		✓	✓		✓		✓							✓	✓			✓	✓		✓						✓	✓	✓	✓	✓	✓	✓	

STAYING FLEXIBLE

Stay open to new ideas. Once you have developed a sense of yourself and what's right for you, it's going to be impossible for you to make big mistakes. If you've really worked through the steps I've listed for you above, you will know yourself well enough to be able to adapt any new idea that comes along that you think will suit you. If you know yourself and what's right for you, you can't go wrong. You'll develop an ideal passport picture of yourself, good for unlimited travel in your world.

1. Like yourself—beauty begins with self-confidence that builds up to an attitude of total self-respect.

2. Make a commitment to yourself to spend the time and the energy necessary to define your own personal beauty.

3. Strip yourself of all your clothing and your make-up—and of all the preconceptions you hold about what is beautiful and who is beautiful. Forget what anybody has told you about your own looks—see yourself freshly.

4. While looking in the mirror, analyze yourself. Analyze your strengths and weaknesses. Put a name to your looks, your build, your life-style.

5. Keep a record of yourself in photos. See yourself as others see you, and learn what parts of your body you should maximize or minimize.

6. Decide to get healthy. Plan a diet and exercise routine and a skin and hair care system that are right for you.

7. Discipline yourself. Care about yourself enough to stick to your routines and schedules.

8. Control your environment—your home or your office—to make sure it shows you off to the best advantage.

9. Go back to basics. Keep your hair, make-up and clothes simple, and expand your style only as you become comfortable with yourself.

10. Stay open to all ideas. Keep yourself and your style flexible so that you will be able to change as change is necessary. It's okay to imitate, but you should make sure that you know yourself really well first.

Mario Badescu

ON SKIN CARE

Before you start any kind of skin care program, before any product touches your face, you must know what kind of skin you have. If you have never gone to a skin care specialist, here is a simple method to test for your kind of skin at home.

Cleanse your skin with shaving cream and warm water. Wait two or three hours so that the skin can regain its acid balance. Then place small pieces of cigarette paper on different parts of the face and press firmly; release your hand.

> *Normal skin—paper stays on the face and, on examination, shows no oily spot.*
>
> *Dry or dehydrated skin—paper will not stick to the face.*
>
> *Oily skin—paper adheres to the face and shows an oily spot.*
>
> *Combination skin—will show oily spots in some areas, dry in others.*

Also check to see if your skin shows any evidence of broken capillaries. If it does, you must treat your skin as sensitive and use products and take measures that will give skin more protection from sun and the elements.

Whatever your skin type, the most important thing you can do for it is to keep it clean. Never go to bed with make-up on. When you cleanse your skin, avoid the use of too hot or too cold water and drying soaps (particularly if your skin is sensitive). After the age of twenty-five, the sebaceous glands which produce the sebum that keeps your skin lubricated tend to become lazy and do not operate as efficiently as before—all the more reason to cleanse your face only when necessary (morning and night) and with as mild a product as will clean effectively without robbing the skin of natural oils.

As a rule, for any skin, a light moisturizer applied after cleansing and before make-up is essential. A night cream at bedtime is also a must for skin. However, when the weather changes, so should your skin care system.

Moisturizers, in general, can contain from 50 to 70 percent water. This is great for parched summer skin, skin exposed to heat or normal weather. However, in winter, that water works against your skin, freezing with the cold weather rather than forming a protective film. Winter is the time to switch to a protective cream or even night cream for daytime use, as its richer formula provides the protection without the water content. Moisturizer should be used winter nights when steam heat is turned on high, and water in the air at home is scarce.

SKIN IN THE SUN

What kind of skin you have dictates your limitations for exposure to the sun. Dry, sensitive skin obviously should not be exposed to the dehydrating effects of wind and sun. People with normal skin should also take it easy and never stay exposed more than half an hour at a time to direct sunlight. (Also remember that cloudy days can be as crowded with invisible and damaging sun rays as the brightest. You should only expose skin in the afternoon when the sun's rays are less intense.) All skins should make use of sun screen and sun tan products to tan lightly without burning the skin. Don't forget hats and scarves when you are going to be exposed to the sun for a long time . . . and don't forget to cover your neck as well. Consider your neck as part of your face, and give it all the care and treatment you give your face. After any exposure to the sun, be sure to apply moisturizer to both face and body (you don't need a heavy cream or petroleum jelly—the skin is dehydrated and needs *water*).

HOME FACIAL

After the age of twenty-five women generally need facials once or twice a month. Again, sensitive skins should stay away from exceedingly hot towels and steam. Boil water with a pinch of camomile tea and sit far enough away from the steam that it is not uncomfortable. (For dry and sensitive skins, apply a protective cream before steaming.) Then apply a moisturizer and gently massage the face with feathery strokes moving upward. Do not pull at your skin. The exercise of light massage is to bring blood circulation to the surface so that oxygen from within the bloodstream can nourish the skin cells.

Do not touch blackheads that you may notice. This is really a job for a professional.

After the massage, you can apply a mask that suits your skin type. The mask serves to smooth the skin, dissolve the impurities brought out by steaming and generally improve the texture of the skin.

The last step is to apply moisturizer once more. Do not apply make-up for at least two hours, as the acid mantle of the skin needs time to restore itself. Since the acid mantle is what protects your skin from the bacteria in the air, the pollution in the atmosphere, and the pollution of make-up, it is important that it restore itself before any make-up goes on.

A FINAL WORD

Don't try to cover up your problems with make-up. That will only make them more serious. Consult a skin specialist or a doctor if you have persistant skin problems.

Way Bandy

ON MAKE-UP

WHERE TO MAKE UP

When you're making up at home, use natural light, but don't sit right at the window so that the light is floating in directly on you. Sit back from the window about six or eight feet. The light from the window should be coming in *on* your face (not on the mirror). If you are too close to natural light, you'll either put on too much make-up or too little, because natural light is "raw" and you will end up compensating for it in the wrong way.

If the room you're sitting in is relatively dark, supplement window light by putting lamps on either side of your face so that the light comes onto your face at eye level.

WHAT MAKE-UP TO PUT ON ... AND HOW

1. If you need it, and most women do, start by applying a treatment to the skin—a moisturizer, a hydrating fluid or a protective lotion.

2. If you need to cover imperfections, use a thin liquid foundation or cover stick in a flesh tone (just on the areas that need it, around the nostrils, for instance). You can also use under-eye cover cream to cover any discoloration on the face, as well as to lighten the area under the eyes.

3. Because moisturizers, treatment lotions, etc., tend to leave your skin a bit shiny, you may need a very sheer, finely milled, translucent powder to give a more matte finish to your face. This powder doesn't give complete coverage but smoothes the uneven tones in your skin. Take the powder and put a dash in the palm of your hand. Now take a complexion brush or blush-on brush in your other hand and dab it in the powder. Then flick the brush in a swift motion, as if you were flicking an ash off a cigarette to get rid of excess, and go over your face very lightly with the brush, to dull any sheen.

4. You may want to use an eyelash curler, because curling your lashes really opens up your eyes and gives them a sunburst effect. (Anything that has a raylike appearance automatically looks larger and more open.) The technique of curling: Once you have the curler in place on the eyelashes, don't grip and hold for a certain number of seconds, rather, give the curler several split-second squeezes. Don't open the curler between each squeeze, simply relax your grip. Curl the lashes up from as close to their base as possible to make them look their longest.

5. To blend the most natural of blushes onto your skin, pinch your cheeks so that the blood rushes up to give you a natural flush. Find a thin liquid or gel-type blusher that duplicates the color of this flush. Apply it to the "apple" of your cheek or to the highest point of the cheekbone near the temple.

6. For emphasizing eyes, I prefer a cake eyeliner in a round pot to mascara. Wet a narrow-bristled brush, dip it in the pot, and just dot the eyeliner in among your lashes, top and bottom. A little more definition can be added with an eyebrow pencil, used to rim the eye and smudged in with your fingertips.

Note: To eliminate the use of mascara on lashes, try having your eyelashes dyed black or dark brown, depending on your natural hair color.

7. Nature is an intelligent blender of colors. Your skin has very subtle natural tones, and you should take a lesson from nature when learning how to blend colors for your face—particularly eye shadows. For instance, a blue eye shadow will always be bluer than the blue of an eye. If you put on a blue eye shadow to make your eyes look bluer, all you have done, really, is conquer the color of your eye. Rather, you should contour your eye with gray-brown, taupe-brown, or flesh-brown, and highlight with a peach or beige tone to get a definition of your eye without conquering its natural color. As a result, the color of your eyes, blue, green or brown, becomes stronger and more important.

8. Lips look best with just a little tinted lip gloss. Experiment with different, subtle colors before you start to crayon on more strong, definite lip colors.

PIMPLES

I find that plain alcohol is the best thing for cleansing a pimple, and keeping it out of danger of developing a red-color infection.

AND ONE WORD TO PARENTS

Encourage your child to take care of her skin. All children start out with clear skin, and they should be aware that they must work to keep it that way. In my opinion, a child who is fed a nutritionally balanced diet of natural, raw food free of synthetic and processed ingredients should do nothing more than splash her face with mineral water in the morning and blot it with a clean towel. That's all the treatment a normal skin needs. Try to show her the beauty she already has. Let her learn to apply make-up by experimenting—when she finds it fun.

Harry King

ON HAIR

I think that the color, condition, and shape of hair can make or break a person. It's that important. It's a feeling of self-confidence. Hair can make you feel marvelous or desperate, depending on the cut. Before I give a haircut, I like to talk to the person to find out about her, to sum up her life-style. Whether she works or is a housewife, her haircut should fit her life. I look at the individual woman, I study her, her mannerisms, her personality; I ask her about the kinds of clothes she likes to wear and how much time she can afford to spend on herself. I try to cut her hair according to the kind of life she leads, to suit her. I think if it takes you ten minutes to get dressed, it shouldn't take you an hour and a half to get your hair together. I think one should be able to wash one's hair and forget about it. It should be as easy as that. But in order for hair to do that, it must be cut according to its own natural inclinations, cut the way it wants to go. If it needs to be set, fine; but if you're using heated rollers I suggest wrapping the roller first with Kleenex to prevent hair from splitting and breaking.

Of course, when you talk about hair, you're talking about health first. Diet, stress, climate are all going to affect the way your hair looks. Naturally the most important thing you can do for hair is keep it clean. I would suggest changing your brand of shampoo every so often, as hair tends to get used to one. As far as conditioners go, I think the best one is simple coconut oil, because ordinary conditioners, I find, can leave hair greasy and heavy.

Robert Renn

ON HAIR COLOR

Hair color must do something to make you look better—not just different. And to make sure you get the maximum benefit from any hair-coloring process, the first step should always be a consultation with a colorist with whom you can communicate and whose taste you trust. Any good colorist will ask you life-style questions. Do you work? You'll want the easiest, least time-consuming hair color that will look right in every situation. How much time do you spend in the sun? You may simply need to tone down brassiness caused by exposure to the sun. What colors predominate in the wardrobe? You don't want to go home a redhead to face a closet of brunette clothes. You should also discuss the time, care and expense involved in the particular kind of color you want. Plus, the cut you want should be worked out in advance so that the color can complement the new shape of your hair.

It is not always necessary or desirable to change from one complete color to another, or even to put in "streaks" of a much lighter color than your base tone. Particularly if you're a newcomer to coloring, you may find that subtle highlights or undertones may be best for you. They can add the excitement that natural color sometimes lacks without the shock of an all-over unfamiliar color. And they're much less expensive. Since undertones and highlights grow out naturally, there'll be no "roots" to show—and you won't be making frequent visits to the salon.

Color can do wonderful things for your hair, as well as your looks. It can give added body to your hair; it can retexturize it. Adding the proper tones to hair can pick up your skin tone, or add the illusion of contouring to the face. Putting darker tones underneath lighter ones can even make thin hair appear thicker.

If you're undertaking home hair coloring, be scrupulous about reading the directions, and you'll be assured of getting good results from any reputable product. If you don't quite trust your taste yet, hair-painting and high-lighting kits are available that will provide temporary color while you experiment and develop an eye for what will work best for you.

If your hair and skin are naturally beautiful, keep the rest understated

Princess Aga Khan

Scavullo: How long have you been studying classical singing?
Princess Aga Khan: Eight years.
Q. You just decided you had a voice at one point?
A. Yes, I was in boarding school, joined the school chorus, was given a solo, and really loved it. I discovered I had a voice and that I could really express myself. It made me feel very good, a very positive sort of a feeling.
Q. Is America the best place to study voice?
A. Yes, I think at the moment it is the best place for me to study.
Q. So you like living in New York . . .
A. Yes, my friends and music involvements are in New York and I can't live without the two. And also there's a lot of opportunity for musicians. There are so many places for a young musician to audition—it's exciting!
Q. You're a very beautiful young girl, and I've always thought that New York destroys a woman's hair and skin. How do you take care of your skin?
A. Yes, one has to. I go once a month and have my skin cleaned and use special herbal products from Jane Sebeyran of New York.
Q. Is that it? Or do you take care of it at home, too?
A. I just use natural products.
Q. Do you watch what you eat?
A. No, not always.
Q. Are there things that you eat that you know are bad?
A. Yes, candy, cookies, etc.

Q. What do you eat, then?
A. Vegetables, meat, fruit, tomato soup, cottage cheese, Swiss cheese, peanut butter and an Oreo cookie here and there.
Q. But peanut butter is very good food.
A. It's bad for your skin, apparently.
Q. It is? Diana Vreeland told me she raised her children on peanut butter.
A. Well, a lot of dermatologists have told me to stay away from peanut butter and chocolate.
Q. So you don't have any kind of a diet?
A. No, I feel healthy, and I am healthy—knock on wood.

"I eat a lot of junk, mostly junk, unless I'm going out to a restaurant with friends— then I have a proper meal."

Q. Do you exercise?
A. I play tennis, ski, swim, ride my bike and do a lot of walking. I have no real routine. But I'm a pretty athletic type of person.
Q. Do you go to school every day?
A. Every day.
Q. What do you do in the summertime?
A. I keep on with classes until the end of July usually and then I take August off. During June and July I'll go to the country on weekends.
Q. If you have time off where do you like to spend it?
A. It depends. If I have work to do I stay in New York and do that, and if I find that I've memorized my music or I've got it pretty much under control, then I'll take the weekend off. I spend the Christmas holidays and the month of August in Europe.

"I discovered that I had a voice and that I could really open my heart and it made me feel very good."

Q. What is your idea of a marvelous evening?
A. A marvelous evening can be with very good friends at a house or out at a restaurant. It can be going to a play or a concert and seeing a great performance. A super performance is so inspiring and uplifting. That can really make the week.
Q. Do you like to go to discotheques and night clubs?
A. Yes, I do enjoy it once in a while.
Q. What are your feelings about clothes?
A. I like clothes and shoes very much.
Q. Do you like the clothes you can buy here in America?
A. I just have to look very hard.
Q. Do you have favorite designers or shops?
A. I love Chloe, Ungaro, St. Laurent, and Valentino. Their clothes are works of art!

When I met Yasmin I wanted to photograph her instantly. She has a magnetic aura about her that reminds me of her mother, Rita Hayworth.

Her mouth is sensational—it can be pure "actress," pure excitement, laughing or lips closed. It's perfect.

She needs almost no make-up, since her eyes and skin coloring are naturally dramatic. Her features—like her presence—are fine, sensitive, subtle.

10

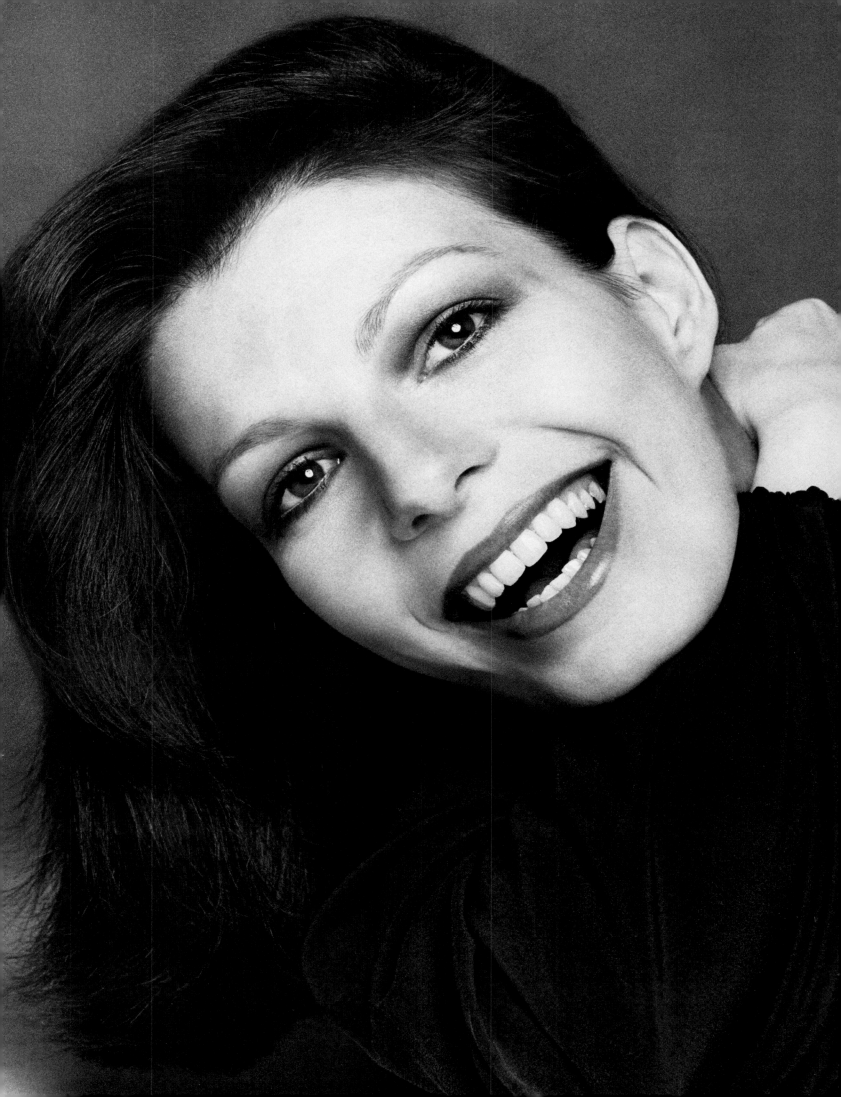

If you're young, experiment

Andrea Portago

"I think anybody who says, 'Oh, she's a beautiful person' is just a kook."

Scavullo: What is your personal approach to beauty?
Ms. Portago: I think it's important to be clean.
Q. Do you like to use make-up?
A. I use a little eye shadow and I always put on mascara, rarely anything else but sometimes a little rouge. If I have to go out someplace special then I put on base, but that's once a year.
Q. Have you ever worn a great deal of make-up?
A. When I was a teen-ager in the sixties at the time of Twiggy et al. I used to run home with her photograph in front of me and sit in front of the mirror and make up. I looked like a monster. In fact I wore so much make-up that you couldn't even see what I looked like. I went through that extreme stage in the sixties.
Q. What do you do about your hair?
A. One thing I hate is dirty hair; hair has to be always clean, and skin should be clean. I spray Evian water on my hair and because I've got kinky Spanish hair I blow my hair dry to make it look long and straighter.
Q. What about your diet?
A. I drink a lot of mineral water. I love milk. I eat a packet of Oreos and a carton of milk, at least, once a day. I also eat vegetables and a lot of meat. I don't have any particular diet.
Q. How do you feel about clothes?
A. I love old American Indian dress and Eskimo dress. They dress beautifully for the lives and the climate they have. Things that work for your life and don't get in your way.

Q. What are some of the things you need for beauty?
A. I love to be alone. It's a holy thing for me. I love space around me—physical space. But the thing I need to make me feel good is privacy, sitting around my apartment and working. I have to have freedom. I love it when I'm really laughing.
Q. What do you think beauty is?
A. I don't relate to the word beauty, but there's an emotion you can get. It's the beauty in the human experience and what we all go through, and that's what moves me so much and that's beauty to me. It has absolutely nothing to do with the physical appearance. Nothing at all! I'll tell you what else beauty can be . . . it can be someone who is extremely compassionate. For me beauty is something elusive, it is a sudden flash, a clear bright light that sparkles for a few moments. It is those moments when you are suddenly transplanted somewhere else, that place where you have for an instant lost yourself or given yourself totally, to the point where you are no longer thinking of you. You are simply being transfixed by this other thing. It mesmerizes you. Or perhaps you see a family, a young man, a woman or a child, and you can see all the tenderness between them; it almost always seems to have a certain sadness which runs through it—perhaps because it is something fleeting—it is only there at that time *once,* and then in an instant it has gone. It will never come back, it will never be the same—that is the real reason that it is beautiful. That is life and our inevitable death.
Q. Who are the women you really admire?
A. I tend to lean more toward men. I always wanted to do the things the men do. I always read plays, and the man's part I understand 100 percent; the women's kind of go beyond me. I admire people, not just women, people who have removed themselves from a very

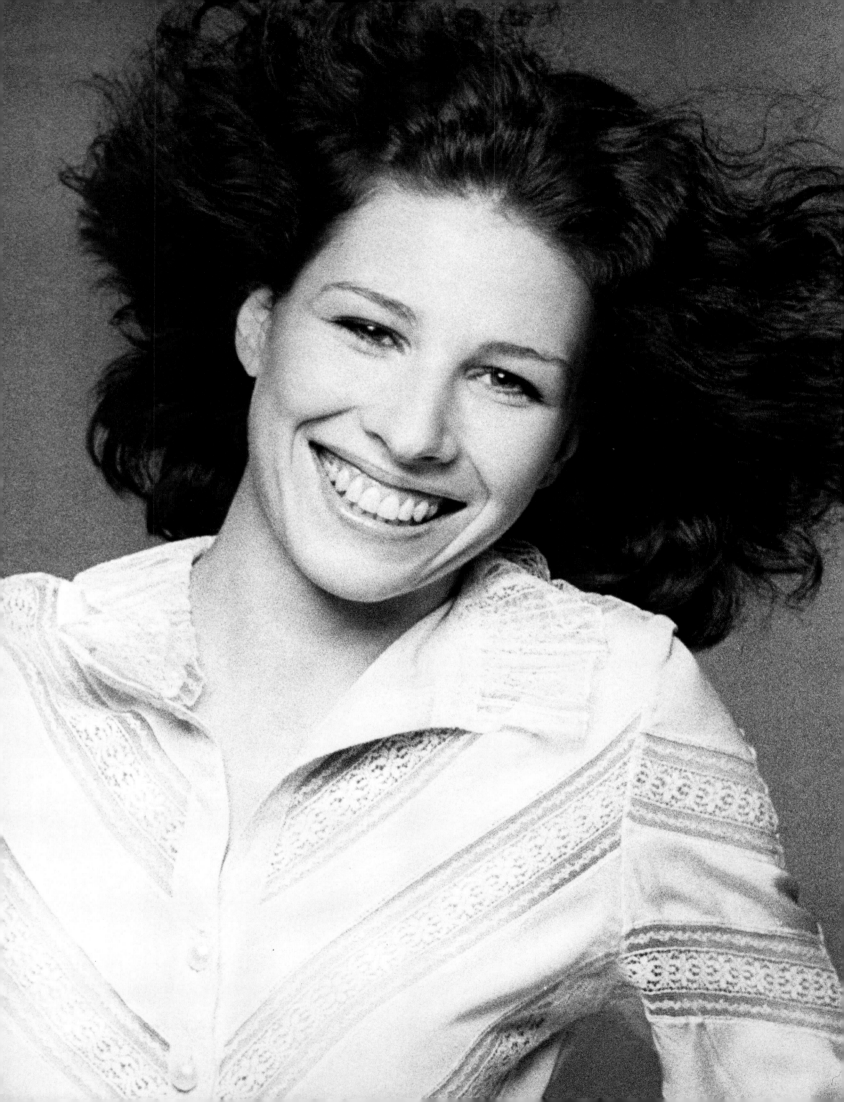

difficult trap or situation that is dead. For example, people who have gone outside of the element that society dictates to them or that they are supposed to be in. People who have been strong enough to go out of whatever environment they're supposed to be in, people who are strong enough to be loners, people who are not club members—on every level I admire that. Or people who can transcend all that and go somewhere else. But I think that my family is very much like that—I've always done that. You have to go through that to get out. But I just admire people who are strong enough to break away from any sort of a mold, pattern—and that includes people who carry around their "hip" cards. They're not hip, they're not hip at all. They're just as un-hip as the so-called straights you see walking around. They have been unable to remove themselves from the security of backslapping among themselves. It's just a clubhouse, and I admire people who are strong enough to break away.

Q. You once told me you admired Marlene Dietrich?
A. The reason I said those things in those days was that I didn't know who I was. I used to sit in front of the TV and watch old movies and try to find someone to be, and at that time it was Marlene Dietrich I was imitating. She would not be on my list today.

Q. Do you have any hang-ups?
A. Yes, my privacy and being intruded upon. I'm terrified of being misunderstood, and I frequently am because people tend to take me seriously. That's my big problem. Another hang-up is that sometimes I feel guilty about not concentrating on one particular thing or having specific work or a career. But really it's because I'm so interested in so many different things, and I don't think I have to limit myself to one area.

Q. Can you list quickly ten things you love in life?
A. I love cigarettes (I know you wish I didn't love cigarettes so much). I love soft old cotton sheets, white, plain. I love my dog (female Siberian Huskie—name: So Good). I love chocolate. I love milk, especially I love milk. I love my cowboy boots. I love my blue jeans. I love the quiet in the middle of the night especially. It's holy to me, it's a holy thing. Somebody else can be with me, but the quiet in the night . . . no one bothers you then. I love America. I love airports and cheap diners because of their anonymity. I love motoring around in the middle of the night with the lights from the dashboard as company. Music is very important to me. I love the fantasy of cowboys. I love the earth. I love to be alone. I love it when I'm really laughing, I love to laugh. I love kitchens. If I have ten dollars in my pocket I'll go buy a new pot or something like that to cook in. I buy stuff for my kitchen before I buy anything else. I like taxis too, but I like to walk. I love the idea of the country. Country like Wyoming and New Mexico. I love my cactus when it starts to flower. One thing I really love is meeting somebody that lifts off the top of your head—it's like setting you free. They show you something or make you see something that maybe you've been looking at for ten years and you never saw it that way before, and they show you a new way to think about it. I love people like that. I love people who are excited, who want to do something. I love seeing a great performance where an actor or an actress really shows you something wonderful. I love

it when I do something that is very disciplined and concentrated and that I've had to work hard for—I love that. I hate status, too, any kind of status. I hate clubs, any kind of clubs. I don't mean that it has to be a building that you join or the golf course. I mean just a club of people, cliques, clubs . . . I hate those sorts of things. I love *Hogan's Heroes* and old *Lucy* shows.

Q. You have dozens of pairs of shoes.
A. I'm a shoe freak and a boot freak, especially boots. Things I'm most comfortable in are things I have a sense of humor about. I love blue jeans because you can wipe your hands on them.

Q. What is your idea of an ideal evening in New York?
A. Getting a newspaper and picking out a movie I really want to see and go see it and go have dinner afterwards, just pizza or something.

"The things I'm most comfortable in are the things I have a sense of humor about."

Q. Alone?
A. No, with a friend. That's my idea of a hot evening.

Q. Can you describe your own looks?
A. I think I'm interesting looking, and I'm different looking and perhaps a little exotic. I think what's interesting about my face is not that it is beautiful or it's ugly or any of those adjectives, it's that my face expresses what I'm feeling and thinking, and that's what is strong about my face.

Q. What does it take to make you look and feel good?
A. Yoga.

Q. What is your favorite color?
A. I love colors so much that if I see a pair of shoes that are in ten different colors I'll be there all day trying to figure out which pair to buy, and I always end up buying none of them.

I adore Andrea. Always changing and every change is fabulous. I think the excitement she creates comes from her darkness, the Spanish blood of her father. It gives her an eroticism and sexiness that shows in the way she carries herself, the way she talks, and the things she does. Andrea is a very dynamic girl; proud, intelligent.

I love Andrea's beauty without make-up. She looks wonderful with scrubbed skin and shiny hair, but the power of her looks is in her eyes and the fullness of her mouth so she comes off impeccable but energetic and sexy.

Andrea can wear different looks: romantic, the dressed-up young woman, chic and tailored, or sporty in dungarees and suits.

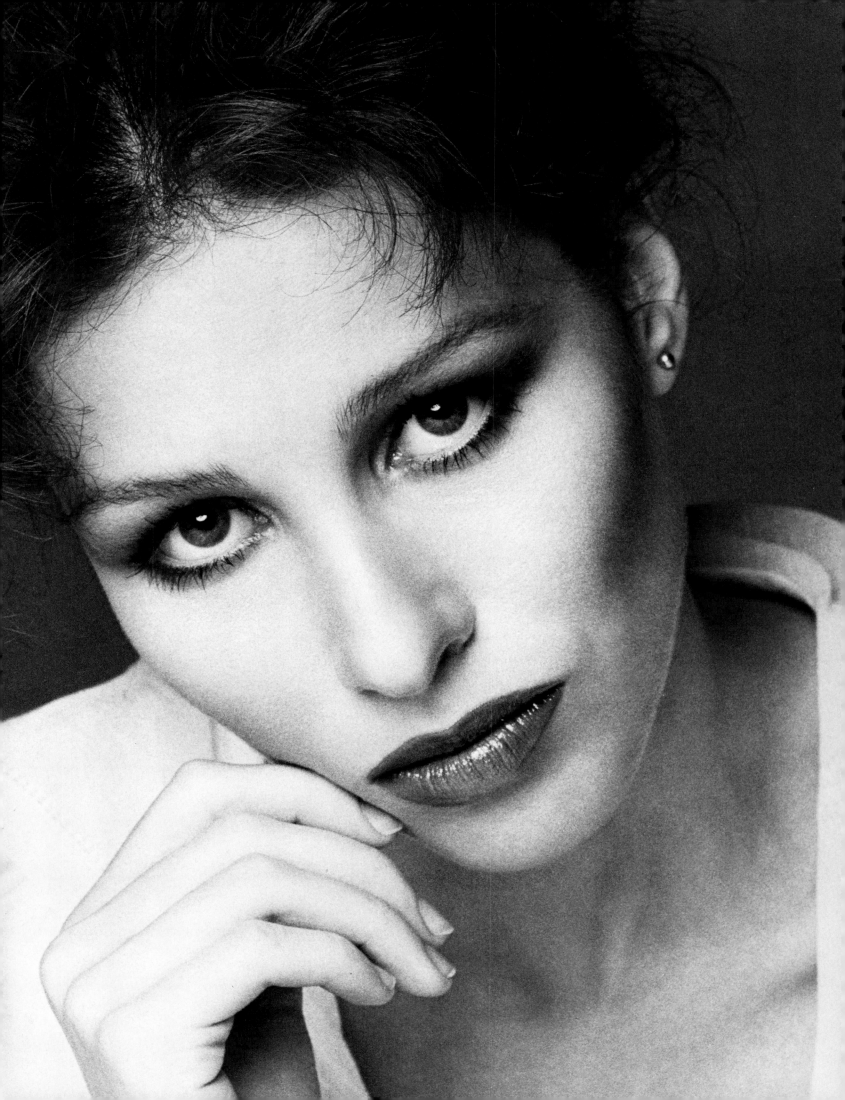

Sensational looks rely on a strict health regimen

Marisa Berenson

Scavullo: What does beauty mean to you?
Ms. Berenson: It has more to do with someone's aura than with specific features. It's something that comes out of people and surrounds them and is in their personality and part of their soul.

Q. Do you consider yourself beautiful?
A. If you're talking about beauty in the classical sense, if you're talking about someone like Garbo, I don't find myself physically perfect at all.

Q. What are some of your beauty problems?
A. Obviously it's important in my profession to look good, but I think you can get hooked on that—as people do when you are constantly being photographed and when, as a model, you have to stay skinny—it can become an obsession. As long as people accept me for what I am, I accept myself. Let's face it. No one is ever really pleased with how she looks. One always wants to be different. I always wanted to have sunken cheeks and great bone structure.

Q. What do you think about make-up?
A. I say "Thank God for it." I really love it. It's necessary when you want to look extra glamorous or you feel tired and depressed.

Q. What kind of make-up? A lot or a little?
A. I don't wear a lot of make-up. Sometimes in the evening I wear a little more on the eyes. I wear blush-on and a very light make-up, because I like the look of very pale skin. I just put a little mascara on during the day, and in the evening, I shade my eyes with black or purple, very misty. I like things that aren't hard. I used to wear very red lipstick, but I've gotten away from that. It's nice to be able to change; sometimes you feel like being dramatic and other times you feel like just being natural.

Q. Do you think that wearing make-up changes you?
A. It can make you feel more sophisticated or make you feel more sensuous or make you feel more natural. Clothes do the same thing.

Q. What kinds of clothes do you like to wear?
A. I can wear anything. I have old clothes, designer clothes, relax clothes, blue jeans, very dressed-up clothes, very sophisticated clothes. I have everything you can imagine. I dress according to my moods, the way I feel and the way I want to be.

Q. What do you do to keep your body in such beautiful shape?

A. I love dancing—it's one of my favorite things.

Q. Do you walk a lot?
A. I have a problem with my feet. Unless I'm in very comfortable flat walking shoes, after a long period of walking, my feet hurt. I just hate the idea of getting up and having to do exercises—it's such a bore. And in the summer you obviously stay in shape because you're always swimming or something.

Q. Do you sit in the sun?
A. Yes, in the summer I can get very brown if I want to—I have that kind of skin. I used to be really brown all year round, and then I decided I didn't like being suntanned all the time. In the winter it's so beautiful to look pale and transparent. I love that look.

Q. What about your hair? How do you take care of it?
A. I had a wig made for me, and it is the most fantastic wig. When I have it on, everybody thinks I have cut my hair. I'm tired of having long hair, but shoulder-length hair is just the wrong length for me. For me, and for movies, it's better that I keep my hair long.

Q. Do you set it or just let it dry?
A. In the summer I just wash it myself and leave it alone. It falls naturally into a pre-Raphaelite style, and I love it like that—very frizzy. But in the winter I have it washed.

Q. What about diet? I understand you take a lot of vitamins.
A. I take a lot of B-12; especially if I'm tired. I take Ginseng and I like Golden Seal Root tea. I take lots of vitamins—a multiple vitamin in the morning which has everything in it, and then I take vitamin C, E, B-6, Lecithin.

"I don't like to talk about the negative things. I always try to be positive."

Q. Do you drink or smoke?
A. No. I really believe in keeping myself as pure as possible.

Q. What do you take if you're very nervous and under stress?
A. I have a sensitive nervous system, and the nervous system can really put your whole body off-balance. I have some herb drops that I take

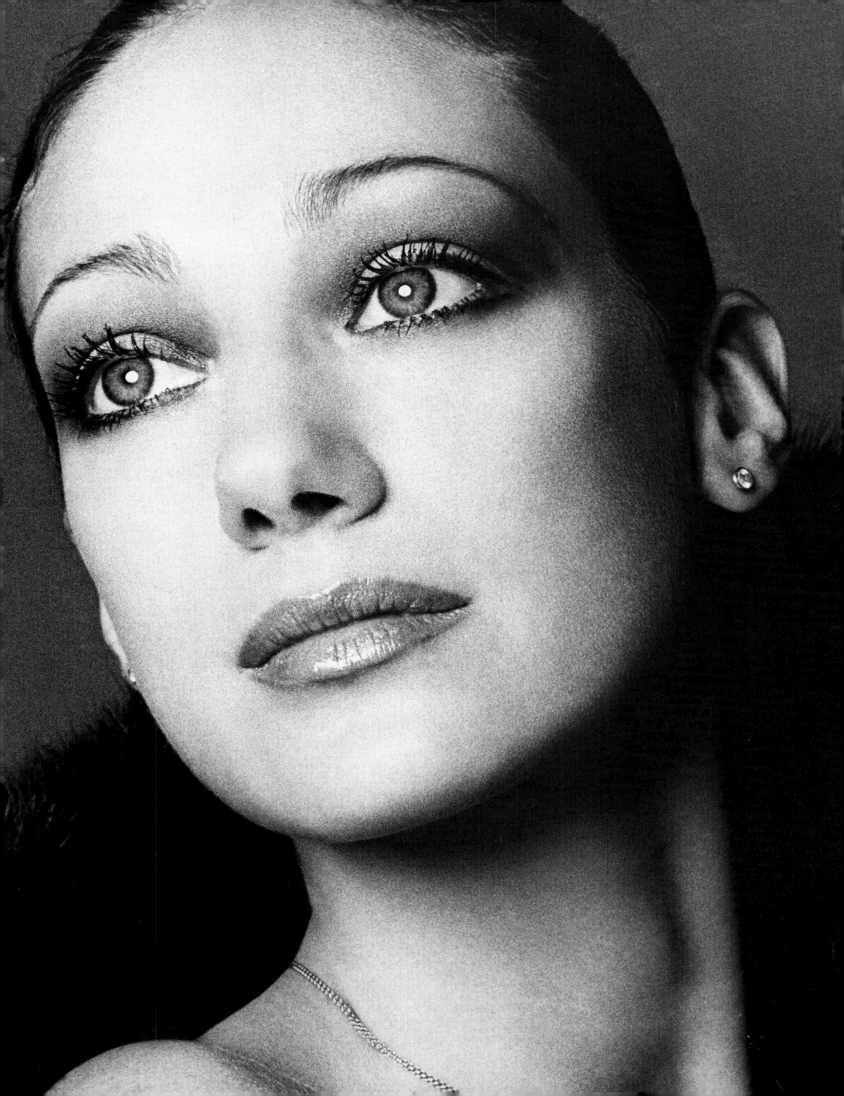

occasionally. A doctor in Paris I know works with Aromatherapy—everything is based on plants and herbs—and he has some interesting remedies for me.

Q. What about perfume? Do you ever wear it?
A. I adore perfume. I wear it all the time—with great effect. It is one of a woman's most alluring features. It makes me feel so light and lovely.

Q. When you're in love do you think you're more beautiful?
A. To be in love makes you glow. But I also think one has to be able to experience love and fulfillment through one's self and through other people as well. You can't always count on the one you're in love with to fulfill you, in order to feel terrific.

Q. Who are some of the women you really admire?
A. I really think Mrs. Diana Vreeland is wonderful. I just adore her. I've learned so much from her in every way. She's somebody you learn from constantly.

Q. Do you think she contributed to your individual sense of style?
A. I don't know about that because I think one either has individuality or one doesn't. She is so individual. She's never copied anyone's style—she's just Mrs. Vreeland. And I feel the same way about myself. I don't feel I've ever copied or been influenced by anybody in particular. She's taught me so much because she is the most positive person, the most enthusiastic person, the most young and incredibly inspir-

"I know I sound like the most crashing bore, but I don't drink or smoke. I just really believe in keeping myself as pure as possible."

Q. Do you like being feminine?
A. Indeed! I think it's very important for a woman always to stay a woman and always to be feminine. I believe in women's rights—to be able to work and to be talented and to have intelligence and to be given a chance to do what men do—but I disagree with wanting to compete with men and losing all one's femininity, and of putting men down. It's unnatural. Life and nature were made to have a feminine and masculine. I think it's important for a woman to keep up the side of her that's attractive, and that's why women should care about the way they dress, and about looking good, though obviously this should not be exaggerated.

Q. What kind of man do you find attractive?
A. The qualities I like in a man are intelligence and a sense of humor. And sensitivity. I like creative men . . . I must be able to respect a man for what he does.

Q. Do you have any hang-ups?
A. I don't like to talk about negative things, because I always try to be positive.

Q. You're an incurable romantic.
A. Yes, I am. I love my friends . . . I like luxury as a way of life. Luxury doesn't necessarily mean that you have to go around in a Rolls Royce and a mink coat, dripping with diamonds; it's just a way of living, a refined lifestyle. You can live luxuriously and not be wealthy. But I like stones. I love the feel of gold. I like the way things shine and I like the natural colors of stones.

Q. What are some of your favorite pastimes?
A. I write a bit, and as I said, I go dancing and I take singing classes. And I love to go to the movies because I'm a real movie fan and I love to watch old movies on television. I sit up and watch *The Late Late Show* even if I'm cross-eyed. I read a lot and I like to go to the country. I'd love to have a house in the country just to be able to get away and have lots of animals and friends. Friends are so important.

Q. What do you think about decadence?
A. I think decadence is very attractive on the screen but it's not attractive off the screen, in everyday life.

Q. Are there parts in movies you would like to play?
A. Yes, there are a lot of very interesting women that I would love to play—George Sand or Mata Hari, for example.

ing person I know. She is the most creative also, she sees everything in a way that nobody else does. I've always wanted to go on a trip with her because I think she must really *see* places. She comes back and she always has something unusual to say.

Q. Are there other women you think are really beautiful?
A. I think Maxime McKendry and LouLou de la Falaise are. Katharine Hepburn is wonderful; Audrey Hepburn has always been my favorite person.

Q. What about your sister Berry?
A. Well, she's the most divine person in the world.

Q. What do you think of American women in general—the ones you see on the street?
A. What I like are those people who have their own style today, and who can do what they want and look the way they want. You can wear whatever and be whoever and do whatever you want. It's much better because people can wear what truly suits them rather than merely what's in fashion.

Marisa is an international romantic star with extraordinary soul. To me, she is one of the most exciting women in the world today. She knows who she is and what she wants. She can't fail with that attitude.

Marisa's face is very finely shaped, but you don't see the strong cheekbones or features without make-up. There is a lot of emphasis on her eyes to enlarge them; they are contoured to bring out the natural shape. The mouth is given a lusciousness but not a dark color.

Her hair is marvelous for the movies, but for real life Marisa should walk down the street with an electric fan in front of her to give it lift, as it is long and there's a lot of it.

Marisa has her own, very diverse style in clothes. She wears everything from blue jeans to couture and always comes out with a strong, individual look. She has a great body. She always looks perfect, unique and special. She's the kind who can throw a sable coat over a Levi shirt and dungarees. She loves luxury and wears real jewelry with everything—some of it she never takes off. She also has a wonderful collection of hats.

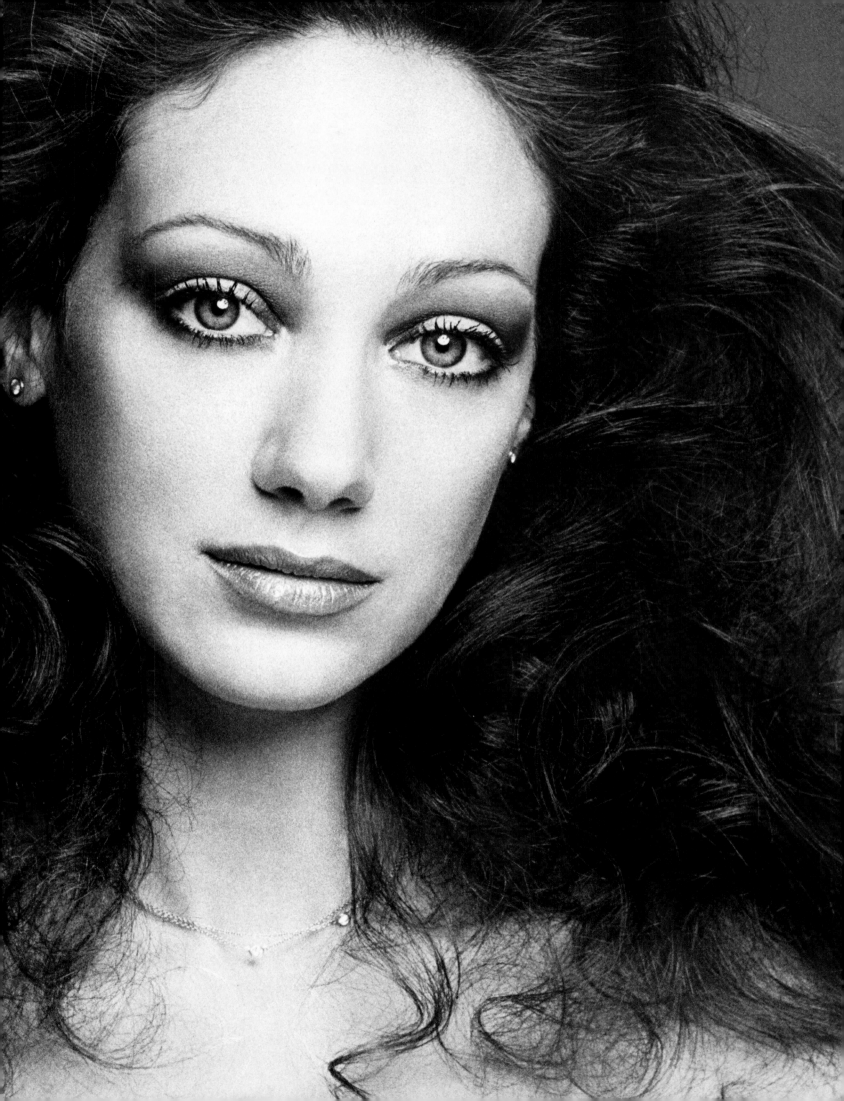

Cut and shape: the solution to fine hair

Jacqueline Bisset

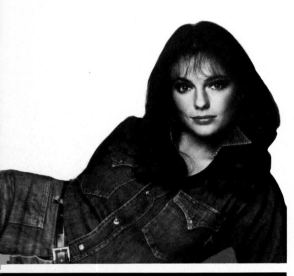

"I find that I have a great deal of admiration for a woman who reaches the age of forty or forty-five and has some of her own character and her own identity in her face."

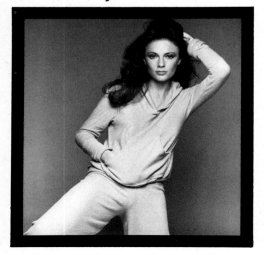

Scavullo: What is your idea of a "star"?
Ms. Bisset: It's sort of being a little bit bigger than reality.

Q. What does beauty mean to you?
A. Harmony and energy.

Q. Do you diet or exercise?
A. Very sporadically. I make plans and then get very involved with life and completely forget about them.

Q. What are the areas in which you are very disciplined?
A. I'm very disciplined when I'm working. I cannot survive unless I sleep a lot.

Q. What does it take to make *you* look and feel good?
A. I need a non-extreme, warmish climate to be fairly relaxed. I'm better in California, for example, than I am in an English winter. I find my skin and hair are frequently better because it's not too humid. But the comforts of my home, my family, my friends are my energy base.

Q. I've heard you talk about your hair being fine and that people used to call you "Miss Fifteen Hairs."
A. I had my hair straightened, and it actually all fell out, so I had very little hair on my head about eight or ten years ago. But it has improved lately.

Q. How did it improve?
A. I started using baby shampoo, and balsam conditioner. It stopped my hair from snagging and I now have a reasonable head of hair, although the length of my hair is a life's work—it never grows.

Q. Does your very fine hair stay put?
A. It doesn't stay. It has that funny, floppy quality, but if it gets too "set" it *looks* horrible. It suits me to be soft. I've gone off baby shampoo now, and I'm using something that's supposed to be a natural shampoo. Also, I love to have my head massaged.

Q. Besides your acting career, what are the other things that interest you?
A. I'm a house freak. If you want to talk about Women's Lib, I suppose I wouldn't sound typical. My house is terribly important to me, as are my friends, food and furniture. Things don't have to be luxurious at all. I don't need luxury—I just like simple surroundings.

Q. Can you list some of the things you really love in life?
A. I love silks, wood, men. I've always hated roses. I don't know why. I have a very strange reaction to roses. To me they represent formality. But I like daisies and flowers like that—funny flowers, marigolds and nasturtium, and field flowers. I love French villages.

Q. What about clothes? Do you shop a lot?
A. Not that much. I don't particularly like clothes. I like materials and fabrics.

Q. What kinds of clothes are you happiest in?
A. Well, at the moment, I'm wearing trouser suits with waistcoats, just sort of men's suits.

Q. What women do you really admire?
A. My mother, and Lauren Bacall, because she's got energy and she's a fighter. I like Rachel Roberts a lot, too. She's got a lot of passion. An actress I really admire is Ingrid Thulin. I also, in a funny way, admire Brigitte Bardot. I find that I have a great deal of admiration for a woman who reaches the age of forty or forty-five and has some of her own character and her own identity in her own face. I think so many women become very stereotyped as they grow older and very few retain their character and their energy and their dreams of youth. People like Chanel, Simone Signoret—I love that kind of lady. Those ladies all suggest a strong, almost violent past to me. I would include Jeanne Moreau in that, too. These women all lived to the hilt. Let's say they had courage. There's a whole breed of ladies out here in California who preserve themselves for some event that's going to happen God knows when. They never eat, they never do anything except exercise madly, and they look so miserable that it makes me feel quite despairing. There are others who look a little plump, and they'll have men friends when they're ninety.

Q. How would you describe your own looks?
A. I really couldn't. I have a very changeable face.

Q. Do you think life is easier when you're beautiful?
A. Well, I mean, what is beauty? I don't know. I have regular features, I know how to make myself up, and I know how to dress fairly well, and I'm interested in people. I think people can feel that, so if I put my energy in the direction of the people I want to talk to, I can probably, on some level, seduce them.

Q. Do you have any permanent beauty problems you can't change?
A. I have something new which has just come up in the past six months. I have pimples. I get very funny about it because I've always had this feeling in me that associates pimples with bad health and bad discipline. I like my skin; I think it's important to have clean nice-looking skin.

Q. Do you use a lot of creams on your face?
A. At the moment I'm not using any and it kills me, but my dermatologist won't let me use anything. I don't look after myself as I should, and I'm aware of it. I buy stuff that I need and then get frantic—I take on rather a lot during the day. I always overload myself.

Jacqueline could be said to have the sexy movie-star kind of glamour, I suppose. But I see her as a quiet, sensitive beauty, a woman who is self-contained rather than flashy.

Jacqueline has beautiful skin, beautiful features. She has a slight overhang of skin from the ridge of her eyebone that can give a puffy look to the eyes. They must be darkened with shadow to recede the area visually, and to bring the eye "forward."

Jacqueline says she has a problem with thin hair. Slightly shorter hair can de-emphasize thinness, neaten up the shape.

Her favorite look in clothes is Levi jeans and a Levi shirt, with her hair hanging straight down. She can be casual in jeans or suits or be completely feminine in silk, satin, chiffon—floaty fabrics for shirts and pajamas, the new, very soft look.

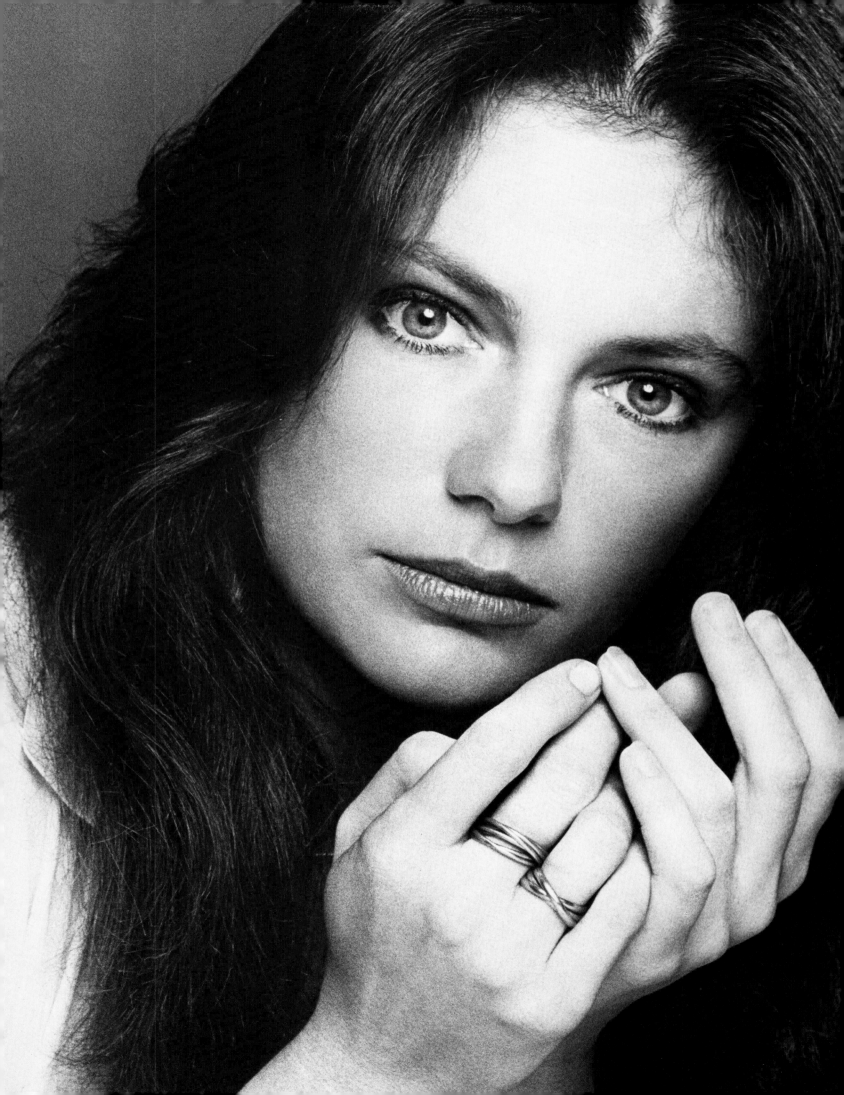

Set off fair coloring with natural solid colors

Karen Bjornson

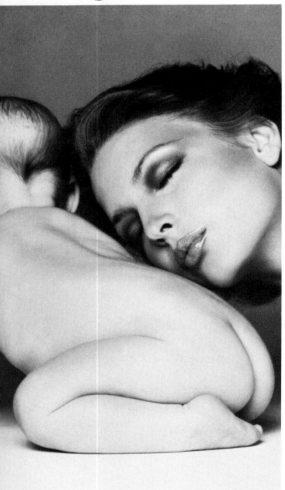

"I either like to wear clothes that are narrow on the top and fuller on the hips or vice versa—otherwise you look like a pillow tied in the middle."

Scavullo: How would you characterize your looks?

Ms. Bjornson: I don't think I'm particularly voluptuous or strong. Romantic, maybe.

Q. Do you stick to any kind of diet?

A. No. I usually have tea for breakfast, a yoghurt for lunch if I'm working, and dinner is usually some meat like lamb, and vegetables or a salad. I don't stay away from things I know are fattening because, actually, I should gain weight.

Q. What make-up colors do you wear?

A. I'm fairly pale, so I use a reddish-brown blush or a peach color. Mainly brown on the eyes, or gray-blue, since I don't really like to put colors on my eyes.

Q. Do you have facials?

A. Occasionally—not that often. I think a facial might make your skin a little too active, bringing out the impurities.

Q. What about clothes?

A. Clothes aren't that important to me. If something looks right, I wear it. It should be comfortable and clean and look fresh.

Q. What do you consider your worst feature?

A. Well, maybe my hands are the worst. I don't really take care of them the way I should. Also, I have wide hips—the bones are wide set. And it doesn't bother me, but I think another girl might be upset about being flat-chested.

Q. Do you take any vitamins?

A. If I remember . . . iron, C and E.

Q. How do you indulge yourself?

A. I take a Vitabath and follow it with a nice body lotion. Nothing fancy.

Q. What are the beauty essentials you can't do without?

A. I only need to have mascara, lip gloss and a little blush, and maybe a brown pencil, and maybe some Erase, and a little bit of base, and about ten pounds of cosmetics. (I'm just kidding.)

Q. Do you think trying to be attractive helps?

A. Oh, I think looks help a lot. Stunning looks can be an inconvenience, but a self-confidence in your looks helps. Once you go out the door you shouldn't be concerned about yourself. You get yourself started at home, and then you forget about it.

Q. Do you think it's important to be thought of as a beautiful girl?

A. If I'm going to work, yes.

Q. Do you ever think that you must try to improve yourself?

A. Well, in make-up, yes, when I'm in one of those weeks where nothing works, I'll pick up a magazine or look at what someone else is doing. That's how you learn something new. I'm always watching.

Q. So you're always eager to try something new?

A. Well, I'm not eager to buy it. I've got such a pile of make-up, I never need to buy any more. In cosmetics you can have anything, but everything won't work. Before I buy anything I want to know it works, and buying cosmetics in a department store where the lighting is so bad is tough.

"Since I don't eat too much I have more energy."

Q. What do you think of American women in general?

A. I see people that are out of shape, which is a little sad. I think the American diet, the sugar, is not very good. And the synthetic polyester fabrics never look very good unless they're cut really well, but they never are. People always buy so many things; if they only had two or three really good things, that would be enough.

I can't look at Karen without being reminded of Grace Kelly in her movie days. She has flawless, translucent, peaches-and-cream complexion, very pale coloring and hair—the elegant look of a Wasp-y beauty.

She has the boniest of facial structures and uses it to perfection. She doesn't have an ounce of flesh, but she never looks hard. Her face has a serene expression. She can take all kinds of make-up.

Her very thin hair should be kept short to add body and fullness, but long enough to wear tied back off her face or parted to the side and left to hang straight.

Karen looks chic in everything from her day-to-day Levis and shirts or in special slim, sexy evening dresses by Halston.

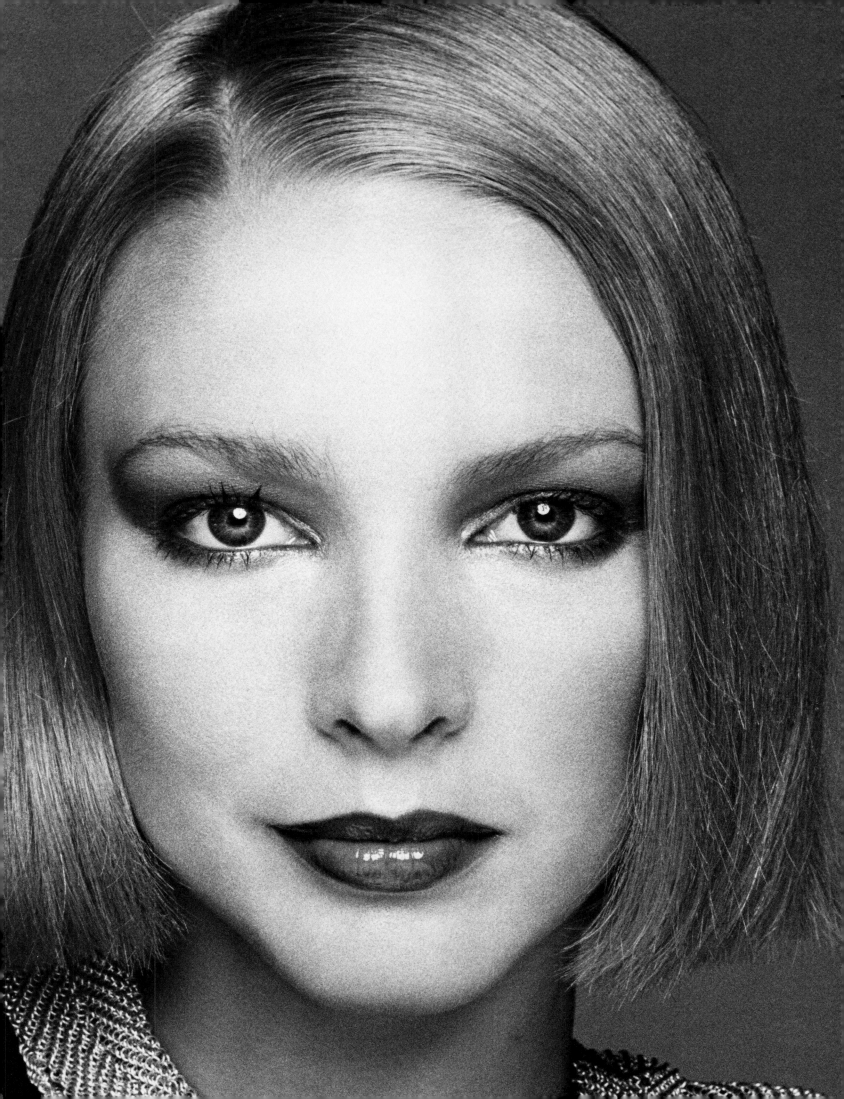

If there aren't enough hours in the day, you need to have a disciplined routine to keep yourself in shape

Helen Gurley Brown

Scavullo: What does the word beauty mean to you?

Ms. Brown: Beauty, to me, will always mean, alas, a beautiful girl, woman, a really gorgeous-looking person. I wish I could rise above that concept of beauty because I know about beautiful souls, beautiful people, beautiful friendships, and beautiful meaningful relationships in life. I feel I've had a few of those, and I know that beauty is far more than just physical. But let's just say that I was probably blighted as a child. I grew up in Little Rock, Arkansas, in the thirties, when beauty meant everything; I mean, you really had to be beautiful. It was desperately important. And if you were not technically beautiful, you might as well go out and jump in the Arkansas River. Well, some of us were not great beauties, and it's entirely responsible for whatever success I've had in life because, not being beautiful, I had to make up for it with brains, charm, drive, personality—you name it. But when you say the word beauty, to me it will never mean anything except Anne Mahafey, that peached-skinned, tawny-haired, incredibly beautiful eight-year-old moppet with whom I was supposed to compete, and there was no way!

Q. Who are some of the women of today that you really think are beautiful?

A. In the technical sense of beauty that we've been discussing here, I would say practically every *Cosmopolitan* cover girl. And that would be some of the lovely ones we used in the earlier days such as Anne Marie Dizinkiev, Jennifer O'Neill, a girl named Keisha. Starting with those girls all the way up until Rene Russo and Barbara Minty. And then there are great technical beauties such as Candice Bergen and Dina Merrill. Dina Merrill has that face . . . it doesn't matter what age she is, or whether she's rich, or whether she can act, or

whether she's married to Cliff Robertson. That face is technically exquisite.

Q. Can you describe some of the kinds of clothes you like to wear? Daytime clothes and evening clothes?

A. That's a very intimidating question because I've always felt that that was one of my weak areas. You know I edit *Cosmopolitan* successfully and I have, I think, many good friends, but I've never felt that the way I look running around town is one of my particular strong points. I come into my office late in the morning and come out at ten o'clock at night, so what does it matter what I'm wearing? I wish I could give you a more stylish answer, but frankly some of my skirts are two inches above the knee, but I happen to think they look better on me that way than longer lengths. I have on two-hundred-dollar Charles Jourdan boots, Yves St. Laurent stockings, a fifty-dollar scarf and a pure silk shirt, so it's not that I don't spend a little money putting an outfit together. But I think occasionally I probably look tacky, because you mustn't go around in a short skirt right now. But I still think the style looks okay, and pink is my best color, so it's pink, pink, pink, even if pink is German measles to the fashion industry. So let's say I wear something if 1) it's becoming, never mind if it's not very stylish; 2) it is reasonably comfortable, because I do work hard all day; and 3) if there's anything left over to worry about, I worry about whether it might be in style. I never liked pants because I'm short and hippy, and three hundred thousand people have said it doesn't make any difference—"You look cute

> "Some of us are not great beauties. That notion is entirely responsible for whatever success I have had in life, because, not being beautiful, I had to make up for it with brains, charm, drive, personality—you name it."

I think Helen Gurley Brown looks wonderful. She has such extraordinary discipline with her exercises and her work. She really keeps herself in shape, which is essential for a woman who works as hard as she does.

She has neutral skin tone and very angular bones, a high forehead. She needs make-up that heightens the look of vitality but softens the edges of her features. A lot of color was used on her cheeks to make her look lush and vibrant—but not to chisel out her features. Her face and mouth need rounding out, and she is a woman who looks younger with make-up—it's the reverse for most women.

Solid colors such as red, pink, beige, steel-blue and steel-gray look best on her. She should wear nothing more than a shirt and skirt or simple shirtwaist dress, which she could buy in several different colors and wear as a uniform with just a change of jewelry and beautiful shoes.

> "One of the paramount reasons for staying attractive is so you can have somebody to go to bed with."

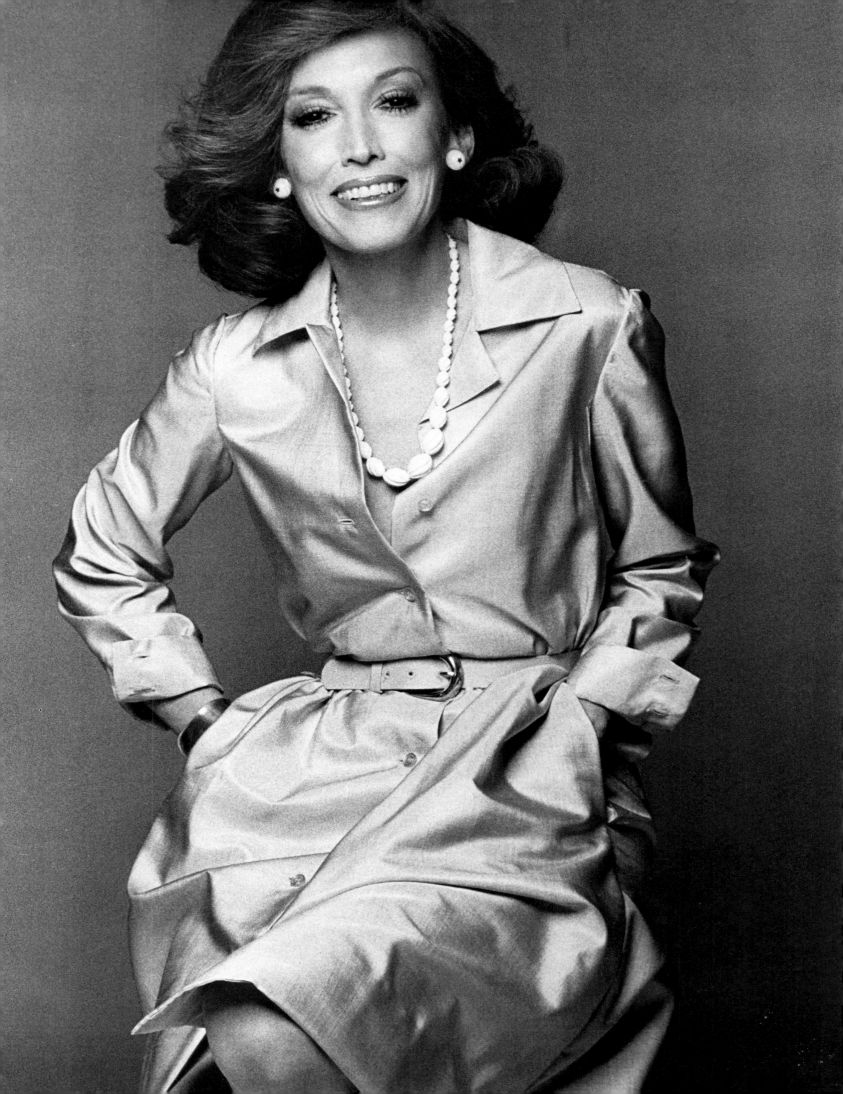

in pants"—but I know better. When you have short legs and wide hips, pants are not your best style. I still prefer skirts or dresses, and at night I just like something slinky and sexy and skinny. I probably look better at night than I do in the daytime.

Q. Do you like jewelry?
A. I love jewelry. I've got this problem because I'm now in my fifties and beginning to collect ... jewelry, clothes, antiques, paintings, dishes, furniture ... and everybody else is trying to simplify his or her life and is getting rid of the clothes, the jewels, the furniture, the paintings, and saying, "Just leave me a few good artifacts." Well, I've always done everything too late. I, too, should be simplifying, but instead I'm just beginning to buy, and I love every single purchase.

Q. Could you tell us about your exercising?
A. One hour every morning, and *nothing* gets in the way. I've only missed two days in eight years, and then I was in the hospital. The minute I got home I started again. I exercise when I get out of bed because if I wait an hour I'll never get to it. It's got to come first because it's so hideous! The routine is just a compilation of different exercises that I picked up from various places. There's a screen writer in Los Angeles whom I wish I'd never met, though he's a dear. Sitting next to me at dinner one night, he told me about lifting your feet six inches off the floor for about one minute, and now I have to do it. I know one day I'll have a coronary because it's terribly hard to do, excruciatingly painful, to hold them up for a minute. I also stand on my head and jump rope. I use exercises from Jennifer Yoels of Mensendieck, from Marjorie Craig at Elizabeth Arden and from the Royal Canadian exercise book.

Q. What about diet?
A. I wouldn't say I was a *compulsive* dieter because the only way you can stay as skinny as I am (105) at my age is to starve, but not in an unhealthy way. I'm not literally starving—just longing for all the lovely things I'd love to eat and can't. I eat 1500 calories per day, and you can't manage very much on that. Mostly I subsist on tuna salad, which I happen to like, and it is total protein, so I can live with that. Granola, powdered yeast, liver, lecithin, wheat germ—lots of things like that—I get at a health food store. But I do eat compulsively at times—I eat everything that's not moving. For example, I can go through an entire package of unsulphured prunes, about 3800 calories worth, and thousands of sunflower seeds in one sitting. The next day there's nothing to do but fast. When I've been out of control and eaten all that stuff, then I try to get it all out of my

"Beauty to me, alas, means a beautiful girl, a beautiful woman, a really gorgeous-looking person. I wish I could rise above that concept of beauty because I know about beautiful souls, beautiful people, beautiful friendships, and beautiful meaningful relationships in life. I feel I've had a few of those, and I know that beauty is far more than just physical."

system fast. I think I'm going to have this problem all my life—the compulsive eating, then the compulsive fasting. I really don't want to live within that 1500-calorie range—it's so boring—but I also don't want to be fat. The only way I can seem to exist is to eat everything I want and then pay for it.

Q. How do you feel about make-up?
A. I'm all for make-up. Listen, I go schlepping around town for an hour and it's all blown off, but make-up is one of the good things in life. I think far from being a chore, it's a pleasure. I understand people who don't want to use make-up at all, but I think it's fun to see how much you can change with make-up.

Q. Would you like to take more care with the way you dress—for style?
A. I need someone in my life to do it for me. I'm so committed to *Cosmo*, to the television show I do every Friday morning, to trying to be a good wife, to writing a book on the weekends ... I have so many responsibilities that I

selves, and who ought to be arrested because they're so pretty. Some just let it go to waste, whereas God knows how fantastic they could look if they got it together. I know how much better I look when I get it together.

Q. Do you ever wear blue jeans, Levi shirts, things like that?
A. Yes, but not to very many places. I work every weekend and never come out until Monday, so I usually wear just a nightgown, because it's comfortable, or nothing at all. I'm hippy and I have a tummy, and tight blue jeans are *really* tight and are not comfortable. Usually I need to wear something dressier anyway. I do sometimes wear jeans to the office in the summertime but, again, it's the hip business. I'm not Lauren Hutton or Sally Kellerman or any of the other original skinny-hipped tall girls.

Q. How do you feel about your hair?
A. I think I now have the capability to be ... I hate to say beautiful, that's going a bit far ... but with the knowledge I have about beauty and caring about beauty as I do, plus the poise that comes from being successful and a little older, I think I have the capability to be quite an attractive woman—if I could just slow down and do it. Hair is a problem for me, and I don't believe there is anything more I can do about that. I've been going to a dermatologist for three years, and I use all his hormone stuff, and in addition I go to a wonderful Japanese lady for a shiatsu massage. But I have terrible hair and it isn't getting any better.

Q. Do you cut it?
A. I trim it every two or three weeks. If you have skinny hair, cutting it short isn't necessarily the answer because it's just skinnier than ever. I have real hairpieces and Dynel hairpieces, and I use those for television and big-deal nights. But you can't go running around wearing hairpieces all the time—it isn't comfortable or sexy. Let's just say I've done everything and been everywhere, to have more gorgeous hair, but finally the time comes when

"I think a woman should remain sexually active forever. I don't know that it makes you beautiful, but it probably clears your sinuses."

just don't seem to have been able to fit in the style thing. I do think I would rather enjoy it.
Q. Do you think a beautiful woman consists of a total look or do you just think that if she's beautiful, that's it? Do you think clothes have an effect?
A. They definitely have an effect. We all know beautiful women who do nothing about them-

you just have to say "That's a flaw, and I can't do anything about it other than what I'm doing, so I will live with it."
Q. What are the world's two greatest inventions?
A. My Waring blender, and probably the pill, because it has changed sexuality for women in this country.

"When you say the word beauty to me it will never mean anything except Anne Mahafey, that peached-skinned, tawny-haired, incredibly beautiful eight-year-old moppet with whom I was supposed to compete."

Q. Some women are frightened of the pill.
A. I know many women are frightened. I've been taking it for twelve years, and watch carefully—a Pap smear three times a year—but I'm still a believer. So is my high-powered doctor, and he treats some very famous aging ladies.

Q. What about sex and beauty?
A. Well, I think a woman should remain sexually active forever. I don't know that it makes you beautiful, but it probably clears your sinuses and makes you feel alive! It may be a problem for some women to find someone to be sexual with after a certain age but that's another reason for staying attractive—so you can have somebody to go to bed with. I think sex and beauty are totally concomitant. I don't think you can really be beautiful without caring for somebody sexually.

On the magazine cover:

COSMOPOLITAN

June 1973 • $1.00

What's Happening to Couples Who Are Trying "Open Marriage" (Letting Others In)

At Last, What's Really True or False About Nutrition— A Shocker If You've Been Listening Only to Doctors

Dominique Sanda, Today's Most Sensual Movie Star

What French Lovers Are Like

Fantasies That Wildly Excite (Nice Suburban) Women (and Men) and Make A Love Relationship Terrific

Me and Ali MacGraw: The Enchanting Tale of a Look-Alike

Double Book Bonus: The Year's Happiest Best Seller: All Creatures Great and Small and The Making of a Psychiatrist Plus Two Marvelous Novels

"When I think about clothes I start with 1) Is it becoming to me? 2) Is it comfortable? and 3) If there's anything left over to worry about, I worry about whether it is in style."

Q. Do you think you would have been more beautiful if you hadn't had to work so hard in this life, if you didn't have to dedicate so much time to the magazine, to whatever you're doing?
A. Yes. I think you can be more beautiful if you're more calm and if your face isn't working and frowning all the time from trying to talk fast and run so hard. Yes, I think serenity has something to do with having a relaxed face, but then being "too busy" also makes you more alive and interesting to people.

Q. Even your hair, do you think it would be falling out if you weren't so busy?
A. No, not so much. I think my hair has definitely been affected by this madness!

Q. How many hours do you sleep at night?
A. I need eight very badly—I'm frenetic all day and burn down quickly—but I only get six or seven. One day I'll rest and sleep and be stylish and calm and all my hair will grow back in!

"The only way you can stay as skinny as I am at my age is to starve."

"When you have short legs and big hips, pants are not your very best style."

27

The Latin look

Irene Cara

Scavullo: Were you born in a trunk?
Ms. Cara: I did my first Broadway play with Jack Cassidy and Shirley Jones when I was eight.

Q. How do you feel about the way you look?
A. My mother is white Cuban, and my father is black Puerto Rican, so I have mulatto features. I'm very proud of the way I look because that's me.

Q. What kinds of make-up do you use?
A. Well, my eyes are very dark—they're almost black—so I like to do my eyes. They're not "almond" shaped or anything that's considered beautiful, but they have a unique look of their own because they're dark.

Q. How do you like your hair?
A. It's not straight and it's not totally kinky. I've always had long hair. I could never afford to go to hairdressers and have them do stylish things to my hair. I think I look best with long hair, since my face is kind of round.

Q. Do you take care of your own hair?
A. I used to straighten my hair when I was younger because the frizzy look wasn't too much in style. But I don't straighten it any more—I just wash it, put conditioner on it and roll it. I have a permanent now.

Q. Your hands are beautiful.
A. I don't like nail polish. There's something about color on the nails that's very ugly to me—artificial, catty, unhuman-looking. I never use it. I don't like long nails on me.

Q. Do you pay much attention to your diet?
A. When I was about eight until I was eleven I was very fat, from a lot of rice and beans. I lost it when I was twelve, and now I'm pretty skinny—I'm where I want to be. I'm at an age ... my metabolism is such, that I burn everything very quickly. I can lose four pounds in a day. Even mental work helps me to lose weight. I worry a lot. I'm always under pressure. I'm a bit too sensitive. But in the long run it helps me grow.

"The Hispanic complexion picks up so much color from clothes and make-up."

Q. What kinds of clothes do you like to wear most often?
A. I like a variety of clothing. There are times when I just like jeans, earth shoes and a T-shirt, but then I also like to be very elegantly dressed. I like a long look that makes me look taller than I am. Colors? Well, my complexion is brown, really olive, and rust makes me look healthy. With rust I don't even need to use rouge because it reflects colors. I like soft colors; my favorite color is green, any kind. For clothing I like a nice light green, a sea green, and for make-up I use a dark green on my eyes, a forest green. I like yellows and orange. I look very good in beige because it kind of blends in with my complexion so it's a very soft look.

"My complexion is brown, really olive, and rust colors make me look healthy."

Q. What's your best look?
A. Well-fitting clothes in flattering monotone colors; I love black. I wear hats a lot—I like black hats, mannish hats. Sometimes, on my eyes, I just wear a dark color on the lid and leave my skin to show through under the eyebrow—it's a natural highlight, a rich, natural brown color. Latins have very good skin quality anyway, nice complexions. The liquids and gels blend in beautifully. I think the way a woman does her make-up is an indication of who she is, where her head's at. I think it's very artistic and very creative. Of course, I'm against make-up as a thing that women *have* to do in order to be women. Sometimes I don't wear anything, and I think that's pretty too.

Q. Do you ever wear lipstick?
A. I leave my lips very pale. I think that's a nice look, because my lips are naturally a light pink/red, and it makes me look like I have less make-up on.

Q. Do you have any beauty problems?
A. Yes, I scar very easily with my kind of skin.

Irene Cara is a special, talented young woman whose fascinating looks are the result of a mixture of black Puerto Rican and white Cuban parents.

She has sharp, bright eyes, with very thick dark eyebrows that were shaped slightly so that they wouldn't overpower her face. She has to be careful about her skin, and the tone needs to be evened out, but it's just a refinement. Her mouth is full and important, and she has beautiful teeth.

Irene's thick, curly hair is done as a mass of angel hair to make her look romantic.

Her own personal style of dressing tends toward beautiful old clothes, old chiffon dresses and old silks. She's a very festive dresser and a festive girl. She looks as wonderful in prints as she does in more chic solid-color skirt and blouse outfits with just a scarf tied around her neck. She also looks great in the clothes her mother makes for her.

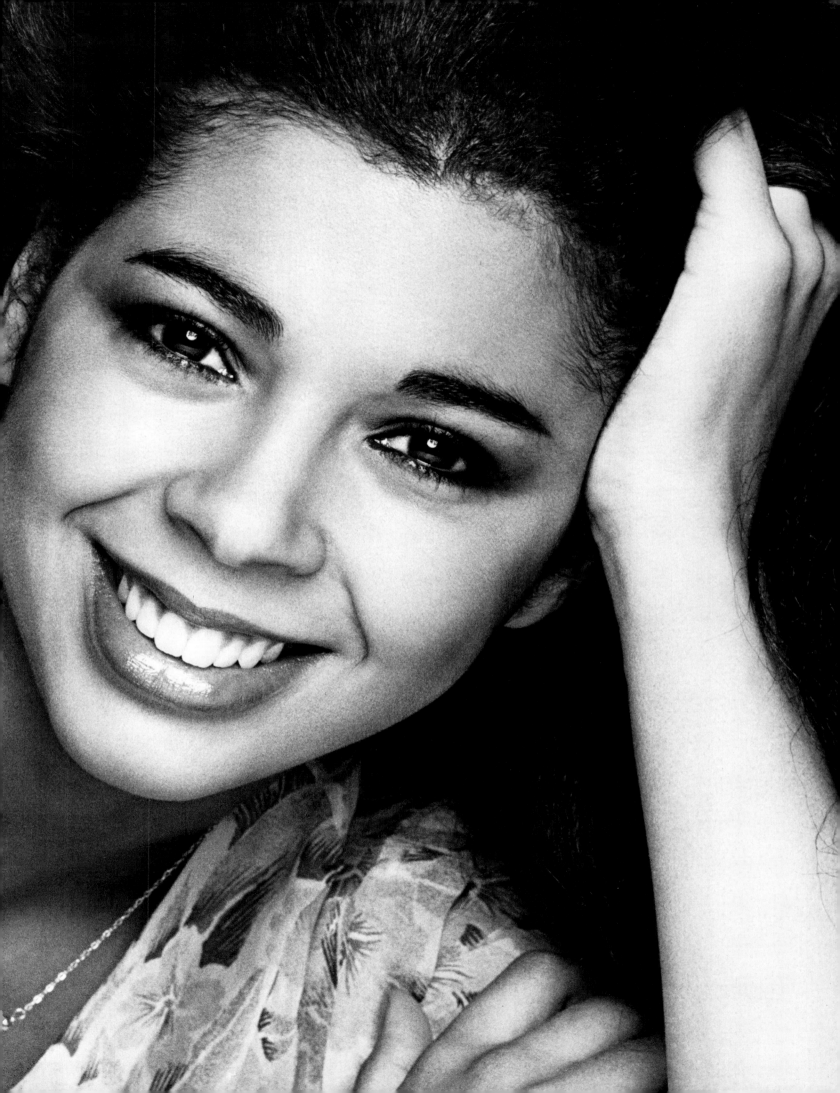

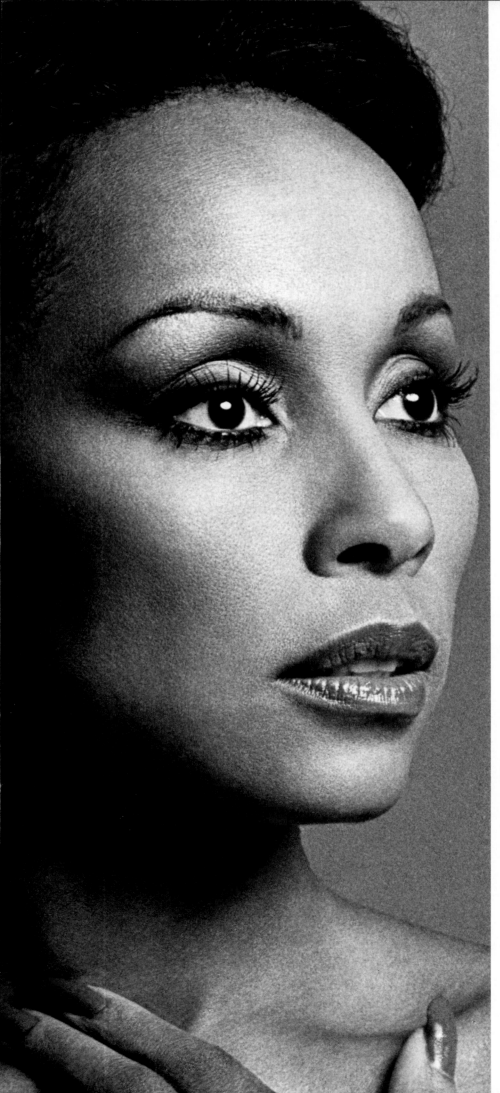

Make-up for eyes that communicate

Diahann Carroll

"I try to get my eyes as large and as definite as possible so that I can communicate."

Scavullo: Are you a soap-and-water woman?
Ms. Carroll: I won't use soaps with perfume in them. If I have trouble with my skin it's usually because I'm playing games with my diet, because I use only natural products. I get pimples from chocolate like a fourteen-year-old.
Q. What about make-up?
A. I don't wear a lot of make-up. When I wear any it's concentrated around my eyes. In my business, communication is my major concern. I try to get my eyes as large and as definite as possible so that I can communicate. I'm also in the habit of shadowing my nose—it's a habit—there's nothing wrong with my nose.
Q. Do you have problem features?
A. My face has bothered me for years. I have to learn about it. When I get to know it, I like it better; it begins to do more for me.
Q. Do you stay away from the sun?
A. I try. It depends on what part of the world we're discussing. In Mexico I tan quite well—in California the sun turns me charcoal gray.
Q. What is your most important beauty accessory?
A. My skin is extremely dry and I would never sleep without a little moisturizer. And for me a humidifier is crucial.
Q. How do you take care of your hair?
A. It's cleanliness first with hair too. But shape is very important. I like to tuck it back to show

"I use a mayonnaise and avocado compact on my hair, and it keeps it in great condition."

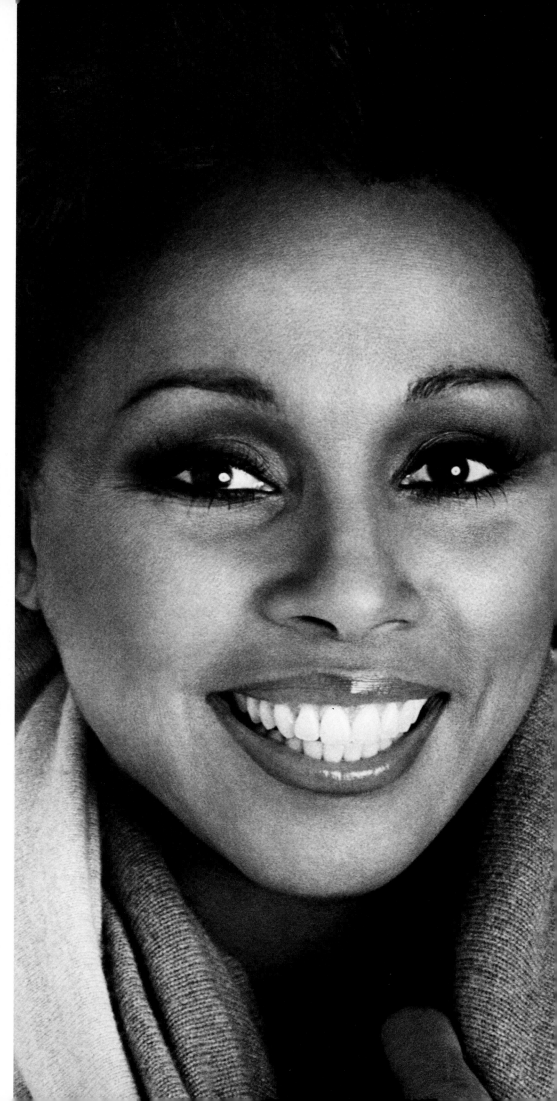

my ears. At one time I used to use wigs quite a lot, but now I use a mayonnaise and avocado compact on my hair, and it keeps it in great condition. I wrap my hair in Saran Wrap so that the heat is captured and works with the avocado and mayonnaise.

Q. Do you take special care of your hands and feet?

A. My hands and feet are like potato chips. It's great to be able to slather Vaseline all over your hands and sleep with gloves on—when you're alone.

Q. What about diet?

A. There's no coffee or tea in my home. Only the stalest cigarettes—I smoke only a pack a month. It's important to me that I don't have any junk in my body.

Q. What do you think about having a certain beauty?

A. I think it's devastating when someone comes up to you and says, "Excuse me, but I just wanted to look at you."

A beautiful woman and a lady who looks lovely in easy, casual and spectacular evening clothes. I photographed her with her natural hair, a shining, fresh face, big eyes. Her best look.

Her bone structure was emphasized because it is her most important feature. Her skin is a wonderful light color and fine texture. The drama of her face is in the upper half, the cheekbones, eyes and nose. Her mouth was lightly glossed and relatively unimportant. She needs shape to her eyebrows and should not wear them so thin. The shape needs to extend out toward the temples.

She's gotten her hair in such good condition that she no longer relies on wigs.

Diahann has a lot of style and looks particularly well in evening clothes. She looks good in beiges and grays for day, black and white at night.

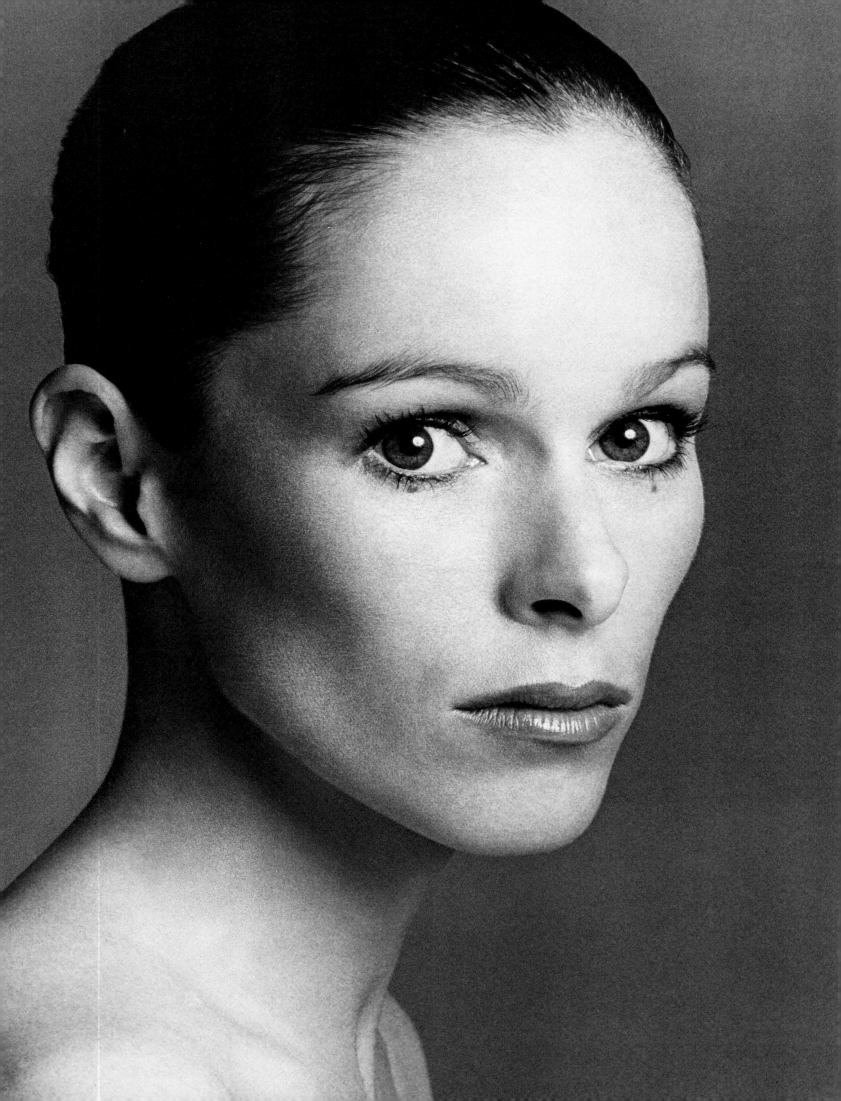

Strong bones: minimum make-up

Geraldine Chaplin

Scavullo: I know all about your approach to beauty—simply eat all the wrong things.
Ms. Chaplin: I eat just about anything but chocolate. I never eat chocolate. I love Mexican food. I really shouldn't eat it because my face breaks out, but I love Mexican food more than anything. I can't get it in Spain, where I live. In Spain I eat a lot of goat but not that hot, spicy food that makes me go wild.
Q. Do you do anything to take care of yourself, your skin, your hair?
A. No. I have terrible skin because I eat just everything. I've never been a vegetarian, I love junk food, hamburgers. And my weight still stays where I want it.
Q. I think you have a beautiful complexion. I was sure that you ate only organic food.
A. I also like booze.
Q. You drink, too?
A. Oh, yes, whiskey. You see, I don't think about food or drink much. I just know the meat is better in Europe, and I don't particularly like the food in America—it's overcooked, mushy.
Q. Are there any women whom you particularly admire?
A. I admire Eva Kalinski. I'd like to be her. She's a great actress, she's so beautiful.
Q. What does it take to make you look and feel good?
A. I don't know. I usually feel good.
Q. What are some of the things you really like?
A. Eating, drinking, smoking, making love, acting. I also like lying in the sun. I like to come out of the water and lie in the sun and then go back in the water. Generally, I like all sensual things.
Q. What don't you like?
A. Having to go to work on a project I don't like, which has only happened once. And cold weather. It gets cold in Madrid, where I live.
Q. Were you a beautiful baby?
A. I was a cute baby. I had a really round face

"I have terrible skin because I eat just everything."

until I was twenty-five, then it all started caving in.
Q. Do you think life is easier if you're beautiful?
A. Definitely.
Q. How would you describe your own looks? Do you analyze yourself?
A. Not really. Being an actress, I always think of myself in terms of the part that I'm doing, or the part that I'm going to do, or the part that I've just done.
Q. You are into your work so much that you can't describe yourself objectively? You save all that analysis for the parts you play?
A. I guess so. I guess something rubs off on me from the parts I play. When I'm playing a part, I try to look like that part and I find it lasts for a while afterwards.
Q. So you change constantly, then?
A. Yes, I'll change for the part completely.

"I think a lot of make-up looks horrible."

Q. Do you have any feelings about cutting your hair or leaving it long?
A. I don't like to cut my hair. I had it very short and I hated it. I looked awful with it short. I had bangs, and I hated them. I like long hair, no bangs.
Q. What are your favorite clothes?
A. I wear jeans mostly. My two favorite dresses that I have for dressing up belonged to my mother. They're Fortuny. For me there's nothing between jeans and Fortuny.
Q. Do you like jewelry, perfume?
A. I love jewelry, any kind. I love silver. My favorite perfume is Amazone by Hermès.
Q. Have you got any beauty problems you can't change?
A. I think my mouth. I hate it when I see it in still photographs or in movies.

"I hate my mouth when I see it in photographs and movies."

Q. Do you take any special care of your face or your hair?
A. I use a sun screen when I go out in the sun, a complete blockout. I don't like to get tanned, I just like the feeling of the sun. As for make-up, I take it off with anything that's around—hand lotion.
Q. Do you wear make-up?
A. A little bit on my eyes and face.
Q. Is there any special trick you use when you're putting on make-up?
A. I wear little dots on my face—like a clown. I have many beauty marks naturally anyway. But I don't usually wear very much make-up. I think a lot of make-up looks horrible.

"I had a really round face until I was twenty-five. Then it all started caving in."

I loved Geraldine in all her movie roles, Dr. Zhivago, Nashville, etc., but no matter how strong a character she plays she maintains a very tentative quality of beauty, as though she were a forest animal that had been startled.

She has a chiseled-out sculpture of a face. She doesn't like to wear a lot of make-up, and she shouldn't, but her eyes are played up to give them importance and to balance the strong tooth structure which makes her mouth "difficult" to her. Her skin tends toward dryness, so she shouldn't wear foundation and should stay away from powder.

Her face needs no hair "style" at all. It was worn straight or pulled back in a chignon.

Geraldine says that there's nothing for her in between jeans and Fortuny. I think she's right.

The special look of all-out glamour Cher

"I try to look attractive for both men and women, which is hard because the things women find attractive, men don't. Men are easier to please than women."

Scavullo: Do you diet?
Cher: I like really good food but I also like junk food. I hope it gets balanced out.

Q. What about your hair?
A. I wash it every day with Milk and Honey shampoo from Jheri Redding, and then I use a Pantene conditioner which I've found to be the absolute best for long hair. I have it trimmed once or twice a year.

Q. Do you ordinarily use make-up when you're not filming?
A. While shooting I wear a lot, but when I'm home I go almost without anything.

Q. Do you always wear eye make-up?
A. No, the most important things for me are blusher and lipstick.

Q. Have your friends described your looks in a word?
A. I don't know. Beauty and how you look are things that I am not into. I like to talk about the way *other* people look.

Q. Who do you think is beautiful?
A. I think Mica Ertegun is beautiful. Marisa Berenson is physically beautiful. I think a beautiful-looking lady is Charlotte Rampling, she's better than beautiful. Just beautiful gets boring.

Q. Do you think life is easier if you have done your best to be attractive?
A. Yes, I do. It's a drag when you're too fat or your face is broken out. When you feel your best you usually can do your best.

Q. For whom do you like to look attractive?
A. I don't know, I never look attractive to myself. I guess men find me attractive, but I guess I try to look good for both men and women, which is hard because the things women find attractive, men don't. Men are easier to please than women are.

Q. Do you feel that you are your own beauty expert?
A. Yes, I definitely do. I do my make-up myself and I always have. I feel that I do, maybe not the best that can be done with shading, etc., but what I feel most comfortable with.

Q. What colors do you feel look best on you?
A. I love white, turquoise and purple. I don't look good in gray or brown.

Q. Do you think the American woman could stand some improvement?
A. There's just a small percentage that are knockouts. The ladies in Beverly Hills have all got their uniform together, but they have no adventure, so they just wear what's right. They have their Vuitton bag and a Gucci belt, and they go places where everyone looks like they belong. I like the individual look and a look that says, "I know what to do with myself." I remember that I always wanted to be blond. Well, I'll never be blond. You do the best with what you have!

Q. Is there anything about yourself you'd like to change or improve?
A. I guess I'm satisfied. I'm really not, but what the hell. If I started tinkering I'd be working on myself forever.

Q. What are your favorite indulgences?
A. I always work pretty hard, but what I really like to do is go to New York. That's my favorite thing. I love to go shopping and I love the theatre.

Q. Do you enjoy daytime or nighttime?
A. I like them both. I always look better in the evening, though—everybody does.

Q. Because there's a fantasy involved?
A. Also, the lighting's much better at night.

Cher adds something special to America. It's glamour. She's more than a beauty, she's a phenomenon. She creates excitement with much more than her looks, it's her talent, her sense of comedy, her warmth.

Cher is good with her own make-up, and our only big change was to eliminate any spiky-looking eyelashes, replacing them with tiny, individual pieces put in among her own. She does need the importance of her eyes, so mascara was part of her make-up, too. But it's all very soft, very blended, not hard or harsh.

I think Cher's hair is beautiful. She should never cut it.

Her clothes are all originals, designed especially for her—one of a kind. Made of beautiful, luxurious fabrics, cut especially for her body, they make her very sexy and glamorous.

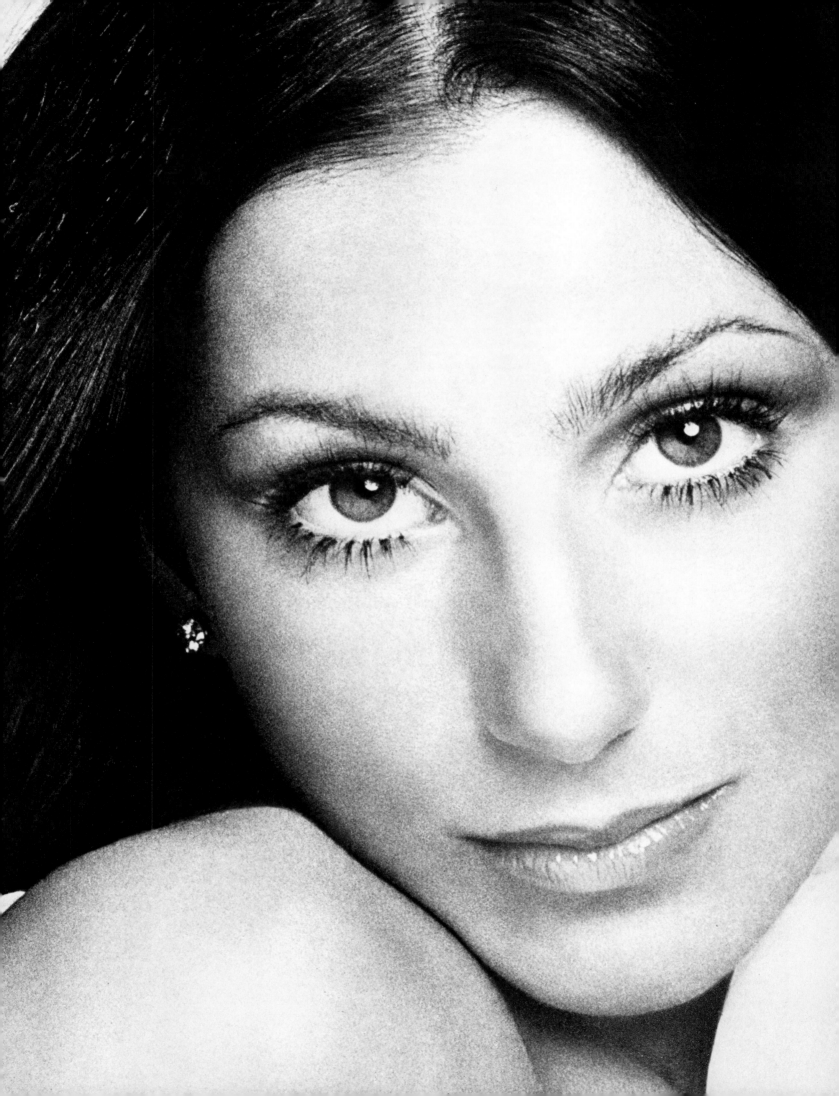

If your face is very special, keep the rest simple

Lois Chiles

Scavullo: How have your ideas about yourself and about beauty changed since you came to New York?
Ms. Chiles: Coming from Texas, my ideas about make-up and hair were pretty strange, and I never really took care of myself before coming here. I never considered myself an attractive girl either. I was just O.K., not as glamorous as all the popular blond cheerleaders back in Texas. Modeling taught me a great deal; specifically, it taught me how important it is for a woman to accept her own looks.

Q. Did modeling give you more confidence?
A. After modeling for a while, I began to believe that I *was* attractive, but suddenly I got scared, thinking that it was simply the make-up, the lighting, the hair stylist—everything but me. I found myself becoming very scared, always feeling that I had to put a mask on, that I had to look beautiful all the time. I don't feel that way any more. Now I just work on the things I enjoy doing: acting, dancing, voice lessons—things that help me to see myself. It no longer matters that I can narrow my nose or color my eyes blue or green. I don't want to be aware of which profile is best or what angle. I think you have to be able to accept your whole face, and if you have bad hair, you have bad hair—deal with it!

> **"I think you have to be able to accept your whole face; if you have bad hair, you have bad hair—deal with it!"**

Q. Do you feel your looks have changed as your life has changed?
A. I don't feel I need the make-up any more, because I no longer feel that I have to live up to other people's expectations. I don't think of myself as a great beauty. I feel what's really important is how you feel about yourself inside, and if that changes, your looks will change. I feel good about myself right now.
Q. Do you spend less time on yourself?
A. I've become more self-indulgent, lazy in a way. I was a compulsive worker when I was a model, but now I take time off every day. I plan quiet time and I use it.

Q. What about diet and exercise?
A. Well, I've discovered bran. I find if I eat it for breakfast it fills me up and I don't get hungry. As far as exercise is concerned, I take dance, but not so much to tone up the muscles as to experience my body moving through space.
Q. When do you feel at your best?
A. When I'm with my friends. I'd like always to be the way I am with my friends—that's my idea of freedom. Not to have to worry about the things I say or that I'm going to do something strange . . . but to act as I really am all the time. I would love to be totally free, that's the only creative experience. If you feel totally free within, then you don't allow things to intimidate you. You don't allow situations to happen that will misrepresent you. In the public eye you are representing yourself every minute, and you become afraid that you won't be able to express who you are . . . or that who you are isn't enough.

> **"I don't think of myself as a great beauty. I feel what's really important is how you feel about yourself inside."**

Q. That's true in the "private" eye too, isn't it?
A. Yes. We all feel we have to look like Elizabeth Taylor. We're sad because we don't have high cheekbones. We say we're too fat or that we have too much hair. When you come right down to it, all these things are ridiculous.

Lois has one of the great faces of all time. It has the haunting quality of a Dietrich or a Garbo. There's a mystery to her and a danger—it's the vixeny look of a fiery cat. You don't forget a face like hers.

The wonderful contrast between her white skin and dark eyes is almost severe. She has really learned how to deal with her face with make-up, softening her features to bring out the bone structure with subtle blending. She contours her eyes, not with heavy lining but with smoky shades well smudged and blended in.

Her very thick hair always has a beautiful cut, so she can manage it easily.

Lois knows what looks good on her—simple straightforward suits, pants and shirts make her look most striking. She doesn't look as if she concentrated for five years figuring out what to wear. She has big bones, and her face is strong, so she wouldn't look right in flashy clothes. Everything should work to accentuate her.

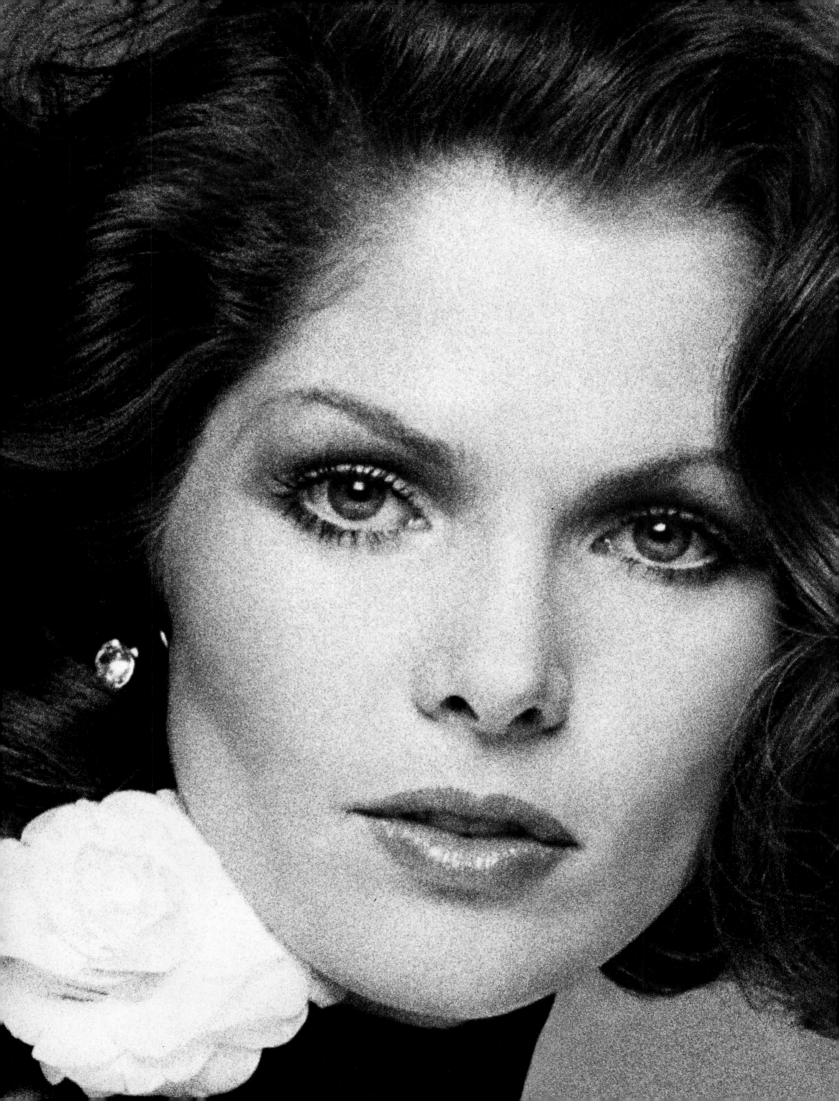

Small changes can create a totally new appearance

Ellen Coughlin

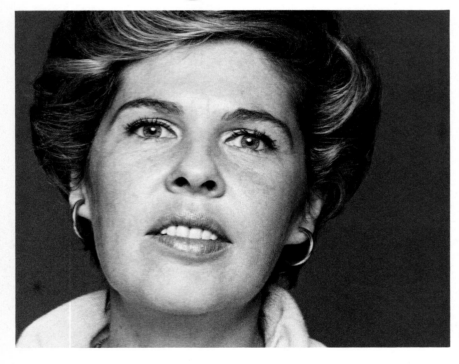

that minor efforts (such as using brown eye shadow instead of blue) could cause such dramatic changes. Just a different highlighting of my hair and a new haircut now save me time, money and concern. My life is easier. And if you do look a little bit better you probably have a little more confidence. The whole experience proved to me that there was a better me and showed me exactly what that better me looks like.

"You couldn't have had a happier subject. Every change that was done made me into a new person."

A great-looking woman who was making some typical mistakes with her make-up, hair and hair color (and who also had a tendency to hold her chin too high). She was delighted to know, as a person who did not much follow current fashion or beauty trends, that she could be made to look so glamorous, and that certain things we recommended could fit easily into her life-style to make it more simple—and less expensive!

Ellen was using a foundation much too dark for her skin tone. She should go without base and just make up the color with rouge over moisturizer. She had been using straight blue eye shadow on her blue eyes, but the simple trick of substituting brown gives shape and importance to the color of her eyes.

Ellen's hair is fine, and she had used teasing and hair spray to give it shape. Her shorter haircut, with a shape of it's own, eliminated fuss and further visits to the hairdresser.

Ellen was in a "frosting" syndrome, and it looked a bit old-fashioned. On top of that, the frosting was too light, looking almost gray, and making Ellen look much older. A lot of the old color was removed and new, warmer highlights were added, because she has very good, pale skin that needed the natural pink brought out. As a result I believe she doesn't have to wear as much make-up.

As a working woman, Ellen has clothes that make sense for her life. Skirts, shirts and sweaters that can be mixed and matched for different looks, and some special clothes for evening. She should stay away from loud, fancy prints and stick to natural fabrics.

Scavullo: Can you describe how you felt about your experience at my studio?
Ms. Coughlin: First of all, let me explain that you would not find a copy of *Vogue* or *Harper's Bazaar* around my apartment. I am happy to be the person I am anyway, without changing a thing, but it was fascinating to know I could be made to look so different.

Q. What about skin care?
A. I started using Pond's Dry Skin Cream a long time ago. Then I got some Estée Lauder treatment creams, and I use them every night and believe me, it works. My skin is clearer—it's fantastic.

Q. Do you equate this beauty process with expense?
A. Yes. That's why I'm so happy I don't have to go to the hairdresser's any more. Over the course of the year, I'll save over $1000—which will be an incredible ease on my checkbook each month and which will pay for my yearly summer trip to Europe.

Q. Do you diet or play sports?
A. I gain weight at the drop of a hat, and I lose it so slowly that I'm dieting constantly. I do exercise with Miss Craig's program on a tape deck—I'm under a doctor's care with all of this—and I love sports, playing tennis and swimming (and now I can go in the water and not have to worry about my hair!), but my sporting life isn't organized.

Q. Did your "makeover" make you see yourself in a different way?
A. The way you look has a lot to do with what you're like, how you feel. I think a lot of people feel that they have to be very made up, terribly beautiful all the time. I feel so good about the makeover because they made me look better without transforming me totally. I feel I look more like the way I would like to look, without being a raving beauty or looking like I spent a lot of time on it. I didn't realize that plucking my eyebrows a certain way could change my whole expression. I didn't realize

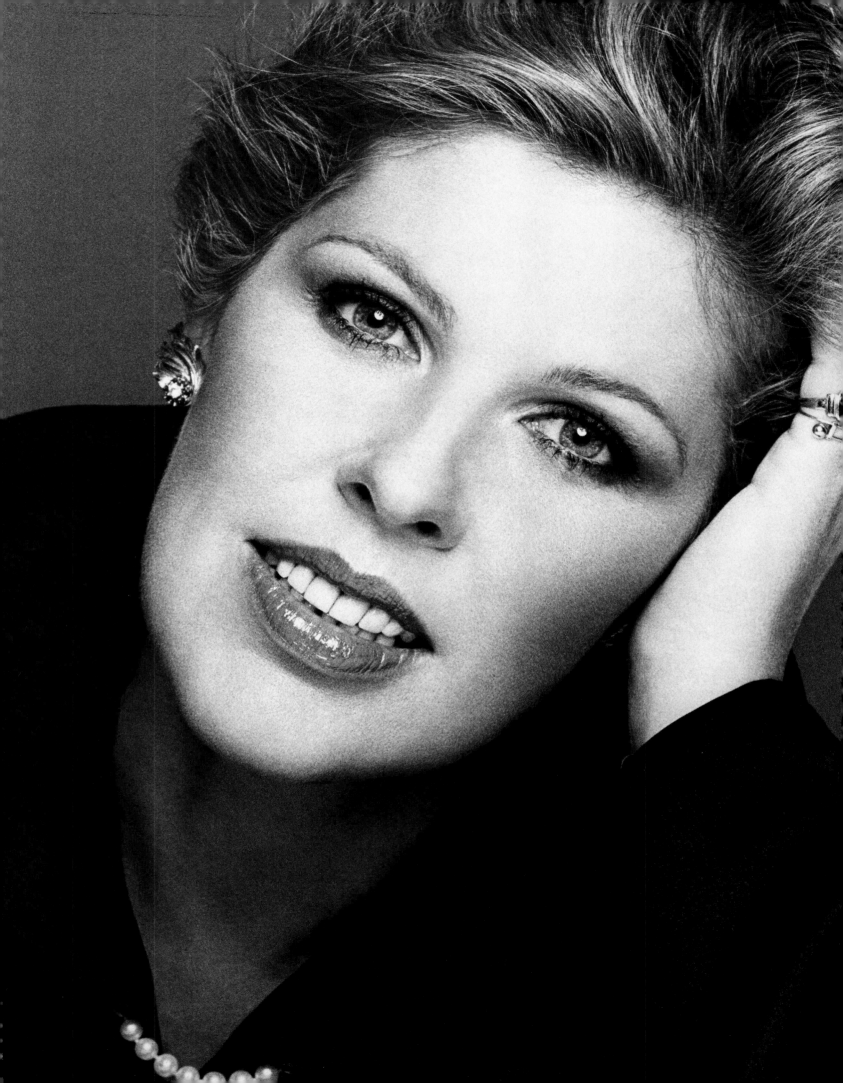

A haircut you can comb with your hands

Dalila di Lazzaro

Scavullo: Whenever I see a beautiful girl, I have to ask her, "Were you born beautiful?" Were you?

Ms. di Lazzaro: Yes, I believe so.

Q. Do you have a special beauty routine? Do you eat special things or exercise?

A. I eat a lot. I love sweets and cake, spaghetti and meat. Eating is a big thing.

Q. What about your skin?

A. I don't do anything for my skin. I use Nivea to take off make-up. I don't drink liquor, I hate it, only occasionally wine. I don't smoke or drink coffee; they make me nervous.

Q. What about exercise?

"I hate exercise, but I swim and I walk a great deal."

A. No exercise, I hate it, but I swim and I'm very active. I walk a great deal.

Q. Do you take care of your own hair?

A. Yes, I dye it myself. I used to be a hairdresser in Venice. My mother had a salon.

Q. Do you have any make-up tricks?

A. I use very little make-up on my mouth. I just put gloss in the middle and line it with brown crayon.

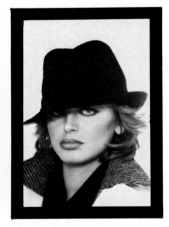

"Eating is a big thing with me. I love sweets and cake."

Dalila, the Italian movie star, is as hot and sexy as they come. She's a very provocative beauty who can look utterly feminine or slightly androgynous, depending on what she wears. She came to my house to fix a spaghetti dinner in a black chiffon see-through blouse and black velvet pants.

The major make-up emphasis is on her eyes. With her hair short and with her face it's her strongest point. No color on the mouth.

She's magnificent with her short hair all thrown in her face. She just combs it with her hands.

Dalila looks fabulous in jeans, thin gold chains around her neck, in a Fendi unlined Ermine coat and with that shake of hair. She looks sensational in a jumpsuit or a sheer blouse. Her best colors: all white, black, brown, gray and red. She has a throwaway attitude about clothes—when it gets dirty, throw it away.

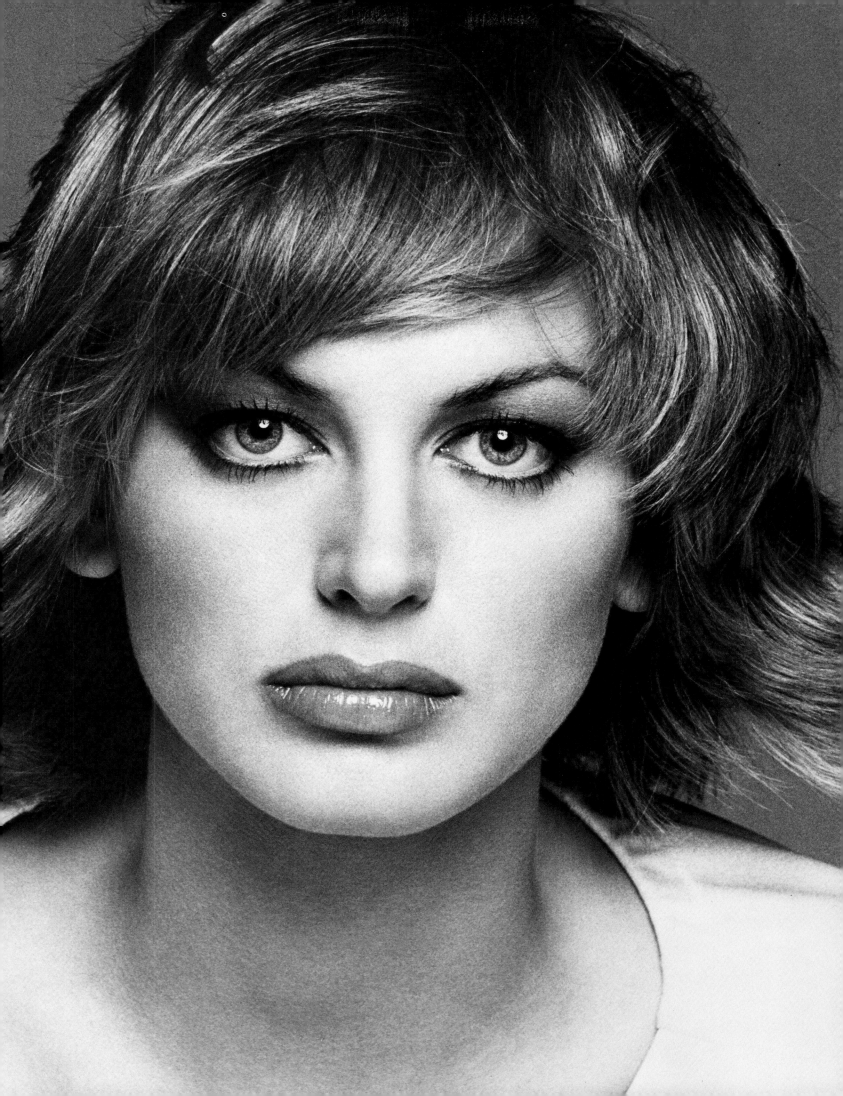

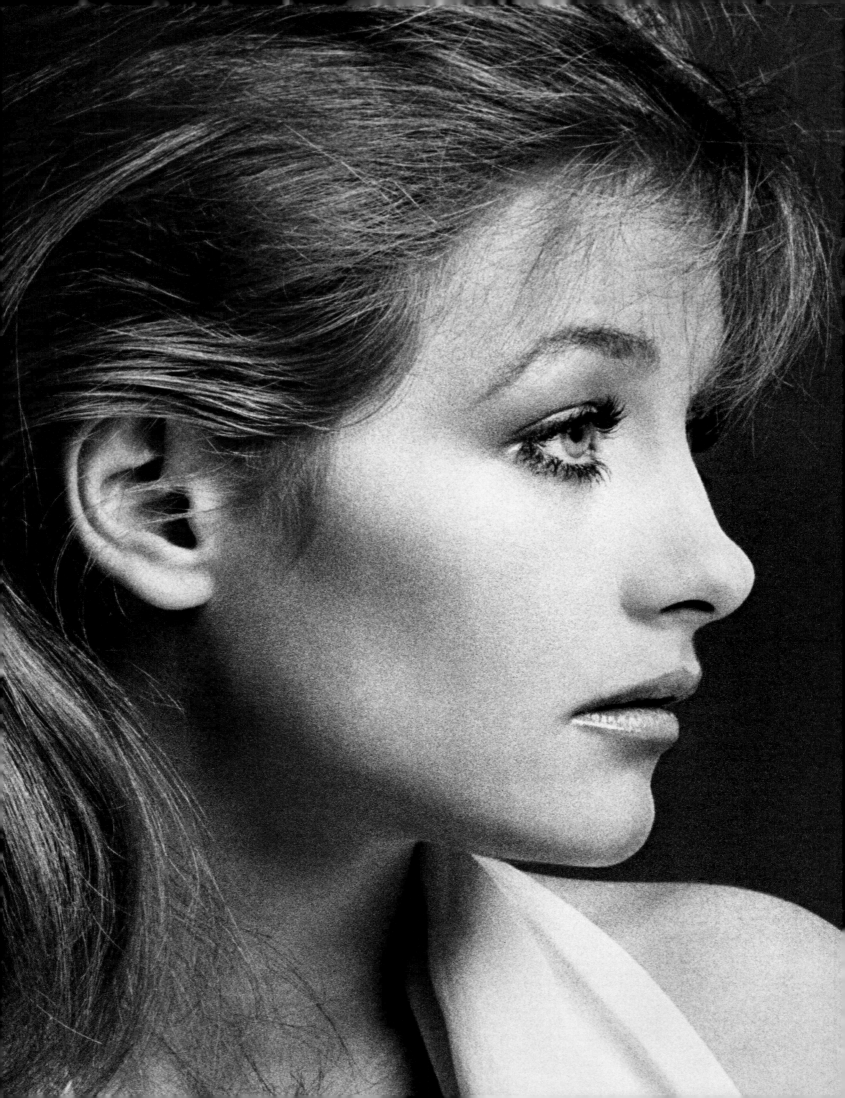

Subtle to sexy: make-up makes the difference

Patti D'Arbanville

Scavullo: Were you a beautiful baby?
Ms. d'Arbanville: My grandmother took me to Bloomingdale's at the tender age of three, and I won a beautiful child contest and as a result of that I was an Ivory Soap baby for three years. I used to have to sit in the bathtub with my underpants on and say, "Get some today."

Q. Do you think your beauty has changed over the years?
A. I used to overdo things—there isn't a thing I haven't done except have a baby. I don't regret anything I've done, but I've just learned moderation.

Q. What is your idea of beauty?
A. It's such a difficult question. Beauty is anything that excites you when you look at it, anything! But I like warped, degenerate beauty.

Q. Do you think you are beautiful?
A. I have my beautiful days. My beauty really depends on my mood, and if I'm being active enough. I can't sit still. Right now I'm bobbing my foot up and down under the table. I think beauty is being able to get angry with your best friends.

Q. I think you are beautiful, but you are also pretty . . .
A. There is something sweet about pretty. Beautiful is something that is sometimes too studied.

Q. What about your skin?
A. I've never had any problem with it, except when I was making that movie in Paris and they put so much junk on my face. The lights were so hot, it opened my pores and everything seeped inside. And I'd get hives from nerves. I went on some kind of herbal treatment for that—I don't have any routine.

Q. Do you diet?
A. I don't eat a lot in the daytime, but I eat at night. I gained a bit of weight. I was 118 pounds after I finished *Rancho DeLuxe*—that was a shock, boy! My stomach is the big problem. I should be taking dancing lessons, and I do when I'm in California and in Paris, but not as much as I should.

Q. Do you exercise?
A. Oh, sure—during the game shows on TV! I jump up and down a lot when somebody wins twenty thousand dollars on the $25,000 Pyramid. I love to ride, and I love to ski. I stand up great on skis. I put the skis on, I take the ski lift, and then I just stand there at the top. I stand up good and I look very good on skis and in ski clothes. I have a lot of good pictures of myself on skis. I haven't been in California long enough to stand in tennis clothes holding a racket.

Q. Do you have any special beauty routines?
A. I have my legs waxed. I have a system for my nails: I bite them regularly, and I push the cuticles down with my other fingernails so that they break. I have a great pedicure system: I bite my toenails. I've always got my foot in my mouth.

Q. When you see someone you think is beautiful, what do you look at first?
A. The eyes. When I talk I look at people's eyes.

"I'm very sensitive about my stomach because I would like to have a twelve-inch waist."

Q. Who are some of the women you really think are beautiful and admirable?
A. I think Bianca Jagger is beautiful, a surface beauty. I'm bored with Elizabeth Taylor, but I used to think she was great. I think Charlotte Rampling is beautiful. I like her eyes. She's so beautiful; she's so smoky and sultry. I really admire Jane Fonda and Geraldine Smith, both very witty and intelligent.

Q. What do you consider your best feature?
A. My eyes are my best feature, and I have a good mouth. I'm very sensitive about my stomach because I would like to have a twelve-inch waist and no protrusion at all, but I have a little tummy.

Q. Do you have a beauty problem that you can't do anything about?
A. Yes. Under my left eye there's a little fatty deposit.

Q. What are some of the things you like best?
A. Good movies, my mother, Cinzano ashtrays, a good bottle of white wine—Pouilly-Fuissé; I love it when I get a good haircut, marble tabletops, I love going into restaurants with a whole group of people and turning it upside down, I love being outrageous, I love making out in the movies, dancing, I took a bath once for seven hours and read the whole of *Mila Eighteen* by Leon Uris in the bathtub in between the cold and hot water.

Q. How do you indulge yourself?
A. Eat pizza.

Q. Do you care a lot about possessions?
A. To a certain degree. I wouldn't give everything up and go and live on a mountain in Tibet, but I'm not that materialistic.

Q. What do you consider your best look?
A. I like the idea of whipping down Park Avenue with a long cashmere scarf on a winter day. I like the way I look in the evening, because I really go all out when I dress up.

Q. I noticed the other day that you wanted to show a lot of cleavage for your photograph . . . Do you like to look very sexy?
A. Yeah, since I started taking these French birth-control pills my breasts are bigger. I figure I can get a nice pushup bra and wear it one night to some kind of opening in California—that would be nice.

Q. Do you analyze your looks?
A. What I do is to just get in the shower with all my make-up on and let it run all over my face. And when all the mascara smears and all the black starts smearing over your cheeks, you just take all that off and look incredible. Or take a shower and let the mirror frost up and look at yourself that way, if you're really hopeless.

Q. Do you dress for men, women, yourself or your career?
A. Myself, because myself is a part of all of that. Everything I do is for me and the people I love.

Q. Do you think American women could stand a little improvement?
A. Yes, because they are about ten years behind everybody. American women just don't believe in themselves enough. With all this talk about expanding yourself and becoming more of a person and Women's Lib and all this . . . It all comes from inside, and if your motors aren't working inside . . .

Q. Where do you think values are the highest?
A. At least the French women try to look nice for themselves, and to be pleasing to the eye. French women like to look nice even walking into a butcher shop. And the woman giving the change behind the counter is well dressed, and she's pleasing to the eye. She may not be pleasing to talk to, and you might want to spit in her face, but at least she looks good.

Q. If you want to improve yourself, what's the first step you should take now?
A. Well, you should probably just stand naked in the middle of Broadway and Forty-second Street and see if you can stop traffic.

Patti is a delectable beauty with a kittenish quality that's pure enchantment.

Make-up is very important to Patti because she tends to look tired without it. It also makes her look more glamorous. Her slightly thin mouth needs to be rounded out and given importance. Her eyes have a puffy quality that disappears if dark shadow is put on the whole lid area from lash to brow. It's a matter of giving the mouth lushness and the eyes openness.

She has very beautiful natural hair color—a subtle honey blond that you have to be born with. In the photograph, she has the right length of hair.

Patti's own sense of style is quite perfect. She looks great in a man's plaid shirt or just a scarf tied crisscross over her breasts. She's sexy, small and feminine.

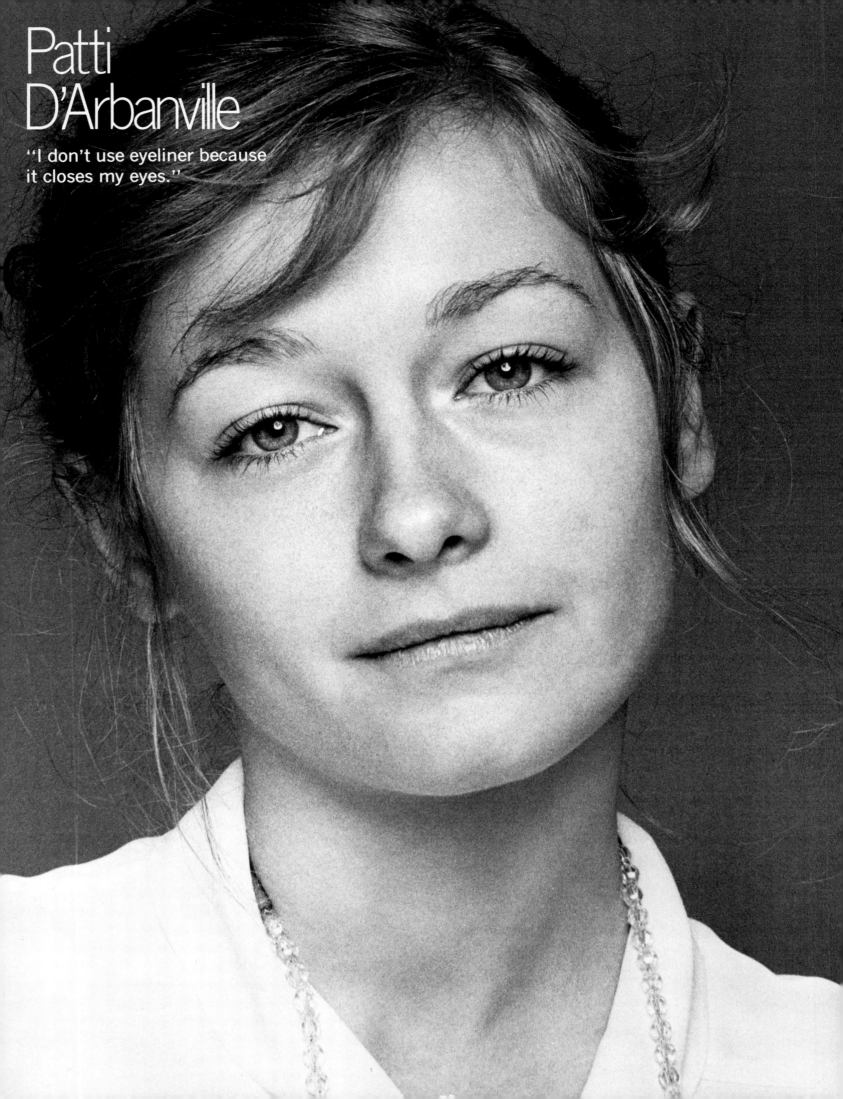

Patti D'Arbanville

"I don't use eyeliner because it closes my eyes."

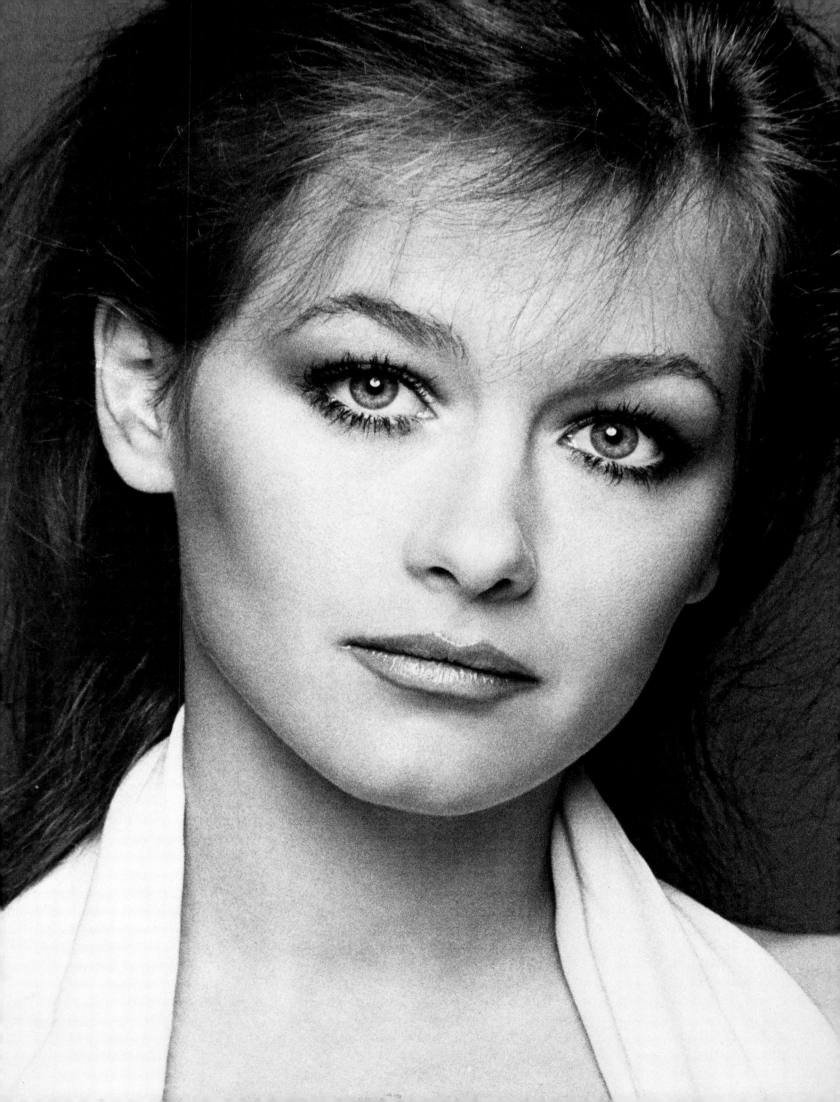

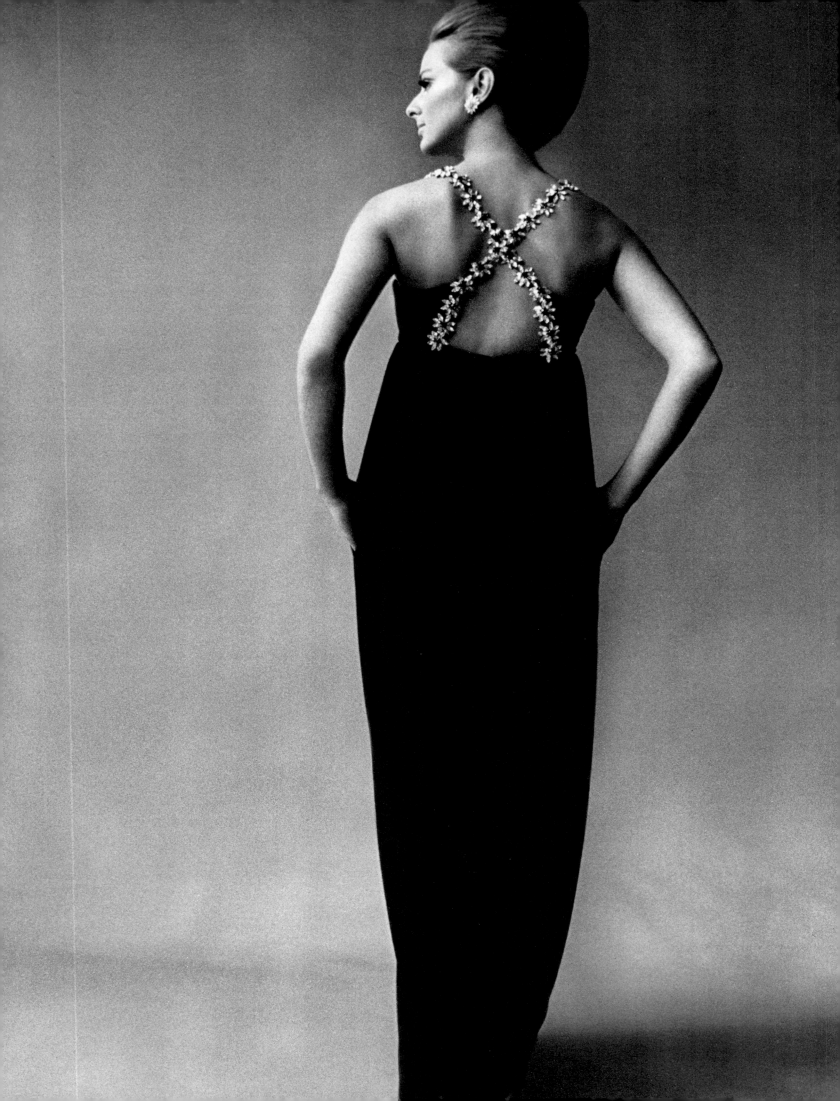

Bangs: for a fresh look

Agnetta Daren von Rosen

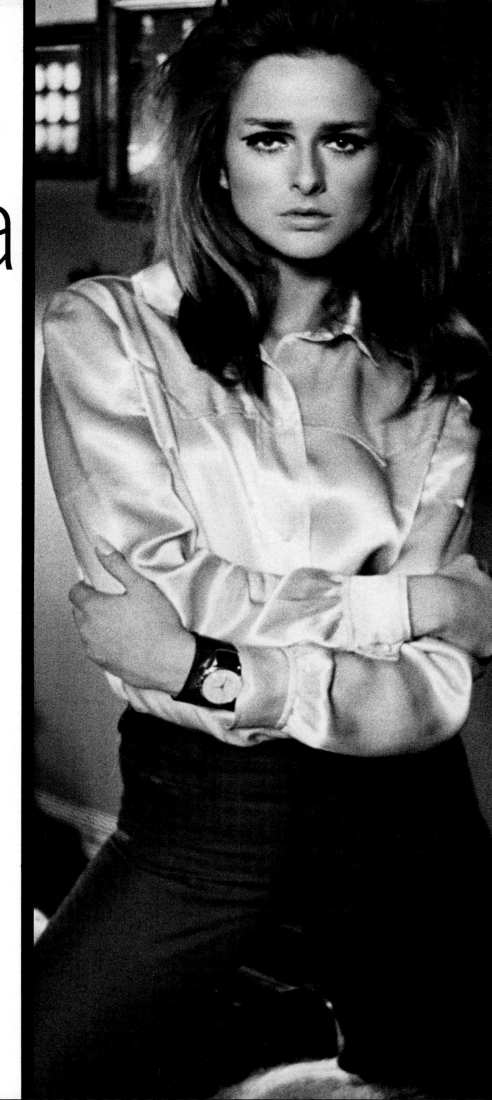

When Agnetta first walked into my studio in the 1960's I fell in love with her. To me, she was one of the great fashion models of that decade. Her face has great depth and strength.

When she came to New York recently from Africa, where she now lives, with no make-up on, she looked like a madonna. I made a few changes to bring more energy to her look.

Agnetta has the bone structure of the century. Her eyes are not lined, and no rouge is used on her cheeks—just a soft blending of tones.

Giving Agnetta bangs gave spunk to her look. Her hair just straight and hanging lacked vitality. It's a simple cut that needs no special attention—very practical for her life in Africa.

Her Moroccan style in clothes is very personal. The shawls and jewelry she's picked up in Africa are beautiful with the full-cut cotton skirts and cotton blouses that she wears.

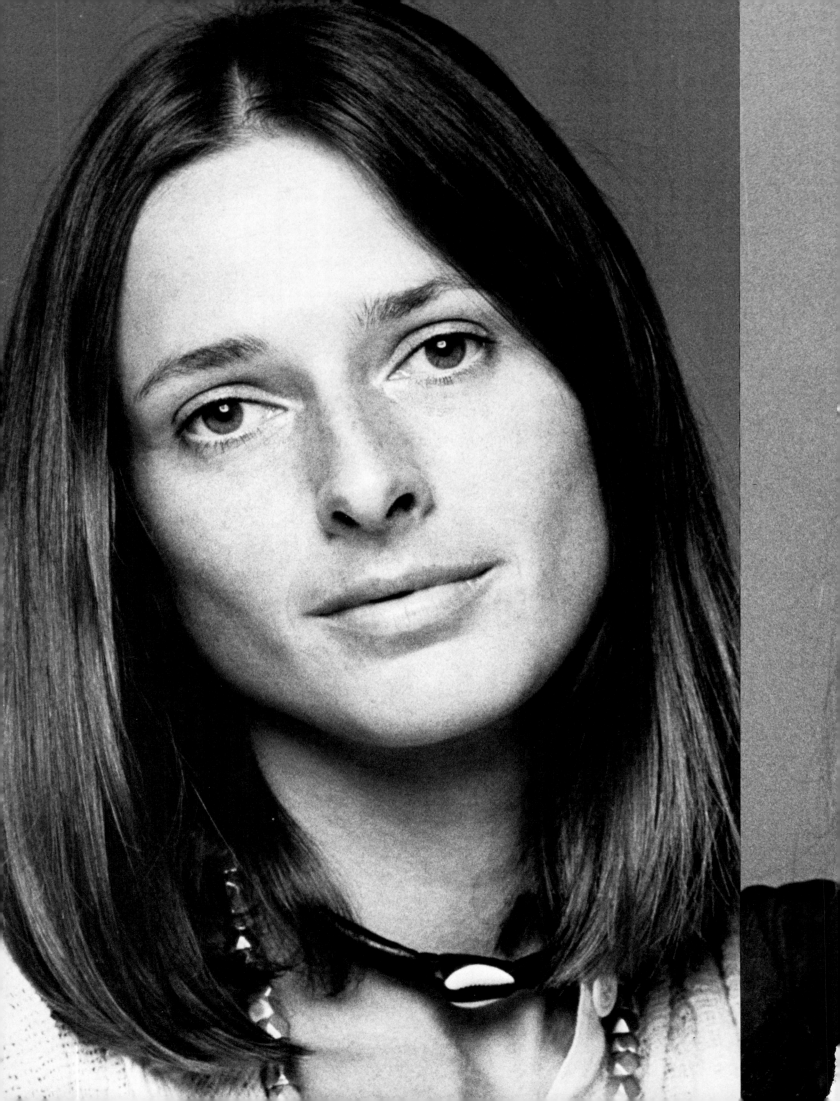

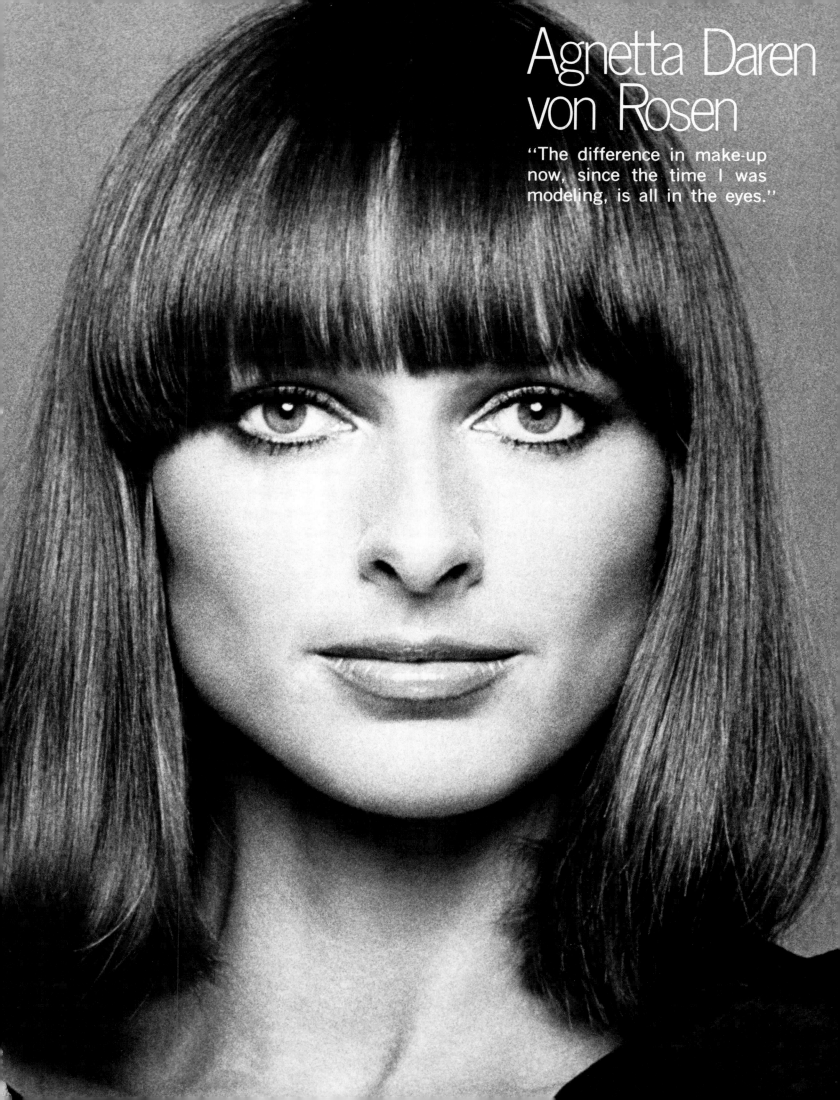

Agnetta Daren von Rosen

"The difference in make-up now, since the time I was modeling, is all in the eyes."

The new, unfussy look
LouLou de la Falaise

Scavullo: What does it take to make you look and feel your best?

Ms. de la Falaise: I like to be stimulated, interested, to have people tell me original things that will surprise me.

Q. Where is life most beautiful for you?

A. I could really live anywhere, as long as I have my own little scene going.

Q. Do you have any hang-ups?

A. I have obsessions, but I don't have hang-ups.

Q. What are some of your obsessions?

A. Things I want to make, or things I want to find out. No beauty obsessions. If I have bad skin, I worry about my pimples for a couple of days.

Q. Have you always had short hair?

A. I've never had it long. I love having it cut. It's so easy to take care of. I don't have the kind of straight hair that you can just leave alone.

> "Some women are totally professional about beauty. They don't drink, smoke, they take vitamins by the handful. If you can be bothered to live that kind of life . . . you know it works."

Q. Are there things you don't like?

A. I get irritated by laws and authority.

Q. What are some of the things you do like?

A. I like people talking to me best of all, making plans, intrigue, excitement, travel. I like to be amazed.

Q. What women do you admire?

A. I think my mother, Maxime McKendry, is great, and Maria Schneider, Elsa Peretti.

Q. Do you like to wear perfume?

A. I buy tons and then forget to put it on. Vol de Nuit, Nuit de Noël, and Narcisse Noir are my favorites.

Q. What is your favorite beauty drink?

A. I just drink scotch and soda. I don't really like health foods, I love greasy hamburgers, pop and French fries.

Q. You have a very unfussy look.

A. I don't like that kind of All-American image girl, all natural look. I really like foreign faces—that's why I love Japan so much. You know, girls are always going to get some different idea of how to look. Only a few girls look the way boys like them to look. Boys have very bad taste. They like long blond hair . . . they still like the same old thing. They can't stand lipstick, make-up. My boy friend likes me to look very "butch," he doesn't like make-up very much, and he hates the really feminine look. He likes me to look like a boy. I love it.

Q. How would you describe the way you look?

A. My looks are fairly androgynous, really. Girls have all got the breasts and the hair, while my look is completely the other thing—completely unfrilly. English girls always seem to go out in dresses that look like nightgowns. They wash their hair all the time. Under that mess of confection all of them are real beauties. I think French girls are very fashion-y. They're always accessorized to the hilt, but they're not frilly. They look very strong and make more of an impression. In fact they're less pretty than English girls, but the English are dead scared of them. They think French girls have tricks that the English haven't got. French girls make more of an effort with boys. They go all out to look nice—to have a whole look.

Q. What about Americans?

A. Americans are very un-fashion-concious, which is very nice. They make an effort always to have clean hair and clean teeth. They look nice. Some women, like Marisa Berenson, are totally professional about beauty. They don't drink, smoke, they take vitamins by the handful. If you can be bothered to live that kind of life . . . you know it works. I think when I collapse, I'll just have the whole thing pulled up—lifted.

Q. What is your day like?

A. I design clothes, I handle licensing agreements for the sale of designer clothes. I never make appointments before eleven in the morning. The more I work, the more energy I have, the more I stay up late. Finally I collapse and get sick, and there's no way I can be pulled out of bed.

LouLou is creative assistant to Yves St. Laurent. A totally modern, self-disciplined girl with an aristocratic, intelligent beauty, she always projects an "up" attitude.

The picture I took of her two years ago for Interview *magazine shows light skin, dark lips, rounded eyes. Now her make-up is much easier, more subtle.*

LouLou's gone back to her natural hair color—from dyed red to natural brown—and her hair is now quite short. She can just wash it and shake it dry like a poodle.

She has great style. She looks incredible in suits, fantastic in dresses and pajamas. She wears the layered look well because she's so thin. She can mix everything up and throw it together. She even borrows her boy friend's peg-leg pants, circa 1950.

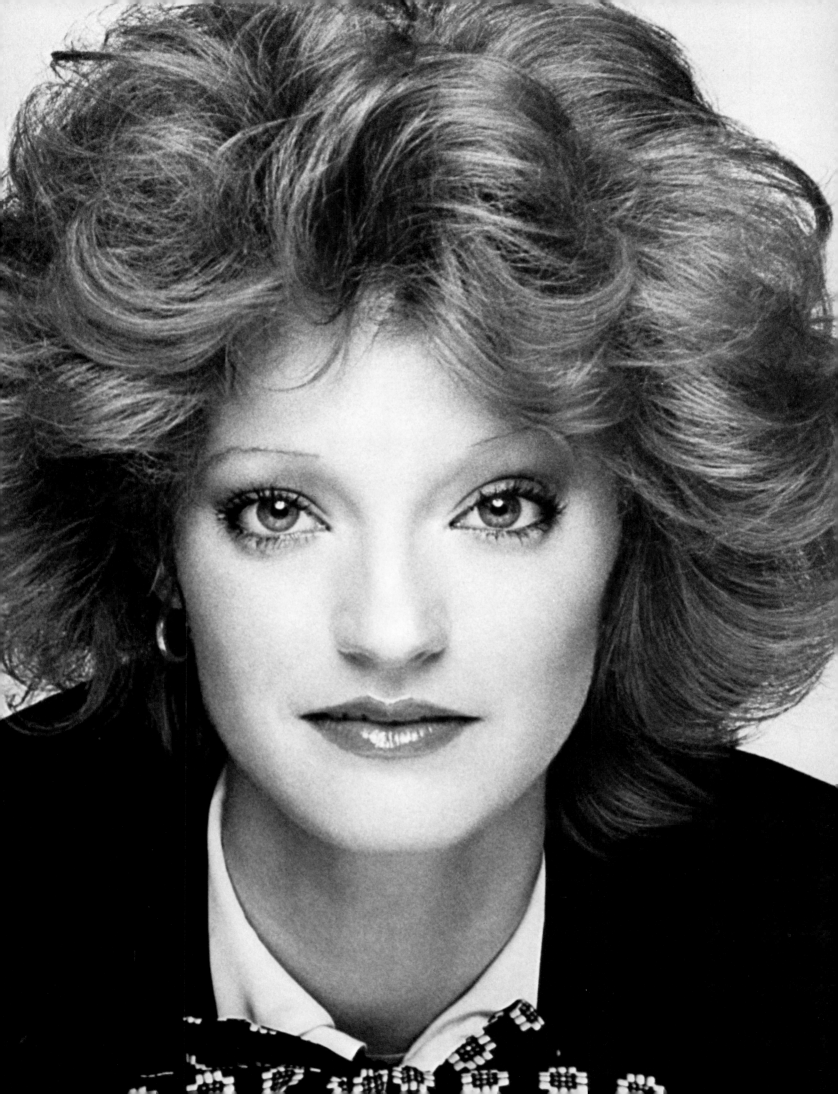

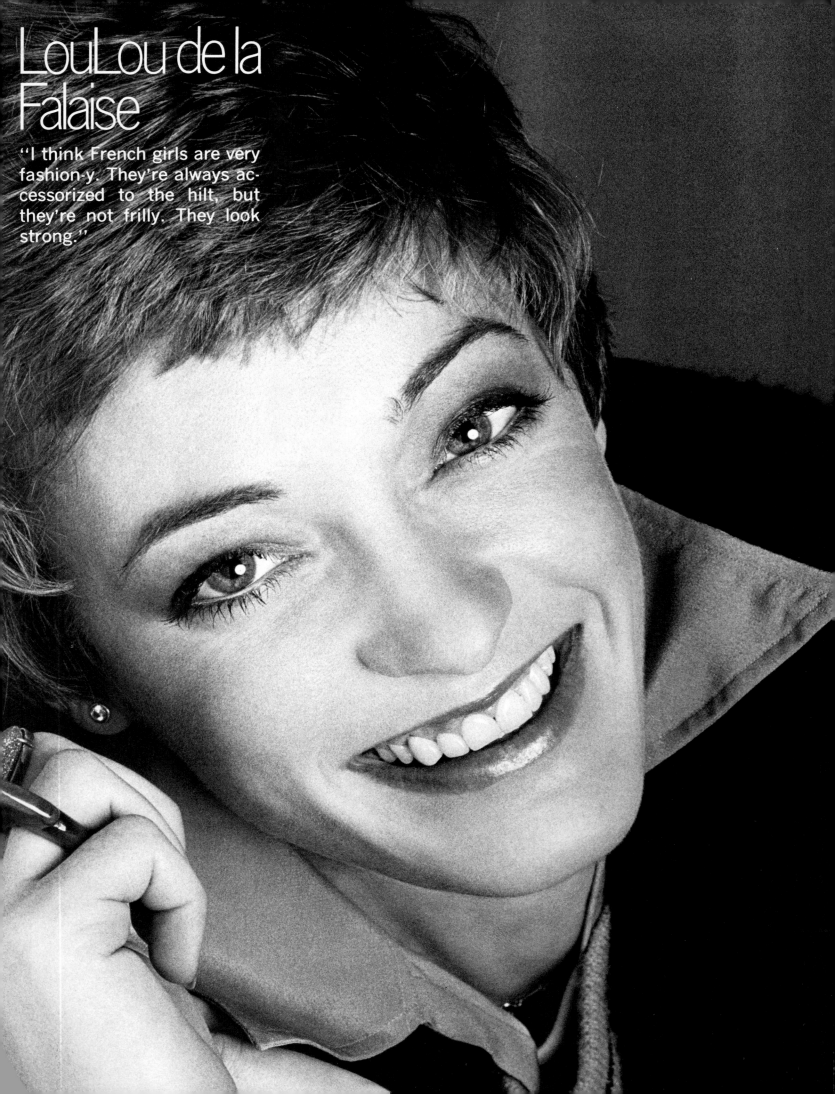

LouLou de la Falaise

"I think French girls are very fashion-y. They're always accessorized to the hilt, but they're not frilly. They look strong."

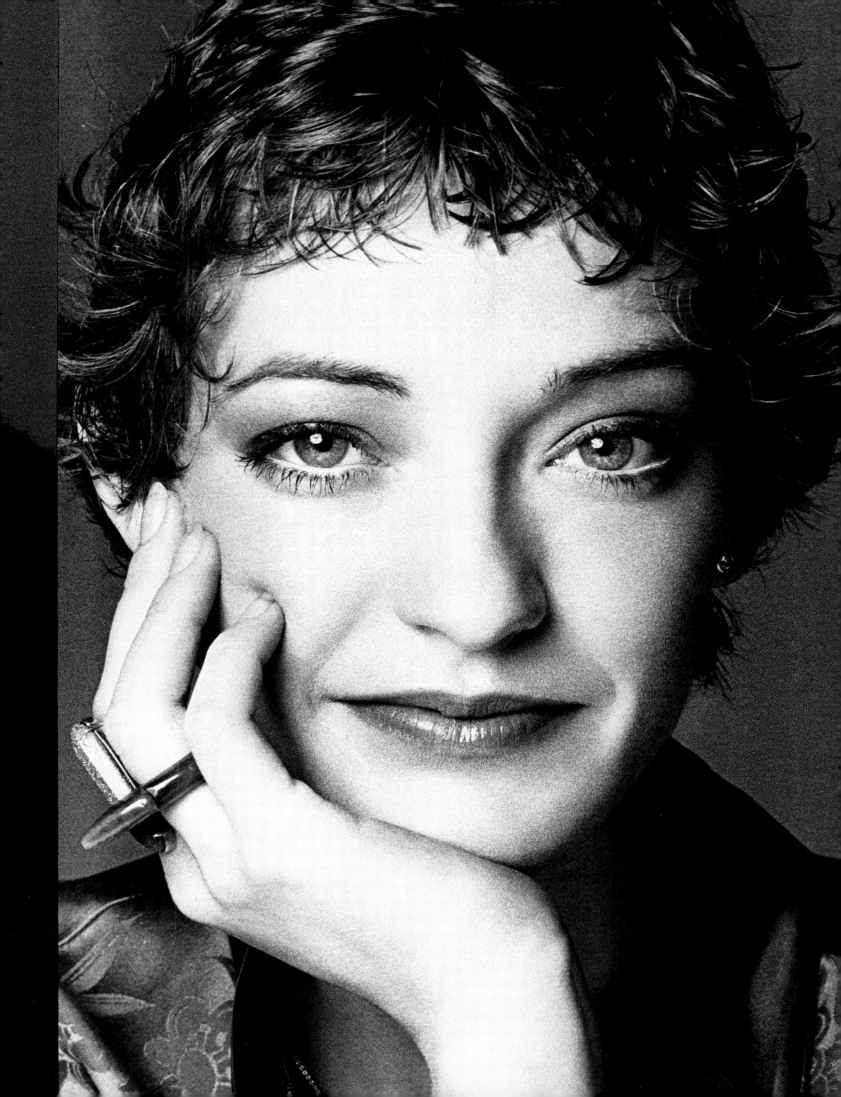

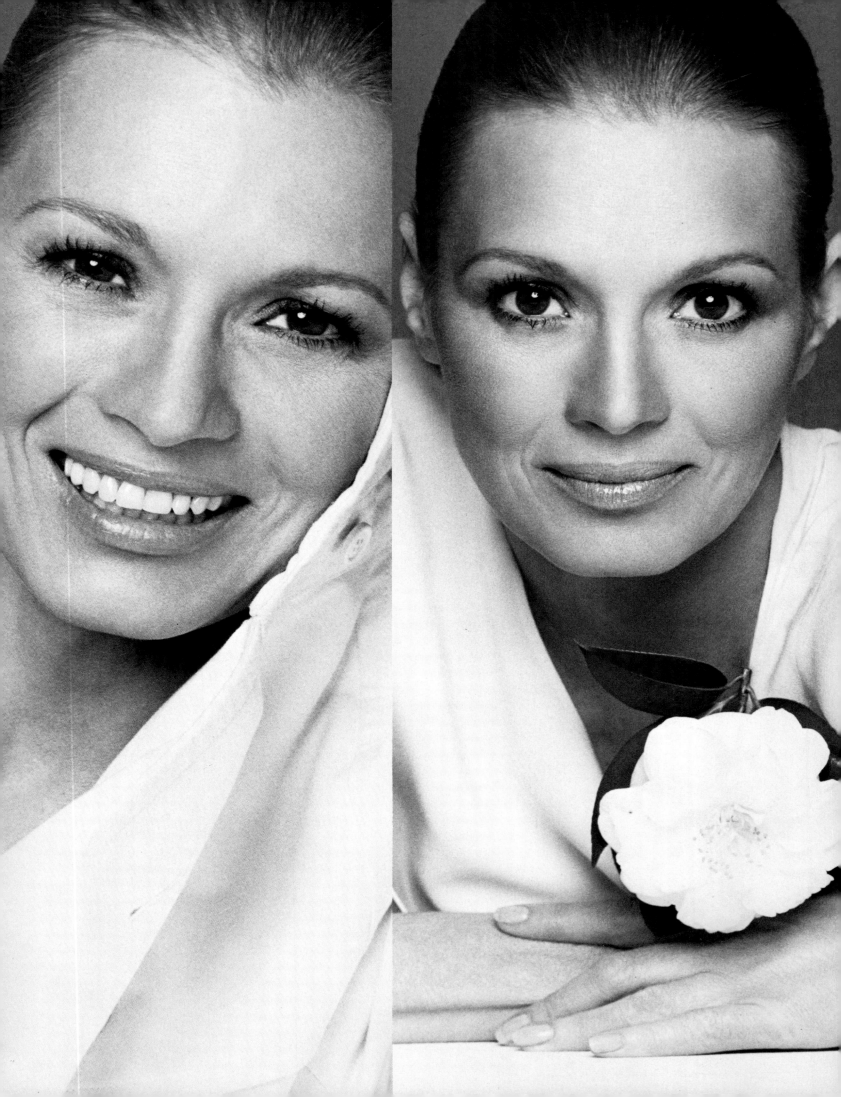

Accentuate fragile features with pulled-back hair

Angie Dickinson

Scavullo: How do you take care of yourself?
Ms. Dickinson: Very well—with proper health-food eating, vitamins and as much rest as possible.
Q. Do you exercise or do sports?
A. I jog and run in place. Swimming is my only sport.
Q. Do you diet?
A. Yes. I diet every day. An important part of my diet is fruit juice.
Q. How do you take care of your hair?
A. I wash my hair daily, using Wella Balsam plus a Fermodyl conditioner once a week. I like to wear it flying loose.
Q. How do you take care of your skin?
A. I use Shaklee cleanser every night and follow that with an astringent and a night cream. During the day I use an oil on my face if I don't have to wear make-up.
Q. When do you use make-up?
A. I use a medium amount when I have to only—which is before a camera or when I go out to dinner.
Q. When do you feel your best?
A. Always. I feel even better during the day than I do during the evening.
Q. What is your favorite look?
A. Freshly washed, blown-dry hair, Levis and a sexy simple knit shirt top. I love soft colors.
Q. What are your best features?
A. I'm rather blessed with a well-proportioned body. But I hate the current length of skirt—I never get a chance to show my nice-looking legs.
Q. Do you have any beauty problems?
A. If I eat too much because of emotional distress, I get to the cause as quickly as possible, then the problem is minor.
Q. What is your favorite indulgence?
A. Chocolate mousse.
Q. What kinds of clothes are you most comfortable in?
A. Casual clothes. Levis. My favorite colors are yellow, pink, lavender or purple, golds and white. I love soft materials.

> "American women eat too much."

Q. How might your friends describe you?
A. They would describe me as terrific, or I guess they wouldn't be my friends. I'm a little too fussy for some of my friends, I think. Persnickety.

> "If I lived alone I'd never put make-up on. I'd be in old Levis and bare feet all the time."

Q. How do you evaluate your looks?
A. I know I'm not what you call beautiful, as we think of Sophia Loren or Elizabeth Taylor, but I look like Angie. In Italy they say I'm "sympatico," I think it's a compliment.
Q. Are you your own best beauty expert?
A. I try to look the best I can in the time allowed at that particular moment. Time, time, time. I go by my mirror and try not to be fooled and try not to talk myself into wearing something wrong, or wearing my hair in a way that won't work. I try to answer honestly the question: Does it look good? My biggest beauty mistake: cutting my hair very, very short in 1970.

> "I go by the mirror and try not to be fooled."

Q. Do you think life is easier if you've done your best to be attractive?
A. Life may not be easier, but it feels better.
Q. For whom do you try to look attractive?
A. I try to look attractive for others. If I lived alone I'd never put make-up on—I would wash my hair and be clean, but I'd be in old Levis and bare feet all the time.
Q. Do you feel you could do better with your appearance?
A. One can always do better, unless that's all you've got to do all day. It does matter to do better but, again, time permits you to stay with it only so long. It is a matter of time. Time to exercise. Time to brush your teeth thoroughly. Time for clothes fittings (ugh!). Time for relaxing the body and the mind. Time to condition the hair, wrap it in hot towels. Yes, time is the biggest problem.

Q. What do you think of the way American women look?
A. American women eat too much. I don't think they look at themselves and "see" themselves. I'm not talking about the 20 percent (that's a guess) that are attractive and slim and blessed with a God-given outward beauty. But weight is the most important thing. If you have a nice body, you'll dress it properly, fix your face and your hair. I don't like the stiff-looking hairdo for American women. Hair spray should be banned, unless it is used to hold a soft hairdo in place a little longer. I love the look for teen-agers today—the loose hair, whether it's long or short. The miniskirt was the best time. It started a style that let people dress any way they want to, and I think it's great. What I love about any fashion most is that it comes and goes. But I miss the miniskirt. Bring back legs.
Q. What should you do to improve yourself?
A. Read the Bible, and then *The Prophet* (and by the time I finished, my hair would be nice and long, and I wouldn't have to fuss with it all the time). I'm always trying to improve myself. Everything is changing every day. The first step I would take, I guess, is to go to the closet and pack up those clothes I hate to part with because I somehow think they'll look good again, and send them off to Guatemala. It would do us all a lot of good.

I think this is the way Angie Dickinson should always look. Neat, pulled-back hair accentuating her beautifully shaped, small head and her delicate features. She looks womanly here, soft and sensuous. It's my favorite look for her.

She has a no-make-up look. Her features are so fine you wouldn't want to overpower them with color. Her skin just glows.

She has a very angular body, and with her looks could go with simple, straight clothes, Army/Navy, or extremely feminine for evening. Since she's so small, solids are best, and she should bring back gloves and wear them always.

Know when less is more

Faye Dunaway

"The best thing for beauty is just being happy."

Scavullo: What's the secret of your great looks?

Ms. Dunaway: The best thing is to be happy. I think the greater your measure of personal happiness, the more it shows physically.

Q. Do you use a lot of make-up?

A. I don't wear a lot for film or stage, unless the character calls for it. Off screen, I never wear make-up. It's like a mask and I feel better without it.

Q. How do you take care of your hair?

A. Nothing special. I just use a mild shampoo.

Q. And diet? Do you like junk foods?

A. I adore junk foods, but when I work I eat foods that are healthy for me.

"I adore junk foods, but I don't eat them a lot . . . I eat a lot of liver."

Q. So you're like a dancer or an athlete when you're working—you live for that work.

A. You have to. The demands are there. And if you don't work that way, you just can't do it. When I'm not working, I'm less strict on myself.

Faye Dunaway just gets better and better. Her hair is a beautiful natural brown, her skin is smooth and radiant, and she looks absolutely beautiful without a trace of make-up. She's a woman with a fawnlike vulnerability that I love—and I think she's a great actress.

Her favorite color is purple. She has six purple shirts from St. Laurent that she wears day to day. She wears trousers, loose sweaters and scarves that look great with berets.

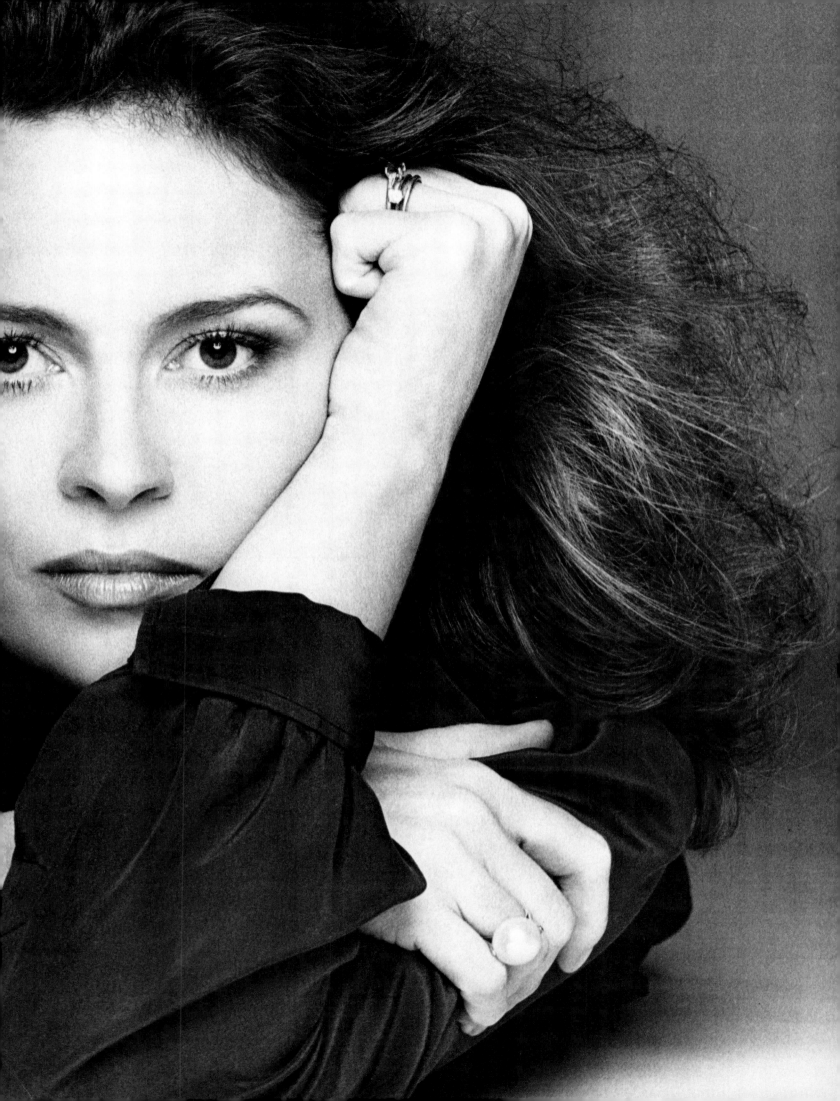

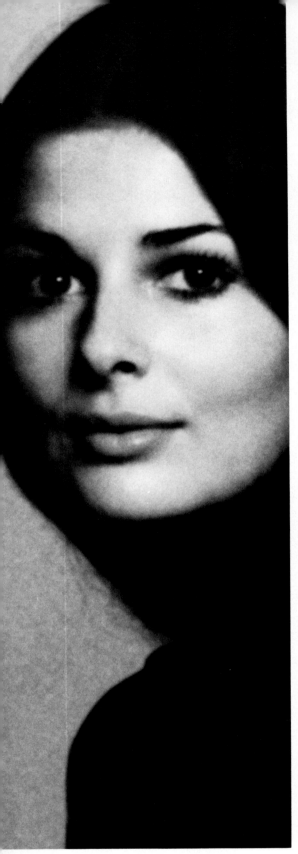

Good looks— yesterday and today

Christina Ferrare

Scavullo: How would you describe yourself?
Ms. Ferrare: I'm an emotional Italian.

Q. Are you plagued by any permanent beauty problems?
A. Yes. My bottom teeth are crooked.

Q. What does beauty mean to you?
A. Beauty is simplicity; the less you do the better. It's a healthy glow on your face. You don't need money to wash your face with soap and water and to put a little lotion on it, a little foundation. Of course, money helps when you have a crooked nose and you want it straightened. My code of living is simplify. You don't need expensive clothes or jewelry to be alluring. It's all in your attitude.

Q. Do you like perfume?
A. I like Nina Ricci, it's very clean-smelling. I prefer a natural scent.

Q. What about sleep and beauty?
A. I need a good night's sleep. If I don't get seven to eight hours' sleep, I feel terrible, and I feel I look terrible.

Q. What do you do to make yourself feel better?
A. I take a very warm bath, clean my face extremely well and lie on my bed under a thin cloth and catnap for fifteen or twenty minutes. It rejuvenates me, especially if I've had a busy day and I must go out at night. I always make sure that I have enough time in the afternoon to get ready. I've got it all down to a routine that's as simple as possible—it works. I don't sit and fuss, I'd be a nervous wreck.

Q. Have you done anything recently to better yourself?
A. Yes. I grew up.

Q. How old are you?
A. Twenty-four.

Q. What else have you done?
A. I've had my hair cut off. I'm much thinner. I've learned how to apply make-up. I'm much more sure of myself and relate to people much better. When I'm thirty I expect to look even better. I think a woman reaches her peak at forty.

Q. Are there women you admire?
A. I think Grace Kelly is beautiful, and Sophia Loren. Katharine Hepburn has so much style, she has always been a trendsetter. Bianca Jagger has style, and Jacqueline Onassis.

Q. Do you think life is easier because you're beautiful?
A. Definitely.

Q. What sort of things give you a lift?
A. I like nice clothes, a nice place to live. I'm very into the way things smell. I like the way grass smells after it's been cut. I think that's the way heaven smells—although I'll never see it.

Q. What don't you like?
A. I don't like loud, boisterous people. I'm not too crazy about large parties that people go to just to be seen. I also think there's no excuse for being fat. Fat is ugly.

Q. What is your personal approach to beauty?
A. I live my life in a very European manner. I'm a different person than I was last year. I think you get to like yourself better as you get older. I look forward to it. I don't mind the fact that I'm getting older.

Q. Do you have any hang-ups?
A. Food.

These pictures represent Christina yesterday and Christina today. Christina has cut her hair and changed into a very contemporary beauty. Still, she is what I would call a man's woman, a woman who does everything to please a man.

In her earlier picture there seems to be a heaviness in Christina's coloring—a lot of dark hair, dark eyebrows. Of course, she was still a beauty, but the recent picture shows a much lighter tone to her whole face and appearance. Her eyebrows are thinned and shaped. She still wears eyeliner and eye make-up, but it's not heavy or dark. It makes for a much cleaner look and makes for a more refined bone structure.

She shouldn't have hair that's too long—it would weigh her down. A trim once a month should keep it in shape.

Christina is a big, tall girl who gets a slim silhouette from classic, simply designed clothes. They make her look as if she were sculptured.

"Beauty is simplicity; the less you do the better. You don't need money to wash your face."

"I think you get to like yourself better as you get older. I look forward to it."

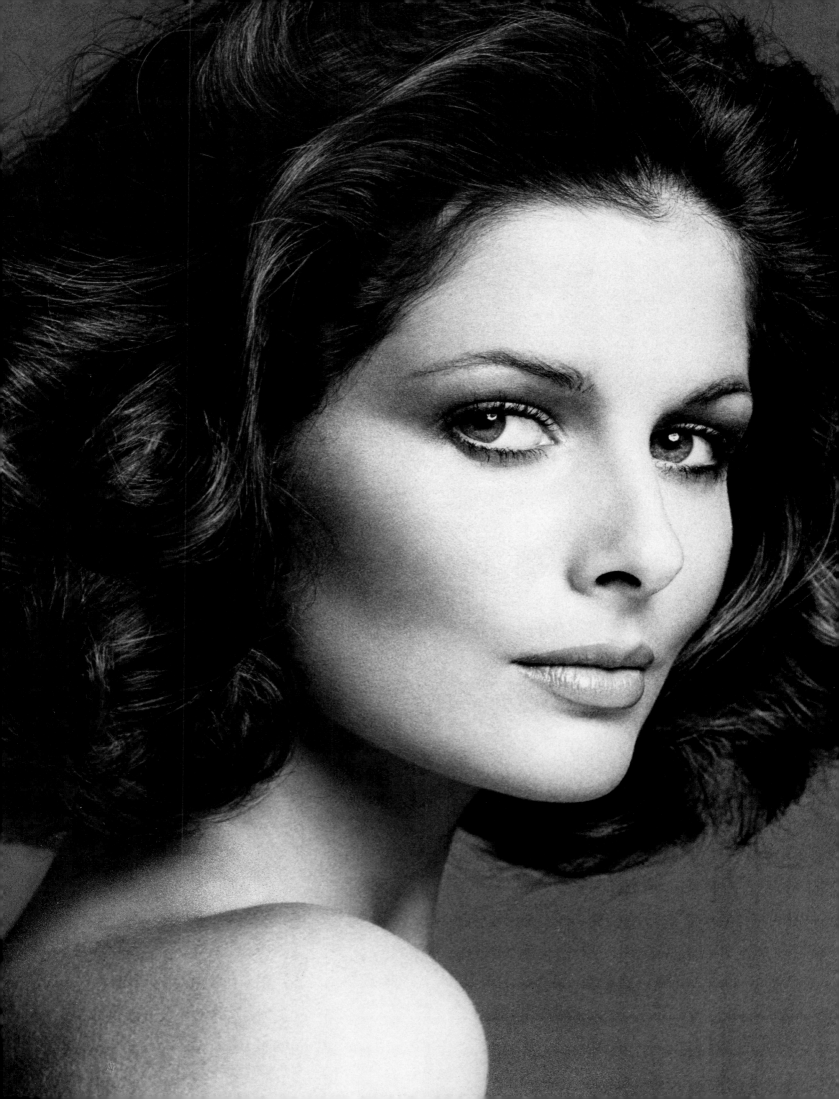

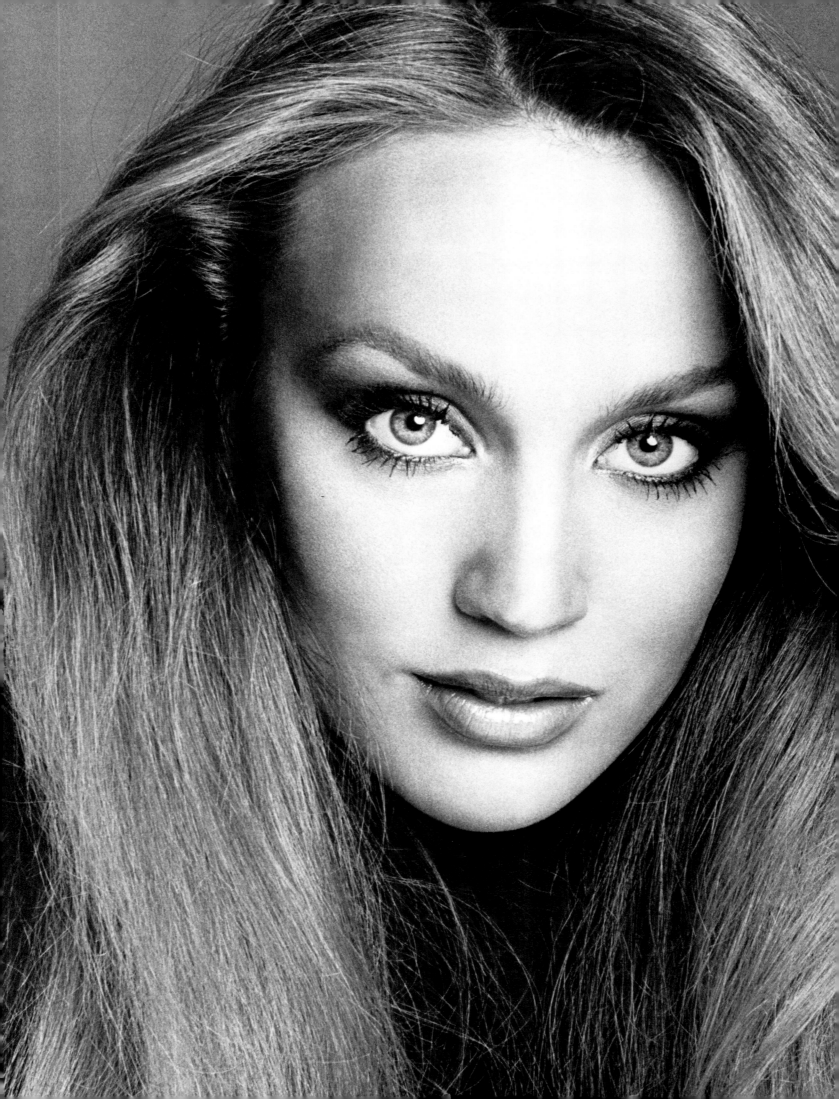

Beauty and the sexy self

Jerry Hall

Scavullo: What is your personal approach to beauty?

Ms. Hall: A completely natural and healthy approach. I strip away everything, because I think you have to look beautiful and feel solid before you start. I take off all my clothes and look at myself in the mirror at least twice a day to see how my body is changing. I believe everything you eat changes you, and I'm concerned about that. So I'm a vegetarian. I exercise an hour or two every day to keep healthy.

Q. What are some of your beauty tips?

A. I take only cold baths and showers. I wash my face with water. It seems to me that when you start to have more respect for yourself you automatically pick up your own tips. I often wonder why people are always writing beauty tips for women who don't really care. They'll read them and go "Hum, I think I'll do that," and then they forget it.

Q. I've read that you're always in bed by eleven P.M.

A. That's not true. I've never been in bed by eleven. I never go to bed before one or two in the morning. I can't. I don't need a lot of sleep because I eat only things that require little digestion. That keeps my energy high. It is so easy to become a wreck if you party too much. But I've learned how to have fun without spoiling it and ending up with bags under my eyes. I take very few drugs; I never drink alcohol—only wine occasionally.

Q. Do you spend a lot of money on beauty?

A. Yes. Quite a lot. I go to a facialist once a week to have my face cleaned and massaged. I buy a great deal of make-up . . . I love to sit around and play with it.

Q. Do you have your hair done?

A. Never. I have really long hair, and hairdressers just love to get into it and mess it up. Once a week I put olive oil on my hair and wrap it up in a scarf all day and night. When I wash it out my hair shines like crazy and looks golden.

Q. Why haven't you ever cut it?

A. Because it's part of me. I love to feel it on my back when I walk, every time I move. When I laugh I love to throw it around.

Q. Do you have any permanent beauty problems you can't change?

A. No.

Q. You're perfect?

A. Well, my feet are large, but then so is the rest of my body. No problem is permanent because you can change anything about your body you don't like.

Q. When you have a temporary beauty problem, do you point it out?

A. No. I never talk about it. If I have a pimple or something, I don't bring attention to it. I just put on more make-up and cross my fingers.

Q. Do you buy a lot of clothes?

A. Yes, I love clothes. I love Johnathan Hitchcock's clothes because they're so sexy and slinky. I love to get dressed up and go out at night wearing my floor-length mink coat from Revillon. I never worry about what I do when I'm out . . . I think when you're all dressed up and looking gorgeous, it's impossible to do something terrible.

Q. How would you describe your own looks?

A. I think of myself as the girl that King Kong held at the top of the Empire State building . . . I'm Shena, Queen of the Jungle.

Q. What women do you admire?

A. Jackie Onassis, I think she's great. She was First Lady, which is a very hard thing to be, and then she was married to a millionaire. I also love Marlene Dietrich and Elizabeth Taylor. When I was a little girl I went to the movies constantly and dreamed of being a movie star. When I got older and started listening to comedy, I wanted to be a comedian—Carol Burnett or Lucy.

Q. What other things do you like?

A. I like diamonds, rubies, mink coats, exercise, singing, acting, dancing. I love perfume . . . you can hypnotize men with it. I wear six different kinds at once, each in a different spot.

> ## "I've learned how to have fun without spoiling it and ending up with bags under my eyes."

Q. How did you learn about what works best for you in terms of beauty?

A. I went to Paris at sixteen. I graduated from high school a year early, and then I had a car wreck. I got $800 insurance money, and decided to go to Paris on it. I always thought I used to be French in my last lifetime. So I went and learned how to speak French immediately. And I learned sophistication by watching the women around me that I admired. Antonio Lopez, the illustrator, also taught me a lot. I was just a kid from Texas hanging around in jeans, and he started to draw me the way he thought I could look in a few years, very glamorous and sexy. I could see that it was me, and I wanted to look like that, so I began using make-up just the way he drew it on my face.

Q. Do you think life is easier when you're beautiful?

A. Much easier. But sometimes I think that if I weren't so beautiful maybe I would have more character. Because I'm so young, everything is so easy. I'm just beautiful and everybody likes me, so I don't feel I have to talk as much.

Q. You're only nineteen; what are you going to have to look forward to when you're older?

A. Well, I want to buy a ranch in Texas. And I'm sure I'd like to get married a couple of times.

Q. Who do you like to go out with?

A. Only older men . . . "Youth is wasted on the young," as the saying goes. Youth is beauty, age is wisdom. They need each other.

Q. Do you think that if you're called a beauty of today you should try and stay the same?

A. I don't know. I think when you have a certain beauty, it stays with you forever. As you grow older, you should get better instead of getting worse. You lose your youth, but your beauty mixes with your character and you grow with it. Beauty does change, but when you know you're beautiful, you are beautiful. It doesn't matter what color your hair is or how you wear your make-up.

Q. Do you think that beauty in photographs is different from beauty in real life?

A. Definitely. A photograph captures a woman for a moment and sets her aside from her personality. When you see her in real life you realize that she has many different expressions. It's hard to say how someone will photograph unless you have that kind of eye. It's unfair to say that someone photographs well but looks terrible in real life.

> ## "I love perfume . . . you can hypnotize men with it."

Q. A model's life must be very, very hard work—more work than glamour.

A. So few people realize that it is. They think "Oh, you're so lucky, you make all that money." I think models should get more recognition—should be more like stars—because beauty is a rare thing. There's not that much in the world.

Q. How do you feel when people recognize you on the street?

A. I feel very happy. It makes me proud that someone appreciates me without even knowing me, just for the talents I have.

Q. What is your definition of a "star"?

A. A star is someone who works very hard to get what she wants. Someone who has quality, who really knows herself. You have to know yourself in order to have other people like you; then you will have good things to offer, and you will know that you are good. You could say, "Oh, well, I know I'm good, so I don't have to do it." But to make others know you are good, you really have to work hard.

Jerry shows that a little narcissism goes a long way. She is an extraordinary creature in many ways. If I had met a girl like that in the fifties I would have blown a gasket, but Jerry is strictly a product of the seventies. She's even futuristic. Jerry loves to express herself. She looks into the camera as though she were looking at herself. She's mad and marvelous.

Jerry wears a lot of make-up, and her face can take it . . . a lot of emphasis on the eye bone and around the eye. She has a large mouth, which should be bright and colorful. She has great skin and she has that "liquid" eye, and exquisite cheekbones. She does her own make-up very well. Jerry is a "hair" person—I love it all and so does she.

You just wouldn't want to tone down Jerry Hall. She is a riot with her furs and jewels and ruby earrings, but she carries it off with great panache. She has a tall, broad body. A simple black dress with high heels and hair flashing is the most striking look for her, or just the sexiness of blue jeans and a T-shirt or a man's suit.

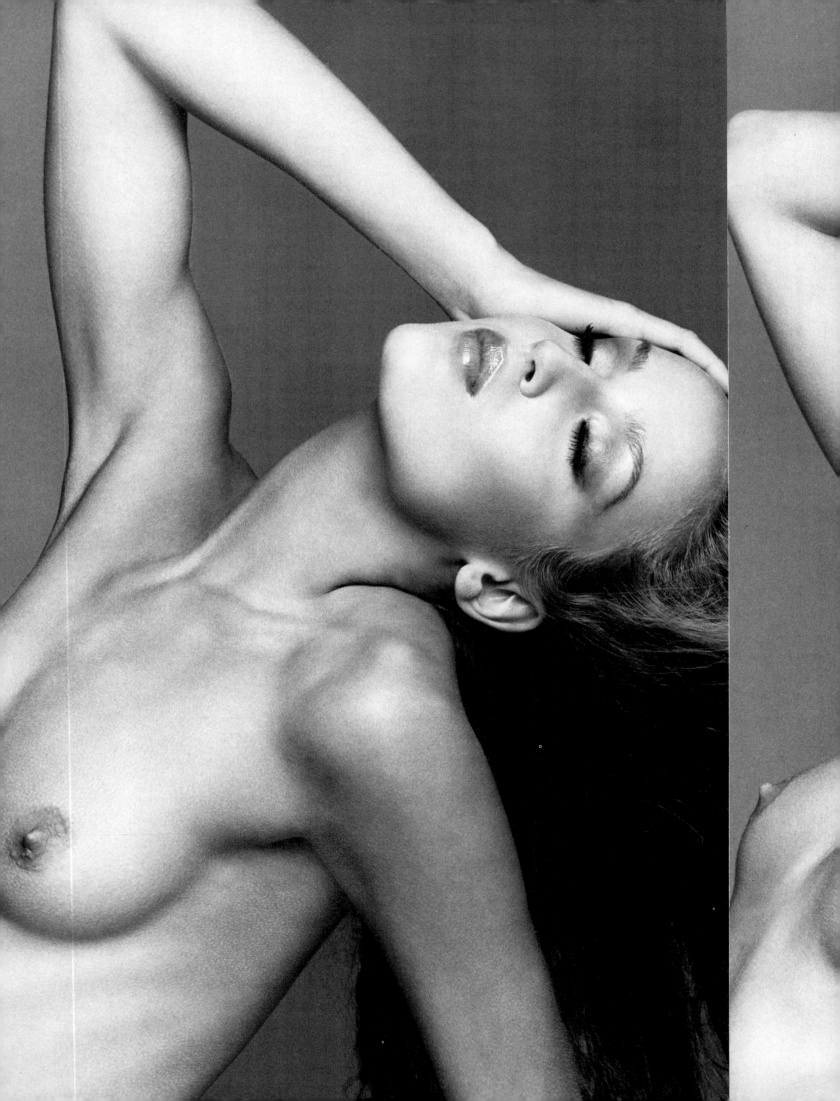

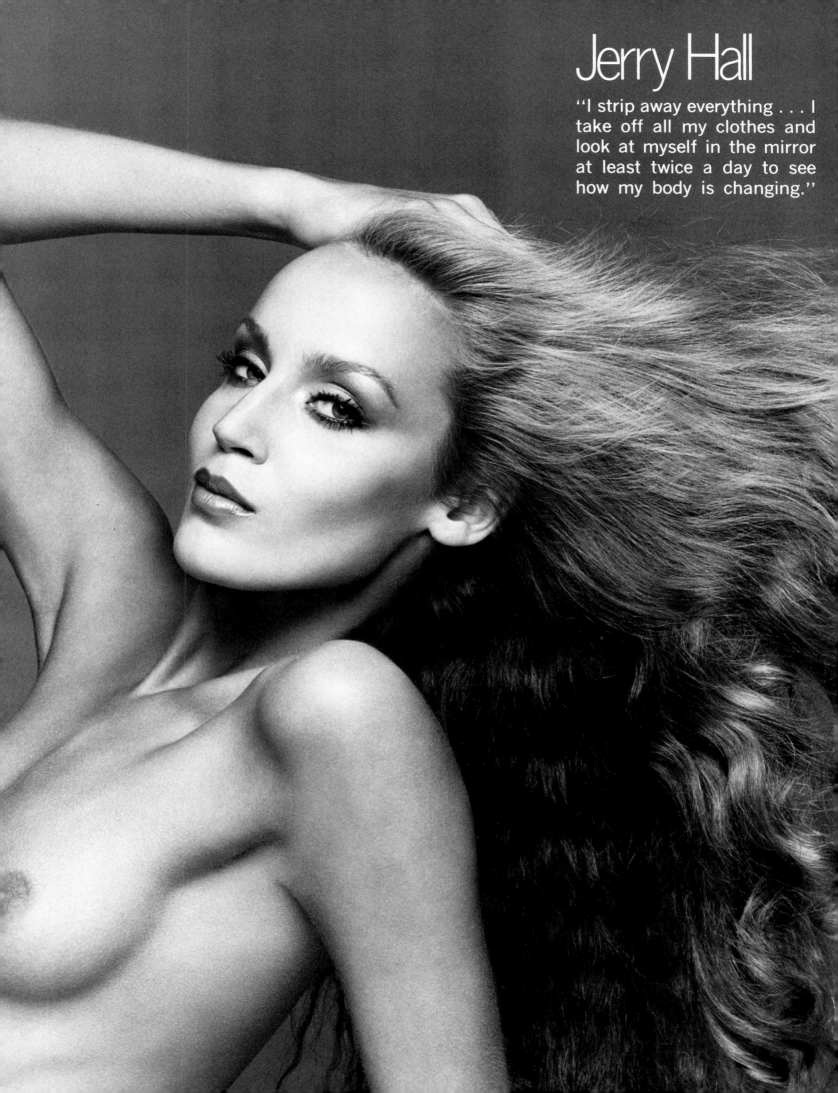

Jerry Hall

"I strip away everything . . . I take off all my clothes and look at myself in the mirror at least twice a day to see how my body is changing."

Muffet as she entered studio.

The first of a classic American family

Joan Hemingway

Scavullo: Do you like getting your hair cut?
Ms. Hemingway: Yes. Every time you have your hair cut you become a different person. You have a different attitude about yourself. Actually, people are different each moment. When you wake up in the morning your body is different from what it is at night, and you feel different in the middle of the day than you do in the middle of the night. It's the same with a new haircut—it makes you a different person.

Q. What is your idea of beauty?
A. It's not drinking Coca-Cola! It's eating natural foods, staying healthy, feeling good, breathing and appreciating the air around you—the light in the morning. The first man in my life was John Keats. I discovered him at fourteen, fell in love with him, his world and his poetry. "Beauty is truth, truth beauty, that is all ye know on earth, and all ye need to know." Beauty is special and rare. It's in a gesture, an object, an invisible feeling, the ineffable perfection of nature.

Q. Can you describe your own looks?
A. Well, I think my personality is rather fey, innocent. I don't always look at myself objectively, and I don't always think of myself as beautiful. People might tell me that, and I'm always a little surprised to hear it, but I don't hear it frequently. Maybe I take my looks for granted. And yet there are moments . . . You know, it is the same thing with a haircut as with make-up—each day as you make up your face, you become slightly different, as if painting a new picture.

Q. How do you feel when Way does your make-up and corrects your bags?
A. Bags! They're my circles. And they come from my moon being in Sagittarius. My sisters are the same; they have circles under their eyes, and that means they are intuitive and psychic and perhaps a little decadent. Everybody with a moon in Sagittarius stays out all night, and it's not the life you could understand. But you can see it with my circles. These circles at twenty-five are too much!

Q. Way didn't put too much make-up on you.
A. No, he created a natural look by blending dark and golden-peachy browns to enhance my natural bone structures and tone down areas that needed a glow. He used color subtly to bring out a glow. It's beautiful watching him work. Way is an artist.

Q. You said you hate Coca-Cola and you like natural foods?
A. Yes, in natural settings. You see, I'm writing a gourmet picnic cookbook, and I hope picnicking will catch on because I think it's very special. You can have a picnic on a nice tablecloth, with a good bottle of wine. You're sharing food with friends, you're outdoors, the sun is shining. There's something great about food on a picnic. I think the way you present the food is important; if it's visually appealing, then it's going to be appetizing. I don't really hate Coca-Cola—if it's served in an icy decanter and laced with rum, nothing could taste better.

"I'm fairly ambitious, and I get hung up worrying that I won't accomplish what I want to do."

Q. Do you think that your beauty comes from eating natural foods and living in Idaho in the mountains?
A. I didn't grow up there. I lived in Paris, Cuba, San Francisco. I read a lot about nutrition. I was very interested in it. I read all the books everybody else did about it, for instance, learning how to put natural foods together so you utilize foods as proteins. If you know how to put your foods together, your body doesn't turn them into carbohydrates. I often eat potatoes—they're one of the few foods that contain sulphur, they are full of Vitamin C. I don't limit myself to natural foods only. I love nothing better than good strong French coffee and chocolate cake. I do eat meat, but not too much of it—maybe three times a week. I try to undercook food. I've just learned to appreciate food more in its natural state. Learning about food helps you appreciate what it's all about so you can take things in moderation.

Q. Do you do any exercise at all?
A. I do yoga half an hour to an hour every day. I really enjoy walking, I walk five miles every day at home. And I never take taxis in New York—I walk every place. I took an eight-hour-a-day dance training program with Dance Los Angeles last summer, and I'd never done anything so intensive before. Everything from musicology classes to learning about structures of the body—how muscles and bones are put together in different areas. If you know how muscles are put together, and why and how far they can move to what angles, you know what you can do with your body.

Q. Is that why you can twist your body around so much?
A. It's that and yoga, I've been doing yoga for seven years every day. I have a lot of energy, and I also dance. And I walk everywhere.

Q. What are some of your hang-ups?
A. I'm fairly ambitious and sometimes I worry about accomplishing all that I want to do. And not being disciplined and scheduled each day.

Q. What do you like to wear to a picnic?
A. You wouldn't believe what beautiful picnics we have. Somebody goes out and scouts a meadow with wild flowers. If we really have planned the picnic in advance, and if there're thirty or forty people coming, and everybody's bringing a separate dish, we dress in lovely straw hats and long romantic dresses, cotton dresses—Thea Porter, Gina Fratini. And we put our Liberty-print pillows all around, and tablecloths, and we have silver trays full of pyramids of cream puffs. Sometimes we have place cards.

Q. What do you like to wear for a city look?
A. I like wearing dresses and skirts just below the knee, and men's suits can be very sexy on a woman. I love St. Laurent, Thibaut Bouet, Scali, Jean Halm, Italian silks. Furs are classic, leather sophisticated, and there is nothing nicer than a favorite, worn-out cotton blouson. If something's comfortable, soft and sensual, it's divine. If an outfit is, planned to perfection—tailored and accessorized—it is just as great.

Q. What are your feelings about clothes?
A. I like a classic design with individuality. I like to be able to buy something and think that I can wear it forever.

Q. Who are some of the women you really think are beautiful?
A. The women in my family all possess a certain beauty. A painting of a Renoir woman, Botticelli's Venus. All women are beautiful, though some reveal more.

There is obviously a strong family resemblance among the three Hemingway sisters—granddaughters of Ernest Hemingway—photographed here and on the next seven pages. But each has an individual style. Joan had her hair slicked back when I met her, and looked very bookish and intelligent—which she is, but I thought she could look younger, sexier with freer hair, without looking frivolous. I see her as having an Ingrid Bergman quality.

Joan's features have a very fine quality, so she shouldn't use a lot of make-up. Her eyebrows were cleaned up a bit, just to emphasize her direct look. It's more grooming the face to bring out its refinement than making it up.

Her hair just needed a good shape.

Joan prefers to do other things than shop for clothes, so her wardrobe is easy, straight, not studied. Her body is nice, can and does wear anything: suits, fatigues, Levis, her colorful picnic skirts.

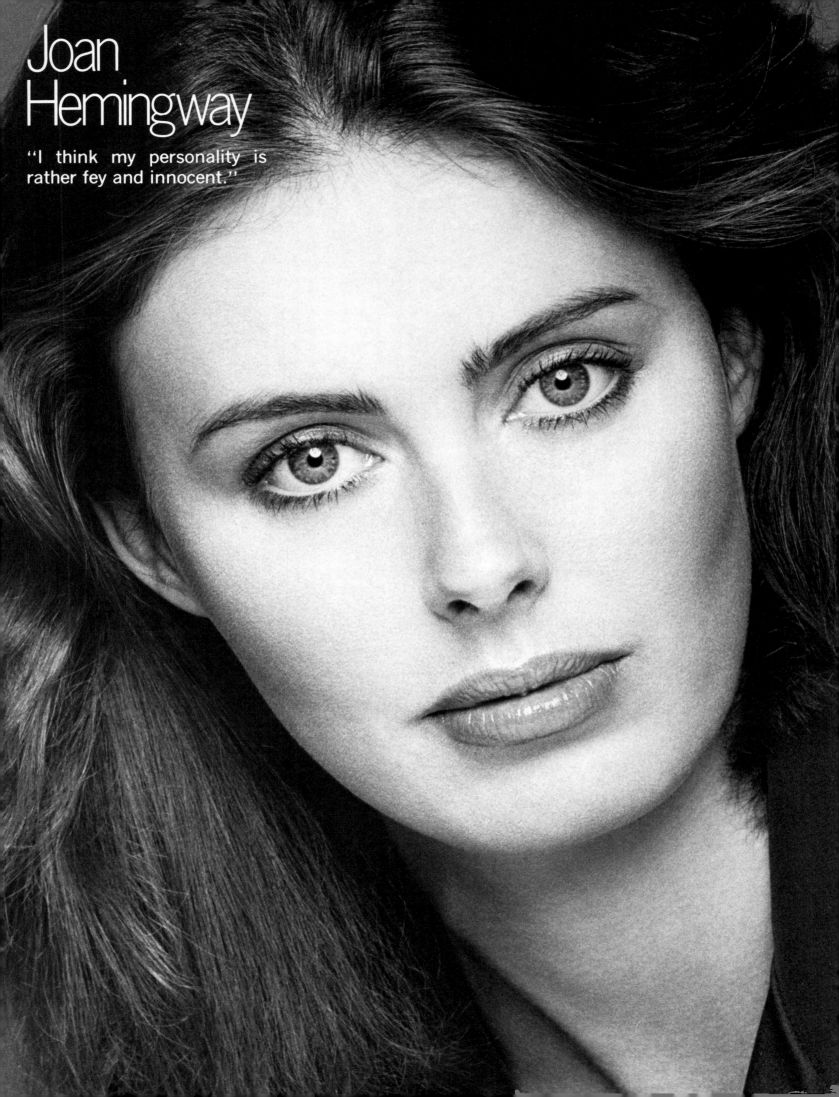

Joan
Hemingway

"I think my personality is
rather fey and innocent."

The sensuality of full features

Margaux Hemingway

"What things do I love? A Grand Marnier soufflé, sunflower seeds and carrot juice, wearing no make-up, Harry King, myself when I don't eat too much, and truckin' like a Willys in four-wheel drive!"

"I was a fat, husky little baby—a Siberian husky. Now I'm a big girl with a lot to grab on to. I'm healthy, energizing."

"I guess I could make them into a beauty problem, but I love 'em, those big legs of mine! They work well."

Margaux is the great all-American beauty—with the features of a striking white-skinned African. She's all power and energy, a completely kinetic beauty: There's no way that big body of hers can't move or stretch. Margaux is not the kind of girl who floats into a room; she stalks, she storms in—it's part of her great appeal. She's feminine, sexy and tomboy all rolled into one—an athlete, a charmer, with a face that stops traffic. She is anything and everything but demure.

Margaux has prominent bones that require a bit of shadowing because she tends to look heavy. We contoured under the cheekbones, under the jaw, and around the eye. Her eyes have a "closed" look, so her make-up has to open up her eyes; her lashes are curled.

Her mouth should be left full. She has a strong, exquisite face that needs only contouring, not make-up. Margaux has such a great face that she looks best with her hair wet or all pulled back so it doesn't distract.

Margaux has a lot of blond in her hair from spending so much time in the sun. It needs to be toned down in parts so that there is more of a contrast between dark and light playing in her hair. It plays up her eyebrows and her eyes and makes a frame for her face better than straight blond hair and makes her much more exciting.

With her body, Margaux needs special things to wear, and she's got them. Long silk dresses for evening with beautiful six-foot-long scarves. She's a sunshine girl who looks good in sporty clothes.

"Money to me is a reward for very hard work. It has allowed me to travel, to meet some of the most interesting people in the world, and to grow."

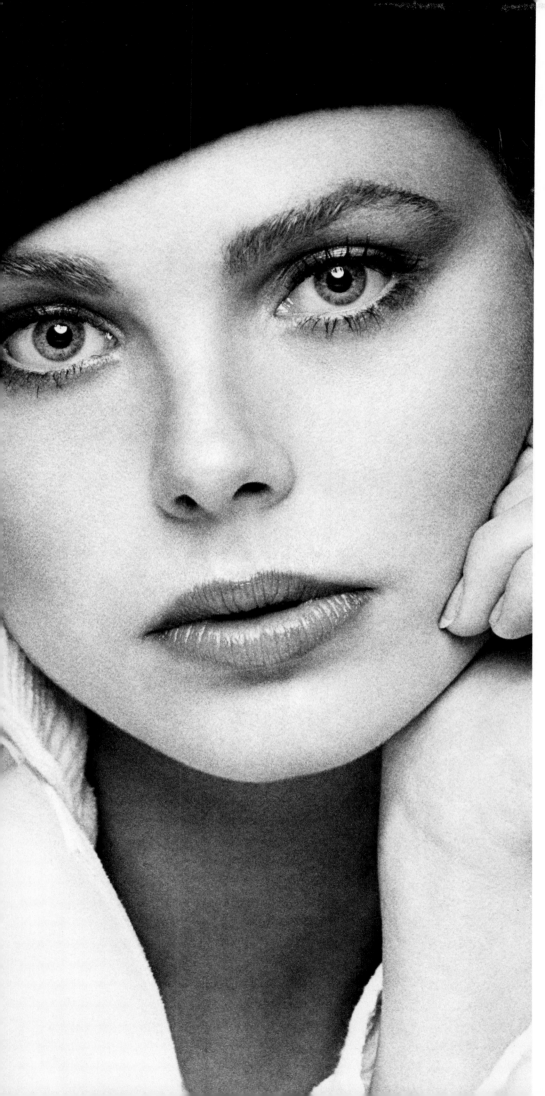

The beginnings of beauty

Mariel Hemingway

Q. What do you feel beauty is?
Ms. Hemingway: Being all cold and getting out and skiing and having a good time.
Q. Do you worry about how you look?
A. I don't want to look all pimply, and I don't want to have oily hair and all that stuff, but I don't worry too much about it.
Q. What do you do if you get a pimple?
A. I wash my face about a hundred times.
Q. Do you like to change your shampoos and buy beauty products?
A. Well, I did, but I couldn't find anything that didn't make my hair greasy, so now I'm just using Johnson's Baby Shampoo. I go out and buy things sometimes, but then I find the whole bathroom is full of everything, and I've got to use them up.
Q. What kinds of clothes do you like?
A. Really nice slacks, I like dark blue or black. I like Frye boots. I also like boot jeans, straight-legged jeans that you wear when you ride.

> "To me, beauty is being all cold and getting out and skiing and having a good time."

Q. When do you think you look and feel your best?
A. After I take a shower, and in the morning after I've washed my face.
Q. Do you go on diets?
A. No, that's one thing I don't think I'll ever have to do. I like chicken and salads; I like fruit. And I don't like candy much. Desserts after dinner are good, but I don't eat them all the time.
Q. Do you want to be famous like Margaux and Joan?
A. I want to go to college, and then I'll decide all that.
Q. Are there any women you really admire?
A. Anne Bancroft.
Q. What are the qualities in your sisters that you really like?
A. Well, Joan has a wide face. She's happy and she's fun and she likes to try new things.
Q. What about Margaux?
A. She's real outdoorsy and stuff; she's always open and funny.
Q. Do you think your mother is beautiful?
A. Oh, yes. Her bone structure is really neat, she's got a good figure, and she has a funny personality.

▌ *With the Hemingway beauty, energy and talent, Mariel is a girl to watch—closely!*

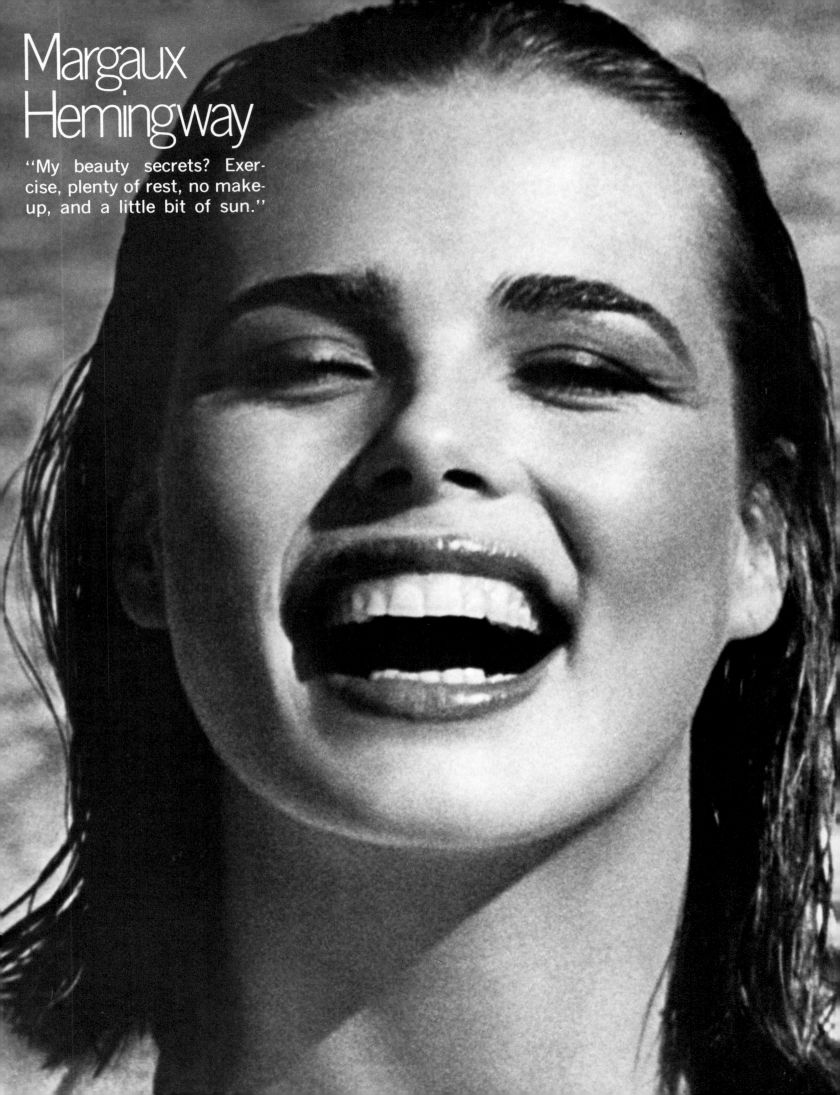

Margaux Hemingway

"My beauty secrets? Exercise, plenty of rest, no make-up, and a little bit of sun."

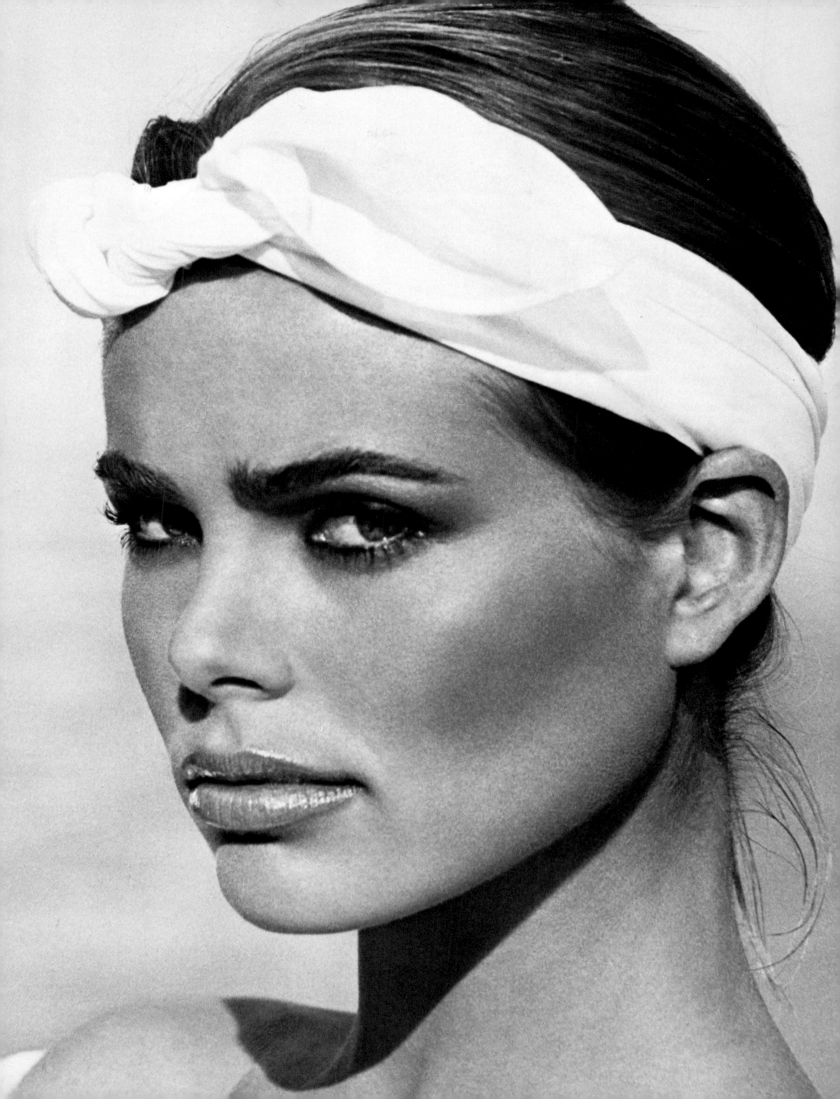

Nobody's perfect...
Lauren Hutton

Scavullo: Do you spend a lot of time taking care of your skin?
Ms. Hutton: No. I just use coconut oil when I sit in the sun.

Q. Do you use soap on your face?
A. Yes.

Q. Do you take good care of your hair?
A. I wash it every night.

Q. Is a good haircut important to you?
A. It's not a big deal because I wear my hair long.

Q. What kinds of foods do you eat?
A. Lots of salads, fresh fruit and vegetables, fish and fowl.

Q. Do you ever eat meat?
A. Sometimes.

Q. Do you ever go on food binges?
A. Very seldom.

Q. Do you drink coffee?
A. I drink tea.

Q. Do you exercise?
A. Yes, I generally do a little bit in the morning. I do it for about a month and then I forget about it. I travel a lot, so when I travel I do a lot of exercise. I swim and I'm always hiking and doing stuff like that.

Q. Do you do breathing exercises or yoga?
A. No.

Q. Do you ever go to have a facial?
A. No.

Q. So you never did the things that most models do to stay in shape?
A. No. Once I started working, I was working so hard I never bothered with any of that.

Q. Do you like to wear make-up?
A. Yes. Sometimes it's a lot of fun. Now I don't have to work with it as much as I used to, so it's even more fun.

"Make-up is supposed to enhance you, not cover you up or change you."

Q. Can you describe what you do with make-up and how you like to change it for a different look?
A. I wear make-up and use it very carefully. It's supposed to enhance you, not cover you up or change you. It should bring out what's there. The mistake most women make is that they put on too much. They look like they're made up, and you really shouldn't look like you're made up at all.

Q. Can you describe your looks? How your friends would describe you?

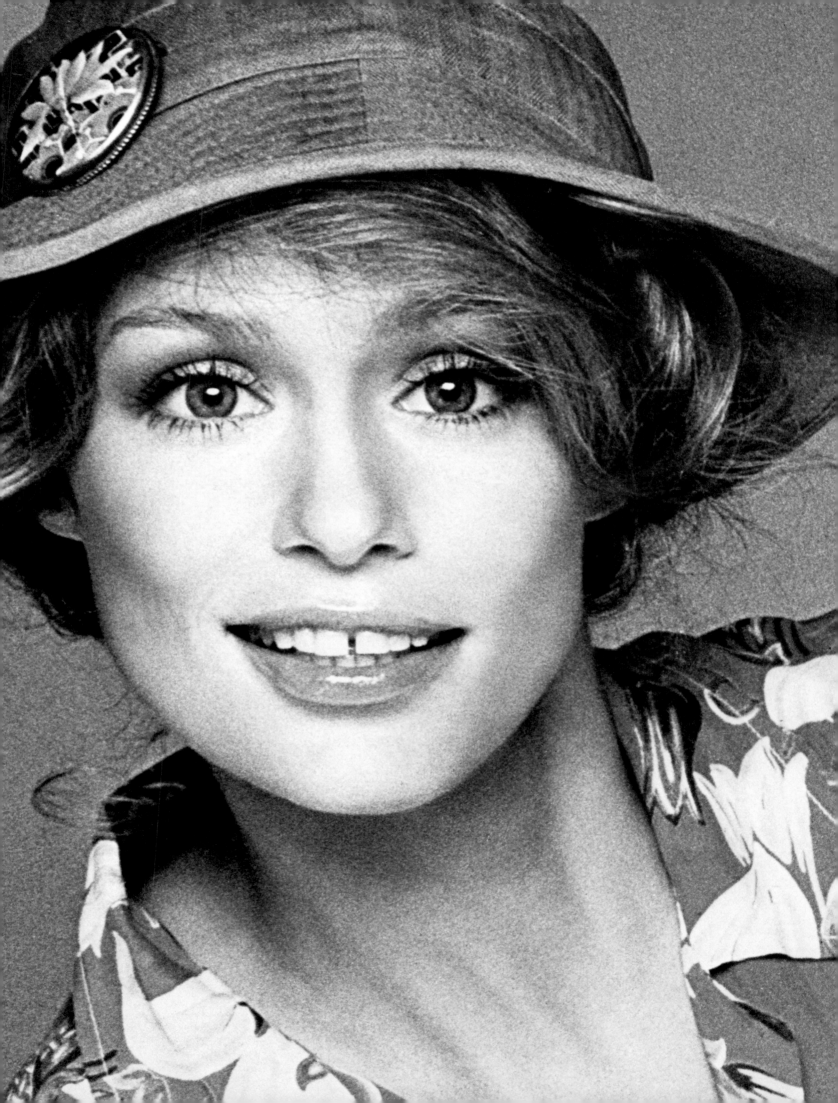

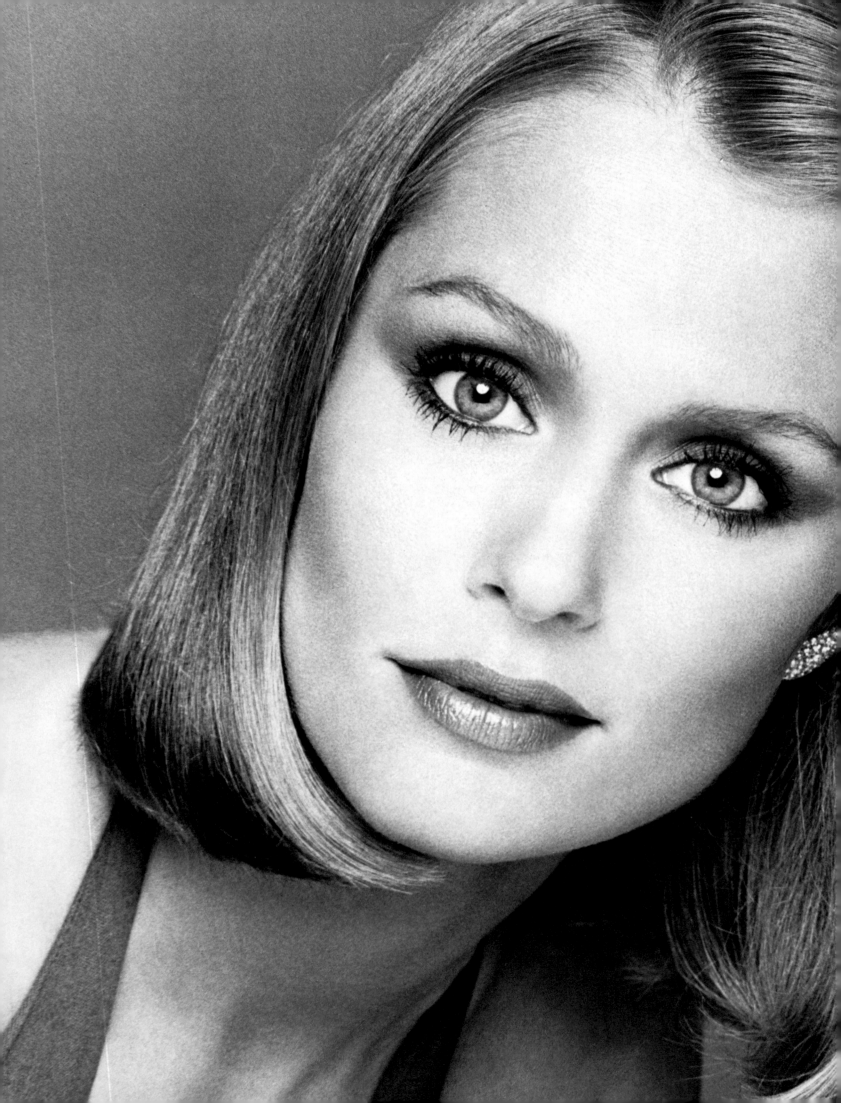

A. I'm sort of tall and gangly. I always think of myself as being a cross between an ostrich and an antelope. Sometimes I'm very graceful and other times I'm really awkward. I've had a couple of friends describe me as coltish.

Q. What catches your attention primarily when you look at someone that you consider beautiful?

A. Their eyes. It's the soul you look at.

Q. Who are some of the women you think are very beautiful, and also women you admire?

A. I think Vivien Leigh is beautiful. I think Geraldine Chaplin is beautiful. I like beauty that keeps changing and growing. Most everybody that I know that I think is beautiful is usually beautiful because of quality of spirit. I think Diana Vreeland is beautiful. She has just great, great style.

Q. What kinds of clothes do you feel most comfortable in?

A. Comfortable clothes. For hanging out I always wear jeans, shirts and tennis shoes.

Q. Do you like evening clothes?

A. Sometimes I love to dress up. I recently found an old beaded gown from the 1930's that I love to put on and slink around in—with egret feathers yet. I like to wear different things. I like to change, depending on where I am and what's going on.

Q. Do you like to wear designer clothes such as Halston and St. Laurent?

A. Sometimes.

Q. What do you like to do when you want to indulge yourself?

A. I like to leave the country and go someplace where there are no telephones.

Q. What do you like to do when you're in New York?

A. I like to see movies, I like to eat and go to good restaurants and cook.

Q. What colors do you think you look best in?

A. I usually like strong, bright colors with true hues.

Q. How would you tell other people to do a self-analysis and to evaluate their looks?

A. Just try to look at yourself as a stranger, not the way you've always thought you looked.

Q. Do you think American women could stand a little improvement in the way they dress and look at themselves?

A. We haven't had time to develop a national style. To me the most stylish people in the world are the people like the Masai in Africa or the Karamojo or the Tibetans—various people I've seen around the world. They have developed a style of dress that comes out of the land where they live. It's a life pattern that hasn't changed that much over hundreds of years—so everything they have is very functional and also very beautiful.

Lauren is one of the greatest models ever. She took America out of the sixties and showed us what the seventies' woman should look like—natural, sexy and intelligent. Lauren is now turning her talents to acting.

She has always known how to do her own make-up, and her hair looks right at any length. She has fabulous hair.

Lauren has a great body; she can wear anything. She was the first model to make jeans, an antique shirt and an Army fatigue hat her working uniform. She wears American classic clothes also and collects antique French clothes.

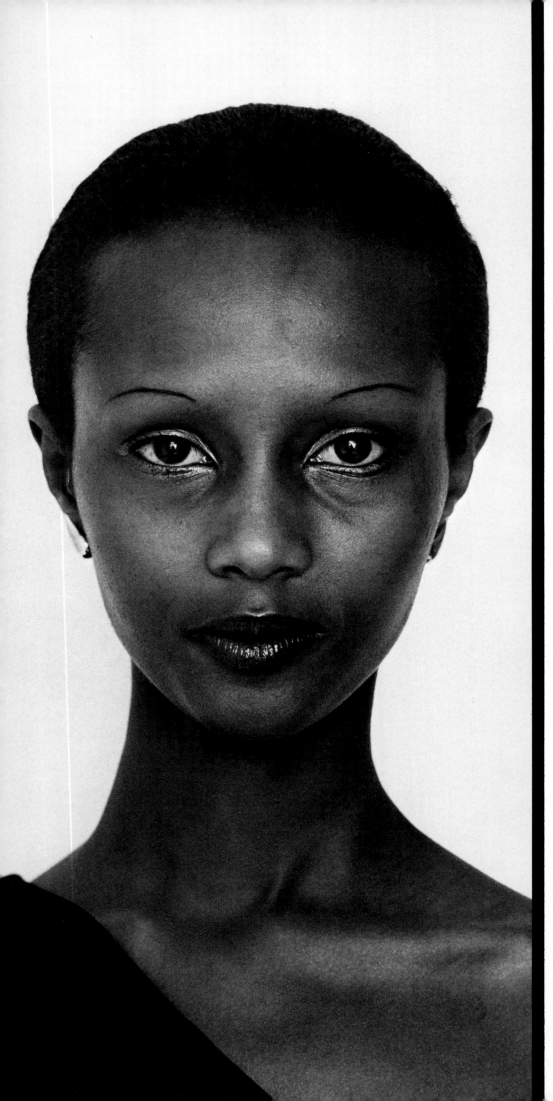

African look goes Western

Iman

Scavullo: What tribe are you from in Africa?
Iman: Somali.

Q. When you were little did you paint your face?

A. No. Our tribe doesn't do that.

Q. Do you have any treatment for the skin when you are home in Africa?

A. Yes, we take it from a special plant. All of our tribe uses it and has done so for ages. My mother looks no older than myself.

Q. Do the Somalis come from Egypt originally?

A. They say so. Our features are very fine rather than broad and flat. However, I have the flattest nose in the family. The others have long, straight noses.

Q. Are you considered extraordinarily beautiful by the other members of your tribe?

A. I was an exception, because I don't look like most of them. People might look at me because I am different, not because I am exceptionally beautiful.

Q. What kinds of food do you eat?

A. A lot of meat. I love meat. When I get up in the morning in Africa I have a traditional breakfast of something that looks like a pancake but bigger, and which tastes quite different from your pancakes. It's made of grain, and we serve it with honey or butter and milk. We have milk with everything we eat. We don't drink coffee, just tea. We have a heavy lunch that is usually several courses of meat, a very heavy lunch with milk that is low-fat and a bit bitter. Lunch takes two hours and is eaten with the whole family. We also never eat meat without fat. When I drink a cup of tea I put in four teaspoons of sugar. There is a certain age, though, that if you don't watch what you eat you just go.

Q. What age?

A. Thirty.

Q. Are you doing your own cooking here?

A. I don't cook at all, but now that I've been told about the health food in the United States I may start cooking that.

Q. What do you think of the food here?

A. The food is a disaster. It shocks me. I'm scared to eat it because everything is so artificially flavored.

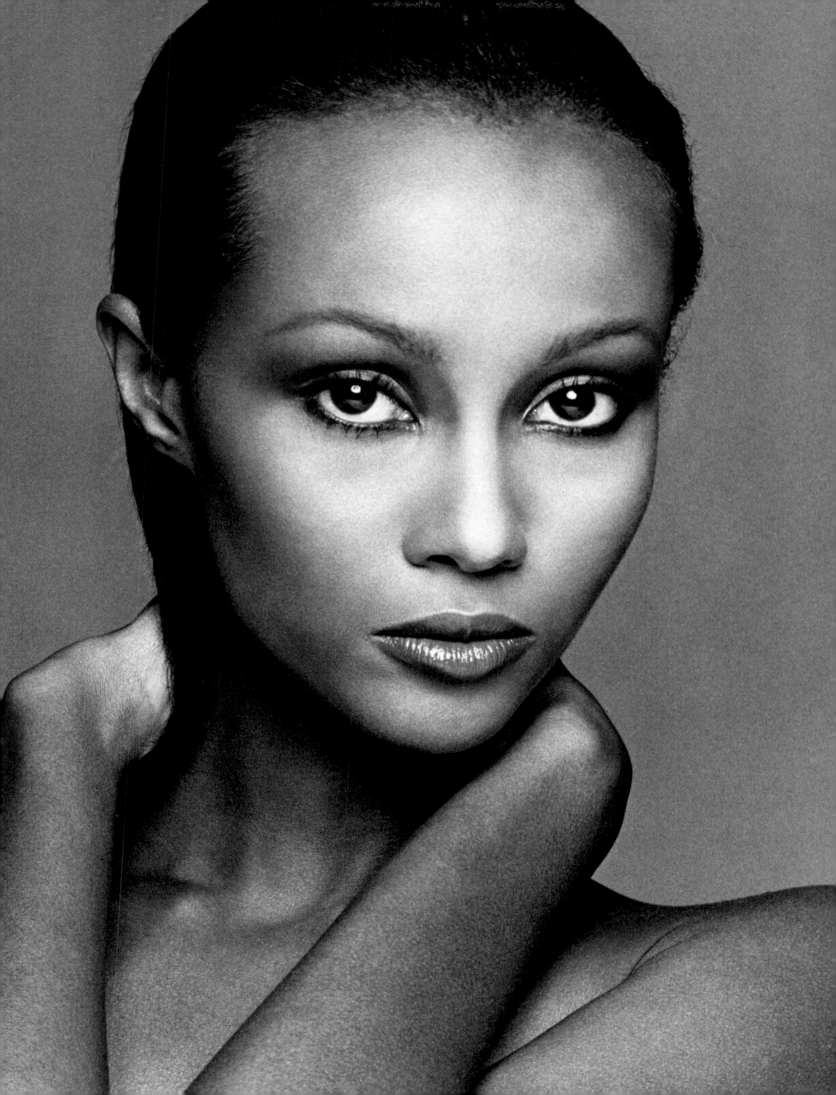

"There are no beauty secrets."

Q. **Have you discovered that you gain weight in New York?**
A. No. I have lost so much weight. When I came here I was 117 pounds, and now I'm 110.

Q. **Are you enjoying New York?**
A. I'm trying to.

Q. **Have you learned any new beauty secrets since you've been here?**
A. I want to tell you something: there is no beauty secret at all.

Q. **Have you gone for a facial or a massage anywhere?**
A. No. But I would like to have a massage because I have tension in my neck sometimes. I think one of these days my neck is going to break.

Q. **How has your skin reacted to the climate in New York?**
A. I have normal skin, but since I came to New York it's very dry. It has done a lot of damage to my hair. My hair is breaking, and the water is so hard. I do use coconut oil on my hair.

Q. **Do you like to wear make-up?**
A. Yes, but I like to look as if I had none on. I like to make up my eyes especially, that's all. I think some people put on such heavy make-up, and it takes hours to clean off your face.

Q. **Do you need much sleep?**
A. When I first came here I used to get up at five or six o'clock because the noise in the city starts at five o'clock. In Africa the only noise you hear is the insects. I go to bed very, very early. To me, eleven o'clock is late.

Q. **What is the night life like in Africa?**
A. It depends. In the cities you go to the movies, to the theater, just like the night life here. But when I'm in the village where I come from originally, in the evenings we light a fire outside and everybody sits down and tells stories. Because the Somali literature is not a written literature, but oral, the elder people relate several hundred years' worth of history and stories—how our race started, how our tribe has mixed, etc.

Q. **Do you miss home? Do you stay in touch with your family?**
A. I get daily letters from home.

Q. **What do they think about what you're doing here?**
A. My family thinks what I am doing here is terrible.

Q. **They want you to leave this evil life?**
A. Yes.

Q. **Is there anything that you have found to like about New York?**
A. Nothing, absolutely nothing.

Q. **Why do you stay?**
A. I think so that I can know people better or the country better by having the patience to stay and wait and see the best. If I stayed for only a month I wouldn't know anything about New York. The people here interest me.

Q. **Was your reception in New York anything like what you expected?**
A. I wasn't prepared. I never thought about the tremendous publicity or interviewing at the time I arrived. I got off the plane and went to Peter Beard's flat, and there were sixteen press people waiting for me.

Q. **What did Peter tell you about New York and modeling?**
A. He told me the truth, that it was a very hard business. "A lot of people are very rude," he said. He actually called it a "rat race." He didn't say that everything would come to me, he told me I would really have to work hard to get any kind of recognition. He said that it all really depended on me and that I shouldn't let people bother me.

Q. **What do you find the strangest thing about New York?**
A. A lot of people don't know anything about Africa. And they don't believe anything I tell them. One of the stupidest questions anybody ever asked me was "Were you barefoot when you met Peter Beard?" I am a Moslem and we don't go around naked, carrying spears. I know a lot of people love fantasy and they wanted to believe all of that about me, but I wouldn't permit it. That's not the way it was, or is.

Q. **Do you still wear African dress?**
A. Oh, yes. Wrapped fabric and my head wrapped or a veil, a chiffon veil that I can see through. I have all my traditional clothes here, but they're all obviously for warm weather. I have had to buy winter clothes.

Q. **Do you wear any perfume?**
A. Charlie! I love it. That's the main and most important beauty thing I have. I'll put on no make-up, but I could never be without perfume.

Q. **Do you find that you have any permanent beauty problems?**
A. Yes, I have puffs under my eyes.

Q. **Do you do any exercise?**
A. I like classic dancing—you can do a lot of things with your body. I love ballet.

Q. **Was your day structured quite differently in Africa?**
A. It's different every day there. I wasn't of the working class, so I usually stayed at home to read or study. If I was working I would be doing something for the jewelry shop I modeled for. They always had to alter the necklaces because my neck is so small, so I would always be going in for fittings.

Q. **Do you think coming here will turn out to be fun?**
A. It will all be in what I make of it, I think. I feel if I am nice to people, no one will be nasty to me. Everybody has been nice. My parents told me before I left: "Be good, and good will come to you." They told me not to get caught up in things that are offered on a silver platter, because those are temporary things and I would lose them tomorrow. They told me not to be overwhelmed by people, just to treat everyone as a human being, because if you lose your looks today, tomorrow you will still have your friends.

Q. **Do you believe that you can't lose your looks if you feel beautiful inside?**
A. That's what my mother believes. She said, "The way I see it, where you're going and what you're doing is phony, everything is plastic, nothing is natural, and maybe you are young and beautiful now in your features, but the best compliment anyone can pay you is to tell you that you are a beautiful person inside."

The photographer Peter Beard encouraged Iman to come to New York from Africa, and I took a picture of her practically the minute she stepped off the plane. She is pure beauty, pure African queen, with a very refined, fine-featured look. She's extremely graceful but not overpowering in any way. I believe she has the potential to become a model of international stature.

Iman is stunning naturally and with make-up. Her eyebrows were too thin and worked against the almond shape of her eye; she should let them grow in a bit more. Her lashes were curled and a lot of mascara was added. Gray/brown shading was used in the crease of the eyes and underneath the eyes to make them more important. We put color on her mouth, and her skin was moisturized to make it glow. Liquid tawny shades were used on the cheeks.

Iman's hair needed a lot of shaping. We cut an inch and a half off to give her a neater look.

Iman looks spectacular in her native costumes, caftans, and jewelry. She also handles casual American clothes very well because of her streamlined body.

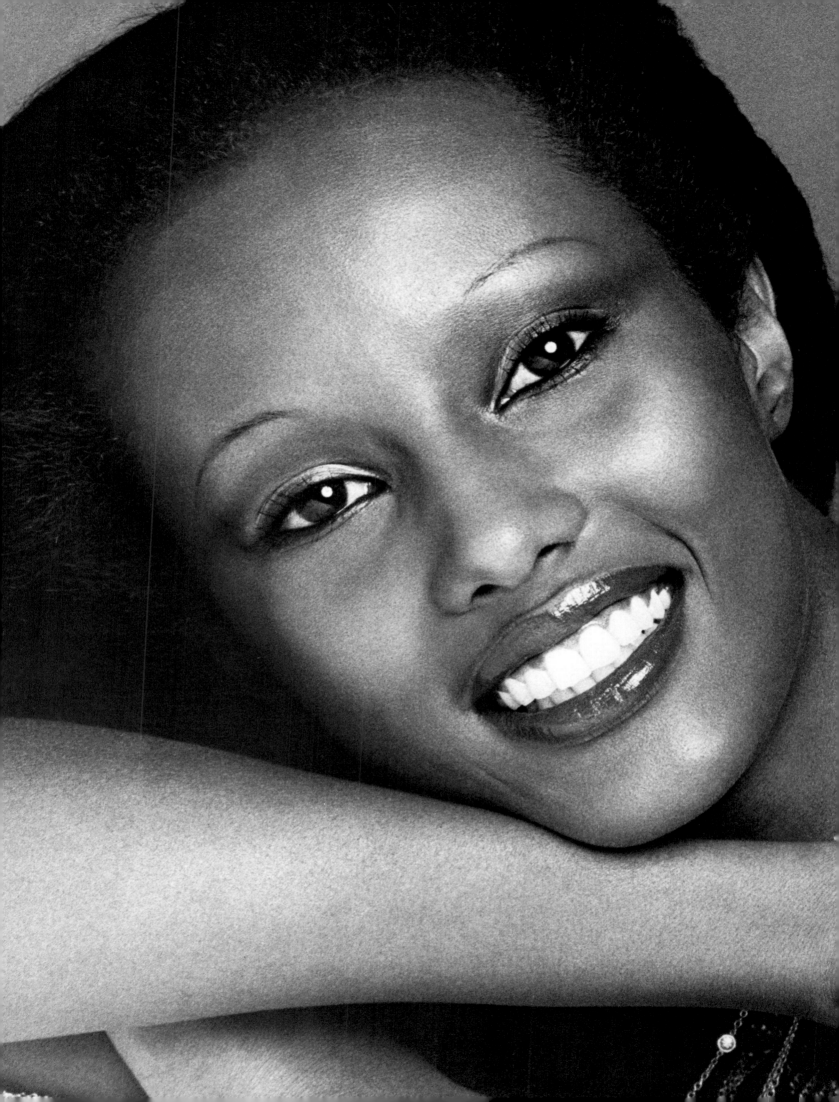

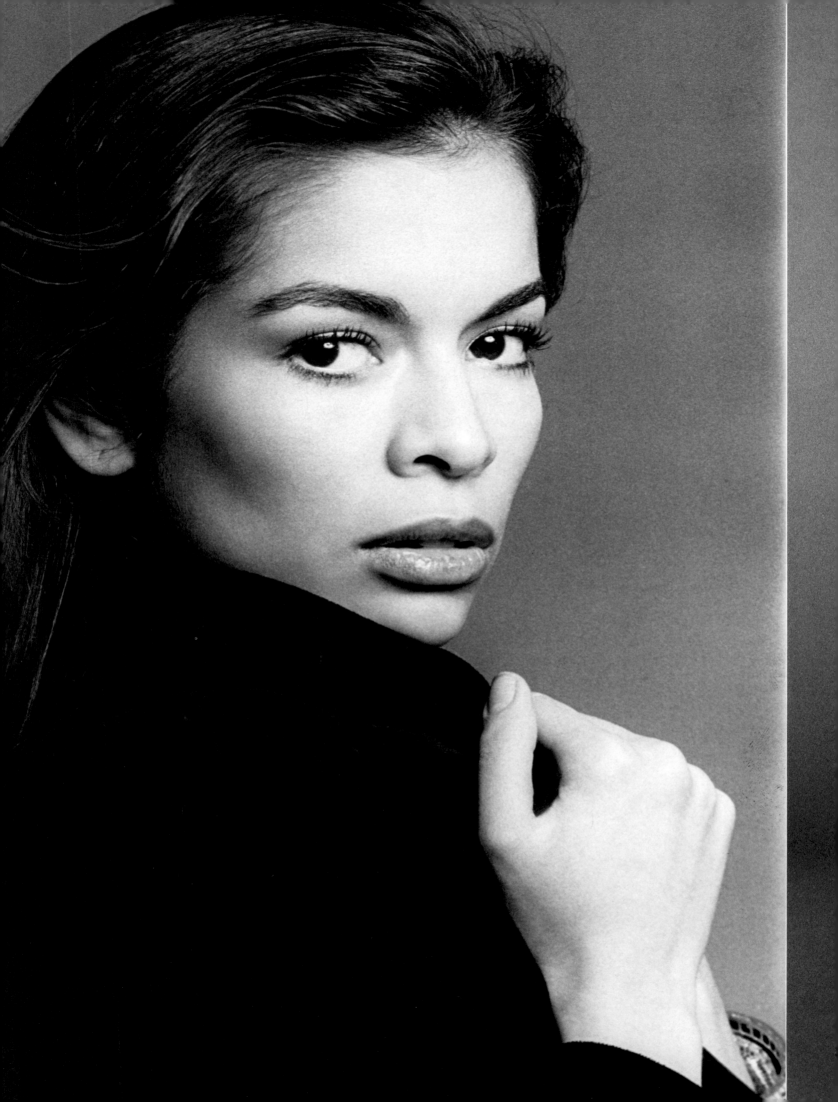

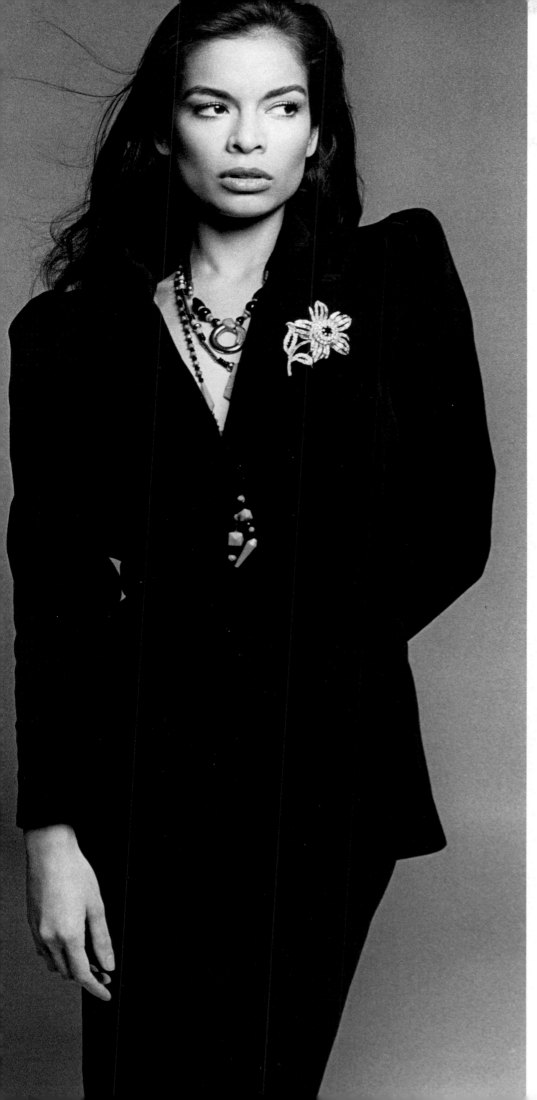

Beauty is presence

Bianca Jagger

Scavullo: You are always out dancing at night and staying out fairly late ... Do you clean your skin before you go to bed?

Ms. Jagger: That's the only beauty thing I do—thoroughly, thoroughly clean my skin. In five years I've maybe gone to bed once with make-up on. Even if I'm falling apart I go and clean my face.

Q. Do you put something on after you wash it?

A. No. I find the best thing is just to let the skin breathe, and let it be.

Q. Do you have any morning beauty routines?

A. I clean my teeth, and then I clean my skin again, and I put a moisturizer on. I use a cleaning thing and then a tonic—just a little bit.

Q. Do you ever go to anyone to have it cleaned?

A. Sometimes, when I have time. But it isn't necessary if you really clean thoroughly all the time and use a little brush sometimes to clean it with oil or cream.

Q. Does New York affect your skin worse than, say, London or Rome?

A. New York and Los Angeles are the worst.

Q. Do you think it's the air or the food?

A. I don't know, because I try to eat healthy food even in New York. I think it has something to do with the air and water. It dries the skin—and California has the worst water.

Q. Do you have straight hair?

A. This is my hair. I don't go to the hairdresser any more. If I ever have my hair done, I have it done in New York by Andre of Cinandre, or in London by Leonard.

Q. Are you going to grow your hair longer?

A. I'm going to grow it long.

Q. Are you ever going to cut it very short again?

A. I'm always dying to do it, but Mick doesn't like it. I love it when it's short, and I don't like the in-between when it's growing.

Q. Why do you get tan? You look very beautiful when you're very white and light.

A. I almost never get tan, but this time I did because I was in the sun for two months. I love

Bianca
Jagger

"I don't think chic has any-
thing to do with money."

to get tan when you can really be completely naked and free.

Q. Do you put anything on for protection against the sun?
A. I put on tons of things. I hate to lie down and just take the sun. I take the sun when I'm swimming, running, walking—always doing things. It's bad for the skin anyway to lie in direct sun in the same position. You should always be doing things. Mick and I jog together.

Q. Did you do a lot of exercises when you were pregnant?
A. I did exercises all the way through my pregnancy—really seriously. I'd take lunch on a standing bicycle every day, and I'd lift little weights till I was in my eighth or ninth month—till the last minute. It keeps the muscles from losing their elasticity. And then seven days after I came out of the hospital, I started doing exercises.

Q. Did a doctor tell you to do that, or did you decide yourself?
A. French doctors are very good because they warn you and tell you everything you should do. The fact that a woman gets stretch marks . . . it's like the skin or a piece of material, and you stretch it. If it's a very good tissue it will give a bit. If it's not, it will just rip, and that's what happens. So if you put on a cream to give elasticity and put certain vitamins in your body, the skin can pull a bit. That's why a woman should never put on more than seven or eight kilos when she's pregnant. If you go over that, of course the skin will break. You can get stretch marks if you don't care. The French have a cream for that, and if you put that plus almond oil on, and take enough vitamins for the skin, it will help you. The other thing that is important is when you have the child, you have to do exercises immediately after. I came out of the hospital with my trousers closed after I had Jade—I put on eight kilos. You lose two or three kilos of water and three kilos of child, and maybe you have one kilo left. You can gain six or seven kilos, and you're perfectly well.

Q. I hear so many women saying, "I don't want to have a baby and get all those stretch marks."
A. It's all a question of how you do it. It requires discipline. I'll tell you something that is very self-indulgent in women that is bad, too: when they get pregnant they decide that they will give themselves nine months of doing everything that they normally wouldn't do, and they give the excuse that they are pregnant. So they just lie there, they don't do any work or any exercise, and they eat and eat. They say that you get terribly hungry, and it's true, that you do get a bit more hungry, but very little. You don't need to gain more than one kilo a month. I remember when I was nine months pregnant, there was a walk for Angela Davis in Paris, and I did five miles. It was five days before I had Jade.

Q. I know that you have most of your clothes made in New York by Giorgio di Sant' Angleo, but I was wondering, since you travel so much, if you get things from other designers.
A. I buy things from other designers, but I like what Georgio does very much because he does things for me, or we do them together and we talk.

"Even if I'm falling apart I wash my face at night."

"The most destructive thing for one physically is traveling."

Q. You've bought things from Kamali, too . . .
A. Oh, yes, I love Kamali, I think she's a very, very talented girl. She's got ideas. If only she had the money to be able to do it the way she would like—to do them all in fantastic materials. She is very sweet to me.

Q. Do you still wear Ossie Clarke's things?
A. I think Ossie is very, very talented. He is one of the top talents in the world.

Q. You like to work with the designer, don't you?
A. Yes. This is what some people don't understand. You dress a woman according to her personality, if she has one. You don't change a personality when you dress her unless she doesn't have one, or hers is not right, so you sort of combine with her. But you can't just tell somebody who has a personality, "Well, this is what you're going to wear." I always work with designers, and when it's finished, we might change things. I might say, "Cut on the bias" or "Cut on the straight." Sometimes I like to go to the extreme, and I do things just to laugh at myself. I go from one extreme to the other, and I destroy everything I ever believed in—in one night. Not change—I just destroy my own self with a joke of myself. I always think that if you get too much into fashion and all those things and you take yourself seriously, you become completely uninteresting and empty. And when I do those things, it's just because I think I believe too much in good taste, and I'll do everything in one night to have bad taste. Otherwise, I can't bear fashion. I have dresses that I love. I carry them wherever I go—even if I don't wear them. Like antique clothes . . .

"I prefer to meet someone at my worst, and then all I have to offer is something better."

Q. Do you wear things twice?
A. When I have one thing that I like, I wear it for a year once a week, at least.

Q. Do you like furs?
A. I love furs, but I don't have any because I feel terribly guilty about animals being killed. The fur I like is Russian wild lynx. And the others I like are ermine and sable, which are facing extinction. Every time I go and draw a coat for a designer, I go home and think about it and call the person and say, "I can't have it." I feel terribly guilty. I can't put it on my shoulders when they're going to kill all those little animals. I ask, "How many skins?" and they say, "Two hundred and eighty." And I can't kill those poor sweet things and I say, "Don't do it." I went to Karl Lagerfeld and I drew this ermine cape and what did he do? He copied the idea and made it for Fendi.

Q. Do you think American girls like you? Or are they jealous because you're married to Mick Jagger?
A. I never used to like women before, but I think women are becoming more tolerant of me. I'm more at peace with them, but maybe I'm wrong.

Q. Is there one country you would particularly like to live in?

A. I used to like traveling around and not living in any one place, but I can't do it any more. I want to live somewhere. My first choice would be England, and second—I think we're going to live there—is New York. I've always felt it's terribly hectic and at the end I'm terribly tired, but I've been living in a hotel. It's different having a house, because you can see people at home—you don't need to go out and run around. The sadness of living in a hotel is it's very sad to go back to it. I can stay all alone for days and weeks in a house, but in a hotel you feel you need to breathe. Maybe it's because I'm on the top floor—I need to breathe, and I've got to go down twenty floors.

Q. What do you think of "cheap chic"—having style for very little money?
A. I don't think chic has anything to do with money. You can have all the money in the world and have no idea what elegance means.

"I did exercises all the way through my pregnancy."

Even if couture people have talent, they sort of forget about it because they have to create clothes for women who are not necessarily the most beautiful, and not necessarily for the women who have the best taste. They can't wear everything, and they are older and they are fat sometimes. But there are women I don't consider old—no matter what age they are, they never age. They are beautiful and they're thin and they take care of themselves. But it's not every woman who does that.

There is one thing about cheap chic that is different. There are things that look cheap, cheap that can be expensive but look cheap—that's awful. But there are other things whose cost is little, but that look like a million dollars, which is a different thing. I don't like things that look cheap, but I don't mind if it's cheap and looks like a million dollars.

Q. Are there any women you admire?
A. I admire Diana Vreeland very, very much. I think she's beautiful. I think women make themselves beautiful. She's beautiful because she's not only just herself—she's unique. There are no two Diana Vreelands in the world; there is only one. She is intelligent and she's vivacious and she's kept this wonderful sense of being marveled—like a child. She dazzles! She's fascinating—there are girls who are twenty who don't have that quality any more. They seem to have seen it all, but it seems like she's never seen anything, and she's always ready to see things in a new way. She's always excited!

I also think Elizabeth Taylor is wonderful. But I generally admire men. I'm not really concerned with women—that's the problem. I admire Madame Pompadour. She was wonderful, and an extraordinary woman.

Q. What do you think beauty is?
A. A thing of the spirit. One day I wake up and I think I've got all the flowers in my hand, and another day I wake up and say, "Oh, I look terrible," and nobody understands and they'll say, "You look all right." But beauty is in the eyes of the beholder, so if I don't feel beautiful, it doesn't matter if someone says, "You look beautiful." If you don't feel beautiful, you don't behave beautifully.

Q. Did you ever pluck your eyebrows?
A. Very little. You are seeing my true face without any make-up.

Q. Is there anything about yourself you don't like?

A. I'd like to be taller.

Q. Who were the first publicized beauties that you took note of?

A. I loved Gene Tierney. God, she was beautiful. And I admired Marilyn Monroe. I think it's all a question of being yourself. Just find who you are or who you think you are. Of course, you can change your mind. But women tend to forget that they are individuals—one person. Nobody should tell them their hair should be a certain way or their eyes should be this way or their clothes should be this length, because it always comes from people who are selling them something. Why do you think they make radical changes every year? Because if they don't, people will wear what they wore the year before.

Q. Do you collect shoes?

A. I have a shoe fetish. I have more shoes than dresses. And I have all these shoes that go with nothing, but I just love them. I say to Mick, "I have no winter clothes," and he says, "You're going to catch a cold." So I go out to buy something for winter and I go and look in the shoe window and I buy one pair of shoes and then I go home. And Mick says, "Did you buy something warm?" And I say, "No, I bought a pair of shoes." And he says, "What are you going to wear them with?" And I say, "I don't know," because I have only summer clothes and spring clothes and autumn clothes. But I can't stand wool, because I'm allergic to it. Maybe I should get a big cashmere blanket and wrap it around me.

Q. Do you like jewelry?

A. I love stones, but I don't like modern jewelry. I love Etruscan and Roman and Grecian jewelry—before Jesus Christ. And I love old gold.

Q. When you haven't seen Mick for a long time, do you do anything special so you look beautiful?

A. I try, but it's always so difficult because I'm always coming out of a plane after eight hours. So I carry a tiny little bag so I can change when I arrive. If I can't, I try to clean my face and sort of look tidy. It's always terrible because the most destructive thing for one physically is traveling. The pressure and the change in climate get me down. I would love to travel and go everywhere if I could just close my eyes and be there by magic carpet. Every time I travel, I never sleep the night before because I'm always packing in the middle of the night. I'm a maniac when I'm packing because I put all these papers in the shoes to protect them.

Q. Do you put on perfume when you're going to see him?

A. I have this old perfume that doesn't exist any more by Chanel called Russian Leather. I have another perfume by Guerlain that is not made any more called Lieu. I mix perfumes; I like to do all kinds of mixtures.

Q. Why do you have such beautiful hands?

A. Maybe because I dance. South American women have very beautiful hands and fine bones.

Q. Do you take special care of them?

A. Every time after a bath, I put cream everywhere—with gloves made of horse hair—and I massage everywhere, and all the dead cells disappear. You increase the circulation. You should put creams on after the bath when your body is still moist. Then it penetrates, because the pores are open.

Q. Does Mick like you to be sexy when he's not with you?

A. No, he likes me to be invisible.

Q. Did you ever want to be a blonde?

A. Not really, only as a joke. I have put on a tiny blond wig with short curly hair. I wish I could have a wig with short hair, but they never look natural. I hate things that are false. I couldn't think of anything I hated more than if you were beautiful because you had false eyelashes, because you had this marvelous wig, because you have this fantastic make-up, because you have this incredible corset, and then you go to bed with this man, and you take all this off one by one, and suddenly this new person appears. Can you imagine? I prefer to meet someone at my worst, and then all I have to offer is something better. Except that sometimes the only impression that counts is the first one . . . So let's hope the first impression is not the one that counts.

Bianca Jagger is a hybrid. She has power in her presence, power in her movements, power in her voice. Bianca is a warm, loving, and beautiful human being.

Fashion magazines dictate, "Cut your hair, think pink," but I'm against dictating. I like people like Bianca who develop their looks themselves.

I've never seen her hands detailed before. In all the photographs that have been taken for all the stories about Bianca, nobody has dealt with her hands—they are exquisite, they express her personality, they're free. They are like sculpture—they automatically assume gestures, and each gesture is a work of art. She doesn't wear as many beautiful bracelets now, or as many hats—she's become much more simple.

If you have unusual looks, play them up

Anna Levine

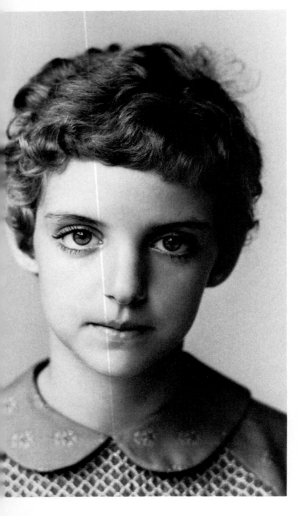

Scavullo: How did you feel about being photographed for this book?
Ms. Levine: I thought the whole thing was a mistake. When you called up and said you were doing a beauty book, I thought you were asking me to come up and deliver the sandwiches. I kept waiting for someone to say that the whole thing had been a clerical error.
Q. Why?
A. Because I do not feel that I am beautiful. There is something so conceited about feeling that you are a beautiful woman. A beauty book ordinarily has to do with bone structures and proportions of the body. Rarely do they go after somebody who is funny looking with a nice heart.
Q. Are you a funny-looking person with a nice heart?
A. Yes. But, you know, the experience of being photographed was wonderful. My hair was left the way it is—which is ratty. Nobody put a roller in it. Make-up was put on me, but only to try and make *me* look good. It was not as if I was hired and then turned into somebody else's idea of beauty. I did not end up looking like Debbie Reynolds or Raquel Welch. I brought hundreds of clothes with me, but I was told I looked prettiest without them, which made me feel wonderful.
Q. Do you feel your clothes are important?
A. Clothes are a means of expression for me. They are something that pull me out from the wall. If I put on rolled-up jeans and a T-shirt, I would disappear, I would be completely unnoticeable; you would just walk into the room, and there would be nobody there. I am very careful about necklines, not just careful not to choose the wrong one, but going out of my way to find the one that suits me. I look for certain colors that I love. I have a rust-colored scarf that I adore because it makes my cheeks look red—it makes me look happy and bright. I use clothes as make-up more than I use make-up. I do not like make-up—I think people look dead in it—and you're always having to fix it. Make-up is great in certain very specific situations. I've been in plays where I went crazy experi-

> "If I could have anything I wanted for Christmas, I'd like a jawline."

menting with make-up, and it really works wonderfully. In a photographer's studio, make-up is a different matter, too. The lights are specially designed to make you look good—but if you go out into the world with it you look green and pasty. God did not design light so it would fall correctly on your make-up. You have to keep it in the environment for which it was designed.
Q. How do you look most of the time, and what do you wear?
A. Some people see me as a mess—mostly my parents' friends—but my friends do not talk to me about the way I look. Ordinarily I just wear lip rouge, use a lot of soap and water, and put on perfume for very dressy occasions. As for clothes, I just put on things that I like. I like to wear clothes that are nice, or funny or colorful, or have interest because people have to look at you, and they should have something interesting to look at. I do not think clothes should be so important—I mean, what do people who run around thinking clothes are important think about when they get home?
Q. You seem to be a very up-front person about your looks.
A. You have to be, or you will attract people on a false premise. You're going to get someone who thinks you have the biggest breasts in the world if you wear falsies, and then when he finally proposes and you accept, you have to say, "I don't know how to tell you this, Gordon, but these are not mine."

> "Rarely, in a beauty book, do they get into somebody who's funny looking with a nice heart."

Q. What's most important to you?
A. The people I care about. Acting is very important, but I'm not one of those people who only has a career. My career is important because I only like people I can respect, and my friends only like people they can respect, and I've found a lot in common with certain people in the theater who work hard at their craft.

Q. Do you have any fantasies?
A. The fantasy I most prefer is that I am very attractive—whichever way I can be attractive, whether it's by being clean-cut (obviously not my style) or being really crazy. I would like to be very attractive . . . I would like to be Raquel Welch. I would like to be very attractive because, in the first place, it is easier to get people to talk to you if you are attractive. People will open up more readily to someone who is very pretty. I believe attractive children are favored. I knew two young boys who, in their own circle of friends, were more respected because they were so incredibly beautiful to look at. They are art. They are their own art. If I can make myself a better painting, I'm going to get along a little better.

Q. Are you in good shape?
A. Yes, I am strong. I take dance classes, and dancing makes you very strong physically.

"Ordinarily I just wear lip rouge—and perfume on very dressy occasions."

have no hard angles. Cats can do the most awful things and still look wonderful—they are so beautiful and pure, and very quiet.

Q. Do you have any beauty problems?
A. If I could have anything I wanted for Christmas, I would choose a jawline. I have a little pointed chin, a double chin. I also have an enormous nose, which I would like to take about a quarter of an inch off. Not that I want it to be flat and tiny and nose-jobbish, but it is

"God didn't design light so that it would fall right on your make-up. You have to keep your make-up in the environment for which it was designed."

too much—I have to get rid of that), when you do not plan it—it is always there as a part of you, not a trick that you did with color or mirrors. That is what I want. To be strong and free as they are. It is not appealing to be completely dependent on someone else. I do not think anyone wants someone hanging around their neck.

Q. What do other people think of you, of the way you dress?
A. I have lots of people say, "Oh, you always look so wonderful. Where did you get those clothes? They're unusual." Then I have another friend who says to me, "Anna, I don't want to insult you, but let me ask you one question. Where do you buy those sacks you wear? Is there something wrong with your body? What is it?" I walk around a little bit frustrated all the time, a little bit aware of something . . . an edge. I am wary. Yet having my picture taken for this book made me feel that I was beautiful . . . which is very relaxing.

"Clothes are a means of expression for me. They are something that pull me out from the wall . . . I use clothes as make-up more than I use make-up."

Q. What about diet?
A. I love cookies, frosting, cake, pastries, spaghetti, and pancakes—I love them. You have one piece of cake at lunch and you feel much better, much lighter . . . not too heavy as if you had eaten a ham omelette or two hamburgers. After all, two hamburgers weigh more than a piece of cake, so they weigh you down as you walk along the street.

Q. What do you see yourself as?
A. I see myself as a cat . . . I am not catty, but I like the softness of cats. I like the fact that they

just too long. I did a television show once, and it seemed to me that everyone was tripping over my nose. I need less nose, more jaw.

Q. What are your best features?
A. My best features are my eyes . . . I do not have much choice.

Q. Are there women you admire?
A. There are four people that I think are very beautiful and, to me, they are very similar: Vanessa Redgrave, Ellen Terry, Isadora Duncan and Isabelle Adjani. Being beautiful is when you do not care how you look (I still care

Anna Levine has timeless, almost mythological beauty. She looks as if she stepped out of a Botticelli painting. She's very creative with clothes, but I photographed her without them because I think Anna, by herself, with her hair wild and natural, is perfect.

For Anna, we wanted subtle blending and shaping that would result in a no-make-up look. We didn't want the eyeliner to show as eyeliner, but simply as a darkness smoothed in above the eyes; the same for the tones used on her face. Using a lot of make-up does not have to result in a made-up look.

Anna looks great in the old clothes she loves to collect. As an actress she adores costume and is capable of easy change from one fantasy to another. She could wear contemporary clothes, but what she does is much more special.

Anna Levine

"The fantasy I most prefer is that I am very attractive."

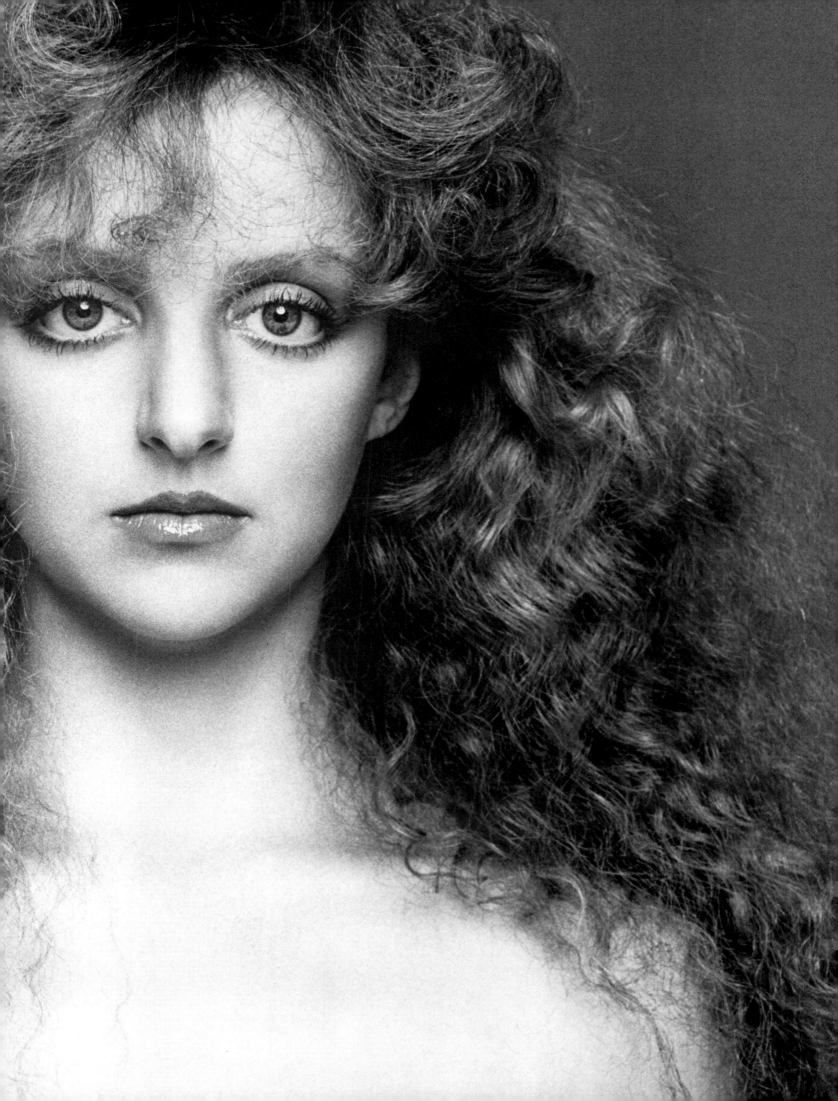

Individuality of character dictates a personalized–and simple–beauty routine

Hilda Lindley

Scavullo: I want to hear all about you. I know you've raised three children by yourself, and you've worked all the time. How did you keep yourself looking terrific?

Ms. Lindley: My secret is Noxzema. But really, I have no secrets. My husband got sick shortly after we were married, so I've always worked. I wanted very much to have children and I elected to have my children—none was accidental. I used to have my doctors induce deliveries so that I'd know when I was going to leave my job. I'd have everything ready and I'd leave the office and I'd come back three weeks later. I didn't do that because I was brave or noble, but because we needed the money and my husband was ill. But then I was divorced when my youngest child—he's now twenty—was eight months old. I used to think that working was a hardship. Actually, working has enlarged my life to an extraordinary degree. I've been very lucky to have worked in a field—book publishing—that I enjoy very much. I always worked for money; I never worked to express myself. My first question to anyone who offered me a job was "How much?" because I needed the money to support us. Now my children are all grown, but I still work. It occupies me and supports me. I have a lot of energy, which I think is fortunate, and I enjoy what I do.

Q. Do you have a special diet?
A. No, I eat everything, but I particularly like raw fish.

Q. Do you like parties and getting dressed up?
A. I love that. I like to have two different lives. One is the life I live in New York—going out a great deal, going to parties. The other is in the country where I live two miles from the nearest road. I like the contrast.

Q. What do you do in the country?
A. About five years ago I inadvertently backed into the environmental struggle. A local official, who is now the supervisor of the town of East Hampton, had proposed bulldozing a thousand acres around my house and building eighteen hundred houses, in addition to hotels and motels along two miles of beach. I was really sorry to think of this beautiful, untouched land being destroyed, so I invited four people to come for lunch and we decided to call ourselves The Concerned Citizens of Montauk and to run a conservation ad in the local paper. We managed to save the land for a county park that will remain forever "unimproved" in its natural state. The organization has really grown to nine hundred taxpayers out of a total of two thousand.

Q. You told me that you had breast cancer. Can you talk about it? How are you feeling now?
A. I had been examined by my gynecologist three months before I had the surgery and he found nothing there. But when I was planning to take an Outward Bound trip I had to have a check-up. When I look back on it, it was a miracle—normally, it might have been months before I went to the gynecologist again, and the cancer would have been bigger.

Q. What did you do when the doctor told you?
A. First I went to Memorial Hospital in New York. A man whom I was close to sent me there to a very fancy society-type, Hollywood-type doctor. He examined my mammogram and said, "Yes, the chances are ninety-nine percent it's malignant, for it is attached to the skin. I recommend a radical mastectomy. Here are the names of three doctors who are good; just choose one. It's a disfiguring operation and you're a beautiful woman; it's too bad to do this to you, but it's an ugly disease. Goodbye." On Monday I went to my gynecologist, who sent me to the best breast surgeon in New York. And he said, "No, I don't believe in radical mastectomies, especially with a small growth like yours. We'll just take the whole

"As long as you have breath in your body you're capable of growth and new experiences."

breast off and then you'll never get cancer in that breast again." I decided to call one of my close friends, a woman in publishing. (She had published George Crile's book on breast cancer.) I said, "I'm going into the hospital this afternoon for a mastectomy; I wanted you to know." She asked me whether I had called Dr. Crile, in Cleveland, who had pioneered a controversial technique of cancer surgery. I said, "No, I've seen two experts and I have really had it. I just want to get this damn thing over with." She told me that I shouldn't just sign a paper allowing the doctors to cut my breast off if the growth was malignant. She said that I would be giving them control over my body, and that she was ashamed of me. I said, "Okay, be ashamed, bye." But on impulse, when I got to my office, I called Helga Sandburg, who is married to Dr. Crile, one of the top surgeons at the Cleveland Clinic, one of the largest hospitals in the country, which has pioneered in an

"Individuality is very hard to come by."

operation that does not remove the entire breast, just the cancerous tissue and an area of healthy cells surrounding it. This operation is performed very widely in England and in Europe, but here most people prefer either to remove the entire breast or to perform a radical mastectomy. Anyway, I called Dr. Crile, whom I had met years ago when I was Carl Sandburg's editor, and he said that he couldn't diagnose me over the telephone. So instead of going to Mt. Sinai in New York at three P.M., I took a plane to Cleveland at twelve noon. When I arrived, he examined me and said that the advice I had been given to remove the breast was good. I told him I hated to lose a breast, that my whole body is important to me; I wouldn't want to lose a toe.

Q. Did he really want to know why your breast was important to you?
A. Yes. But then he saw a shark's tooth I had on a chain around my neck. He asked about it and I told him about catching a white killer shark off Montauk. He then called in his son-in-law, a gifted surgeon, and said, "I think this woman has too much guts to have her breast removed if she wants to keep it. Can we save it?" Dr. Esselstyn said, "I think so." The next morning I went to the hospital for the operation. And then right after Christmas I went back to Cleveland for plastic surgery on my breast. Now my breasts are both even. It just makes me feel more like a woman to have two breasts rather than one. I may get cancer in my other breast someday, or in my head or in my stomach, or I may be hit by a bus or I may die of old age. But I don't think of myself as a cancer victim. A person might stay in bed all the time to be safe, and die of bedsores.

Q. And tell me about the kind of clothes you like to wear.
A. I like very simple clothes—skirts and sweaters and suits. I've never worn pants to work. I wear them in the country, because I'm climbing and digging and that sort of thing, but I prefer skirts. I have nice legs and I like to show them and I also feel more feminine in skirts than I do in pants.

Q. How do you indulge yourself after you've been working? What are some of the things you really like to do?
A. When I was in publishing it used to be reading a book that we weren't publishing.

Q. One last question: What do you think about gossip?
A. I love it. Publishing thrives on it. I don't think we could have an industry without gossip.

Hilda Lindley lives and works most of the time in the high-pressurized atmosphere of New York. But just mention the word "Montauk" and her face lights up. Outer Long Island is where she goes to refresh herself and find adventure and involvement in that naturally beautiful community. It must, at least, be part of the secret to her healthy good looks.

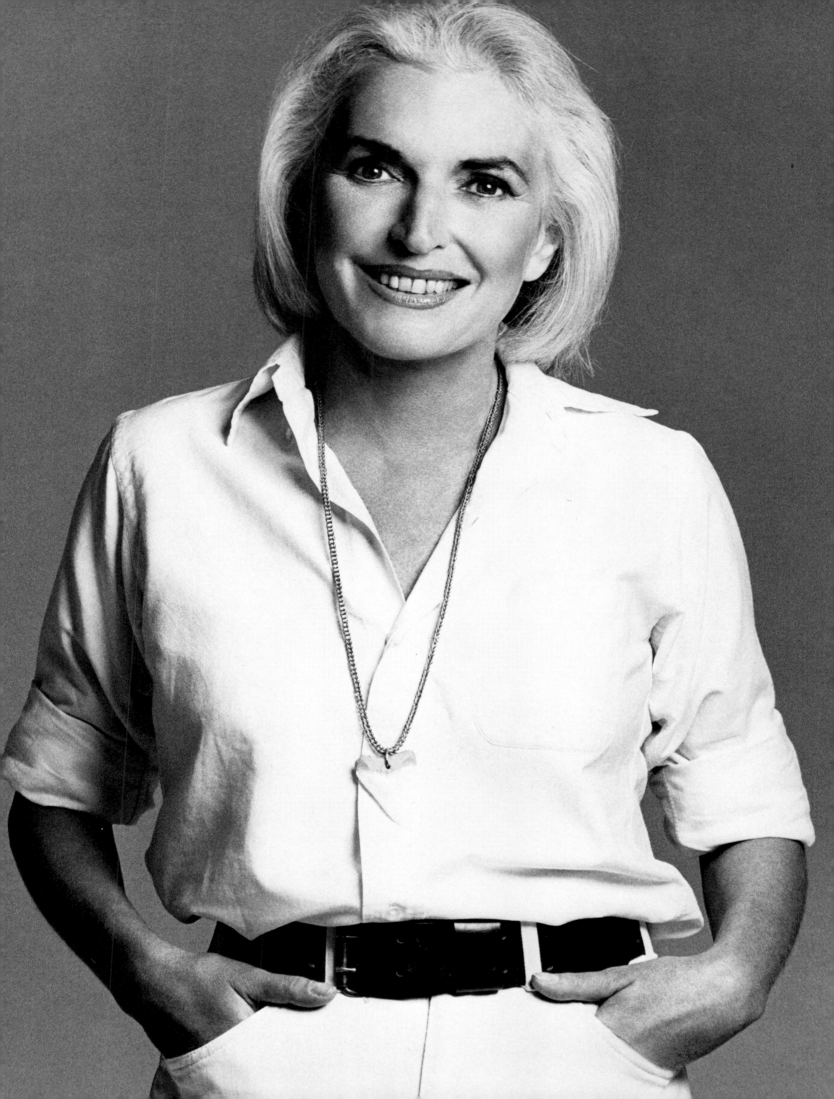

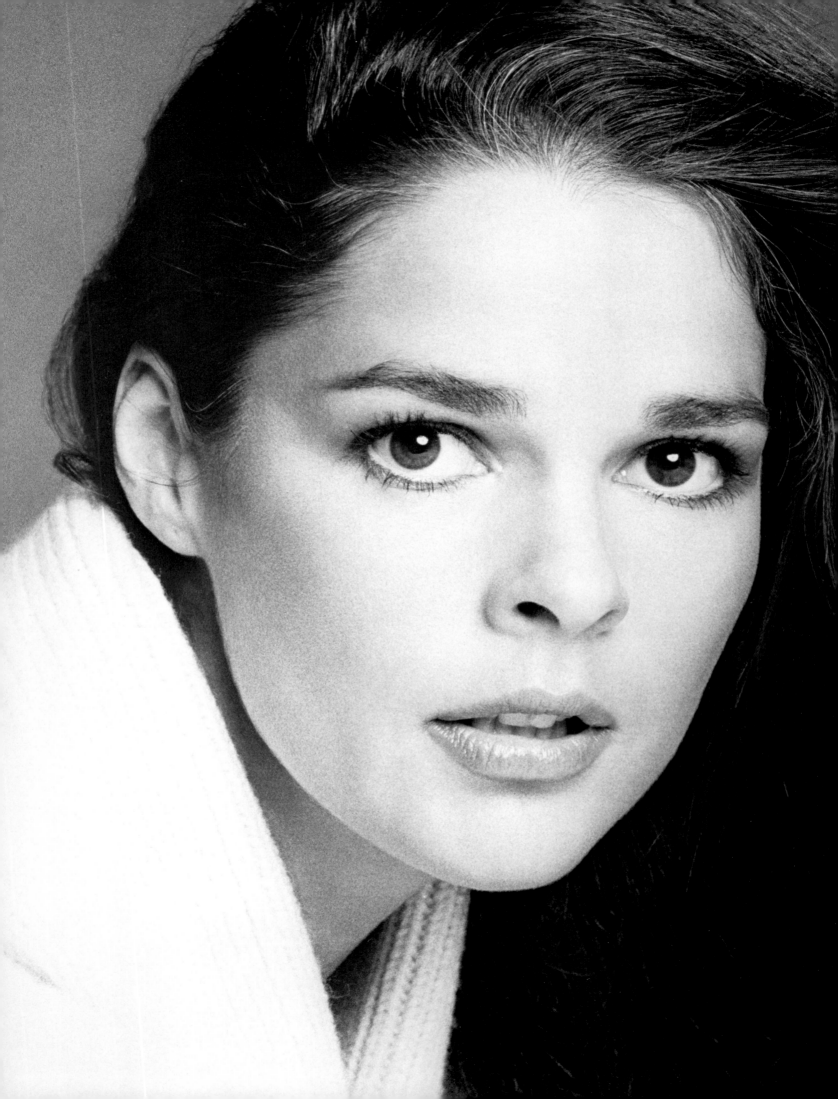

Simple beauty routines when your life centers around your family

Ali MacGraw

Scavullo: Do you have a system for keeping yourself in shape?
Ms. MacGraw: It's the old thing of eating sensibly, sleeping enough and exercising. I've done dance exercises all my life, and in California I've been doing Ron Fletcher's Control-ogy—it makes me feel terrific and often is like a dance class besides. I was brought up with really sane eating habits, and I'm lucky because my system craves vegetables and fish and fruit. I feel better in direct proportion to how conservatively I live.

Q. How many hours a week do you spend on exercise?
A. An hour and a half three times a week on organized exercise. And sometimes I swim in the ocean, but I'm not at all athletic, so I have to make time for exercise. It's not as though I'm going to luck into two sets of tennis.

Q. What about other health things?
A. I don't smoke and I never have. I go in and out of taking vitamins. Right now I'm taking quite a number of them, but then I've always taken C and iron and a multi-vitamin. I'm reading as much as I can about health foods and vitamins because I'm really very nervous about what we've done to our environment.

Q. Do you consult with a doctor on these things?
A. Well, I won't start anything crazy like that without my doctor because I'm getting bombarded with too much information. I've never been much of a faddist of any sort. The only thing I know I need is a lot of rest, very specific peaceful time. It's important because I have a family and little children. I'm always driving and rushing around. So looking the best I can depends on my not being too nervous. I started to do transcendental meditation this fall as a way of forcing myself to take time in the morning and in the afternoon in solitude. I may not have had the brains to tell everyone in the room to just excuse me without a "label," so I've given myself that time, and it calms me

down. Stress is a major beauty problem. There's one other beauty thing that I do. I go and have my skin cleaned once a week at Aida Thibiant; I've been going to her for four years. I think that when you live in a city that's poisoning you, especially a city full of cars, you need more than just washing with soap and water.

Q. What about your routine at home?
A. I get up at six-thirty in the morning and I immediately leap out of bed and superficially wash my face so I can open my eyes. Then I go down and meditate for twenty minutes and watch the sun come up. It's so quiet. And then I wash my face with an almond scrub, and put on moisturizer and a tonic which takes a fast four minutes.

"I have always been considered this instant all-American sporty character; in fact, I'm absolutely the opposite."

Q. No make-up?
A. No, I usually don't wear make-up because my skin doesn't react well to it. It also depends on how tired I look. I think I look better without make-up than with it. So the most I do is maybe put some stuff around my eyes.

Q. How do you see yourself?
A. I think I look much more athletic than I am, for one thing. I have very strong bones and I'm tall and I know that when I was a commercial model, I was given a crack at being the tennis player who could also brush her teeth. I have always been considered this instant all-American sporty character; in fact, I'm absolutely the opposite. I never think of myself as beautiful, but when I look the very best that I can I think I probably look striking, not pretty.

Q. Do you ever really study yourself in the mirror and just want to give up?
A. Oh, yes, sure, doesn't everyone?

Q. How do you get out of it?
A. It's so internal, and I've gotten very philosophical about it; everything has to run its course. It's a circle, the opposite of down is up, and when it stops being grim it's going to be wonderful, inevitably. If I look in the mirror and feel repulsive I'm probably in a repulsive mood, and will continue to look so until I get it together. And the best thing to do is back away from the mirror immediately and close the door.

Q. Have you ever thought about what your best feature is?
A. Not very often, but I guess it's my nose. I am very eye and hand conscious—they're so much a part of expression—so when I want to be aware of what I'm doing, I want to make my eyes look the best they can, and my hands.

Q. What about bad features?
A. Dreadful, huge feet. I'm quite flat-chested, broad-shouldered, and my upper arms are bigger than I wish they were. I'm hung up on those too-thick-arms people, who obviously never had anything to do with their arms, but mine are all muscle from carrying everything. I always look at people who are beautifully lean, head to toe, and I'm never going to be like that. I'm convinced that if I spent every waking minute of my life being pampered and pounded, I could make myself look "terrific," but that seems to me to be the opposite of what life is about.

Q. Do you try to correct your problems?
A. If I don't think my upper arms look too terrific, I'm not likely to go around in a tank top, because that's not the best thing for me. The main thing is that you've got to have your own sense of style and, within reason, not be made insecure by passing fashion so that you sacrifice what you have inside yourself. When I was a model, I remember one year when I had to look in the mirror constantly and I hated what I saw, because a model's job is to sell whatever the thing of the moment is. So the thing of the moment was wonderful ringlets and lacy things, and I look terrible in it.

Q. What kinds of clothes do you feel most comfortable in?
A. Pants, of course. I live in Southern California, and I live a very casual life with a husband and two boys, so it's got to be pretty practical. I wear jeans, which I love, and T-shirts. I spend most of my money in the clothing department on accessories because the rest is just T-shirts that fit, turtleneck sweaters that fit, jeans that fit. Then, I have a fetish for beautiful, beautiful old and ethnic clothes. I wear them very rarely, and I own them for the same reason my hus-

"I'm very worried about turning into a prune. I love the sun."

band has antique cars—because they're beautiful objects that I love.

Q. What about colors in clothes?
A. I have a lot of black. I've bought a beautiful pair of black pants, and a cashmere blanket shawl. And earth colors, and once in a great while I'll run out and buy another T-shirt, but most of my clothing seems to be brown, beige, black, cream-colored.

Q. Do you dress to emphasize anything?
A. I like lean T-shirts, lean turtleneck sweaters, lean, simple, ungimmicky blue jeans, and then I have wonderful accessories, ethnic ones, old ones, bracelets and scarves. I'll wear a skinny black sweater and some Afghani jewelry at night with jeans, and that's one look. An earth-colored T-shirt, a scarf to tie my jeans up and one less bracelet works for daytime, and it doesn't look contrived. I hate to look over-dressed. I used to wonder if it was O.K. to show up in something "less," and now I know it is, as long as it's clean and of good quality. It's also about being comfortable. It's probably one of the reasons for the way I wear my hair. It is so straight that I long ago decided not to have a heart attack in the middle of the night because a hairdo had fallen down. There's nowhere for my hair to go but down. It could look a lot nicer, but I just keep it clean and wrap it up in scarves.

Q. Do you wear your hair long for ease and convenience, or is it security?
A. I was thinking of chopping it all off, as short as Mia Farrow's used to be. I think it's a very psychological moment, to chop it off, thirty-some-odd years of hair. My hair is pretty long now, and it's finally really healthy and nice. I like the way it feels. I wash it three times a week. I use three or four different shampoos, depending on what's around, and no conditioners. And I brush it a lot.

Q. Do you stay out of the sun?
A. I'm very worried about turning into a prune, but I love the sun. I feel the most attractive when I'm brown, and I have abused myself in the sun for my whole life. I thank God every day of the year that it's raining because it means I'll stay out of the sun. I like the way it makes me feel, too. But it is murder on your skin. I wander around like a greased bear, but there's nothing that's going to stop the sun from drying up the skin.

Q. How do you indulge yourself?
A. I know some people think getting a facial is a luxury, but it's not a luxury to me, it's a flat-out necessity. I would like to have that hour and a half for my life, but the good it does my skin is so incalculable that I just do it. That's not an indulgence. And neither is exercise. We're building a hot jacuzzi now, which is I guess an indulgence, but it is so extraordinary for your nerves. It relaxes me down to the marrow and I'm better to be around like that because I'm a very nervous lady. On a trip I may get into French bread and croissants and cream, and I can gain weight; but I'm brainwashed by that "thin is attractive" syndrome. Every man that I've ever known has said that I look better heavier than I allow myself to be, but I feel better this way.

Q. Who do you do it all for?
A. I do it all for me, but if I get myself together in a way that my husband doesn't find attractive, it's no fun. Sexually it doesn't work for me. I certainly don't dress for other women. I dress for myself. I'm very secure about it now, and I know that I don't need somebody to tell me, "Boy, is that a great pair of pants." You can be a slave to that trip, and certainly fifteen years ago I didn't feel as strongly as I do now, especially when I was working in the fashion business. It was very difficult because I didn't have any money, and I was surrounded by that constant barrage of the latest shoe, the latest bracelet, eye make-up, etc. I had a lot of insecurities because I couldn't afford to go out and buy them as everybody else was doing. Now I rarely, rarely buy "the thing of the week." I have a cashmere caftan, not because it's "new," but I know I will have it for the rest of my life.

Q. What do you think the value is of being attractive?
A. It gives you a leg up. It's so lucky, it's really lucky. I think now, fortunately, we are out of the era where there's one look. When I was little, prettier was better. Movies are a good place to point the finger because America is crazy about movie stars, and there have been some extraordinarily unusual looking men and women who have been making us realize that creamy, or curly, or chiseled-chin isn't the only way to look. Adorable and pert used to be the only way to be. I'm still awed by that incredible-looking-all-American dream girl, beautiful skin and beautiful teeth, long hair and the drop-dead body. But I've never been attracted to perfect, comic-strip-beautiful men.

"I live a perpetual fantasy life. I have a difficult time figuring out where reality enters in."

Q. Is there someone that you particularly admire?
A. As a woman to look like? No. I think, though, it would be just incredible fun to have the kind of money to go out and build your whole life around style. To a certain extent, anybody can do it if she's got enough taste—but let's face it, if you have trillions and trillions of dollars, it's easier to call up and order a real Arabian-nights costume. I got bogged down on the level of "I forgot to make lunch for Joshua," but I think it would be wonderful if you could do the whole thing. And I think you can do a lot more than you think. It's really about being yourself. That starts internally with your health, which is just more important than any other thing. And then clean out your head and unload unnecessary people and false relationships which take up time from your life. Then have a little fun.

Q. Do you have any fantasies about yourself?
A. I live a perpetual fantasy life. I'm very visually oriented, so I don't really know what reality is. Fortunately I do have a sense of responsibility to the people I care about, and I'm practical and I spent enough years taking care of myself so totally that I don't have this mad-movie-star-wow!-crazy-indulgent nature (probably I should have a little more). But if I buy a pair of burgundy boots, I'm probably "in Russia" in 1906 for the entire time I've got

them on. I live in the past—I don't mean my past, but in a visual storybook past. I'm a very contemporary woman with a fantasy life that is about 1930.

Q. Do you think American women should improve their self-image?
A. The best thing would be to be less preoccupied with beauty, self-image, etc. I think that beauty is such an internal thing that the less people rushed out and bought the latest nail polish, cut their hair the very special way that you couldn't live without, put on the X-inches above or below the knee skirt, the more time they put into making themselves interesting and helping, the more beautiful they'd be. If you don't have any vitality or inside life, it doesn't matter what you put on or how you do it. I think it's self-examination, however you do it—religiously or through therapy or maybe good friends who sit down with you and talk about your insides. I think we were all probably taught that thinking about yourself is selfish, it's bad. But if you don't know who you are, then you're wasting your life. When you know who you are, then you know how you look—all those little extras just fall into place. You learn about your body. When people present themselves physically, you can tell how they feel about themselves.

Q. What would attract you to somebody who comes into a room?
A. It's just a presence, and I don't mean sequined entrances. I like intelligence a lot, which sounds pompous, but I think curiosity is what attracts me to people. I'm in a business that's full of superficiality—a lot of people have to do a number just to survive, but I think it's very destructive and boring. What you see and hear on the screen is one thing, but to be confronted by it in person isn't interesting. I'd rather pay for my ticket and see it on the screen.

Q. Are there things you really must do in terms of self-improvement?
A. Yes, I must learn more. I'm reading more now than ever. What is so interesting about kids is how open they are and how much they know. There's such a terrible tendency to sit back and say, "Great, I'm educated now; let me live."

Q. Where are you directing your energies now?
A. Into myself and my family. Making my children feel really secure. Children who are made to feel secure early on feel better about themselves quicker.

I see Ali MacGraw as being able to look both casual (which suits the way she lives) and very sophisticated. She takes to the contrasting looks quite easily. She is the dark all-American beauty, with a face that shows a lot of intelligence.

Her casual make-up is lightly applied—brown eye shadow, not much color on the lips. Her sophisticated look takes more make-up, contouring deep around the eyes, and a much stronger mouth.

Her straight hair is great down, or in a chignon.

The easy, sporty look comes naturally to Ali MacGraw. She has smart, practical clothes, with a few elaborate and beautiful shawls. Her love of ethnic clothes and jewelry shows great style. She was one of the first to put the look together.

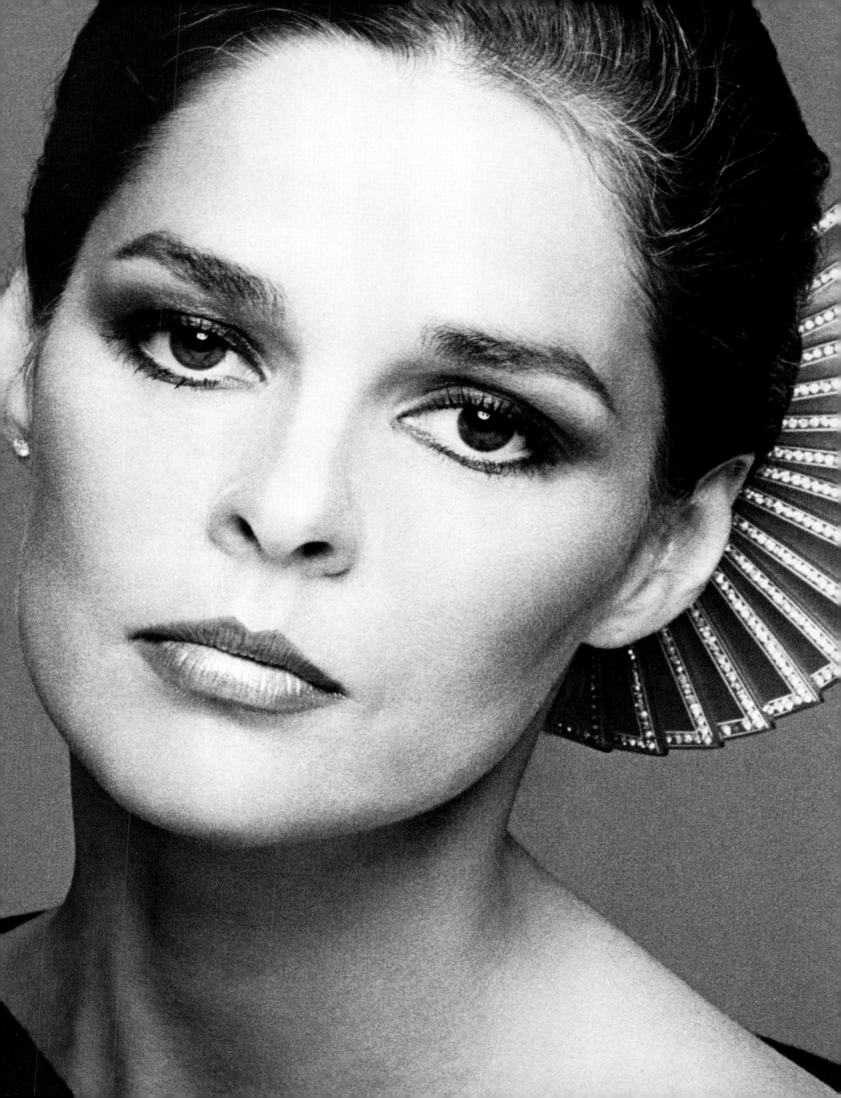

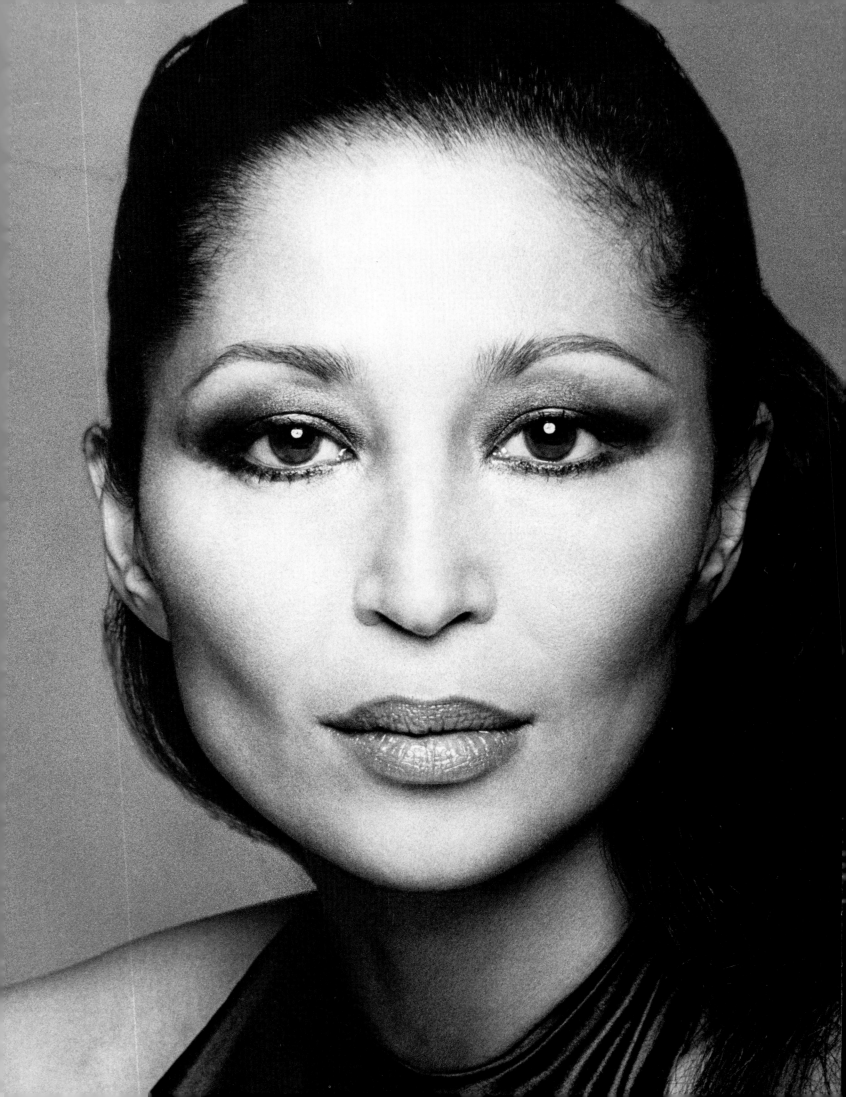

When the shape of your face is your best feature, keep your hair simple

China Machado

Scavullo: What is your personal approach to beauty?
Ms. Machado: I don't really have an approach—I think it's a state of mind.

Q. How do you take care of your skin?
A. I never have. I've had a facial once or twice in my life—usually at Carita in Paris. I take very hot baths. I'm like the Japanese who take enormously hot baths. It opens the pores and, for me, it's a relaxation. I don't think of anything else except that I'm in the bathtub. And I don't use creams.

Q. Do you take care of your hair?
A. Once a week I go to the hairdresser's to have it washed and set. I usually cut it myself. And I have a white streak that I dye black.

Q. Do you diet?
A. No, I like Italian and Chinese food.

Q. Do you exercise?
A. I can't even touch my toes! I'm very strong, and I'm always moving, and I do a lot of things in the country—especially in the springtime—like cutting down trees. I don't exercise, but I'm very resilient because I've always moved a lot.

Q. What about make-up?
A. I don't think it should be too heavy. I do wear make-up on my eyes, but not very much on my skin. The skin should be well-cleansed at night, to give it breathing space. I use Orintrech soap on my face.

Q. What catches your attention first when you look at someone you consider beautiful?
A. Her manner towards people.

Q. What's your best feature?
A. My best feature is the shape of my face. That's why my hair is never a "hairdo," and I don't really wear a lot of accessories. When I first modeled, I said to Balenciaga, "All the clothes that you're making for me are black and so dreary." And he said, "You don't really need much with that face." So I have never overplayed it.

Q. Do you like jewelry?
A. Not really. I love playing. When I travel, I always buy things—I love buying them where they are. I buy bangles and necklaces, and I love fabrics. I like fooling with these things, but only once in a while will I put them on. I'm not a person who dresses up—I dress rather simply.

Q. What kinds of clothes make you feel most comfortable?
A. I wear pants practically always because I have very skinny legs. They only look good if they're in a mini; with midi lengths, I always wear boots. And I like clothes to fit well—not too tight.

Q. Are there any designers you especially like? And what colors do you look good in?
A. I usually wear dark colors—maroon, navy-blue and black. And I buy from different people. I love Oscar de la Renta's things and Halston's things. For fun, I like a couple of things from Giorgio di Sant' Angelo—though I sometimes think they're too much for me. Most of the time, I just wear pants and tops and sweaters.

Q. What kinds of shoes do you wear?
A. I wear very delicate shoes because I have very thin, narrow feet and skinny legs.

Q. Do you wear perfume?
A. Just cologne—I've worn Aliage for the past five years.

Q. Do you try to look attractive for men, other women, yourself, or because it's part of your business life?
A. It's a combination of all of those. Since I've only had long liaisons with men, the man in my life is very important. So I would never wear anything that he didn't like. I'm not a fashion-conscious person at all, even though

> **"The thing that catches my attention first about a beautiful woman? Her manner towards people."**

I've been in the fashion world, and it automatically rubs off. I have always dressed a certain way—things can't be too tight or too loose; they have to be comfortable. I look at something, and I know it will suit me. I very seldom try anything on. I know what will fit, and I also make a lot of my own clothes.

Q. What kind of lighting do you like?
A. I like candlelight. No overhead lamps—they're very bad; they make shadows under your eyes. In the evening, every room should make you look attractive; it should enhance your looks. I don't have that much light around my house. You should have a very good reading lamp by your bed, and you should have one place in the house where it's terribly comfortable where you have a chaise lounge and a very good reading lamp. And the hell with the rest. You should have dimmers in the rooms so that you can turn the lights down for the evening. And I always have candles at the dinner table.

> **"Since my best feature is the shape of my face, my hair is never a 'hairdo.'"**

Q. Do you think American women could stand a little improvement?
A. I admire American women, and I'm not an American. I admire them—they are much more aware and they're exposed to much more than the European. The European—especially the French woman—is a thrifty sort. She takes what she has and makes the most of it. An American is much more spoiled. Every day she's getting bombarded with things. Sometimes she overdoes it. If she would take what she has and make more of it, she'd be able to use it better.

I met China for the first time in the early sixties, and I thought she was very striking. She was a model who later became fashion editor of Harper's Bazaar. *Now China is more involved with her personal life and her interests in the arts.*

China has incredible bone structure. In fact, she's the only woman in this book with a perfect heart-shaped face. Her face without make-up is simple and beautiful—but with make-up she becomes extraordinary. Obviously she needs no contouring, just a light foundation to smooth the skin, and make-up to accentuate her eyes.

I like her with her hair pulled back to reveal the bone structure.

China has a body that can wear all clothes well. But, again, for her personal life she likes very simple, conservative styles. My favorite of China's looks is with a tan in summertime, with her hair braided and hardly any make-up. Another terrific look is when her hair is unbraided and she looks like an Egyptian Medusa.

If you want to change your looks, be adventuresome

Maxime de la Falaise McKendry

Scavullo: I think you're one of the greatest-looking women alive—you're so beautiful, so attractive, you stay thin, your body is great. Do you exercise? Do you diet? How do you take care of yourself?

Ms. McKendry: I don't exercise enough. I bought one of those things advertised on TV with a lot of strings that you put your arms and feet in and sort of waggle them around. That's quite good, because after you've done it, you can feel the muscles that you're trying to get at—like your tummy muscles—really hurting. It's a great little gadget, and you can travel with it, which is nice. I'm also a good, strong swimmer and can swim a mile easily.

I've got a natural sense of what my weight should be, based on a few "clue" clothes. I have pants, jeans and stuff, that I've probably had for ten years. So I know the minute I put something on if it feels a little tight. If it does, I cut out all the wine and everything else that's wrong for dieting. Mostly, I don't eat at all in the daytime. I have a fairly decent breakfast, but then I go without lunch. Actually, I don't find time for lunch. I'm never really hungry at lunchtime unless I'm taken to a wonderful restaurant and I see all these things—and then, of course, greed sets in.

Q. You mean you don't have a feeling for something to eat in the middle of the day, especially if you've been working?
A. A small piece of cheese and I'm satisfied.

Q. What about dinner?
A. All the doctors say you should obviously have a heavy lunch and a light dinner, especially if you're going straight to bed, but then I rarely do go straight to bed after dinner. I dance off quite a lot of my excesses, and I walk a lot and I run around and I just burn up a lot of stuff. I figure my metabolism must go roaring along; for instance, dental anesthetics wear off in a flash, and I can drink too much and feel drunk for about five minutes, and then it's gone.

Q. Do you have manicures or facials?
A. I should do all that. I go and have my hair washed. I have it cut by Howard at Sassoon and they just blow-dry it.

Q. Do you file your nails yourself?
A. Yes, and I have one of those little Japanese kits and I buff them. But I do have pedicures. I have rather fancy red nail varnish on my toes, and very plain fingernails. I think it's pretty in bed to stick a red toenail out. But for the day-time, one uses one's hands so much while working, and I hate slightly imperfect varnish. I only like varnish on nails when it's been done fresh within the hour. I think make-up's like that too; it has to be taken off and renewed all the time.

Q. Do you wear make-up to work?
A. Almost none, and half the time none at all. And when I go home, before I go out, I really clean my face very, very thoroughly.

Q. With soap and water?
A. And loofahs.

Q. Do you just go into any store and buy some kind of cream? How do you find the products you like?
A. I've got a good store of things that are naturally made. And I use Diane von Furstenberg's cleanser; I think it's excellent. It's really like a soap. It takes every bit of dirt off one's face. Really, one should test one's face; as long as that Kleenex has the slightest bit of color on it, one's face is dirty.

Q. But would you use soap on your face?
A. My skin is so dry. If I use soap, I have to balance my skin each time.

Q. That's just something you learned yourself?
A. It's very logical, isn't it? Soap is alkaline, so you need something a little on the acidy side to get back to the pH 7 of your skin. Almost anything would do—like a bit of vinegar and water or lemon juice, which, of course, is drying. Then I use some of the old Moroccan tricks like mixing an egg yolk with lemon juice. In winter, when you want your skin nice and white, you leave it to dehydrate a little bit until it gets kind of sticky, and then you put it all over your face. Then you beat up the white of the egg and you put that on top and let it set. Then you have a bath. After the mixture is dry, you wash it off.

Q. These little routines apparently work for you . . .
A. I usually am much more frantic than I am now. John, my husband, was really ill, on and off, for the last five years, and we were really only married nine years. Over half of our marriage was spent worrying about him, and I finally built up such a mixture of hysteria and hostility within myself that I was really almost going crazy. And then when he died, I got such a feeling of fury and hate that this could have happened. I've talked to other people about this—one hates other people, one hates the person for dying, one hates one's self. A friend sent me to a wonderful psychiatrist because he must have known I really couldn't deal with my feelings any more. I had no idea what psychiatry was like. I'd read Freud and I'd read Jung, but I always thought it had to be about one's sex life, too. And I thought that I wasn't that screwed up sexually that I had to lie on a couch and talk to somebody about it. But it's not like that at all. I've barely mentioned sex to my doctor. What it's done is to somehow lift this weight of hostility and anxiety and has taught me to get it off my own shoulders, to discard it. It sounds very old-fashioned to desire to be happy and to be a good person. And really once you want to do a thing, it's much easier to do than one thinks; I mean, that's the basis of Christianity, isn't it? The intention is the difficult thing.

Q. It took me five doctors to find out what you did quite quickly with this one . . .
A. Despite all my hang-ups , there are people who have always said, "Oh, but you're so strong; oh, you've got such energy." But a lot of that strength and energy was a guilt reaction towards a basic lethargy. For instance, once I tried to see how long I could sleep and how long I could stay in bed. It got to the point where I was awake for ten minutes a day. I could have died of lethargy. This was years and years ago of course, and I pulled myself out of it, but now I think I've got a proper strength.

Q. Do you think that one feels younger when the tension is gone?
A. Admittedly, I've had a facelift. I grew up with gardens—living in the country—and you never let a garden get ratty and overgrown and untidy. You have to weed and keep the flower beds neat. I really think of plastic surgery as neatening up the edges of the flower beds. I don't think it's something radical, I think it's something like extra tidiness, a physical tidiness. I've discussed it with doctors—what the surgery can do. In my case, I had a lot of little ratty lines around my eyes. I love making up my eyes, so I needed a good, clean surface again. And I had a slightly bloodhoundy look about my jaw, and this has been cleaned up. A facelift tightens one's skin a bit, but I don't think that is enough to make one look as good as I feel. There's certainly an interrelation, for both men and women, between how they look and how they feel. Over the last months, my life has changed, very much for the better, I feel. Now I think I'm going to enjoy my life and do some uncommercial things—uncom-

mercial writing, for instance—when I feel like it. It makes me extremely happy, and I also think I'm doing something valuable.

Q. What would make you feel extra happy now, or what would be a big luxury for you?
A. If I could write a really good book.

Q. And what would a fabulous evening for you be now? Would it be what it's always been?
A. To be with my daughter LouLou or my son Alexis! I used to be numb and absent, in some odd ways. Now I'm very wide awake, and so I'd rather spend an evening listening to intelligent people talk. I was always such a chatterbox. When I first started doing interviews for *Interview,* I realized that every time anybody interesting would start to say something, I'd put my two cents in and ruin everything. I've learned that I should shut up a bit more—not completely, because I can make my jokes and get my laughs—and I'm having a very good time listening to people. I have much more to think about now when I go home.

Q. Do you take holidays?
A. I like to see what happens naturally without having to go through elaborate preparations. There seems to be so much to discover right on the spot, at the moment.

Q. Do you prefer the way you look in the day, or in the evening?
A. I think the evening is always fun for a woman because it's fantasy land. I'm nearly always in pants in the daytime, and though I've actually got very good legs, I'm not mad about skirts really—even at night.

Q. Do you think American women dress well and make up well?
A. Well, I suppose that the woman in the street, the female blue-collar worker, is not very well dressed in any country except China, where she has a uniform. The thing I find the least attractive about the way some American women dress is it's so cluttered—they're over-accessorized. They've been sold so many bills of goods that they have too many fancy eyeglass frames and overstyled handbags and too many bracelets and rings.

Q. I think they just read and go and buy everything that's advertised.
A. And they match things too much. But I guess I'm really talking of my mother's generation. The young really look fabulous. Their bodies are so great now. Thank God, the big-tits syndrome is over in America. I love very simple things. Who needs flowered luggage? And I simply can't stand men in patchwork pants—who wants to look like a bed-cover?

Q. I think women do the same thing in all those printed pajama pants suits.
A. Oh, there's a lot of things . . . I think Mrs. Ford would look terrific if she'd just flatten her hair, modernize it.

Q. I think the hair styles are the worst; that's why I love your hair.
A. I can't stand my hair unless I can take pleasure in touching it, because otherwise how can I expect anyone else to stroke my head?

Q. Do you think life is easier if you've done your best to look attractive?
A. Sure—one is several jumps ahead.

Maxime is a decadent English/Irish beauty who is a very hard worker—an author, a designer, an accomplished cook and the mother of LouLou and Alexis de la Falaise. Maxime is a great dame.

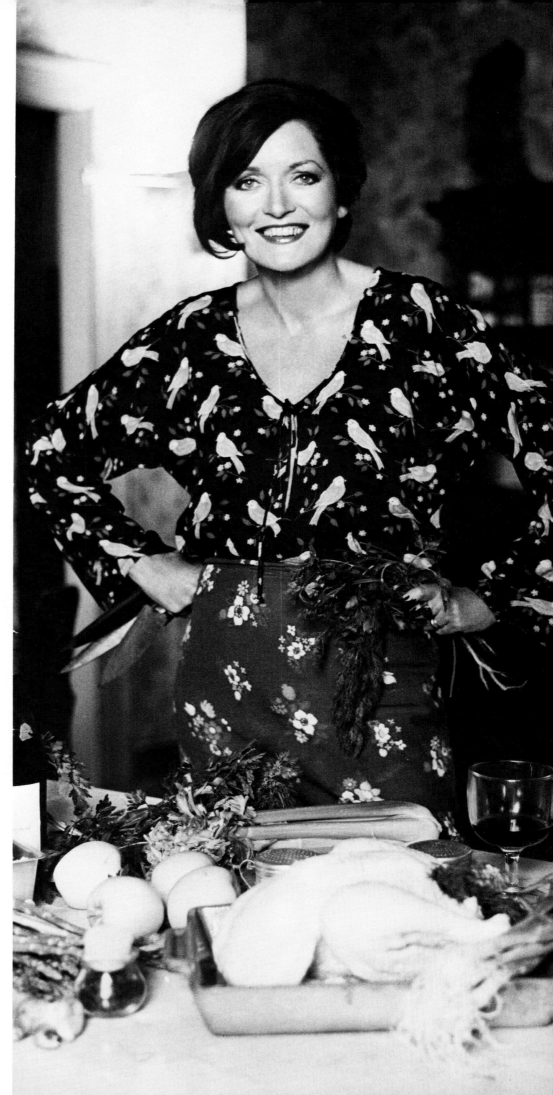

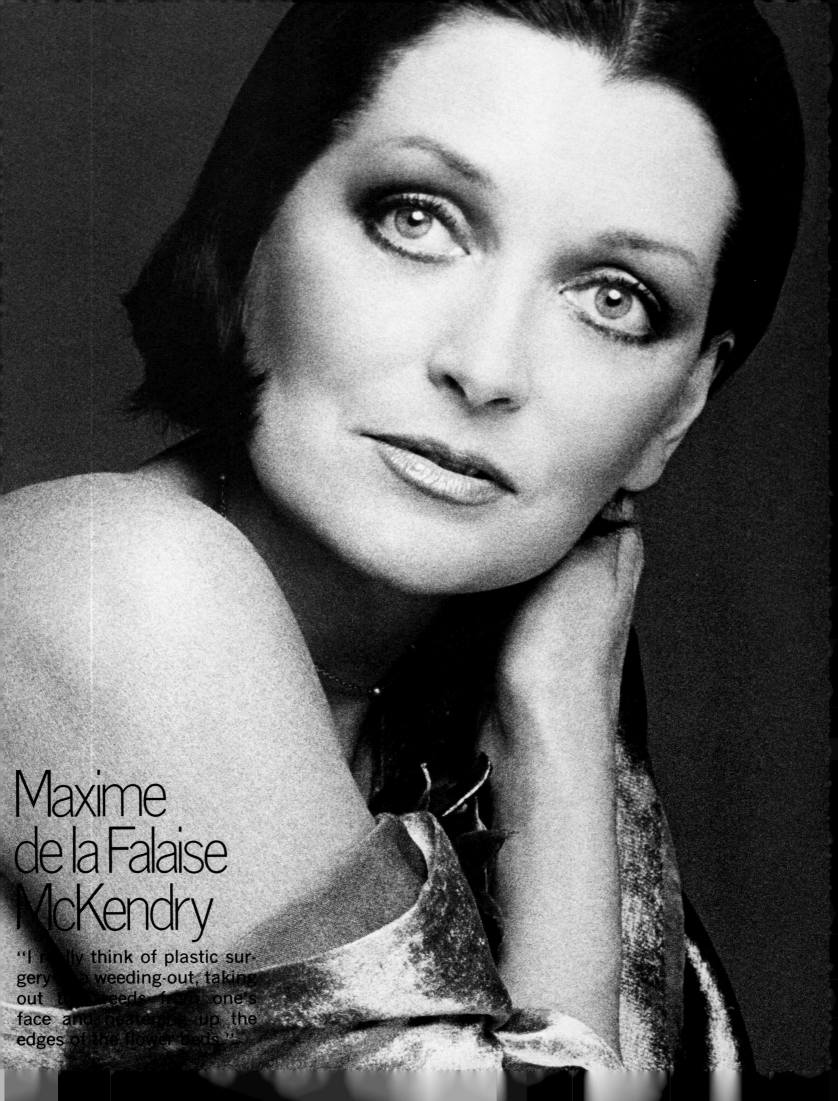

Maxime
de la Falaise
McKendry

"I really think of plastic surgery as a weeding-out, taking out the weeds from one's face and neatening up the edges of the flower beds."

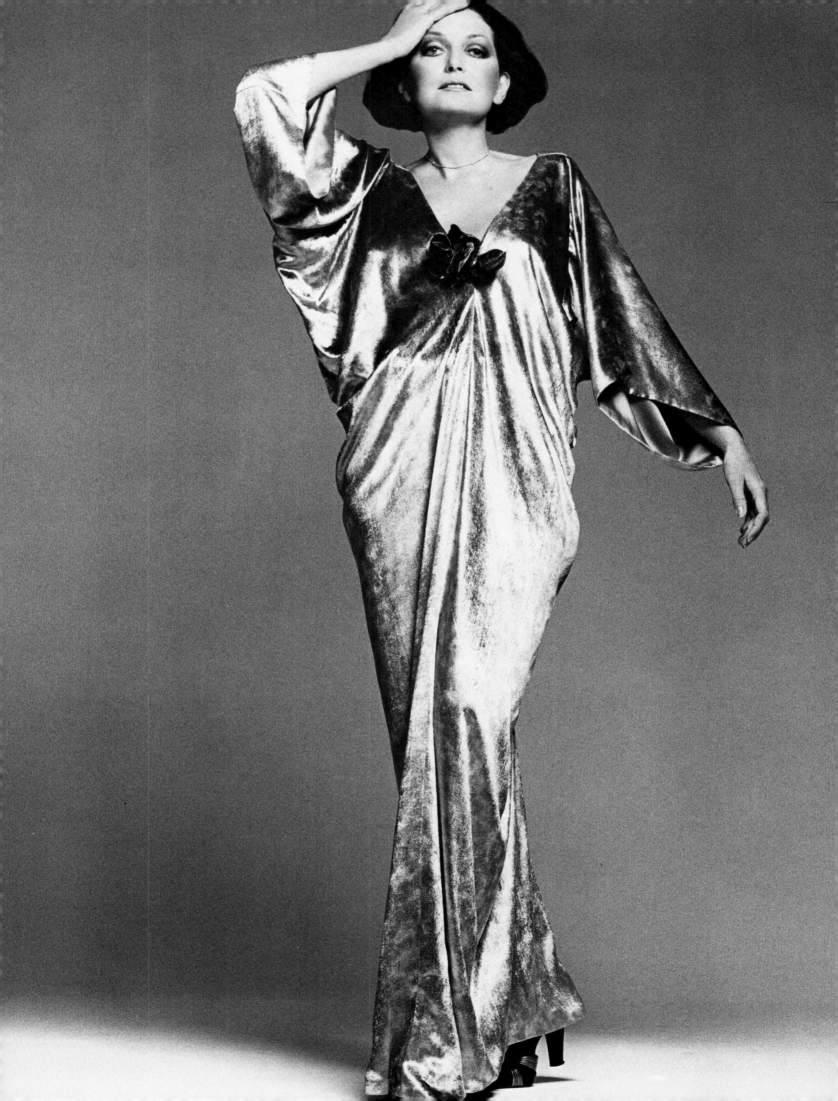

Be modern with new, easy hair

Dina Merrill

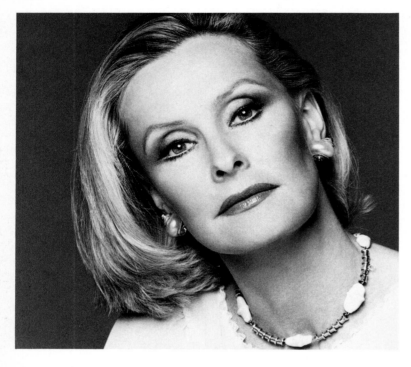

"American women, on the whole, are the *best*-looking women in the world."

Scavullo: What do you think beauty is?
Ms. Merrill: It's the inner person, really, as much as anything else. It's what you are and how you look at life. You can sometimes see people who are very beautiful physically who are so terribly shy that you feel you can't approach them.

Q. Do you spend a lot of time taking care of your skin?
A. No, I believe in three fast steps: 1) cleansing; 2) moisturizing; and 3) protection from the sun.

Q. What kinds of foods do you eat?
A. Well, I don't diet, but I'm a bug on nutrition.

Q. Do you exercise?
A. I play tennis, golf, I ski and I swim.

Q. How do you feel about make-up?
A. I think the older I get the less foundation I use. You need color, but you don't want thickness. When I was in the make-up business, older ladies would come around and say, "Well, I'm trying to cover this up," and I said, "You've got the wrong approach." It just sits in whatever laugh lines you have and adds age to

you. Really, the thinnest possible color you can get that has a lot of moisturizer in it is best, and then a little face powder.

Q. How do you apply it?
A. I kind of pat it on; I don't like it very heavy. Then I dust it off with a Kleenex.

Q. What catches your attention first when you look at someone you consider beautiful?
A. Eyes are always the first thing you look at in a person.

Q. What would you consider your best feature? Your worst feature?
A. I suppose my profile is best. I work on my eyes a lot because they're small.

Q. Since you're blond, do you wear blue eyeshadow?
A. Not too often. I use sort of smoky purply, gray-brown kinds that look more like shadow than color.

Q. What kinds of clothes makes you feel the most comfortable?
A. Easy clothes, not too structured—something that I wear and that doesn't wear me. I don't want people to say, "Gee, what a pretty dress." I want them to say, "Gosh, you look nice tonight."

Q. When you want to indulge yourself, what do you like to do?
A. Go out and play tennis, go to a play or a good movie.

Q. Are there any other things you really enjoy?
A. I love all kinds of foods. I love fruit partic-

ularly, and I love bean sprouts and I love salads and an occasional coconut ice cream; I love coconut on anything. I love mangos in season. And I adore papayas and something called a Star Apple that you get down in the Caribbean and the tropics. And I like Kiwi fruit.

Q. Do you wear perfume?
A. I like Calandre, Chanel 19, Chloe and Calèche.

Q. Have your looks and ideas about beauty changed over the years?
A. Everything changes a wee bit, but the main thrust is the same—not to be overdone and to let the whole speak as one voice.

Q. What do you think is your best look?
A. I'm a morning person, so I always feel more energetic in the mornings than I do at night. And yet I love to get all dressed up at night and go out every now and then—not for a steady diet, but I get a big charge out of getting all done up in a nice evening dress. I love chiffon things—I think they're soft and clingy and beautiful and feminine and just gorgeous.

Q. Are there any pointers you can give to others that might help them evaluate and analyze their looks.
A. A three-way mirror is an awfully good idea. Then you see yourself as others see you, not as you looking at yourself straight on.

Q. Do you look attractive for men, other women, yourself or because it's part of your career?
A. Sort of everything, the whole works.

Q. Do you like jewelry?
A. Not too much. Right now I think fabulous fakes are marvelous. I also love a lot of Elsa Peretti's ivory and silver things.

Q. Do you think American women could stand a little improvement?
A. I think American women, on the whole, are the best-looking women in the world. I really do! I tell you, you go to Europe and you may see a few beauties, but in America you see a lot. I think Americans are marvelous.

Q. Who are some of the women you consider beautiful or who you admire?
A. Babe Paley is gorgeous; she's divine looking. Jacqueline Bisset has lovely looks.

Q. How do you like your new haircut?
A. I'm just thrilled because I look at kids with this kind of hair, and I never thought I could do that, never. It's a whole new thing, it's just marvelous. My husband is going to take one look when I come home and say, "Who are you?" But I think he's going to like it. He's been wanting me to cut my hair.

In my eyes, Dina Merrill has always been the quintessential American Beauty. She has this wonderful vitality and drive that she's put into her career.

We got her to cut her hair, to change it from that set style that she had. Now I think it looks great because she can just shake it around. When I asked her why she had been wearing her hair so stiff and set she said, "Sometimes you get into something and you can't get out of it."

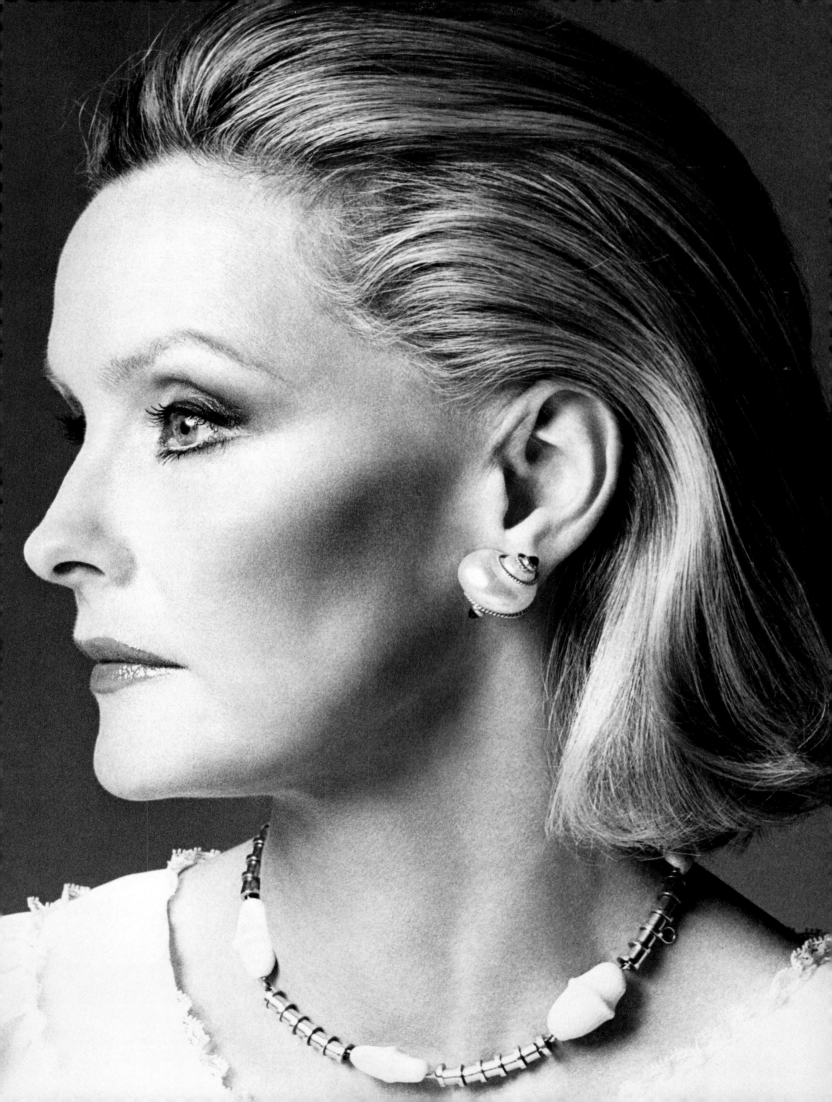

A radiant look starts with a smile

Bette Midler

Scavullo: What do you think beauty is?
Ms. Midler: It's radiance. It's energy that comes off your body and your face that forces people to look at you.

Q. Where does your enormous energy come from?
A. I concentrate.

Q. What catches your attention first when you look at somebody that you really consider beautiful?
A. All kinds of people catch my attention, but the way they carry themselves strikes me first. It's a certain air, a certain kind of self-confidence they radiate—it's heat and energy. This can be great camouflage, too—a person who carries herself elegantly and beautifully, as though she had all the charm and poise and money in the entire world, can fool you into thinking that she really is. The people I look at are the people who carry themselves as though they had the world by the balls.

Q. Do you take good care of your skin?
A. I go to Georgette Klinger, and I try to be careful about what I eat, and I'm very careful about getting the make-up off—that's the most important thing because I have to wear so much of it. I can't work without it, so I try not to wear it when I'm not working. I put on a little moisturizer and let my skin breathe. But it's not the make-up that makes my skin break out; it breaks out from certain kinds of food that I've learned to avoid. Chocolate is the absolute worst offender, and here I am almost ninety-two years old, and I'm still breaking out.

Q. Do you use soap on your face?
A. All the time.

Q. Do you take care of your hair?
A. I have someone to take care of my hair for me, someone who reminds me to have it trimmed or colored. I really don't fuss much. I tend to think about other things besides myself.

Q. What does your diet consist of?
A. Mostly protein—eggs, fish and meat. I work so hard and have so many things going on at once, and I mostly just forget to eat. That's what keeps the weight off.

Q. How would you describe your own looks?
A. I don't really fuss about them too much. There are too many things to learn and too many things to see in life, and spending too much time on yourself tends to drive you a little mad. But anyway, when I'm out and around and not working, I wouldn't say that I was particularly beautiful. I would say that I was sexy, that I have a lot of sexual magnetism, but I wouldn't say that I was pretty. I'm always sexual because that's the kind of human being I am. All my signs are fire signs, so it can't be hidden. But when I work, I go out of my way to make myself exceedingly presentable. It's like wearing your heart on your sleeve, only it's wearing your heart on your face. I wear my heart on my face.

Q. What do you consider your best and worst features?
A. My smile is definitely my best feature. It's a great, ear-to-ear smile, and my teeth are great, so I love to smile. And when I smile, my eyes wrinkle up and you can't see them, so it's almost like a clown face. It's really important for my work that I can transmit a certain kind of happiness that I feel, that I can translate the bubbles inside myself out through that smile. And this amazing nose of mine is my worst feature. My smile is so overpowering that most people don't notice the nose, but it's rough. It has a bump at the top and one on the side, and its tends to go whichever way the wind blows.

Q. Do you exercise?
A. I do my share. First I exercise my mind with a few mental calisthenics. I try to read as much as I can. And I walk—that's my favorite thing.

Q. What kinds of clothes do you like best?
A. I love high heels! In fact, I love all shoes. I went barefoot most of my life, or wore the same pair of saddle shoes for four years, so I'm mad about shoes. And I have great feet and great arches, and I love showing off my feet. I have the greatest legs, which I never show, and I've got pleasant tits. I've found that I stand up straight when I'm wearing high heels. My chest is really big, and I'm built in such a way that I'm perfectly balanced when I'm wearing a pair of high heels.

Q. Do you like your clothes to be loose or tight?
A. They can't be too tight—tight clothes make your skin wrinkle and pucker, so you look like a bag of peanuts after you've gotten out of your clothes. I love Karl Lagerfeld's clothes the best because they're so beautiful—they feel so good next to the skin. They relax you and make you feel as though you are quite beautiful. They enhance your femininity; they make you feel very womanly. His clothes are almost virginal. They also have a certain amount of seductiveness to them because the fabrics are so soft.

Q. What colors do you look best in?
A. I think I look best in pale blue. My mother was always telling me I did, but I always thought blue was a horrendous color until just a few years ago when I noticed she was right. In my younger days, I went for very violent colors because I considered myself a very passionate person. I wanted everyone to know that, so I wore reds, hot pinks, turquoises and very bright greens. I still have those moments when I can't contain myself, and then I whip out something violent. But in the last few years, since I've had a certain amount of success, I tend to dress down. I find myself wearing a lot of brown, and a lot of beige, or gray, navy or black.

Q. How do you indulge yourself?
A. I like to go to Chloe and find a Karl Lagerfeld. And I love the sun—I live for it—and I love to sail.

Q. But don't you burn?
A. I put my zinc oxide on, my oils and grease. I used to freckle and burn, but now I tan. Since I've grown up, I tan. When I'm done working, I always go sit in the sun and snorkel and scuba dive. It's peaceful and exciting and a whole other world. I'm drawn to the sea, I always go back to it. And then I go to Karl Lagerfeld!

Q. What is your idea of a really fun evening in New York?
A. A great meal—Italian or French food. And four wonderful movies all in a row, and after that a wonderful conversation.

"The people I look at are the people who carry themselves as though they had the world by the balls."

Q. Do you like perfume?
A. I like Jiki and Madame Grès' Cabochard. But I only wear it when I think of it, which isn't too often.

Q. Do you think money makes you more beautiful?
A. I think poverty and a lack of imagination can keep you from looking good. Money gives you access to people who can instruct you if you have no imagination or drive or will to do it yourself. Many very rich people are not naturally endowed, but they somehow manage to get it together.

Q. Do you experiment with make-up?
A. Only when I have to go back to work. I spend a few hours in front of the mirror, checking it all out. I think I would probably be better off if I spent more time, but who cares?

Q. Are there any women you really admire?
A. Well, I give Jackie Kennedy a lot of credit . . . for all kinds of things. For surviving when a weaker soul would have thrown in the towel. But I think any number of women are the greatest. Diana Vreeland is an extremely interesting woman. I don't know her at all, but I just love to read what's printed about her. And Magda Lupescu, who was King Carol's mistress. And so many women who had such bizarre, wonderful lives. I'm fascinated by Collette. Gertrude Stein. I tend to read women's biographies; how did they do it?

Q. I've read that you're not going to let your emotions get the better of you . . .
A. I like to work really emotionally, I like to pour it all out. But it doesn't pay in private life.

Q. Have your looks and ideas about beauty changed over the years?
A. I feel pretty much the same way I did when I was younger. It's self-confidence. Sometimes it's money that gives it to you, sometimes it's a

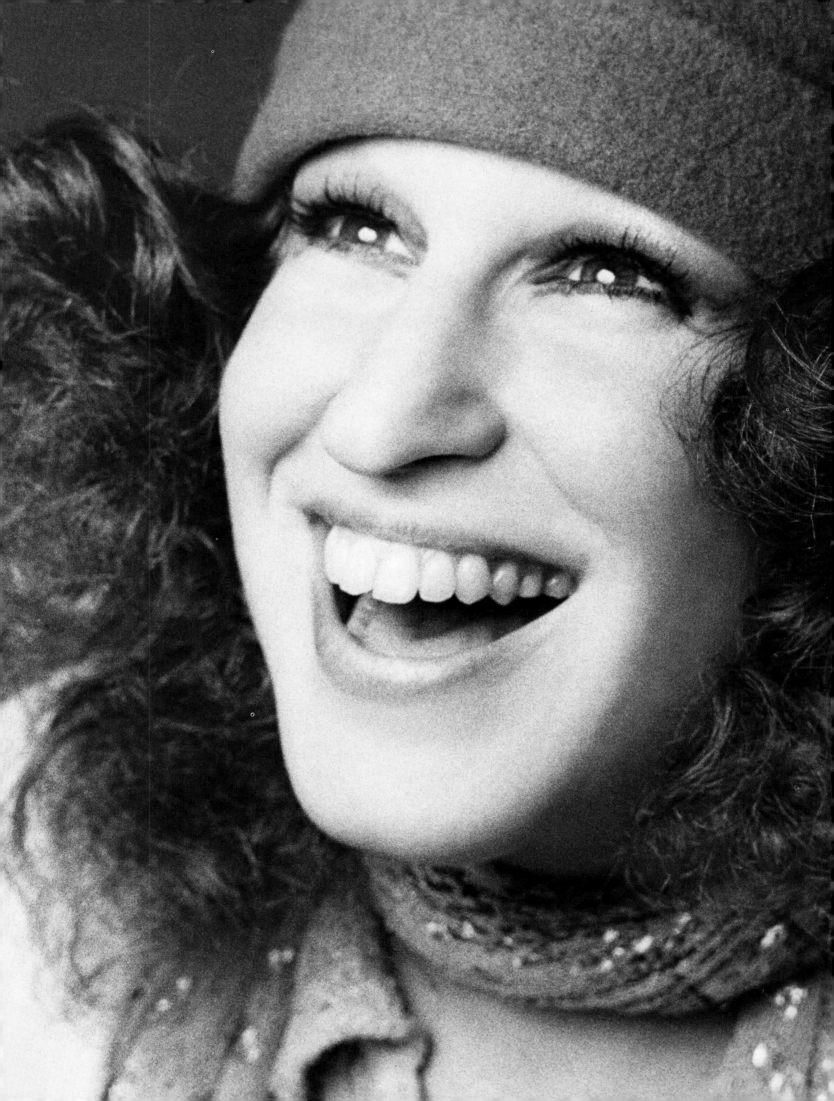

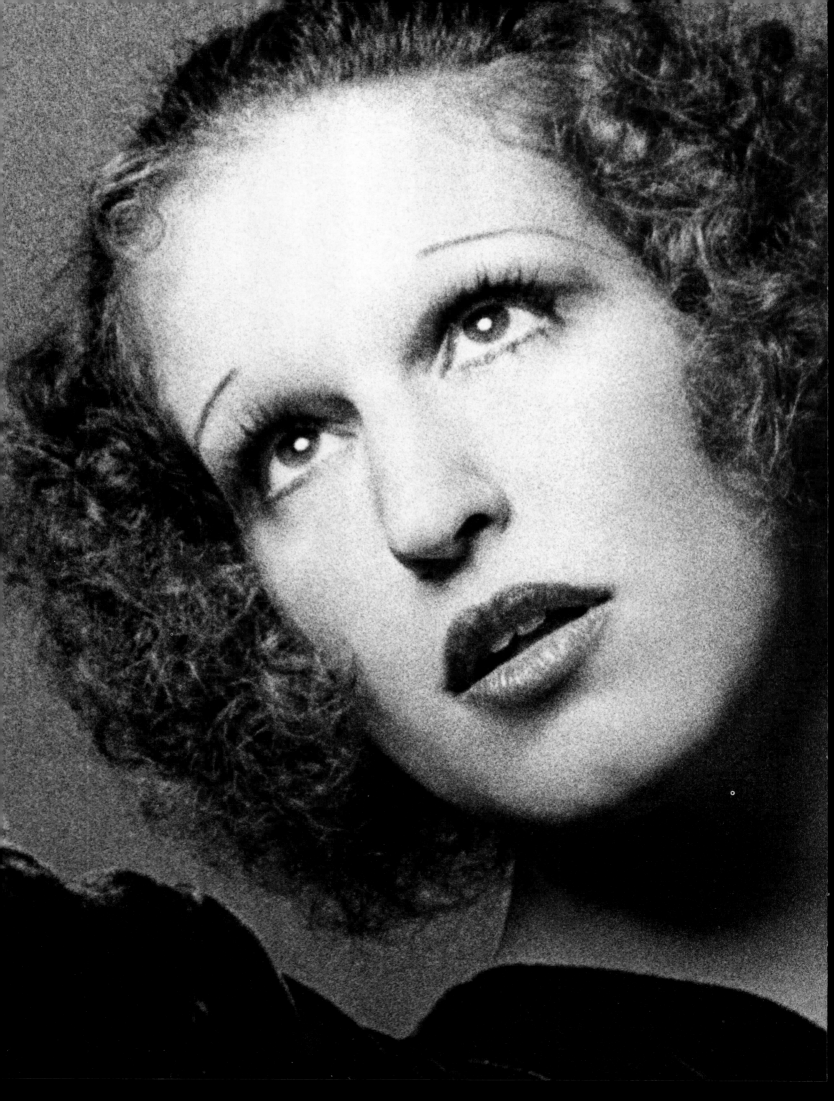

dress, sometimes it's a certain pair of underpants.

Q. What do you think is your best look?

A. I look like death in the morning. I'm one of the all-time terrible waker-uppers. But I always look my best when I'm going out with someone I absolutely adore. I make every effort in the world, and I always wind up looking smashing, and that's because I'm really making a genuine effort. Most of the time I make no effort except when it comes down to the wire, but I go all out when it's someone I love.

Q. Do you try to look attractive for men, other women, yourself or because it's part of your career?

A. I don't like to look attractive for other women. I look attractive because of my business and for men. I love the idea of men—I

"Sometimes it's money that gives you self-confidence, sometimes it's a dress, and sometimes it's a certain pair of underpants."

don't love men—men are rough, men are hard to deal with. I know they say the same things about women; it's written everywhere. But I like the idea of what they are. I like the idea of honor and all the good mythical things about men. That's the idea I'm in love with. And I keep looking for it, unfortunately . . .

Q. Do you have any pointers that would help other women evaluate their looks?

A. Well, I don't have to go to the mirror to know that I'm overweight or that my skin is clogged. I can feel it inside because I'm tuned to my body. I can feel when my blood is going, and when it's not. But I guess I'd say, "If you have it, make the best of it, and if you haven't got it, don't worry, because that will make you look worse."

Q. Do you think life is easier if you've done your best to look attractive?

A. If you look attractive, you generally feel confident, and that generally gives you the upper hand in dealing with everyday situations. But I don't like that feeling of competitiveness with other women as far as looks go— it's emotionally draining. And I don't like to feel that I have to roll out of bed and spend an hour or two getting myself ready to face the world.

Q. Do you think American women could stand a little improvement?

A. Their biggest problems are laziness and double-knit polyester.

Q. If you wanted to improve yourself, what would be the first step?

A. I pick and pull at my face the same way everyone else does. I'm always taking an imaginary tuck here and swinging my nose around and saying, "What would I look like if I had this lift or that tuck?" I think most women do the same thing—out of boredom or idleness. But I'm a pretty practical lady.

Q. How do you feel about growing old?

A. I think I'm going to enjoy it. So far, so good.

Energy is beauty: To photograph Bette, it's essential to tune in on her high electric current. High voltage. She has this untameable energy. It shows in her face, her body, her every movement.

Change your looks to suit your mood

Caterine Milinaire

Scavullo: Why did you want to do your own make-up?

Ms. Milinaire: All I do is my eyes; otherwise I look like a Russian rabbit. Make-up gives me an allergy. It's terrible because I just break out in blotches, and foundation and powder dry my skin out and it hurts. When I see myself made up by somebody else I look like a transvestite. I think it's interesting when make-up can transform you. I just mind when it attacks my skin. I think it's incredible that people have the idea that a lot of make-up looks good when it doesn't. There's nothing nicer than clear skin as it is. I'm much more interested in the lines, in the movements, and the freckles. Many people feel a little bit different when they put all that gook on. But when it gets to a hysterical point I think it becomes very sad. It's like putting your wrists in handcuffs.

"Following your own intuition and not getting computerized is really important."

Q. Whom do you admire?

A. Oh, I should think a thousand people and nobody. It's somebody down the street who has a particularly graceful walk . . . it's a clear eye. It's indefinable. Mostly it has to do with clear eyes. I always seem to look at people's eyes and hands; the way they sit. I don't really care if someone is scrubbed or not—I don't think that's even interesting if somone has something going on in the eyes, something that speaks to you. I don't care what size or shape people are as long as their eyes are full of life. I could photograph anybody as long as they've got life in their eyes and a certain mobility—

when someone sits down, for example, and it's just not a plunk. A certain grace . . . Yesterday I photographed a girl called Carol Marie Strizak. She's a dancer with the New York City Ballet, and she's got exactly that. Another is Carol Kane, and there's a woman, Nicole Maxwell, who's an anthropologist, seventy years old and extraordinarily alive. Nothing will deter her. She goes through everything with great charm, humor and agreement. The same goes for Diana Vreeland. I always thought I would die by the time I was thirty-four, thirty-five. Now I don't think so because I see people like Vreeland and Nicole Maxwell, and to me they are women who have just followed their own intuition. Following your own intuition and not getting computerized is really, really, so important.

Q. What does it take to make you look and feel good.

A. It changes every day. I'm primarily very chamelionlike. One day I'll be very cold and black, and another day full of flowers and curls. It's very much the inspiration of the day rather than the system itself. I do whatever it is to feel comfortable. It's very important to walk a great deal. It spends your energy but it gives you a lot of energy.

Q. What about being a mother?

A. Having Serafine keeps me very much in balance. I have spurts of partying where I'll stay up until five o'clock in the morning, but then I make sure I sleep a lot after that. I don't like to leave Seraphine, so that means I stay home and work. She really is my best companion.

Caterine is photographed with her daughter Seraphine because she feels her daughter is the most important thing about her. Caterine is a very natural, unaffected beauty whose time is taken up by her work, not herself.

Caterine is very bony and angular. Her skin is beautiful—her eyes were lined, and little color was put on her mouth. She's anti-make-up and ordinarily wears nothing.

Caterine is always looking for something different, unusual, and preferably inexpensive to wear. It's not a matter of money, it's just a matter of style, and she has her own.

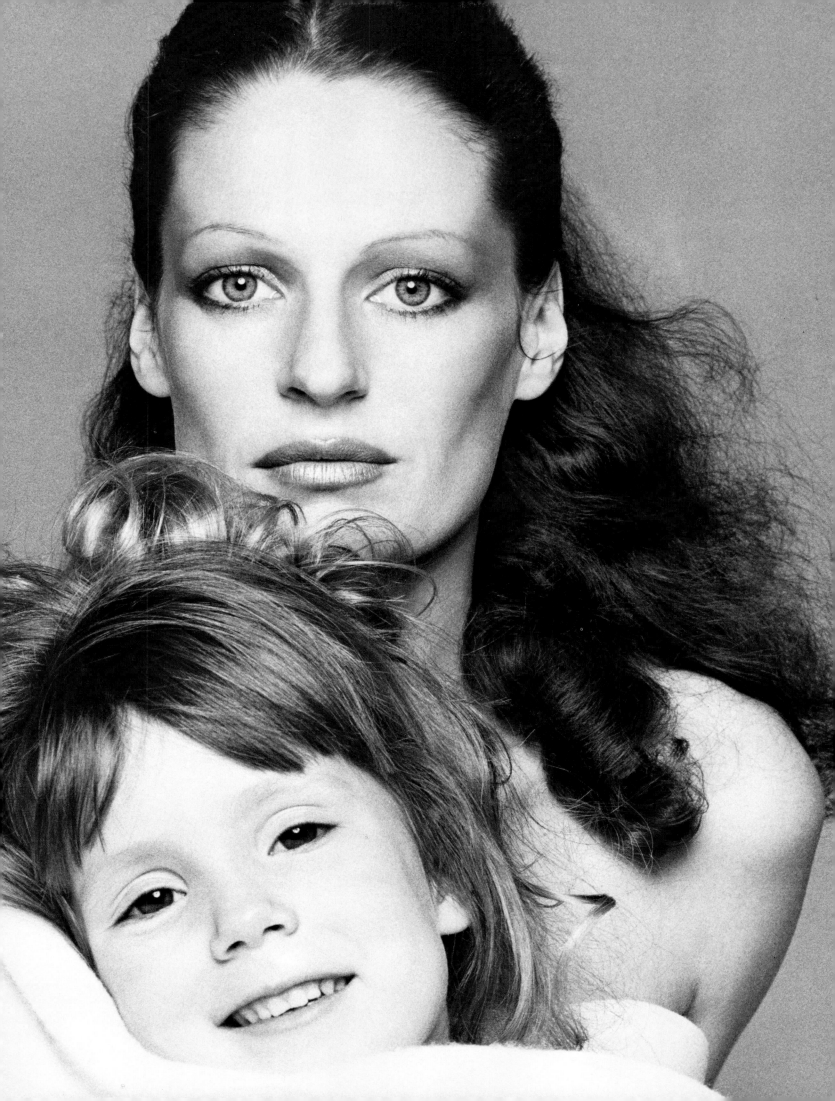

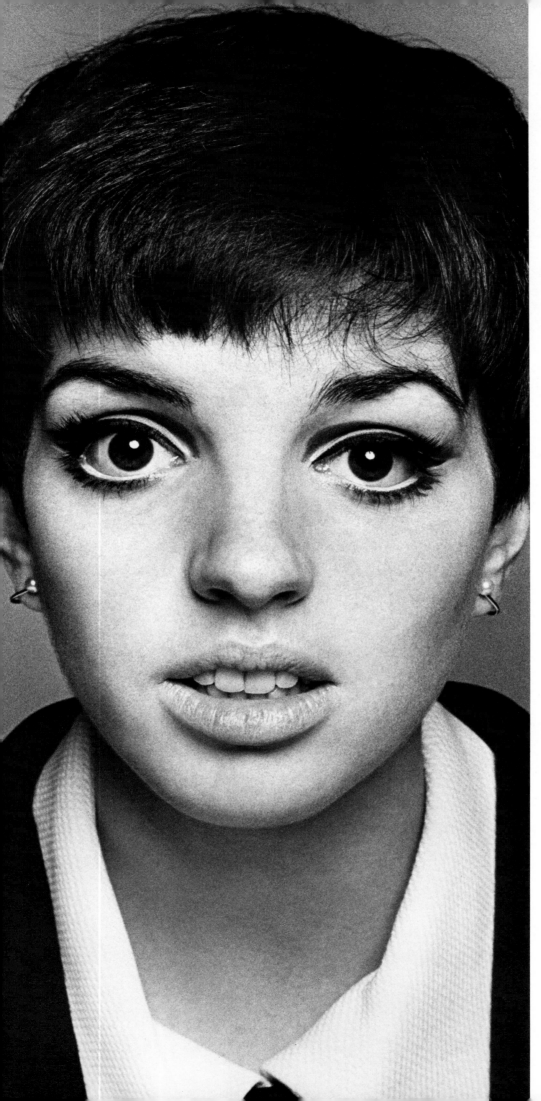

Beauty from energy
Liza Minnelli

Scavullo: What is your approach to beauty?
Ms. Minnelli: Energy.

Q. What do you think beauty is?
A. It can be anything. Good looks, mainly, an inner glow of some kind . . . and being photographed right.

Q. How do you take care of your skin?
A. I clean it very carefully when I take off my make-up. Different people do it different ways, and whatever works for an individual is what she should do, but I use soap and water. I use Dr. Lazlo, then I put on some kind of night cream, and then I go to bed.

Q. What about daytime?
A. If I don't have to, I don't wear a stitch of make-up. I just put a little moisturizer on my skin.

Q. What about your hair?
A. My hair is for convenience, and it just happened to work out terrifically for me. I cut it because it was driving me crazy—having long hair and dancing and trying to keep it in place. Now I wash it in the morning, and then if I'm going out at night, I'll freshen it up and blow it with a hand dryer.

Q. Do you have any kind of beauty routine?
A. No, I don't have time. I just wash my face and my hair and stay clean. Being rested and being natural are the ingredients for looking your best.

Q. What does your diet consist of?
A. A lot of high-protein foods. I stay away from sweets and things, although a Coca-Cola once in a while ain't bad. I like savory foods.

Q. Do you diet?
A. Oh, yes, and I fast quite often. I think the best fast is to drink carrot juice and nothing else.

Q. What kinds of clothes do you feel most comfortable in?
A. Black turtlenecks and black pants. That's my uniform when I'm not working.

Q. What colors look best on you?
A. I like stark colors—black, white, bright red.

Q. How do you like your clothes to fit?
A. I like them to move a half-second after I move.

Q. Are there women you really admire?
A. Marisa Berenson, because she's such a nice person, on top of being absolutely stunning looking. She's got great style and taste and dignity and all the good things. And Chita Rivera has a beauty that comes out of being

purely open and clear. She has fantastic bone structure and a beautiful body. Gosh, I have so many girl friends and people that I admire, it's hard to think. Diana Vreeland is one of the great minds of the century. She's interested in everything. Kay Thompson is sheer energy. I think she is the most beautiful woman I have ever known, but with both Diana and Kay, you feel their allure before they've said anything. By their mere presence they show the essence of women—mystery.

Q. What catches your attention first when you look at someone you think is beautiful?
A. I think I always look at their eyes first.

Q. Can you describe your own looks?
A. I guess I've got big eyes. Sometimes I feel I'm almost a cartoon character.

Q. Do you have any pointers about how to evaluate your looks?
A. A lot of my look is in the way I do my make-up. There're a lot of men who say, "I don't like my wife to wear make-up." That's because they're not putting it on properly and it's too visible. I sometimes do outrageous things with Christina Smith's eyelashes, but in general, a man shouldn't notice that you have make-up on. To learn how to do that, you've got to go to a class, or at least learn about your own facial structure. Just look in the mirror and think, "Mmmmm, what'll I do?" and then go out and do it.

"My looks? Big eyes. Sometimes I feel I'm almost a cartoon character."

Q. How do you indulge yourself after you've been working hard?
A. Sit and watch television.

Q. What are some of your greatest likes?
A. I like Rive Gauche—I always wear the body spray. I put it on right after I get out of the shower; it stays on better. I like to do everything in the shower—I brush my teeth, wash my hair, wash my face. And then I spray on perfume, dry myself, get in my clothes and go.

Q. Do you think American women could stand a little improvement?
A. Oh, no! Stand on the corner of 57th Street and Fifth Avenue in New York, and you see some of the greatest-looking people in the world walk by.

Q. Have your looks and ideas about beauty changed?
A. Oh, sure. You see something new and you think, "My god, that's great looking! Why didn't that ever happen before?" I love the way Margaux Hemingway looks, and I think that wouldn't have been fashionable five years ago. She's so earthy looking.

Q. If a person wants to improve herself, what's the first step she should take?
A. Health! And falling in love.

"In general, a man shouldn't notice that you have make-up on."

I've been photographing Liza since she was seventeen. Liza has a lot of charm and warmth, and a ton of energy.

I love her cropped-off hair and the emphasis she gives her eyes. Her choice in clothes of black, red and white is perfect for her.

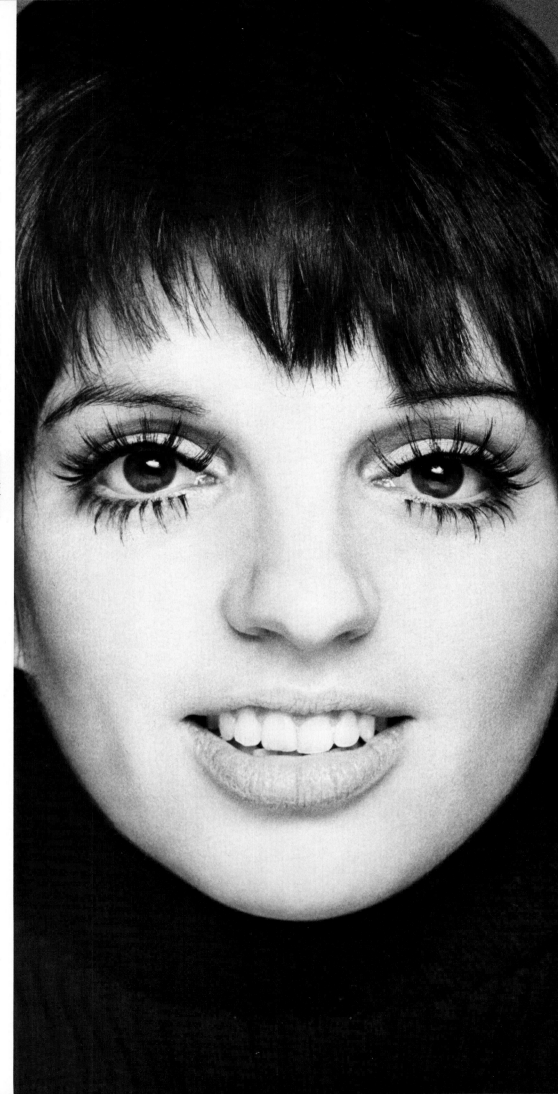

If your smile is your best feature, give it lots of color

Mary Tyler Moore

Scavullo: How do you take care of yourself?
Ms. Moore: I take ballet and occasionally wrap my thighs in Saran Wrap: it's like another skin, and I lose water from any of the spots that are wrapped. Tennis is becoming a way of life for me.

Q. Do you diet?
A. If I become overweight, I go on a protein diet, eating eggs, cottage cheese, meat and fish, raw or cooked vegetables. My breakfast is a half grapefruit, a poached egg and a slice of bacon. Lunch—a mixed salad of cottage cheese, tuna fish, chopped raw carrots, and green pepper. For dinner I have a steak, two cooked vegetables without salt or butter, and a salad with vinegar and lemon dressing.

Q. Do you have a food indulgence?
A. What I adore—but only when I'm not on a diet—are health-food sandwiches. Mainly, though, I'm a big salad eater. And I love cookies—I shouldn't, but sometimes I cheat a little.

Q. How do you take care of your skin.
A. Basically, I'm a soap, water and moisturizer girl. I use a night cream at night and a moisturizing foundation for day. When I'm in the sun I use a suntan oil. Except for Lip Saver on my lips, I don't bother with a sun block, though I probably should. If the facts were otherwise, I would be in the sun all the time. It makes me feel well and look well, but the look is short-range and the damage long-term. I know I should also cover my hair with a hat in the sun, but I never do—I can't be restricted, even in the sun. My life is so very disciplined all the time that it's important for me to be unrestricted when I play.

Q. Do you use make-up?
A. I'm offhand and casual about make-up. It's mostly just eye make-up; I draw fine lashes, with an eye pencil, on the top and bottom of my eyes, and use brown mascara and a brown powder eye shadow.

Q. When do you feel your best?
A. I feel my best in the early morning . . . that's when I wear my favorite casual look—jeans with bright tops. Even when dressed casually, though, I always wear perfume. My favorite is Carven's Ma Griffe.

Q. What do you consider your best feature?
A. I have a love-hate relationship with one part of my body. I consider my smile my best feature and my mouth my worst feature. In both cases I neither play up nor play down this area. Rather than lipsticks I prefer to wear lip gloss.

Q. How do you indulge yourself after working very hard?
A. If I had to pick one favorite indulgence it would be the luxury of a massage every once in a while.

Q. What would you do if you wanted to improve yourself?
A. I have no real desire to change or modify the beauty regimen I now follow.

Q. Are there women you admire?
A. If I could name any one woman I admire for her own unique sense of herself and beauty I would mention Katharine Hepburn. She has shown us that true beauty comes from within and that a sense of well-being is the main key to looking well.

> **"I have a love-hate relationship with one part of my body. I consider my smile my best feature and my mouth my worst feature."**

Q. Are you your own best beauty expert?
A. Sometimes when preparing for a black-tie affair, I'll come home with an elegant, upswept hairdo . . . My husband will often say, "That's not you." But it *is* me—then. It suits a particular mood.

Q. Do you think life is easier if you've done your best to be attractive?
A. When a woman has done her best to be attractive, life may not be easier for her, but it's probably easier for those around her.

Mary Tyler Moore is vitality and the positive approach to life at it's best. She's all animation and humor, a successful woman who easily inspires people to do their best.

Since Mary Tyler Moore is so vital, her make-up goes with her healthy look. There are tricks you can use to the same end which involve actually massaging your face with the fingertips, lightly, to relax the face and bring blood to the surface to plump up the cells. For Miss Moore, who is happiest when she smiles, her mouth gets extra importance and color.

Mary Tyler Moore's sporty way of dressing is just right for her life and attitude. Healthy and free from restriction.

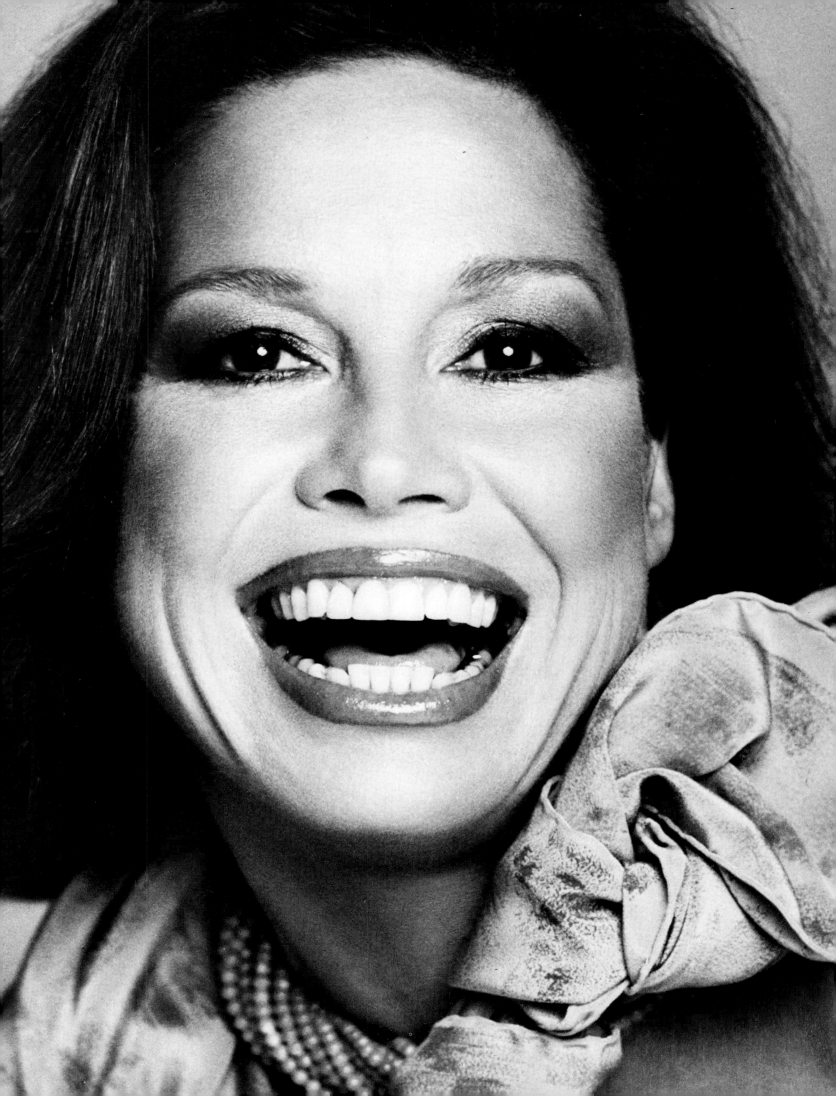

"I like straight blond hair and a natural look."

Way: Do you like shiny gold eye shadow?
Tatum: No.
Way: Mae West likes it; I don't know why you don't.
Tatum: Just think about it. Do you have a mirror so I can see the blush? I don't even know where to begin.
Way: Here's a medium-beige base.
Tatum: That's too dark.
Way: Here's a creamy beige. No-color beige.
Tatum: That's too yellowy. You have so many rouges. This might be a little dark.
Francesco: Where did you learn how to put on all this make-up?
Tatum: By myself. I love it.
Way: If you want to thin out the base you can spray some mineral water in it and mix it around.
Tatum: I've never tried that before.
Francesco: It's good to darken under your chin before a photograph.
Way: These are cover sticks. Do you want one?
Tatum: Do you have a lipstick? I've never worn so much make-up in my life. You should get me with a lot of make-up on and curly hair. I curled it myself the other day, and it looked nice. I bleached my hair, but I went to a barber and had it taken out.
Francesco: Way's going to give you cheekbones.
Tatum: I look like I'm dirty. It's too dark near my mouth. Katharine Hepburn has permanent cheekbones.
Way: Do you want me to take the color off your lips?
Tatum: Yes, I feel dirty with it on.
Francesco: Do you see how you get cheekbones?
Tatum: Yes. Will you outline my mouth?
Way: For eye make-up, open your mouth and don't blink.
Tatum: You're not going to take any pictures of me with my hair up in curlers are you?
Francesco: No, I'm not going to take any.
Tatum: Having your hair up in curlers is boring. Should I let my hair grow?
Harry: Yes, you've always had short hair.

A child with a style of her own

Tatum O'Neal

"I don't know if I'm that beautiful."

Scavullo: What things do you like?
Ms. O'Neal: Horseback riding . . . I love fried chicken, my dad and my family, old cars, the ocean, the beach, good bodies and pretty girls . . . I like riding on motorcycles, and my friends.
Q. Were you a beautiful baby?
A. Yes. My dad says yes.
Q. Why do you think I chose you to be in my book?
A. 'Cause you think I'm a star, I guess, and because you like me.
Q. Mostly because I like you. Do you think life is easier if you're beautiful?
A. Yes. But I don't know if I'm that beautiful.
Q. What do you use on your skin?
A. Basic H, it's an all-organic Shackley product I use for my face.
Q. What about perfumes?
A. I use all of them—Yves St. Laurent, Dior and an organic flowery one.
Q. What kind of look do you like?
A. Straight blond hair and a natural look.

Tatum is a lively, bright and talented girl. She knows how she looks in the camera, and told me to stand back so that her face wouldn't look too round. She wanted Katharine Hepburn cheekbones. So what do you do to a thirteen-year-old girl? She likes make-up, and Way gave her cheekbones. It's fun for her to play around with it.

Tatum dresses in bright, interesting clothes that are as special as she is. It's great how she dresses in little antique shirts with baggy, Yves St. Laurent jeans when she's out at night. She has very sophisticated taste for someone so young. She wears everything—suits, dresses and whatever catches her eye.

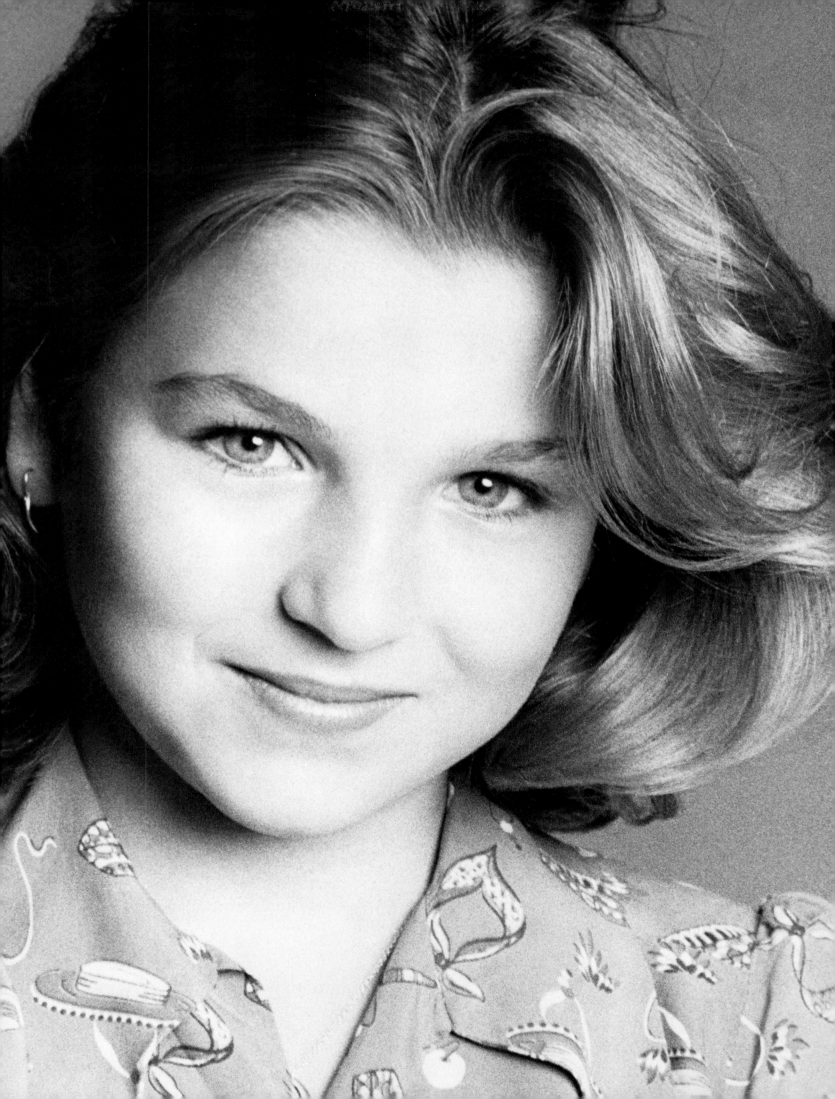

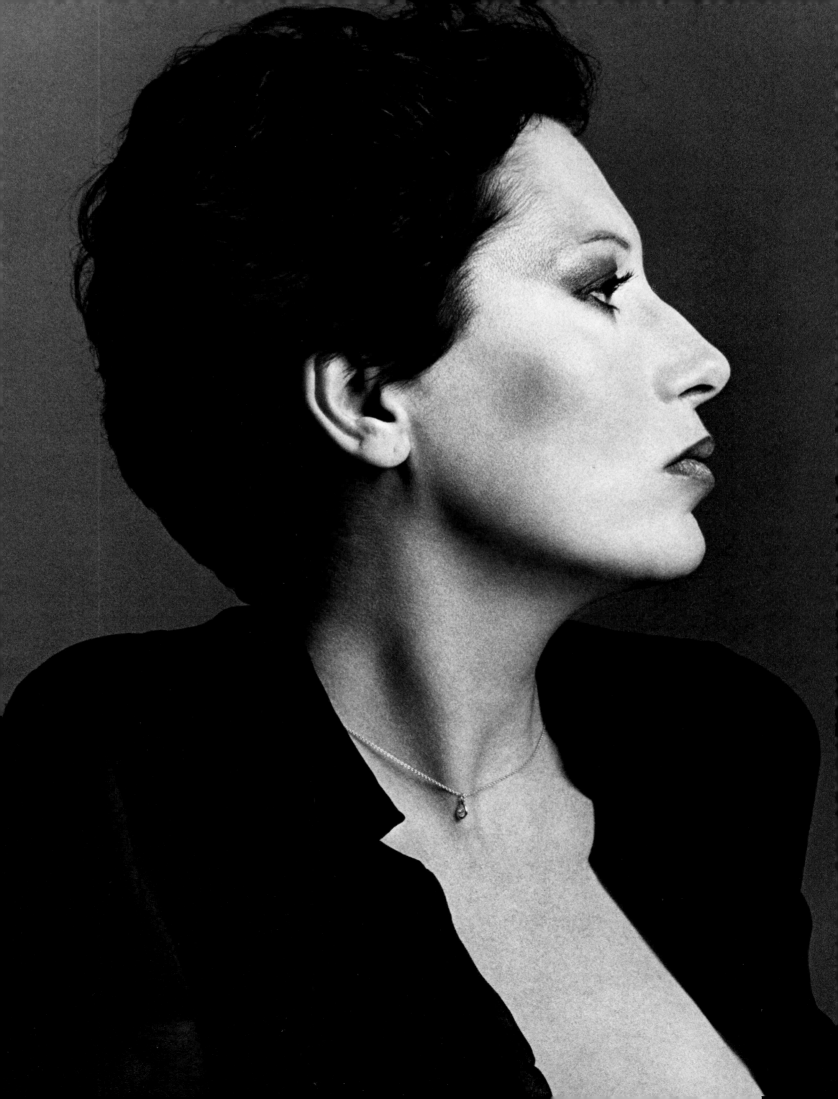

If your profile is strong and classic, consider wearing your hair quite short

Elsa Peretti

Scavullo: What makes you feel beautiful?
Ms. Peretti: Objectively speaking, I am not beautiful. I'm too tall and I have a tendency to look like a Chianti bottle if I don't watch my diet. Beauty is a state of mind. Feeling alive is what counts. A continuous effort to reach an inner balance makes me feel beautiful.
Q. Do you think energy is a part of beauty?
A. I think energy *is* beauty—a Ferrari with an empty tank doesn't run. With experience, energy is what makes the challenge amusing, and not dramatic, especially with one's self. For this reason, I find real beauty mostly in people after thirty—they're the ones who will swim, even knowing the water is cold. To be a good sport is one of my goals in life, and I need energy to do that.

"I keep my hair short because I live in New York and am in dirty, smoky places all the time."

Q. How do your friends describe your looks?
A. They say that I am a kind of stylish mess.
Q. How do you take care of yourself?
A. When I was a model, "beauty was my duty," and I actually did put on a face. Being scared of the camera, I felt totally insecure, but I met a few very good photographers and learned that beauty was not false eyelashes, but communication. To take care of myself now is to try to be healthy. When I am in New York, good food, vitamins and acupuncture are musts. In the country, I feel healthy without effort.
Q. When do you feel your best?
A. When I'm in love.

"I think vitality is part of beauty, because to be vital means to be curious."

Q. What makes you feel happy?
A. To have that energy. I try to absorb it from everything—nature, music, people, my work, other people's work. Being fulfilled is a kind of happiness and the only kind I really want.

"I think that if a woman takes care of herself in regard to food and vitamins, then she will be sure of her body and never try to clutter it up with things that are not useful."

"I'm back to taking great care to eat the right foods and to look after my body."

"I think every woman, when she's relaxed, has nice make-up on, clean hair, and a beautiful dress on, feels more or less secure."

Q. What about your work?
A. I love it and it comes naturally. The exciting things to me are the finding of new shapes for my jewelry, being with people—the craftsmen—whom I respect and trying to reach something with them that will last.

Q. When do you look your best?
A. When I feel good, and I realy begin to feel good when the sun goes down—I'm like a bat. I feel good at night in cities—New York especially, because of the sparkle of it, with a dress on that is part of my skin—one of my friend Halston's dresses, and with a little help from straight vodka. But there's another part of me that feels comfortable in a natural environment.
Q. Are you afraid of getting old?
A. Not if I remain curious.

Elsa Peretti designs jewelry. She's a woman of great style and taste. Her classic Roman profile is superb against her close-cropped hair. Everything she does, the way she dresses, takes care of herself, makes up, is right for her. She was the first to wear big tinted prescription glasses, and they look fabulous on her.

Elsa's make-up was primarily eye make-up—an Egyptian style with the color winging out toward the temples and very little else. She has thick, healthy Italian skin that's light colored and creamy textured. She has a wide important mouth naturally.

Elsa just washes her hair and shakes it dry.

Elsa dresses in black or white. Clothes never wear her. When she travels, she packs five easy pieces, that's it. Everything is simple.

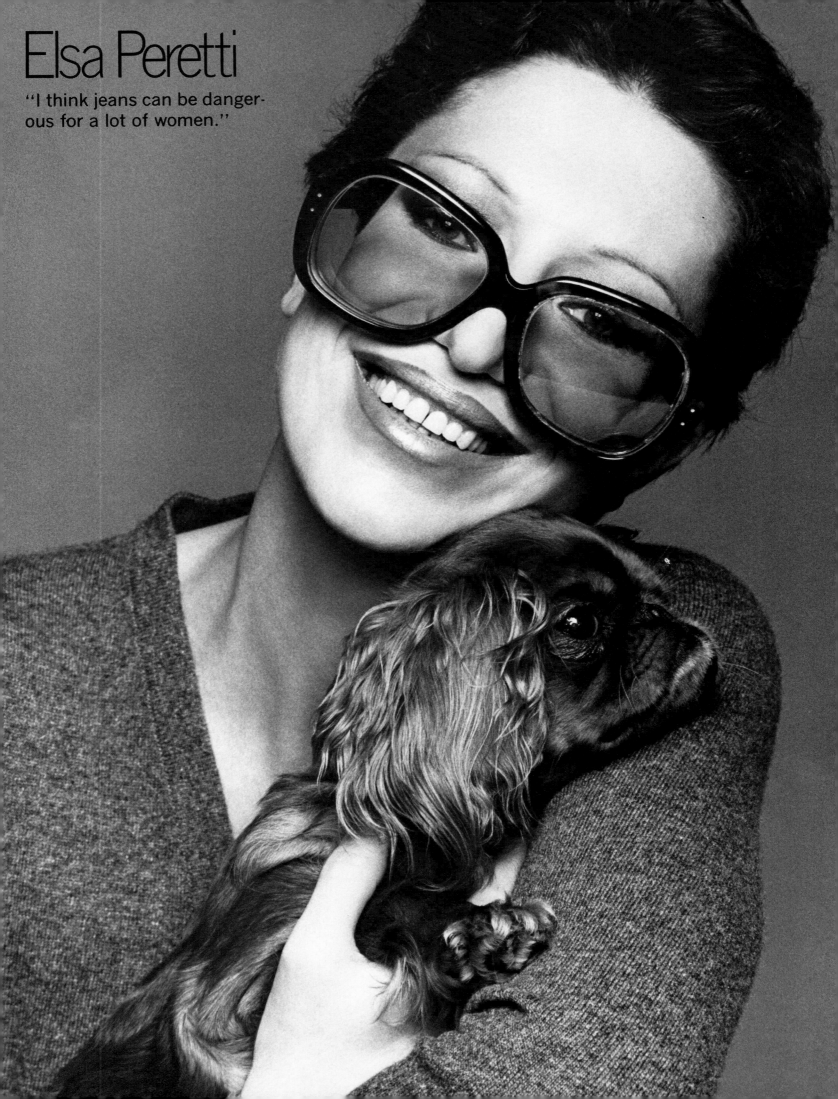

Elsa Peretti

"I think jeans can be danger-
ous for a lot of women."

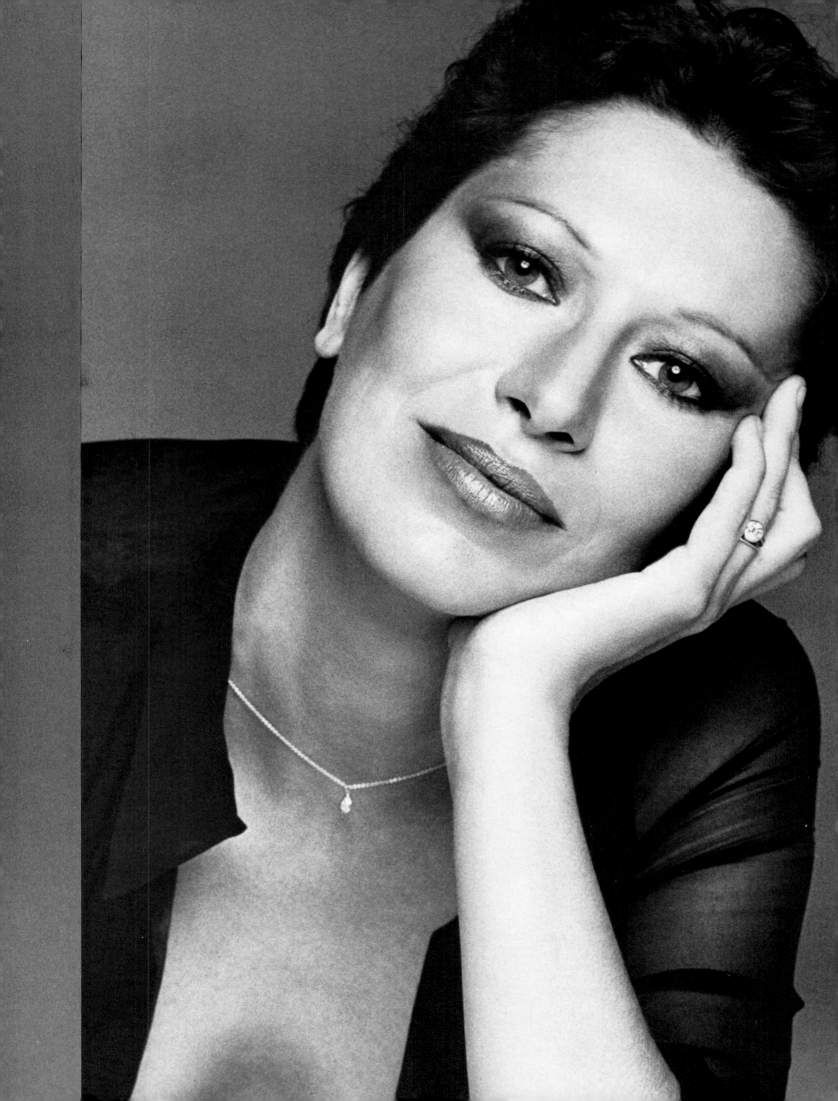

Maximize one feature to minimize another

Brigid Berlin Polk

Scavullo: What do you think beauty is?

Ms. Polk: The voice of Richard Burton is beauty!

Q. Do you spend much time taking care of yourself in terms of skin care, hair, diet, exercise, sports, make-up?

A. I've always had very good skin. It needs no special care. I just keep it very clean. I spray very cold Evian water on it, and I pat it with a hot cloth, then a cold one. During the winter I keep tons of moisturizer on my face day and night. When I'm home the humidifier is always on—that's the secret to good skin in winter. And I never sit in the sun.

Once in a while, I go to the Russian Baths on East 10th Street. (Wednesday is ladies' day.) It's the greatest place—there's a wonderful masseuse who massages you with oil, and then scrubs you very hard with a loofah and Ivory soap. Then she whacks you with dried seaweed and massages all the tense spots. I feel great when I leave.

My bath is a ritual, and for me it's the best way to relax. I light candles and I put all sorts of great-smelling stuff in the tub. I love the finest soaps, like Guerlain's Geranium. I always scrub hard with a loofah. I work on my heels, feet and elbows with a terrific stone called Weiss, a great European discovery for foot care. And shaving my legs and under my arms is an automatic habit that I do every day.

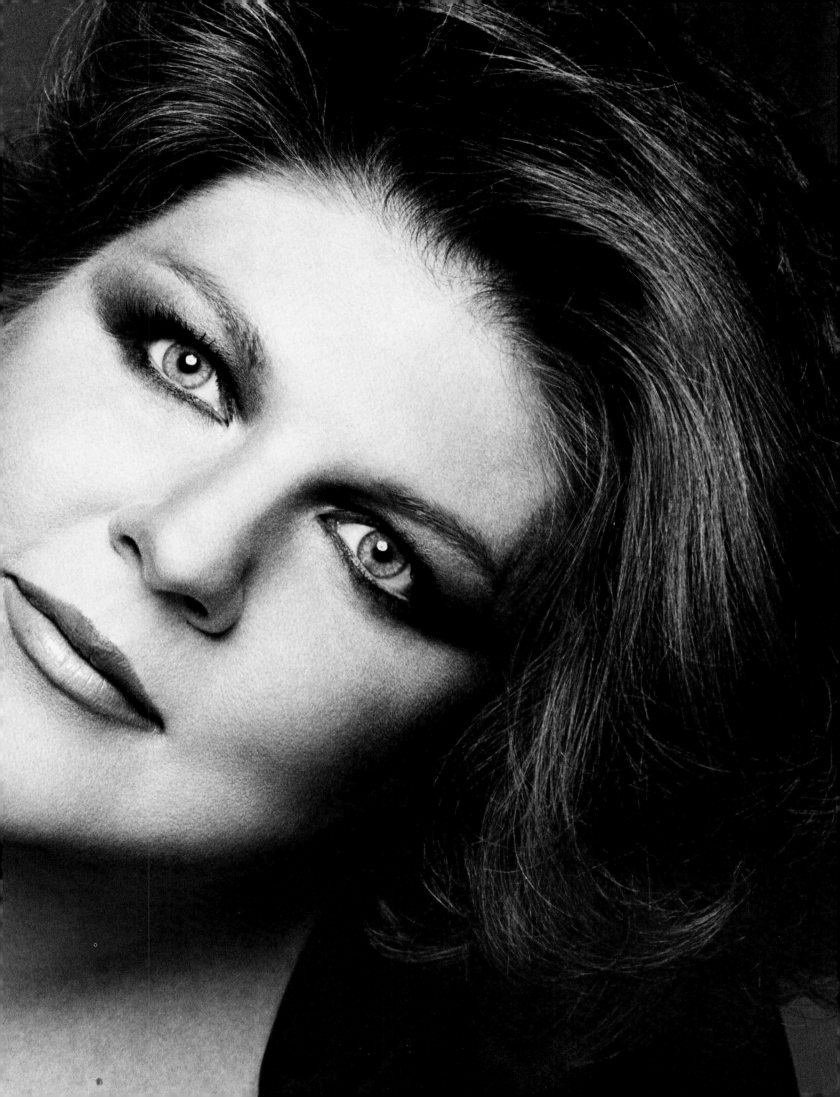

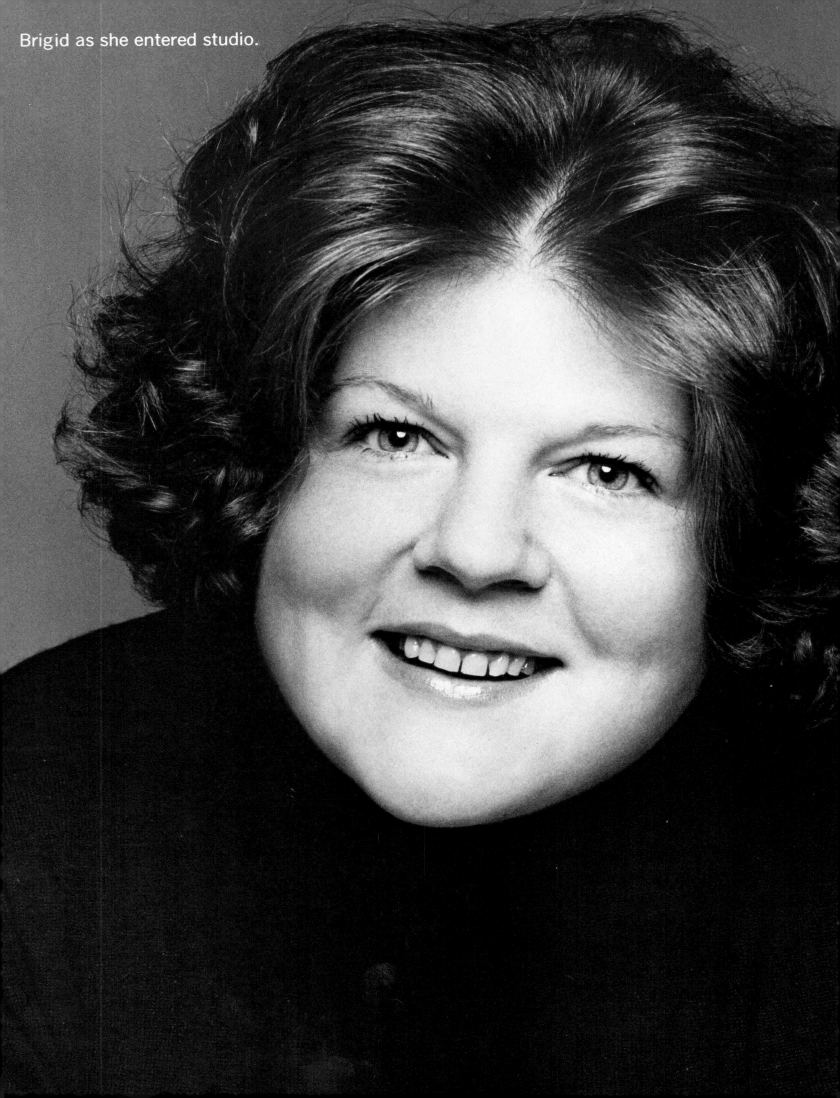
Brigid as she entered studio.

After all the scrubbing, I let the water out and then fill it up again. Then comes my so-called ritual bath. Sometimes I like to just loll for an hour with my neck resting on my bath pillow—I read, sip cold wine or a hot-buttered rum in winter. Something that really takes away all the tension and makes you feel sensational is to dump a half-gallon jar of Epso Pine in very hot water, and twenty minutes later you feel like you've had eight hours' sleep.

"I don't think I look good with make-up on. Make-up makes my face feel dirty."

My hair is a constant problem. Fine hair is no hair. I wash it every other day and change my shampoo all the time. Since my hair has no body, I have to set it. I use Carmen curlers every day. If my hair looks good, I look good. I don't think I can get away with straight hair. If I pull it back flat on top, it makes my face look a lot rounder, so I like my hair to be soft and curled. I lift it with a comb—it gives me a bit of height, and my face looks a little less round. In the summer, I need a body permanent; otherwise, my hair just droops. I trim it myself.

"My worst feature is everything below the neck."

I don't think I look good with make-up on—I use nothing but blush, lip gloss, and occasionally mascara. I like lipstick, but I never seem to be able to find the right shade. Make-up makes my face feel dirty, but I would never go without blush on my cheeks. (I put it on with a brush that's flattened out like a fly swatter.) I'm allergic to eye make-up remover; if I use it, my vision gets blurred.

I really don't exercise, but I run a lot catching cabs.

Q. How would you describe your looks?
A. Sometimes I think I look like three Vanessa Redgraves rolled into one. I've been told I have darting eyes and a pretty face.

Q. What catches your attention first when you look at someone you think is beautiful?
A. I often find myself remembering facial expressions. A face that expresses deep thought is very beautiful. Of course, I look at the eyes, but eyes are very strange. So many times we don't know the eyes we think we know. I can forget the color of a person's eyes and yet feel I know those eyes. My father has my favorite eyes.

"I really don't exercise, but I run a lot catching cabs."

enormous energy and her total command of the English language. She makes an ordinary word extraordinary. I think Clarice Rivers, the wife of painter Larry Rivers, is truly beautiful. She has the sexiest laugh I've ever heard. To be with her can only make one feel good, and I think her kind of beauty is quite rare. And Dina Merrill is the beauty that I always wanted to look like as a child.

Q. What do you consider your best feature? Your worst feature?
A. My best features are my eyes and my nose. My worst is everything below the neck. I need to lose a hundred pounds, and that's a big beauty problem I could change. My weight is my overall major problem.

"A face that expresses deep thought is very beautiful."

Q. What kinds of clothes are you most comfortable in?
A. September through May, I wear black pants, black or navy turtlenecks during the day and evening. In the summer, in the country, I wear pieces of material in bright colors, and prints that I just wrap like a towel and tie in knots. Or I wear long cotton dresses that don't have waistlines—things that are cool and free. I love to go barefoot in the summer.

Q. What does your diet consist of?
A. I eat all the wrong foods with all the right foods.

"Sometimes I think I look like three Vanessa Redgraves rolled into one."

Q. What makes you look best?
A. I look best on a clear cold day in raw sunlight. I love cold weather. I'm very happy when I have a lot of work to do. I don't seem to mind pressure; I rather like it. I get up early, and I don't stay up too late. I adore the theater, movies and reading—I'm a lover of nonfiction. Mondays are great because all the new magazines come out. I hate big parties. I like to be with only good friends, a few people. I'm happy when I'm in love, and I've had a ten-year love affair with the same man—it will probably last forever! I would call it the most modern marriage of the century.

"My bath is a ritual and the best way to relax. I light candles and put all sorts of great-smelling stuff in the tub."

"I admire my mother because she's been married happily to one man for thirty-eight years."

Q. Are there any women you admire, and why?
A. I think my mother is very good looking. I admire her because she's been married happily to one man for thirty-eight years. She's a woman of impeccable morality. I admire Diana Vreeland for her individuality, her

I think that Brigid is bright, beautiful and talented. She makes me feel happy.

Brigid had a lot of eye make-up put on. In a face such as hers it's important to select one feature and really emphasize it.

Since Brigid has a low forehead, she looks best with her hair out of her face and with some height to it.

Brigid is more concerned with things other than clothes. So she has a simple answer: "Blue and black are where it's at."

A daring life-style needs easy up-keep

Marquesa de Portago

Scavullo: I understand you're a big game hunter.

Ms. Portago: Yes, I started that in 1962. I said, "All right, the only thing worth hunting would be an elephant," not knowing what it would be like. The only thing I could visualize was beautiful ivory as a trophy. The guide thought I was absolutely mad. He said, "Nobody comes to Africa who has never shot a gun before." I chased those elephants for twelve days before I got anywhere near one . . . going twenty miles a day, and I loved it. It was the toughest thing, the greatest challenge I've ever met, and I absolutely adored it—the life, everything. And I really didn't stop hunting for eight years.

Q. What was being on safari like, how did you manage to cope?

A. Actually, I like the outdoors and the natural light very much. I love the city life, too, and if I'm in the city, then I make an effort. When you're in the wild, the main thing is to keep yourself clean as best you can. Often there's nothing but a stream, so I'd wash my hair in the stream and brush it back, and that was it. My hair was very short for most of the time I was hunting, so it was easier.

Q. Did the sun cause you any problems?

A. No. I love the sun. I'm a Southerner and I was born in a warm climate; in fact, I'm miserable without the sun. I've never paid any attention to the warnings. Many of my friends say, "How can you do that?" but if my skin gets dry I put a cream on it for two nights running and it's finished, no problem.

Q. Do you have a system?

A. I have used only basic soap for years and years. It's an unscented, super-fatty soap; it's one of the purest soaps ever made.

Q. Do you wear your hair short because it's easier to care for?

A. I had a personal theory that after the age of thirty-five one really is better with shorter hair—perhaps I felt that it would look better with my face. Since I passed that age a few years ago, I now feel that it doesn't matter. I couldn't imagine having seen my own mother with long hair at my age, but I think the world has changed so much, and age has so little meaning.

Q. You have found out how to put yourself together successfully; how should a woman do that?

A. I don't think there's any question about it—it takes time and it takes a very definite identity; otherwise women tend to be simply beautiful, and you can't get past that. When you see a very beautiful woman it's like a beautiful painting: one enjoys looking at it, but after a time more than looks have to come out of it.

Q. Do you encounter any beauty problems?

A. For as long as I can remember I accepted myself as an entity. I don't say, "That's just terrible, what can I do?" because basically I'm not sure there's that much one can do anyway. I do the best I can with what I have and let the rest go. The one thing with me that is necessary is a certain feeling of freedom. When I feel that I have to conform to other people and what they expect of me, rather than what I want to or am capable of doing myself, then I don't like it. I know I can go for periods of time when I look "all wrong," but then I will pull myself together. I knew when I walked into your studio I looked all wrong, but you sent me to Robert Renn, who gave me the right hair color and blew my hair dry, which I thought was only for younger women.

Q. What couldn't you live without?

A. A comb and a brush. How my hair looks is important. When I go to bed I wash my face with soap and water, and that's it, nothing else. I'm beginning to use moisturizer, certainly some light-colored lipstick and perhaps an eyebrow pencil—that would be quite adequate for me. And one thing I found very very handy in the bush was Wash'n Dri.

Q. What about your diet?

A. I've always been a very healthy eater. I need my fruit juice and vitamin C daily, and proteins and fresh vegetables. I'm aware of what I eat all the time. I don't smoke and I don't drink, but I do have a sweet tooth. When I am leading an inactive life I satisfy that mainly by eating a lot of ice cream. Beyond that, I'm not one who buys chocolate candy.

Q. When do you feel at your best?

A. I think I like the evening better. I enjoy making an effort to dress, and I still think that there is something creative about a woman who is well put together. And I'm not as inspired by daytime clothes as by evening fashions. However, if I'm outside doing sports and more in communication with the universe than with people, then I love the daytime. I'm dressing for people on one occasion and my life-style and nature on the other.

Q. How do you indulge yourself?

A. I've never been one for massages, but I love a hot bath—I find that very luxurious. I have a Vitabath every day when I'm in the city.

Q. Any other luxuries?

A. I like to put on eau de cologne because it's light and soft. I never put it on my skin; I only put it on my clothes, under my skirt.

Q. What catches your attention about someone who looks beautiful?

A. There again, I'm not one who tears things apart. I don't see a beautiful face and an ugly body or vice versa: I see the whole thing. So I suppose really it would be a silhouette.

Q. Are there women you admire?

A. I find that a great many women can achieve enormous things. They might not be the ones who are getting the press, but they're doing a great deal of good. I have great admiration for dedicated women.

Q. Do you think women's self-esteem is growing?

A. I noticed that when I was doing so much hunting the guides would take a look at me and say, "What is this woman doing here in a man's world?" I never had it fail that the guide would go further to get a good trophy for me than I had ever anticipated, for once they were working with me they realized that I was willing to accept the hardship, and I was there for that purpose.

"Putting yourself together takes time and a very definite identity."

Q. What about attractiveness as a tool?

A. If you don't appreciate yourself, you cannot expect others to appreciate you. A body that's in good shape and a clean appearance mean that the person cares, and an effort has been made, and if an effort has been made successfully in one direction, there's no reason why it can't be made in all directions.

Q. Do you think that, for a woman, it's important to decide that she does want to take better care of herself?

A. It's born in the individual. Certainly one can want to do better, and having the determination to do better, you will do better.

Carroll Portago is a very adventurous and daring woman who is also controlled and disciplined. Her look has an easy contemporary feeling.

She doesn't wear a lot of make-up, and she would rather do nothing than make a mistake with it. She needs a fuller mouth, a fuller brow and a stronger-looking eye make-up, substituting brown eye shadow for the blue she had been using on her light gray eyes.

Her hair was cut so she can just blow it dry. It doesn't need a set. The color was lightened to warm up the natural tones and to flatter her pale skin.

Carroll Portago looks best in her safari suits, with that wild, outdoorsy look and in her silk, layered Chloe. She insists on fine fabrics that move well with her body.

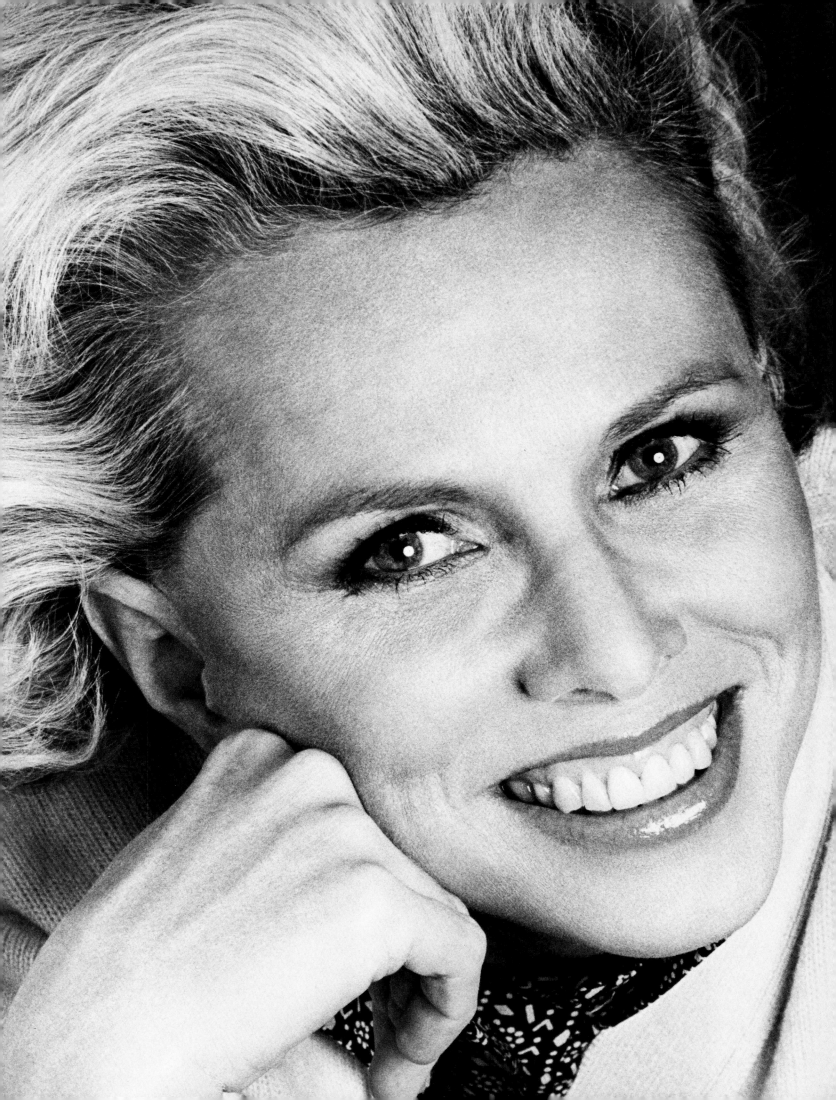

Confidence in your own style

Lee Radziwill

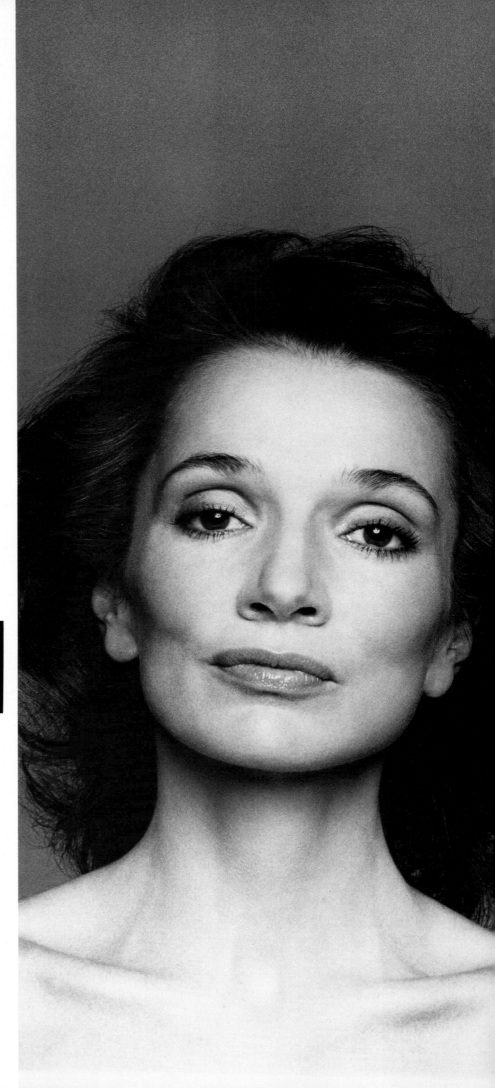

Ms. Radziwill: Beauty is a spirit. It is timeless. Compassion, wit, serenity and enthusiasm are qualities which make beauty life-enhancing. It's a style of character.

There are no rules, no systems, as without any of these qualities, beauty is no more than an inanimate force—a sterile façade.

Lee Radziwill has great aristocratic beauty. She's as fine-boned as a bird and never allows clothes or make-up to overpower her. She is a lady who rules herself.

She never wants to look "done," so she wears only a light make-up over her very healthy, remarkable skin.

She would look best with a straight, blunt cut like a young girl's.

She herself is the force, not her clothes. She never wears too much jewelry or overbearing colors and styles.

126

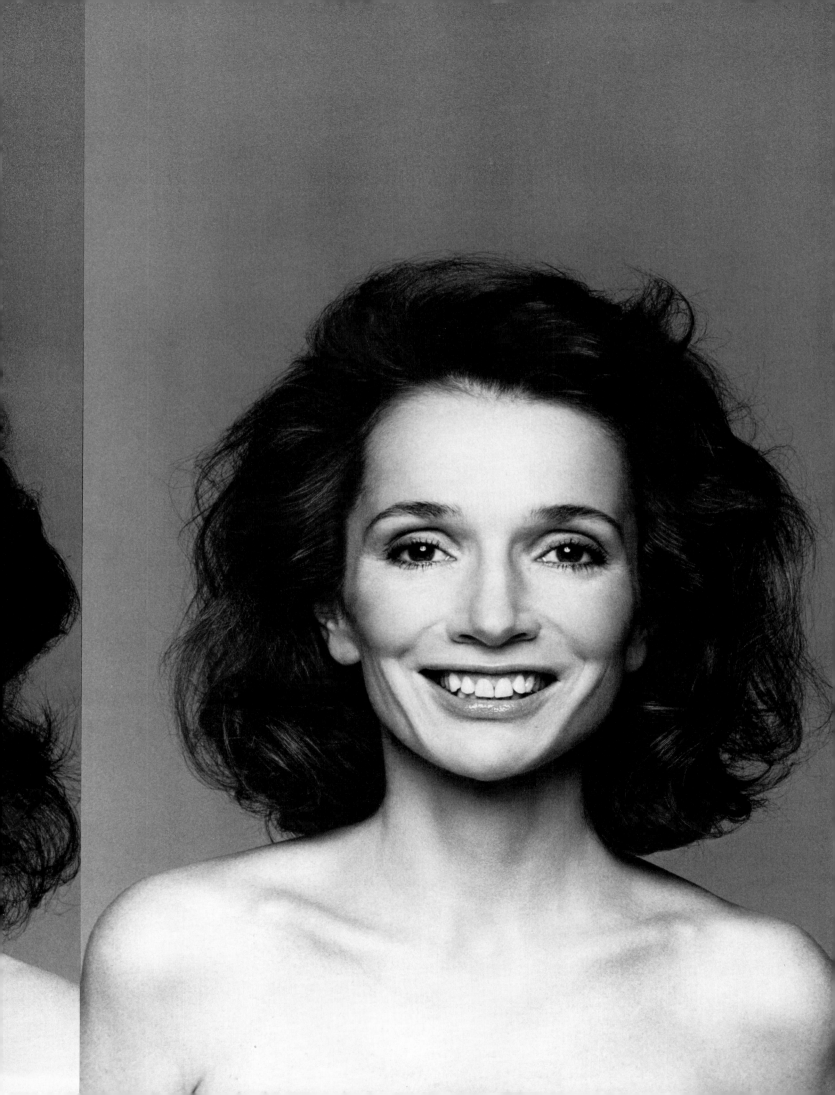

Even if you've got good features, don't be afraid to make them over

Helen Reddy

Scavullo: How do you feel in front of the camera?

Ms. Reddy: Queen for a day.

Q. What does beauty mean to you?

A. Beauty is something that touches your soul. It could be a sunset or a melodic phrase or a human face. But I think it's totally separate and distinct from glamour. Glamour is good packaging.

"One need only spend a day looking bad and an alternate day looking good to observe the difference in others' reactions. We all get more respect when we look our best."

Q. What does it take to make you look and feel good?

A. Accomplishing something successfully. A compliment, if sincere.

Q. How would you describe yourself, your own looks?

A. I have only three features I really like: my eyebrows, my arms and my feet. The rest of me I've learned to live with. My hair is thin, fine, oily and has several cowlicks. My skin is dry and extremely sensitive. My eyes are too small. My nose is too long. My mouth is crooked. My face is too big for my body, and my legs are too short. However, in my own defense, it must be said that I have a good sense of humor and I always cry at weddings.

Q. Name something you really enjoy.

A. Eating chocolates in a bubble bath (the ultimate in self-indulgence).

Q. How would your friends describe you?

A. "Above all, Helen has a sense of humor attached to an arrogant humility." (The above quote is courtesy of my best friend, who is also my husband.)

Q. What makes you happy?

A. My husband, my children and applause.

Q. Why do you think you were chosen for this book?

A. I can only conclude that you like me. You make me feel I was really gorgeous all along and hadn't realized it.

Q. What are your hang-ups?

A. I'm too hung up about them to discuss it.

Q. What have you done during the past year to better yourself?

A. Taken up yoga, stopped smoking.

Q. Do you think life is easier, if you're beautiful?

A. *Definitely.* It's always easier to like an attractive person. We all get more respect when we look our best. I must say I've made more of an effort since I read in a little book by Elisabeth Haich called *Yoga and Destiny:* "It is our duty to offer as pleasant an appearance as possible to those around us."

Helen Reddy is a super-talent with a great sense of humor. The character in her face becomes even more apparent with make-up, and I think we gave her a new look.

A good amount of make-up was put on her eyes to give them more importance. Her brows were accentuated.

She looks best with short hair.

Helen is an entertainer, has to be glamorous, but should not let her clothes dominate her.

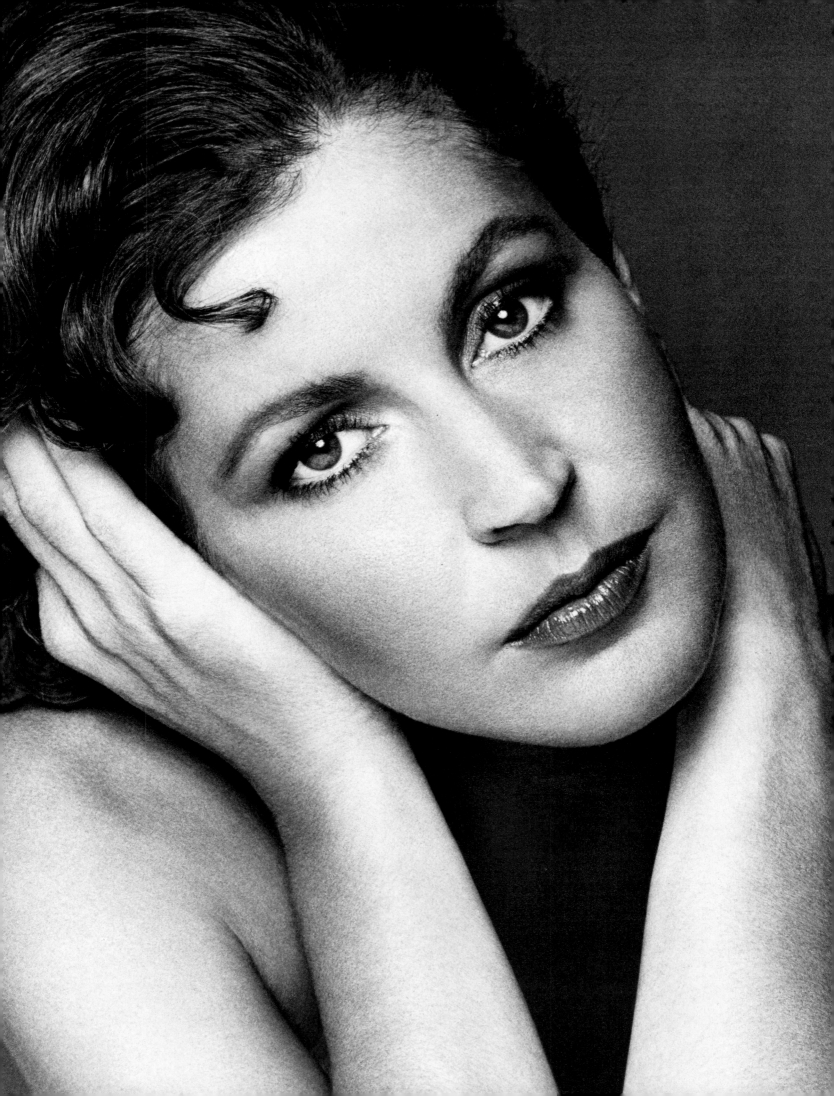

Create drama and excitement through make-up

Chris Royer

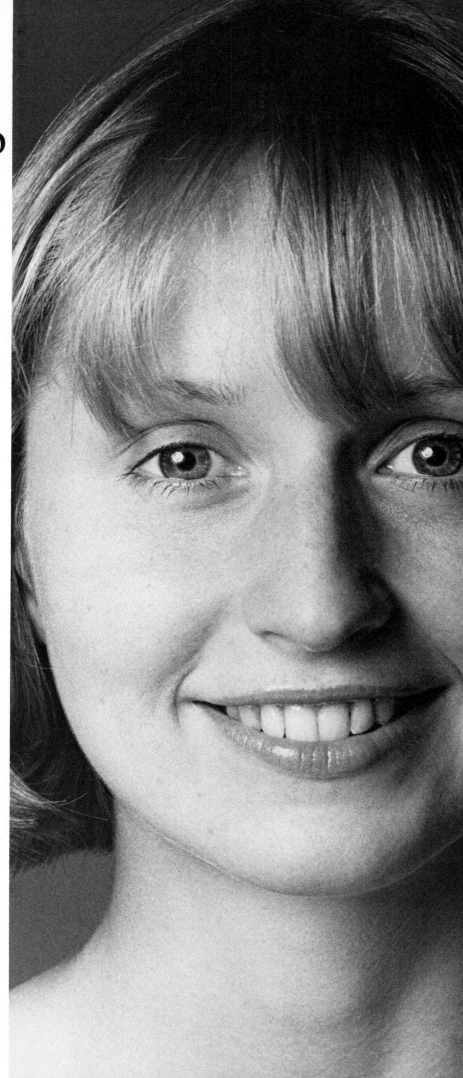

Scavullo: I believe that make-up has been one of the important elements of your success as a model.

Ms. Royer: Certainly, because it has helped me project a stronger look in my photographs.

Q. Do you have to use a lot of make-up to achieve this?

A. No. Good make-up comes from learning how to apply color or shading correctly and sparingly to bring out the natural facial structure. In studying my own face I found a marked resemblance to the Japanese features—an oval face, smooth contours and half-moon eyes. This helped me to refine my make-up to a brown shading and highlighter for my eyes, a little brown shading underneath the cheekbone and a little blusher on the apple of the cheek. In this way my eyes appear larger and wider and my cheekbones more prominent.

Q. How long does it take you to make up?

A. Under an hour for modeling, considerably less otherwise. The basic trick is never to overwork it so that you have a painted face. If the make-up looks natural it will work in any light.

Q. What are the benefits of learning to apply make-up correctly?

A. Symmetry and harmony. Nature rarely provides these, but make-up creates the illusion of them.

> *Chris is an appealing young woman without make-up. But she's a great make-up artist, and that's why she's such a successful model. She can project a peasant innocence or a sophisticated worldliness.*
>
> *Her eyes need shading to bring them out, and her mouth needs to be filled out by rounding the lower lip, contouring underneath it, and then giving more fullness by using light color on the bottom lip and darker color on the top.*
>
> *This is the perfect hair length for Chris, slightly above the shoulder but not too short. It accentuates her bone structure.*
>
> *She dresses fashionably but simply. Chris began as one of Halston's favorite models, and that has set the pace for her own sense of style.*

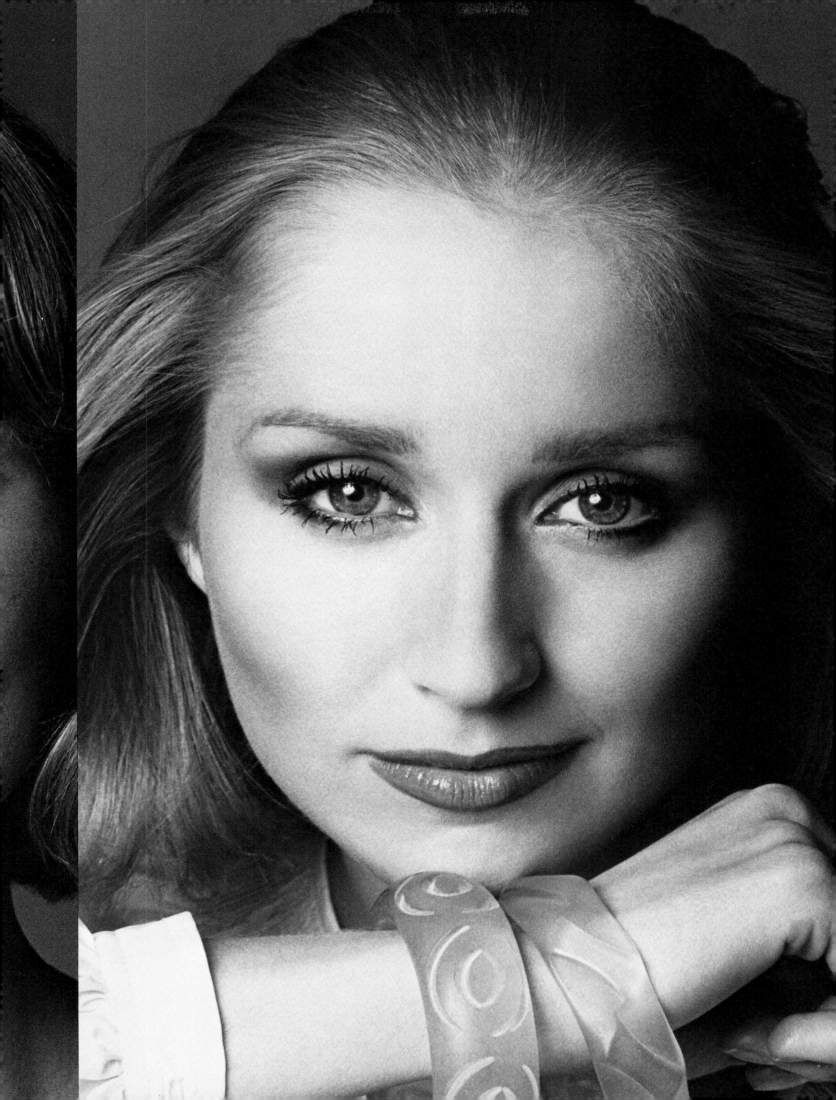

The right haircut can improve even the most beautiful face

Rene Russo

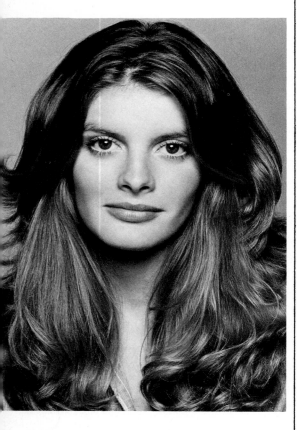

Scavullo: Tell me a little bit about yourself.
Ms. Russo: My last name is Italian and my first name is Rene because my mother named me after a real pretty telephone operator she knew when she was a long-distance operator. My father is Sicilian, and my mother is half Italian, half German.

Q. Were you a beautiful baby?
A. Hideous. I looked like a spider monkey. My mother says they brought me in to her, and I was just a long spidery hairy thing. And I had these huge blue eyes—that's all you could see. And she said I didn't have a forehead—she had to create one by rubbing it back for three or four months. She said I wasn't too cute. I was O.K. around the ages of two and three, then I got rheumatic fever. I looked like I had polio. I had to wear my shoes backwards for three

years, and after that I was in a body cast for four years because I had curvature of the spine. I don't know how I came out decent, I really don't. And that was from the age of eleven through fourteen. I used to watch my mother put on make-up; it fascinated me, and I always thought I was real ugly, real ugly. I guess it was the body cast, and through junior high I was a sight. And then in high school I was always real insecure; in fact, I guess it's just been the last year that I've not been so hung up about my looks.

Q. What made you decide to model?
A. It's really strange. From age eighteen on, people would stop me on the street and they'd say, "Why don't you become a model?" and they'd go on and on. I just didn't even think about it. I really didn't. One time I was at a Rolling Stones' concert and this guy came up to me afterwards, an agent at Creative Management, and he said, "Are you an actress or a model?" And I said, "'None of those." He said, "Well, you should be," and he gave me his card and I thought, "Oh, yeah, another one of these things," but he was with a chick in a Mercedes and he stopped in the middle of the street, so I said, "O.K., I'll call you." I was so nervous. I went in to his office with my mother, and then he sent me to a photographer to have some pictures taken. Then an agent signed me, and I came to New York. I didn't want to be a model, really.

Q. What are the drawbacks of being a model?
A. I don't think there are drawbacks if you're strong enough in your head to handle it. I mean, it's awful when you go to bookings and you hear the photographers and the clients and everyone saying, "Oh, well, so and so used to be this, but, God, she's getting so many wrinkles," etc. That's real depressing.

Q. It's a tough life, isn't it?
A. It's tough if you make it tough. If I weren't a model I'd eat right anyway, just because I've always taken care of myself. I would iron my hair before I went to school, and it would take me an hour to do it. And if I lost a false eyelash, I wouldn't go to school. It's always been way overboard with me, and I don't know why. Maybe it's because when I was a child, my mother would say, "Oh, but you have such a pretty little face." I think she did it because she felt sorry for me because I had the cast on, and I was skinny, skinny, skinny and I wasn't pretty.

Q. What is your approach to beauty?
A. I eat all fresh vegetables, and I eat fish and chicken, and I make sure I don't eat a whole lot of red meat. I try to stay away from foods with a whole lot of preservatives, and frozen foods. I try to have all fresh, steamed vegetables—no sugar, no salt. I eat cheese and milk and lots of fruit, and I think that's important. I just take care of myself.

Q. Do you get up early?

A. It depends. I'll get up at eight one morning, and then I'll sleep all day sometimes. I don't have a real system, but when I'm working every day I have to be up really early and go to bed early. Unfortunately, I'm not strong enough to stay up late and party and everything. I know a lot of models that will model, and then go out to a party, and then get up and be at work the next day at eight; I can't do it.

Q. Do you drink?
A. No, I don't. When I was a little girl I was always curious, and my mother said, "Here, take a swig." It was whiskey, and I remember they had to turn me upside down, I coughed so hard. I think that turned me off. I really don't like it, though straight tequila isn't bad.

Q. What do you consider your best feature?
A. I don't think I have any features that are outstanding, though I think my face structure is probably my best feature.

Q. What is your worst?
A. My body! Totally! That's personal; a lot of people like my body, but I don't particularly like it. I mean, it's too thin for me. I'd like to be a little meatier.

> **"In my high school if you didn't look like Cybil Shepherd, forget it."**

Q. Do you eat a lot?
A. I try to. I get at a good weight, and then all of a sudden if I skip a meal, forget it, I just get too thin.

Q. Can you describe your looks?
A. It's really hard. I thought three years ago that I looked completely different than I do now. I never used to see my profile, and I used to hate it. I used to hate the way I looked because I didn't look like Cybill Shepherd, and in California when I was going to school, if you didn't look like Cybill Shepherd—if you didn't have long hair, big tits, and big blue eyes—forget it. And then I went to New York, and I realized there were many different types of beauties.

> **"I guess it's only been in the last year that I haven't been so insecure about my looks."**

Q. What kind of beauty are you?
A. You know, it really depends. If my hair is straight back, and Way Bandy is doing my make-up, I'm super-severe—I am almost geometric. And when I'm at home and I braid my hair at night and I take it out in the daytime, I look like Gretel from *Hansel and Gretel*. I wear my bangs Egyptian-style straight across, really cut blunt straight across, and I wear my hair in

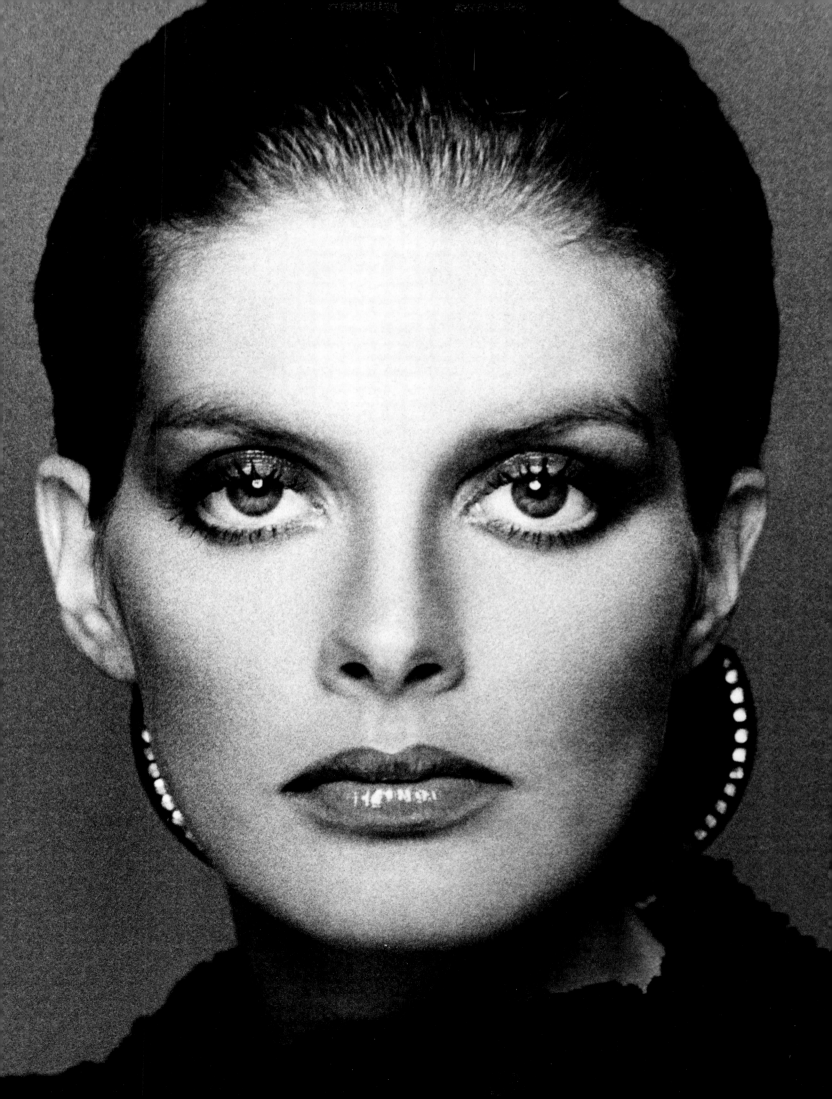

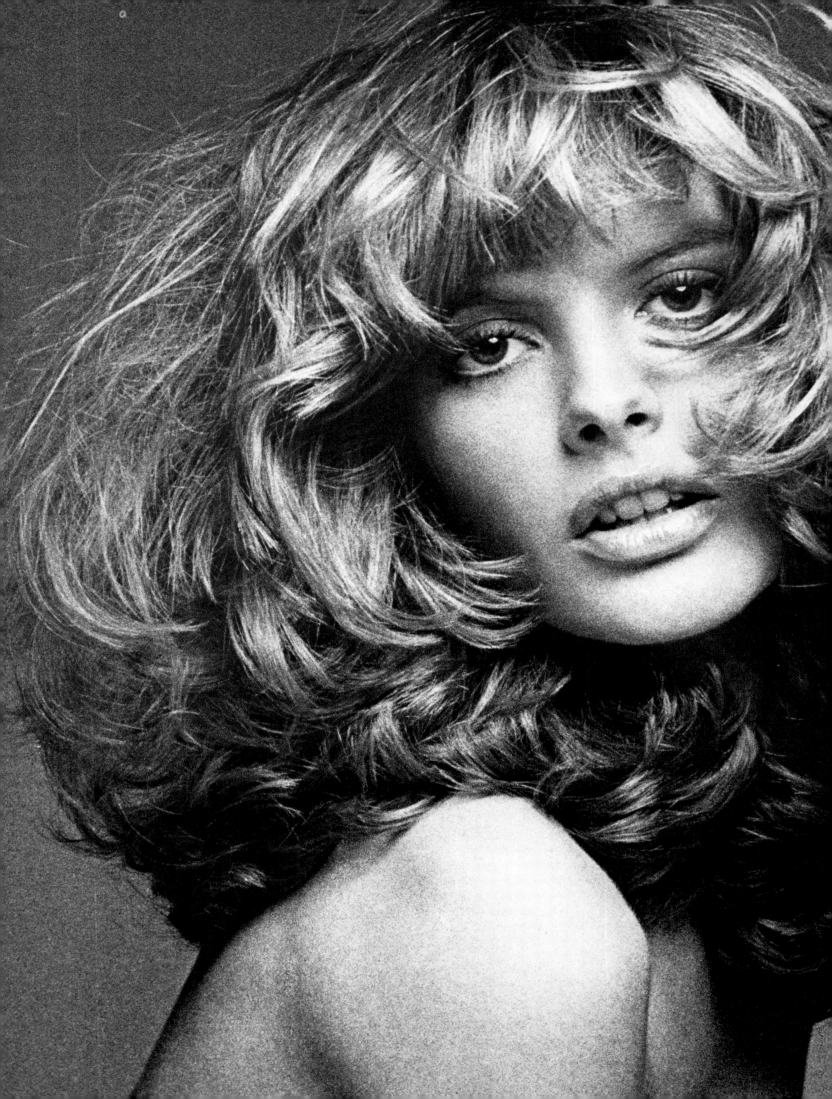

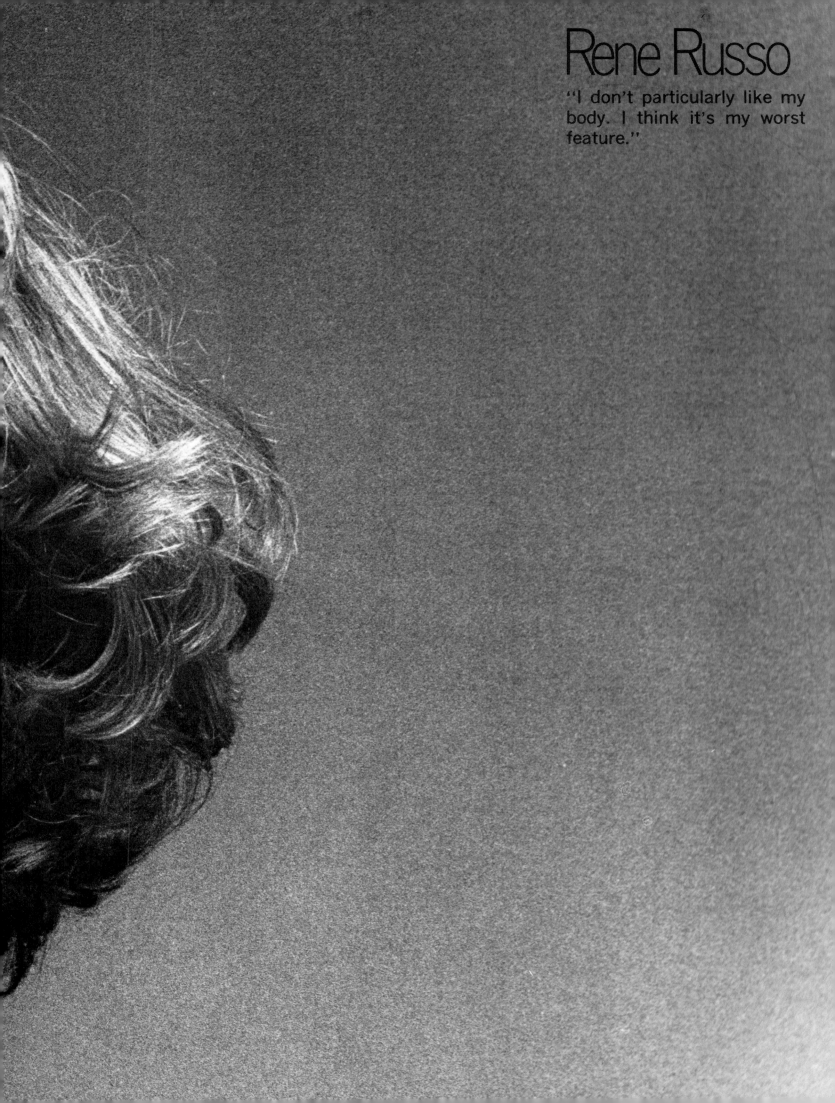

Rene Russo

"I don't particularly like my body. I think it's my worst feature."

"I don't particularly like my body. I think it's my worst feature."

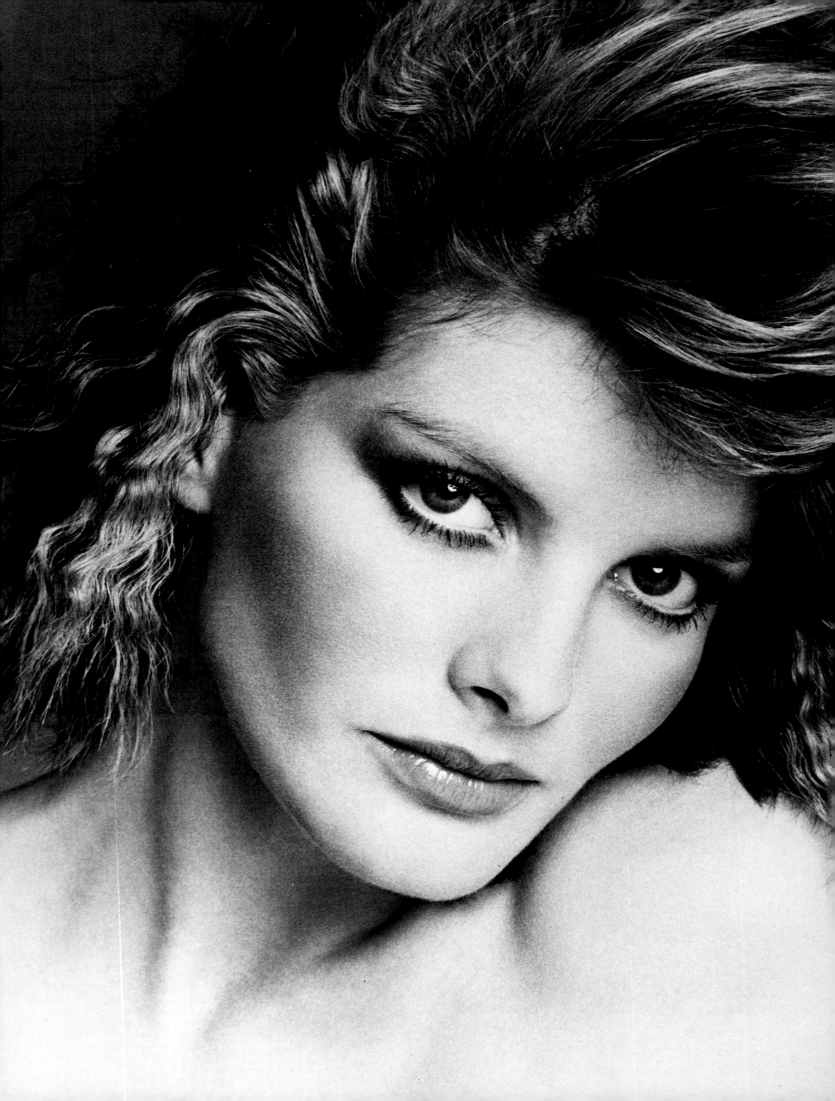

little braids. After the braids are taken out I look like a little German fairy princess—that's how I love to look. I don't like to look really severe—and I can. I would like to be sexy-cute if I had to be anything.

Q. Do you like make-up?
A. It's not a matter of liking it, I need it. A little bit of make-up is nice. I like mascara on the eyes, a little bit of eye shadow and color in the cheeks. I don't like to go out at night without any mascara. I'll go out in the daytime without any mascara, but it does accentuate my eyes and makes me look better. My hair is really light everywhere! My eyelashes are light, so they don't look very nice without any make-up at all.

Q. Do you like your hair color?
A. My color is O.K., though I'd like it a little bit lighter.

Q. So you like light hair?
A. On girls I like it a little lighter, though not blond, just sort of sandy blond. Real rich, though, honey . . . golden. Golden is my favorite color. Honey is my favorite on girls, and for guys I go for dark hair, but not real dark. It depends on complexion and the color of the eyes.

"I'm not strong enough to stay up late and party. I can't work and play too."

Q. Can you talk a bit more about clothes?
A. Well, I'm really not into clothes, and I'm so oblivious to them half the time. If I'm doing a sitting for *Vogue* I won't ask who the designer is, I don't really care. If something knocks me out, I'll say, "Hey, do you think I could have this part?" or "Do you think you could send this to me?" I couldn't name three designers to you right now. I hate polyester, I hate anything that isn't real. I love cottons, and I love real material, and I hate that shit that I have to model every day. I mean, people don't know, they don't see the polyester suits we're put in every other day for catalogues. I hate it. And the thing is, those clothes aren't even cheap. I love cotton, I love simple things that are kind of skimpy.

Q. What is your favorite way to get dressed?
A. I like black. I like those necks that are cut like a boat over the shoulder, with a nice leather belt, maybe a pair of boots or a nice pair of jeans, nice straight-legged jeans. Dark! That's how I like to dress . . . and comfortable.

Q. Don't you like to wear dresses, skirts?
A. I do, but they have to be really special, and I haven't put on that many dresses that knock me out. I like them really simple and sexy. That's hard to find. I'd love it if I could design all my own clothes and say, O.K., this is what I want.

Q. Do you go shopping?
A. I hate it—those fluorescent lights in the department stores. If you look good in a department store in their mirrors, then you're going to look dynamite at home in whatever you buy. If I owned a boutique I'd use natural lighting. And unless you pay a fortune, you can't find anything decent—and I'm a tightwad. So I'll just wear the same thing over and over and over again. I just don't care; even holes in my pants don't bother me.

Q. When you want to indulge yourself, what do you like to do?

A. I sit home and relax and sleep.

Q. Do you give yourself beauty treatments?
A. No, my face can't take it. My face is a combination of dry and oily skin—it's the worst.

"I love to look like a little German fairy-tale princess."

Q. How do you take care of it?
A. I'm having a real tough time with it. It's really dry in California, and it actually gets to the point of cracking. I finally went out and bought a humidifier. I was putting tons and tons of cream on, and I have big pores, and then the cream gets in the pores and causes pimples. It's a hassle. And it's funny, I didn't have that problem until two years ago. All of a sudden my body completely changed.

Q. What are the ingredients of looking your best?
A. I'd have to say good skin. My face, my skin, must look good or forget it! It's strange, but I'll look at some people and their skin is not perfect, and they still look beautiful to me. I don't know why, maybe it's just my eye. But if *my* skin doesn't look good I'm a mess. And I think I look best in the summer.

Q. In a bathing suit?
A. No, maybe wearing something off the shoulders, with my hair at a good length and clean. You have those good and bad days. Sometimes I go through a week and I don't think I look good.

Q. What are your favorite colors?
A. Dust rose, and I like black with that, and a deep deep burgundy. That's probably my favorite color combination.

Q. Do you think life is easier and people are easier to deal with if you've done your best to look attractive?
A. Working, it probably is, but it doesn't make a whole lot of difference with the people I know. I don't think they notice the difference, really. Some people really inspect you when they look at you, you can tell—they're checking you out. When they are talking to you they are talking to you, but they're checking everything out—the skin condition, the head—everything. I could do something really different, and my boy friend wouldn't notice it, yet other people notice the second you do anything—it's really incredible.

"Good skin is the most important thing for me."

Q. Do you think American women could stand a little improvement?
A. Yes, I sure do. They overbleach their hair. They wear too much make-up—they don't realize that if they wore a little bit less, they wouldn't look so bad. When you're getting older you can't put on tons of make-up: it just doesn't work. And they dress in polyester knit suits; they're just not educated about style, that's the thing, that's what makes me feel bad. They are all overweight. Americans are just fat, and they don't look healthy to me. I mean, I've been to Europe and I've seen the women, and they're a little overweight and everything, but they just look healthy and they know how to dress. Even if it's not pulled together and it's a little ratty, it's still better than these pulled-

together little robots that I see in their little suits and stuff, and their bleached hair that looks like it's ready to fall out of their heads. They all go through all the trouble of dyeing their hair to look good, and putting on tons of make-up and pounds of perfume.

Q. Do you seriously want to model?
A. If I could get a cosmetic contract or something like that it would be great. I'm not counting on that happening, but it would be ideal. I don't want to model past twenty-five. I'd really like to be out of the business, but I've said that to a lot of people and they say, "Sure, sure, you wait, you'll be twenty-five and you'll still be doing it." And maybe I will be, if I got a contract from somebody. If I could choose a profession to go into I'd like to be a singer.

Q. Why don't you take voice lessons?
A. Yeah, I know . . .

Q. You're not really motivated, are you?
A. I'm not. I'm just kind of going along, and that's a really bad stage—just hanging in there and waiting for the next thing to happen.

Q. Who are some of the women you really admire for their personal style and beauty?
A. My mother.

Q. Can you tell me why?
A. I tell you, for what she has gone through—her life. My sister was just born when my father left, and she raised the two of us. She went to work every single day, never missed, never went on welfare once, always worked and raised us kids the best she could and really taught us a little bit about life. I'm certainly not really together, but I'm aware about a lot of things, and I have compassion for people, and you know that a lot of people just don't have that—they just don't care, they just don't feel. And I respect my mother for that, and she has gone through it all, God, she really has. We were raised in the slums, and that's no joke. We were raised on probably the worst street in Burbank. It was like welfare row. And I don't know how she did it without going crazy, I really don't, and she pulled through, though we gave her a hell of a time growing up. Oh, we didn't go to school, we didn't care.

Q. Is she proud of you now?
A. Yes, she seems to be pretty content. She's really young, too, and young-hearted; I can tell her anything. She's like a kid. She'll come over to the house with my friends, and I don't even think of her as a mother really, I think of her as a friend. Also, I didn't have a father, so that's maybe why I'm so close to her. But she has always really helped me out, whatever problems I've had, she's really sat down and said, "O.K., Rene . . ." She's real mellow, and she doesn't get too uptight. I'm really hyper compared to her.

I think Rene Russo is the most beautiful girl in the world, and I love her.

You can do anything with Rene's face. She's beautiful without make-up.

I think she has the most beautiful hair—no matter how she wears it.

Rene is so sexy in jeans and T-shirts with boots. She's very skinny, so she can take heavy fabrics such as corduroy, heavy cotton flannel, full silk tops, wide-cut skirts. Everything drapes beautifully on her; she shouldn't wear anything constricting. She's not ready for the bridle and saddle yet.

A healthy mind in a healthy body

Blair Sabol

Scavullo: I know you just got back from California. What do you think about the girls out there?

Ms. Sabol: I was supposed to write a piece on that and I backed out of it because I got half-way into the women out there and I turned around and said, "It is what we think it is." Before you get out there you say, "Well, it can't be as bad as its image, it's got to have texture, it's got to have depth," and you get there and you go, "Jesus, it is that bad, it is superficial." The make-up is different out there, their asses are bigger. I gained fifteen pounds. When I came back to New York, I found myself writing all the time about shape. I was so aware of bodies. The energy level of Los Angeles is so slow-motion in comparison to New York. I went there because I thought it would be good for me at that time of my of my life to slow down. But at the same time, L.A. taught me to be athletic. In fact, now I have to change my style of writing—I'd like to go into sports writing now.

Q. You would?

A. Yes, not sports writing like you read in the paper, but sports writing about concentration and women and body awareness. I want to do a piece called "Fear of Sweating." People shouldn't underestimate that that woman out there can sweat; she can go to a track and run in gym shorts.

Q. I hope a lot of ladies sweat when they have sex.

A. That was something exercise teacher Lydia Bach talked to me about. The area some women are most paralyzed in is their pelvic region—they are afraid to come in contact with it or move it. And forget about giving yourself an internal examination! But I want to tell you that one of the most fabulous women I've interviewed was Diana Nyad. She's a marathon swimmer, she's swimming the Atlantic Ocean. She just swam the Nile. And though Woody Allen wants to cast her as Tarzana in his next picture, she's not a he-man. She doesn't come on like Billie Jean King, whom I find a little bit of a turnoff, though my father thinks Billie Jean oozes juice. Anyway, Diana exudes tremendous energy. She is such a goddess. She's the first woman I've met whom I'd like to train with—she would be an inspiration.

Q. Do you realize that you used to have an image that you projected strongly, a personality that you put forth to the public, but now you seem completely different?

A. You have to understand, I was into something else in the sixties. I was part of the Abbie Hoffman group for a while and I worked out of that, but we all turned thirty. That's the story right there. When you turn thirty, a whole thing happens. Number one, you see yourself acting like your parents. My mother used to hock me and I'd say, "Get off my case." Now I see myself reacting the way my parents did about a lot of things. Also, I want to tell you, how much can you wear jeans and a T-shirt? Even worse than that, there was a period in California when I wore a jogging outfit every-day. I never got in touch with my body—in a jogging outfit you have an elastic waistband and it's a big balloon. People in California *are* body-conscious, but they're all in cars; they're all cruising, but it's only from the face up and reflected in a rear-view mirror.

Q. They don't even walk.

A. They bust their asses on the tennis court, though; they go to UCLA and run around the track four times, but then they're back in the car. And the drinking is tremendous out there; at four o'clock, everybody becomes a big martini.

"Inferiority is wonderful—it makes me creative and competitive."

Q. Did California affect you in any other ways?

A. One of the new experiences I had in California was a visit to a psychic nutritionist, who went over my body with a pendulum and found that I should not be eating any kind of salt, cheese and red wine. She put me on a diet of green soup, for diuretic reasons, a soup made of blended watercress, zucchini and celery, which she called "Bieler's Brew." Her regimen lasted one hour with me, because my blender broke and the soup went on the ceiling. Also, no one in this life should ever have to take her food around in a bag with her—even though Carol Channing does. It's very antisocial. So that didn't work with me. But the thing that did work with me was my high-calonic experience, which next to acid and mescaline, was the truest high I've ever had. All it is is an intense enema; it's not painful. It's very popular now in California: Cloris Leachman takes one once a month—that's a lot—and she swears by it. You know, she looks twenty-five. I don't swear by it, and it's not the fountain of youth, but I think that since I come from that ridiculous Jewish background of constipation in my family, it's good for me, it really is. I might add that in the olden days, it was extremely popular and it was called irrigation. It's no different than going to your dentist twice a year and getting your teeth cleaned. Actually, when you think about it, why shouldn't your intestines get cleaned? How else are they going to get clean? Oh, pretty subject! Unfortunately, when I bring this subject up with my friends in New York, they think I'm either crazy or foul-mouthed.

It's too bad that *Portnoy's Complaint* made such a disgusting issue of bowels.

Q. Do you have any other "regular habits"?

A. Once a year I go to my psychic, Frank Andrews, who is more important to me than a shrink or a doctor. He's incredible. He's been right about all his predictions for me, but I know that he's not God. I don't want to come off sounding like a Manson groupie, and I know a lot of people don't believe in psychics because once they tell you something, you can make it happen. But if that's true, that's pretty incredible also. It means that that guy has enough power to make you do something.

Q. Do you have a daily beauty regimen?

A. I believe in the taking out from the body rather than the putting in. I take a steam bath every day, which I hear is terrible for your body. Rock Hudson's doctor told him that his whole body is deteriorating because he takes steam baths every day. They supposedly dehydrate your skin cells, but that's fine with me because I like a shriveled-prune look; I like the look of Lillian Hellman. Aside from the steam bath, I do one hour of exercise in the morning with Lydia Bach. (This is going to sound terribly didactic. You know, I've always read about people's beauty regimens and hated the people for having them.) So I guess my survival pattern—that's what I would call it, rather than a beauty regimen—is the steam bath, the hour in the morning at seven-thirty with Lydia Bach, and then, instead of lunch, I work out with weights at a health club. On the weekend I become a total fat slob, and undo everything that has been done over the week. I don't move, I overeat—it's total self-destruction. But I believe in the building-up and the tearing-down process; that is, you work out to get in shape and then deshape yourself for two days. If I don't go on binges every now and then, I find exercise boring. That's probably why people should get out of shape when they go on vacation. Now that I'm lifting weights, people ask me what would happen if I stopped, and I tell them that I would never stop for long. If you're really into exercising, you never stop.

Q. Do people ever react adversely to your lifting weights?

A. Some people think it's very vain to go to exercise classes, since they're such lightweight time-wasters. For instance, women who are into tennis don't find exercising competitive. But I've never been a woman jock, and I find exercise classes a form of meditation because I'm alone and I don't have to deal with phones or my responsibilities to the world. It's just me and my body. And as for it's being vain, to me exercise classes aren't vanity, they're necessity.

Q. What about make-up?

A. I don't know from make-up. I have started going to Aida Thibiant and she teaches jerks like me who are not into facial regimens how to wash and cream their faces, and pay attention to their necks. You know, I always wanted to have someone like Helena Rubinstein for my mother. I think a lot of women are attracted to Hungarian older ladies, the Zsa Zsa Gabors, who have thick accents and who would pick your pimples. They look like they would get blackheads out fantastically. They could pick your pimples, find you a husband, and share your fears with you.

Q. Have you thought about what beauty means for you?

A. With beauty, there has to be a sense of struggle—not vitality, which is such a fashion-

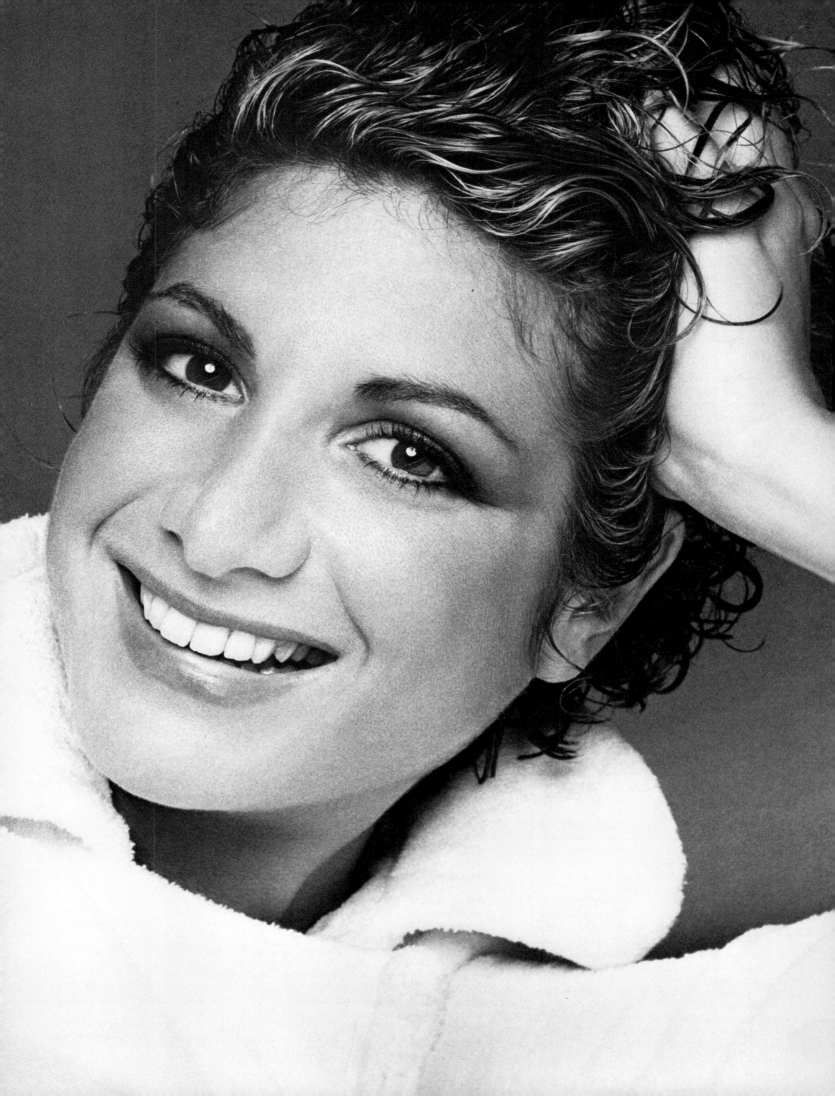

mag word—but struggle. It's why I think Secretariat running is the most beautiful sex symbol, why Muhammed Ali fighting is beautiful, why Baryshnikov dancing is beautiful, and why I think Lauren Hutton in a Revlon ad is dead, nothing. So I think beauty, meaning aliveness, happens only in action. That's also why I love the "bag ladies" at Grand Central Station—they move; they're the real Sonia Rykiels of the world, the original designers of the layered look. But I've got to tell you what my mother would say: All you need in life is clean underwear and a good haircut. And I'd add, A good trench coat.

Q. What about a dress?
A. No dress, just a beige trench coat. But the haircut is very important.

Q. You have good hair, you're lucky.
A. I recently found out that a lot of women, as well as men, are losing their hair. Do you think it means they're all dying?

Q. It's caused by the food we eat that is full of toxic poison, chemicals and everything else. But also, since men lose their hair first, I think it has to do with the tension, the nervousness, the aggressiveness. Now women are picking that up, and they're also getting all the toxic poisoning—particularly from the pill. I believe that what you put into your body and what you don't take out of it is going to make you look like hell or make you look like an angel.
A. If anything is bad for beauty, the pill is. As part of my total California experience, I went on the pill, and as I said, I put on fifteen pounds. But worse than that, it gave me the worst mood swings I've ever had—just like schizophrenia.

Q. What can women do?
A. Go back to the diaphragm and use abortion as birth control. Sure, the diaphragm is inconvenient—no one wants to say, "Excuse me, wait a minute while I run into the bathroom." But you can put it in before you go out. It's better than the pill, which can make you sick or cause skin disfiguration. And I think the IUD wears out your uterus, and who knows if abortion may be just as bad. It's as if God turned around and said, "I'm going to make it really hard on you."

Q. Do you want a baby, do you think that's going to make you happier and more beautiful?
A. I never was brought up that way. You see, my mother told my brother and me not to get married because she got married at eighteen and had children by the time she was twenty. "Don't get married, don't have children, live your life."

Q. Don't you want to have a child who'll maybe be smart, who might write?
A. No, I don't care about that. It's wonderful to have a child, but I think that everybody should just live her life in the here and now. Somebody told me that something happens chemically to a woman around the ages of twenty-eight to thirty-one when she feels that she must produce, but I'm twenty-nine and I haven't had that feeling yet. I don't think today's woman has to have a child to feel fulfilled. All my girl friends are now past thirty-two and none of them has children. There are going to be a lot of women with late babies. Women who are creative and who are working can be very selfish. You have to rid yourself of that before you have children. Maybe some women reach this magical age of twenty-eight to thirty-one and feel that they must give birth to this other soul because they wonder why they're here. If there's nothing here that's

"Beautiful is a word Las Vegas entertainers use to describe Johnny Carson."

making you want to live the next day, and if a little child is going to make you do that, great. Speaking of children, when I went to California I spoke at UCLA and had this incredible experience with younger people, with nourishing these young kids. You know, this generation, not my mind-blowing generation from the sixties, when we were all dropping acid and having a great time, is lost. For once in my life I felt responsible for these people. I've got to give to the younger people and now I'm thinking in terms of teaching.

Q. What kind of teaching? Don't you think your writing reaches a lot of different people?
A. Yes, but it's too remote. You're still alone when you write. I feel that I should give something person-to-person with young people because I went through a lot of terror and trauma and I didn't have that many people around me to get out of it. I feel that it's very important to help, particularly if you're creative. Experiencing that suburban-L.A.-shopping-center mentality really made me a more sympathetic person. You know, when you see those women with the rollers in their hair and you're shopping with them, you aren't going, "Look at them," you are standing next to them, you're one of them. These are women who buy beauty guidebooks in the supermarket and go home and say, "Oh my God, oh look at this, I can roll the hair to the left and then I outline my mouth in red." Of course they all buy Maybelline. I liked when *Vogue* took those women like Mary Tyler Moore and Barbra Streisand and talked about their bad points. At least *Vogue* reached a level of humanity, because when a woman sits in the hairdresser's and reads that Barbra Streisand eats junk food, that's a big wow. I don't know what goes on in those women's minds. I think a lot of it is the kind of life they lead. They watch soap operas in the afternoon. They have children, car pools. They get in such rotten situations where they're schlepping the kids and they're doing the housework . . .

Q. But they've got their men . . .
A. And their man is having an affair with his secretary or screwing this one in the office and she knows it. What's she going to do? Well, she'll put her hair up and she'll try a new hairdo. My father always told me he'd kill me if I ever walked out of the house in rollers. But in California I had to, because you've got to get in the car and you've got to move it, and so the rollers go in the head and stay there all day. I once saw Candice Bergen with rollers in her hair. But now I'm seeing a big turnabout in beauty. Now I believe that the word "beauty" is going to go . . . it won't be beauty, it will all be health. It will be things like body movement, body awareness.

Q. I think that there is beauty in everybody. You are born with it. It's just a matter of what you do with it, and if you lose it, it's like losing your soul. You can lose yourself physically, too.
A. Oh, absolutely. But it seems to me that you're using beauty in the sense of spirit.

Q. Beauty is a health problem, both mentally and physically. It doesn't matter what your nose is shaped like, it doesn't matter what your face is shaped like, it just doesn't matter.

A. That's interesting. I had my nose done because in those days, eleven years ago, if you were born with something bad, you got it fixed.

Q. What is your worst feature now?
A. Oh, I haven't got any bad features. How can you say that, "worst" and "best," you've got to think of the total, the gestalt of the body. If I get up in the morning and feel physically lousy or bloated, then everything is off. Everything looks terrible—my eyes, my stomach. My entire day is lost. When I feel physically great, the rest follows. I don't concentrate on singular features. It's all or nothing. I've gone through my life, along with every other woman, destructively saying I've got a shitty nose, I've got to correct it. My nose job did not change my life, by the way. I thought I'd have every date, every person, that I would be Suzy Parker . . .

Q. Did it change your looks?
A. I had had a nose like Dustin Hoffman's. I didn't have a hook, it was just a fat slab of clay, which is the hardest nose to do.

Q. You have a nice nose.
A. Well, the doctor did it with one nostril off, which is wonderful.

"I feel that my brain is connected to my body, and when my body is in shape I feel great."

Q. But it didn't change your life?
A. No, and that's a big realization, though it did make me a little more confident. You must realize that when I was sixteen it bothered me. (This was before Barbra Streisand.) If I were growing up now, of course, it would be different—I don't think young kids are getting nose jobs. When I was young, I had all kinds of problems. At the age of eighteen I had anorexia nervosa, a serious mental disease in which you don't eat and lose weight.

Q. Why did that happen?
A. Part of it has to do with sex. I was a virgin at the time and the disease springs from fear of penetration of the body, of eating, or having sex, of peeing, of any kind of elimination or entry into the body.

Q. What did you think, that it was vulgar?
A. It was vulgar, it was poison, I was going to die. The disease also comes from anger with your parents, who controlled your body. Finally, by not eating, you have control. It's the true masochistic trip. You're very lonely. I went down to ninety-nine pounds. Naturally, I wanted to be a model and I went to Eileen Ford. By the way, when I went through all this, I saw my parents cry for the first time.

Q. Did you have to go to a hospital?
A. No, I didn't stay on it that long. I was very angry. It's a very bad mental disease. When parents tell you to eat, you get worse. So I went to Eileen Ford and she told me I was too thin, and that started it. And then, of course, what happens is that you go right up the other way. It's a real yo-yo thing. But what I'm trying to tell you is that when I used to go to designer shows, I saw the emaciated forms with which a lot of these designers were working, and I had to make my first women's lib—or rather, human lib—statement about the value of a womanly shape.

Q. Do you feel that designers actually pick one form, one shape, like a hanger, and they

hang their clothes on a hanger and that's it?

A. And I'm insulted because I'm not a hanger.

Q. Okay—now, this is not a beauty question. I happen to think breasts are beautiful on women, I really like them. I like small breasts too, but I like breasts. But there are some women wo go so far as to have their breasts cut down because they're too big. What do you think?

A. I was fantasizing about doing it myself. Part of it has to do with movement. My brother told me that the reason I can't hit a tennis ball is because my tits are too big and I need a brassiere with a Mack truck in it to hold me. I can't walk around in John Kloss bras when I work out, they don't support. I've always hid my big tits, but then I started being with a man who said, "You have great tits and you never show them." I think I'm afraid. Number one, I look at the models and I say, "Look at those tiny little fried eggs, perfect, even in a tee shirt they all stick up." Mine hang, I've got a 34D cup. Also, all the women in my family have big tits and they all have big brassieres; I remember when I was seven, looking at my mother's brassiere on the chair, and thinking, "Ooohhh, that's going to be me someday." But when I walk down the street I have to deal with street activity during the day, and I notice that my whole persona changes when I dress for the street. I now walk around in a jogging outfit in New York and I love it. But when I walk around with a little tit showing, there's street harassment that you must deal with as a woman. Really, do women come up to you and say, "Look, you're well hung, hey, wow"? I have to learn to be confident, to walk into a party and not worry if my tits are hanging or if a man is looking at me and saying, "Hm-m-m, what jugs."

Q. Well, you really do need support. But look at it this way: men wear jockstraps, so why can't women wear bras?

A. Right, exactly. I'm just coming to grips with this.

Q. Have you ever been to a shrink?

A. No, but my friends are telling me that this is the year. I did take est, but I found that when I came out of it, I felt nothing. I wasn't for or against it. I did it as a kick to see what was going on, and it was interesting. But since I've gotten into my body, by doing all these things with my body and getting into writing about it, I thought that I would take all the money that people pay to a shrink and pay it to people to correct my body instead. I feel that my brain is connected to my body, and when my body is in shape I feel great. When my body is out of shape I feel toxic, depressed and disgusted. And every emotion that I feel is connected with what I put in my mouth and how much I weigh, and though it may sound vain and disgusting, that's my hang-up. I don't need a man to tell me about what my father did when I was four years old. I need a trainer to say, "One, two, three, four and lift it. Five times, ten times." Don't tell me that my mother whipped me when I was four. I don't care about that. I know that I'm all connected that way, so when I got into this, I was starting to feel great and

"When you turn thirty, a whole thing happens: you see yourself acting like your parents."

wonderful and positive and radiating fabulous energy. Then I started to look at myself in the mirror. "Look at this stomach, look at the nose, it still isn't right. I gave that doctor a thousand dollars for a turned-up nose and still it's not right." And suddenly it disappeared. I wasn't looking at those pressure points, and it suddenly became a total thing, so that *everything* is either good or bad.

Q. Do you ever feel inferior?

A. Oh yeah, sure. I feel inferior all the time. Inferiority is wonderful—it makes me creative and competitive. But my inferiority turns to anger when I'm near women who don't like women, because I hate a woman if she's not responding to any other woman near her.

Q. What women do you think are beautiful?

A. First of all, I despise the term "beautiful." It's a word Las Vegas entertainers use to describe Johnny Carson. But a woman I admire as a total human being would be Golda Meir—she's got a great face, a real one-of-a-kind visual. and I think Diana Nyad is the most incredible woman I've met in a long time. You know, beauty is also the books you read. It's the life you lead. I've always felt that a real beauty story would be to look in five famous people's closets and medicine cabinets. When I go to a famous person's dinner party, which is usually boring and anticlimactic, I go into their bathroom, and I don't mean the guest bathroom. I sit in the bathroom, like Mary Hartman—I close the door and go through everything. That tells me more about them than what they're doing downstairs tap-dancing with the guests. I went into Stockard Channing's closets. She's very organized, she has her blouses in one thing, her shoes all put away. It was very together and it shows, because she's very together. What I'm saying is that living

"Now I believe that the word 'beauty' is going to go . . . It won't be beauty, it will all be health."

life is a form of beauty. That's the reason I feel the way I do about make-up: if you can't screw in it, you can't use it. That's why I felt false eyelashes were a joke; if a woman gets into bed with a man and something starts ungluing or falling, it's finished. Women are also finding that a fear of sweating has a lot to do with fear of being intimate with someone. I know that I look great when I come out of the steam room. That's my favorite visual. I should have a picture of myself right after the steam room when my cheeks are glowing and I'm stimulated and the sweat is coming down.

Q. Also, it cleanses your body. Sweating is like crying.

A. It's better than taking a shower, although I always shower after I exercise, since your body goes through a trauma when it's exercising. I go to Lydia Bach's to exercise at 7:30 a.m. before I even brush my teeth. And we don't talk. We get on the floor and we start with pelvic exercises, and slowly the body starts to come alive. By the end of forty-five minutes, we're talking and bubbling and it's marvelous and we know each other's names and we're all having a wonderful time and we're booking for lunches. Where do you think most women hold their tension?

Q. Oh, I can see it in their mouths.

A. They ought to exercise—and listen, it's hard

"My psychic is more important to me than a shrink or a doctor."

to work on your body. It's painful. Dieting is painful. I told Diana Nyad, "I'm really getting into discipline, my diet is changing." She's a little high-protein for me—she believes in swallowing eggs out of the shell—but she told me that what's important is food. It is not what you eat; it's what your particular body does with it. Some people love McDonald's and it's great for them. I can't eat dairy products; I love cheese but it gives me a headache immediately. Anyway, she told me not to use the word "discipline." It's a terrible word. It turns women off. When they see that word "discipline," oh, it means "electric chair, I'm strapped, I can't move." Diana said, "There is no discipline. When you accept something that you do, you must do it without judging it." It becomes your life style. After a while you become so in tune with your body that you know what works for you. You find out if you're a late person. When you know you eat that piece of cheese that makes you nauseated an hour later, you keep thinking, I'm going to take responsibility for this. I'm eating this and I'm going to die in an hour, but I'll face it. What was interesting was when she said, "If you're going to talk the word 'discipline' to me, forget the exercise program, because you're not ready for it. If you are going to say, 'I choose to do this because I want to do this,' there is no discussion, and when you're lifting this weight and you're saying to me, 'It's killing me, I hate this,' think of your goddamn underarms and the way they looked when you came to me. You said, 'Look at this, look, it's starting to hang. I'm not happy.' If something makes you unhappy, then you do something about it or you accept that and then it doesn't become an unhappiness. You accept the way you are."

Q. Do you think you'll have the strength to do what she says?

A. I think I will. You know, beauty and health have to do with your family and your upbringing. I just can't get over the fact that the way your parents raised you influences your daily habits. I come from a very close family, a very eccentric family—my father is a jock, my mother is an astrologer and my brother is a filmmaker/jock. We're all interested in mind/body awareness, but it's interesting that all my healthy eating and vitamin taking comes from my mother, and my body movement comes from my father. You just could not be in my family and be inactive or dull. As a matter of fact, academics were never stressed. I was not supposed to be a Vassar-beautiful scholar. I never went to college and my parents didn't care. But they did care that I should take care of my body and expand my mind by getting out in the world and getting involved in whatever interested me. And it's funny because I'm beginning to really appreciate the importance of the family unit. In the sixties everybody was rebelling and running away from their parents and I never could. I didn't hate my parents *that* much to hurt them. After all, they never did anything bad to me. But now that I'm near thirty, I'm understanding, as my world gets smaller, that some of the most important friends you can have are your folks.

Quick and easy clothes for the executive life

Marina Schiano

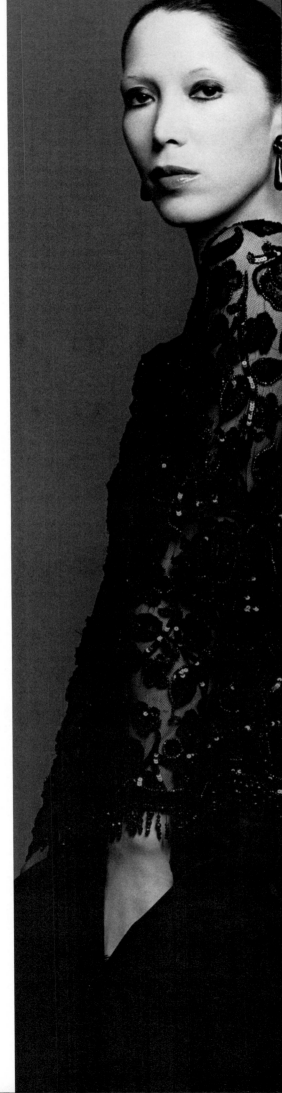

"You've got to sit in front of a mirror and work it all out —exaggerating your faults."

Scavullo: What is your personal approach to beauty?

Ms. Schiano: An enormous laugh. Frankly, I don't know. I just think you have to be in a good humor all the time.

Q. Would you go out without make-up on?

A. I don't think I can afford to. I don't like too much make-up, although I used to like a lot.

Q. Can you describe your own looks?

A. A monster, really. Seriously, totally strong.

Q. What do you think your best features are?

A. There's nothing right on my face. The nose is wrong, the eyes are too small, the face is too long, although it's oval and that's interesting. The mouth is big and the teeth are all wrong, so there is nothing really there. It's just probably that the mixture all together is right.

Q. How do you make it all work for you?

A. You've got to sit in front of the mirror and work it out—exaggerating your own faults. It takes time.

Q. Do you watch your weight?

A. No, I eat like a pig, but I eat very well . . . no junk food.

Q. What does your breakfast consist of?

A. Tea with honey. Then I spray Evian water on my face to wake me up.

Q. What kinds of clothes are you most comfortable in?

A. Pants and a shirt. I only like silk or 100 percent cotton. I can't wear anything else.

Q. You seem to wear turbans.

A. I adore turbans—they are my favorite thing. I can't wear them in my job because I'm a vice president and have to look serious.

Q. What about your hair?

A. I love chignons, but only if it is very neat. I also like to wear my hair down.

Q. What is your favorite kind of evening?

A. Do you want me to tell the truth? Watching television and having dinner at home with a friend. Big dinner parties annoy me because you have to move around every two minutes and you can never concentrate on one person. Once in a while (every other night) it's divine to stay up until four o'clock in the morning, if you can forget that you have to get up for work in the morning.

Q. You studied political science . . . What made you become a model?

A. I wanted to go around the world. Everyone was saying I was too ugly, but I came to the United States penniless and left New York four months later having earned four thousand dollars modeling.

Q. What is your biggest interest in life at the moment?

A. Love! It's the most important thing for me because it's so difficult to love and too easy to be loved.

Q. What do you like to do when you want to indulge yourself?

A. I adore movies. In Italy, when I was young, children were not permitted to see certain movies if they were under 16. My mother, however, understood my need and love for Marlon Brando, so she would take me—all dressed up in a hat and veil—to the cinema. Intermission would come and I would want an ice cream, so the veil would come up and I would be licking the ice cream with lipstick running all over my face. I still dress up when I go to see Marlon Brando!

Marina has a great style and a sense of drama. She is fascinated by the Japanese theater, and you can see its influence in her selection of colors and design.

Marina does her own make-up expertly. For this photograph she rounded her eyes to soften her features.

Her hair looks very well in a chignon. It's a style which accentuates her interesting face.

For her professional life, Marina wears tailored suits, skirts and pants. For evening she prefers the more luxurious look of long gowns worn with turbans.

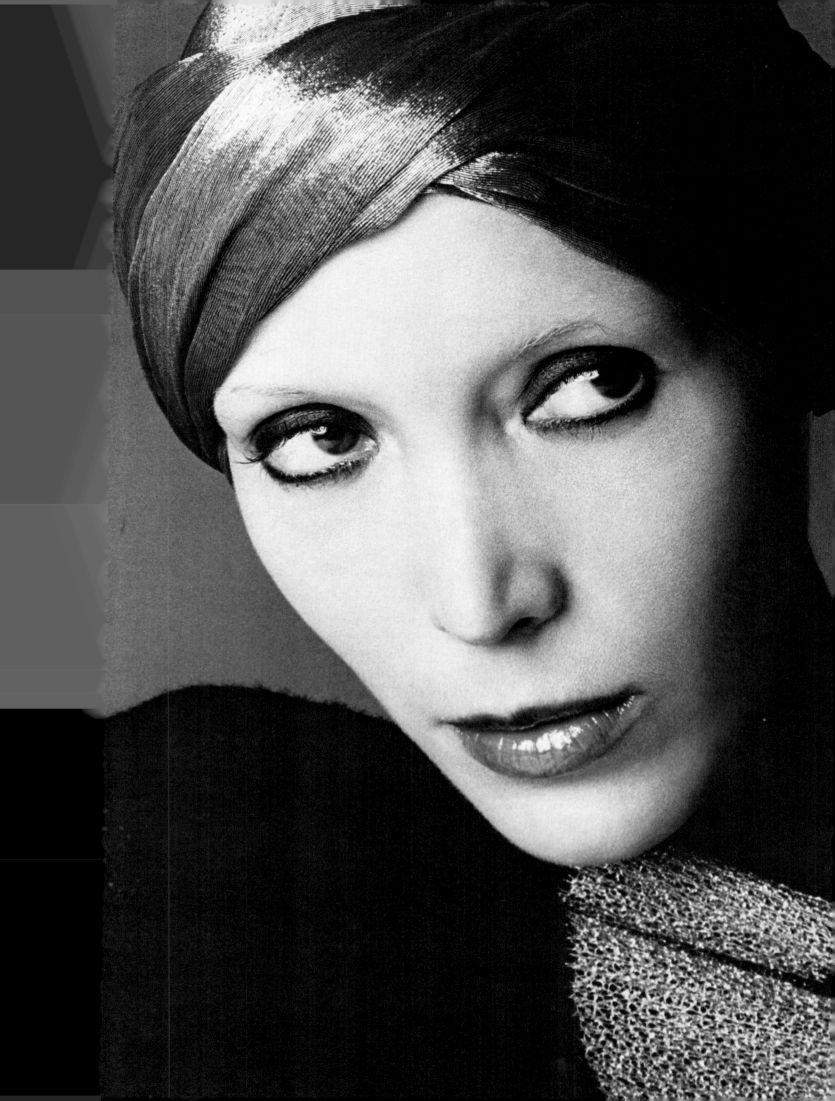

The art of maturing with grace and style

Eddita Sherman

Scavullo: How old are you, Eddita?
Ms. Sherman: Well, age is a quality of the mind.

Q. What color is your hair now?
A. It's gray, but I'm taking some Geritol and some vitamins and my nieces and my sisters agree it's getting black.

Q. You told me about two years ago that your hair was getting black because you were eating lots of yoghurt.
A. That was true. It's a combination of everything I take. I take this new vitamin that's about forty different vitamins in one.

Q. How come you don't seem to get any wrinkles? What's your secret?
A. It's not a facelift, if that's what you think.

Q. But what do you do to stay so beautiful?
A. Well, I guess I really don't live.

Q. Are you a vegetarian?
A. No, I eat everything.

Q. Do you exercise?
A. I dance but someone stole my slippers, so that put an end to that. But I'm skipping rope. And I keep that up for hours and hours.

Q. Do you use soap on your face?
A. I believe in everything that's natural, so I really don't make it a point to use special creams or soaps.

Q. You have make-up on ...
A. Just regular foundation and some powder that is very dark.

Q. Do you think about wrinkles?
A. Every woman does as she gets older. You really know that wrinkles shouldn't be there because you always think of a woman as being beautiful, you know, without lines, don't you?

Q. Why don't you have a facelift, Eddita?
A. I guess I never got really to that point where it had to be lifted. The only thing I would have done would have been my nose. I've had a thing about my nose. I don't know what it was, my father was a photographer, and he always wanted to photograph me from a side view. And I always thought my nose was so long that I just didn't like the idea. I always fought

"Age is a quality of the mind."

against it, and it was my nose and I always thought one of these days I'm going to take the plunge and really have it done. But I don't think it's necessary because it seems like it adds to my character. Now they say I look a little bit like Garbo.

Q. What does beauty mean to you?
A. It is actually the soul that reflects through the eyes and the smile that I would consider beauty. Much more so than two beautiful eyes and a pretty mouth.

Q. Are there any women you really admire?
A. I met Dina Merrill here and I thought she was very lovely. Betty Ford, I think she's a great woman. I admired Mrs. Roosevelt. She wasn't beautiful, but she was beautiful when she was young. She had quality. I used to think Verushka was very lovely.

"I'm very shy, but I seem to be just the opposite."

Q. Do you think old clothes make you more beautiful?
A. I really shouldn't wear those antique clothes but I adore them.

Q. Why do you wear those ribbons around your neck?
A. It's just a form of wearing a necklace.

Q. Do you ever get ill?
A. No. I'm very healthy. If I ever get a cold it's over in one day.

Q. What do you think is the world's greatest invention?
A. Television—it's just like a miracle, really. It's magic.

Q. Do you have any hang-ups?
A. I'm very shy, I seem to be just the opposite but I'm not. I was shy as a child and when I met my husband, who was a great deal older than I was, he said I belonged in the cradle with the rest of them.

Q. That's why you stay so young.
A. Maybe so.

Q. Do you smoke or drink?
A. No. Well, I'm starting to drink a glass of wine when I go to my sister's now. I take it for health's sake because they say it's good for you.

Q. How would you describe your own looks?
A. I'm very modest about myself. Years ago when I was just a teen-ager I always had a lot of trouble with men. I was traveling in Italy, and my parents caught men trying to propose and they caught them running from the dark room, and things like that. I must have had something, I don't know. Now I walk on the street and I get all kinds of comments ... I don't know, it must be my dresses.

Q. What do they say to you?
A. Men whistle. Even this morning I ran across the street and somebody made a comment. What I'm going to do is cut my own hair and have it styled like this wig. And I think I might leave my gray hair now. "THE NEW HAIR IS DEFINITELY COMING IN BLACK!"

Q. What is your favorite color?
A. White! Purity.

Q. How many children do you have?
A. Five. When I was twenty-five I had five children. I'm a good mother.

Q. Do you like perfume?
A. Yes, and I guess it's one of my extravaganzas! I like Joy because it's kind of sweet and it's like roses and I just adore roses.

Q. Talk about sex and beauty ...
A. Well, I think sex is a very personal thing. And I don't like the way people just talk about sex in conversation. To me, it is a very private and very religious, and I always regard it in that fashion, and if I hadn't I probably would have had love affairs with so many of the stars I've photographed.

Q. Do you think you could be more beautiful if you had more money?
A. I don't think about that at all. If I had more money I would invest it in stocks.

Q. Do you eat chocolates?
A. Cake and candy are my favorites, but it's really the worst thing for you—it's like poison.

Q. Do you sit in the sun in summer?
A. No. I used to when I was in Martha's Vineyard, but since I'm in New York I don't sit in the sun. Maybe that's one of the reasons I don't have too many lines.

Q. Do you set aside a day during the week when you take care of all beauty things?
A. No, I don't have time for that, but I'll take some time on a weekend, and I'll probably sleep all day. I've done that for years.

Q. What do you use to wash your hair?
A. I don't think any of the cosmetics really do anything for you or any of these shampoos. It seems that you have it or you don't have it.

Q. Do you have any permanent beauty problems you can't change?
A. Well, I'd probably change my face.

Q. What about your height? Do you wish that you were taller?
A. Yes, I wish I were tall rather than small. My children are all 6' tall. I'm only 5'2".

Q. What is your idea of a star?
A. A star is someone whose name has become a household word.

Eddita Sherman is famous for her portraits of early movie stars. A woman of a thousand faces, a thousand looks. A romantic, an eccentric with so much energy it makes you come alive.

Eddita takes great pride in her large collection of antique clothes.

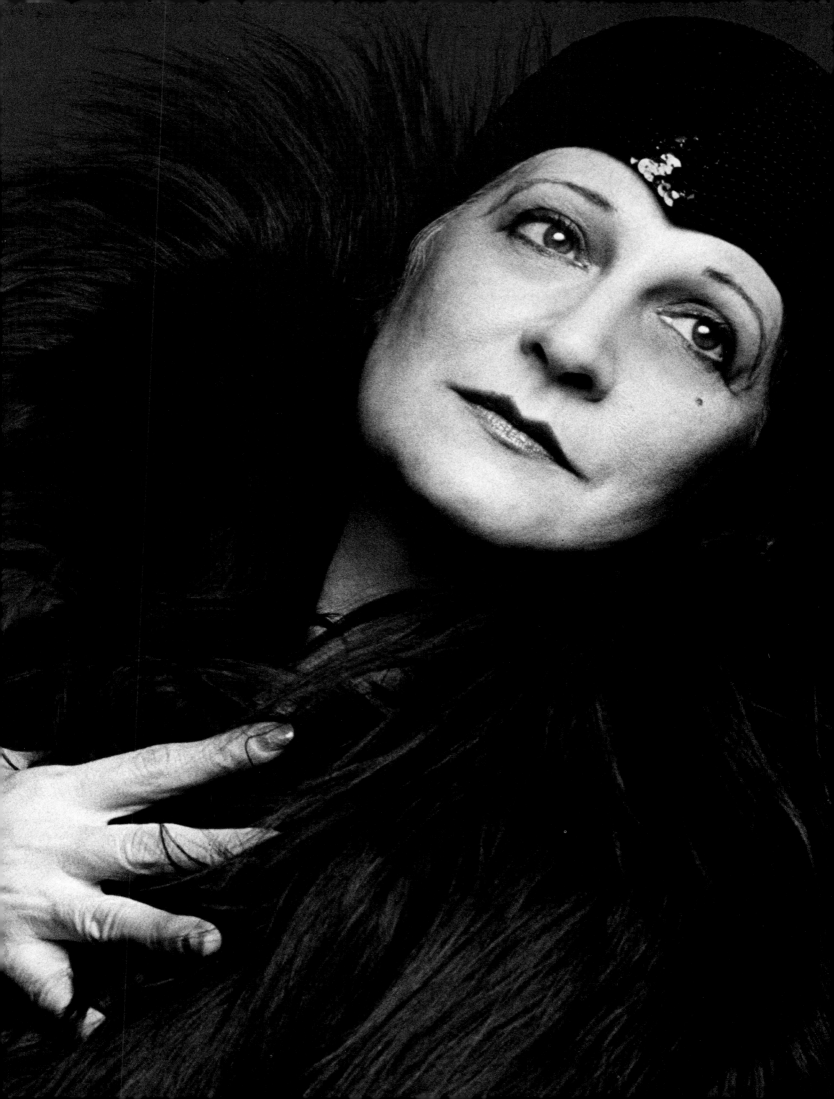

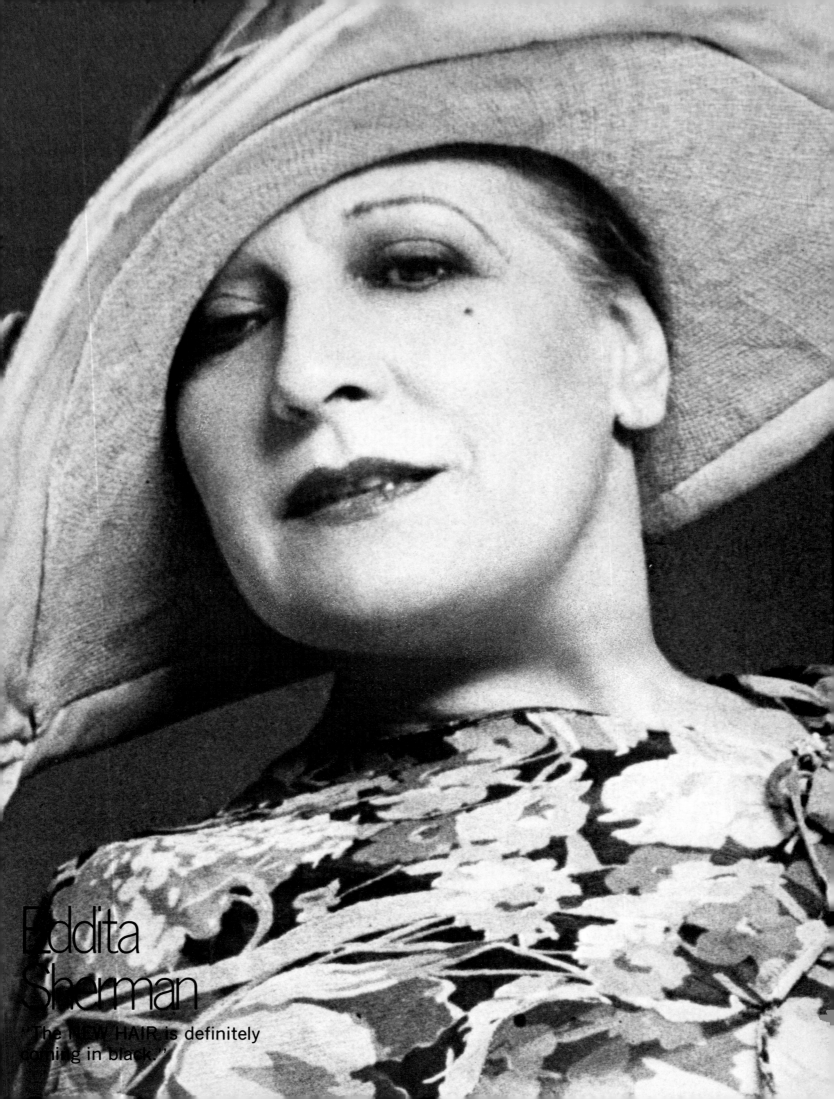

Eddita
Sherman
"The NEW HAIR is definitely
coming in black."

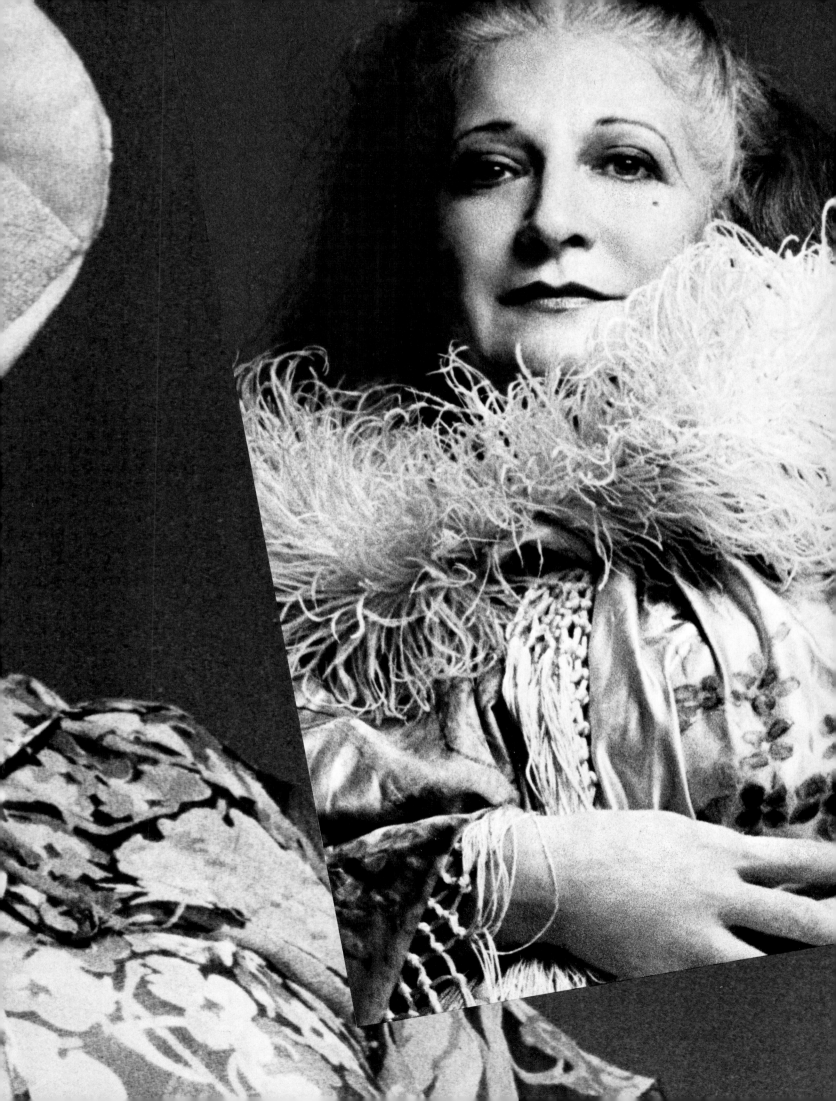

Know when to leave well enough alone

Brooke Shields

Scavullo: Who are your favorite women?
Ms. Shields: My favorite model is Rene Russo, and I like Shirley Temple as a little girl.

Q. Do you feel different from other girls?
A. I'm treated as a regular child. I love when my friends ask me what it's like to be a model, but I don't show off about it; I treat it as a regular job. Inside, I really like being a model. I enjoy it. I like Tatum O'Neal, too. The minute I saw *Paper Moon*, I thought, "I want to be like her." I'd love to be in a movie like that. I kind of like her hair cut short, but I wouldn't like mine that short. I want to cut it a little bit, though.

Q. What don't you like to do?
A. I don't like changing the Kitty Litter. Getting up early. I have to get twelve hours sleep; otherwise I'm not happy in the morning. I don't like it when they say "To be continued" in the middle of a show, it gets me mad. I feel yucky in the morning until I wash my face.

Q. What things do you like best?
A. Going to school, modeling—I think my job is educational, I always learn something— going to the movies and meeting a lot of people; and I have a pretend friend, and I love talking to her at night, I just talk in bed . . . she has no name. She's just a person who is my friend and a very good companion. When I've got troubles I go to my mother and her. And I like gymnastics and horseback riding. I love having my picture taken; it's fun.

Q. What color hair do you like best?
A. I like brown, mostly brown. My color.

Q. What is your favorite food?
A. My favorite meal in the whole world is steak and artichokes and then I like ziti. My father's Italian. My mother's Irish/ French/German.

Q. No wonder you came out so beautiful. Do you eat candy and cakes?
A. I don't like pastries or anything, but I like candy. I never eat cake at a birthday party. I like ice cream. Ginger ale and orange juice. I don't like milk. I like hot chocolate.

Q. Do you have any beauty routines?
A. I have special creams that I use on my skin that I got from my doctor. I have acne, just a little bit. I wash my face in the morning, I put cream on it, and that's it. I wash my hair every other day, and I use cream rinse.

"I like going to school and modeling. I think my job is educational. It never bores me."

Q. How do you think you look?
A. I would say I have dark blond or light brown hair, blue eyes—and when I look in the mirror I think I'm pretty . . . I'm happy. Sometimes I walk around dancing and looking.

Q. How do your friends describe you?
A. They'd probably say I had brown hair, blue eyes . . . I don't know.

Q. What makes you the happiest?
A. Lots of things make me happy, but I like it to be cold and for me to be warm. And I think photography is good. That's my favorite subject in school.

Q. Are beautiful women different in pictures?
A. Some people are really pretty, but when you take a picture they look much different. Sometimes they're prettier in person. Most of the time they look prettier in person.

Brooke Shields is a sparkling, enchanting child model.

She should be dressed in ermine and silk like a little princess.

Brooke
Shields

''I like for it to be cold and for
me to be warm.''

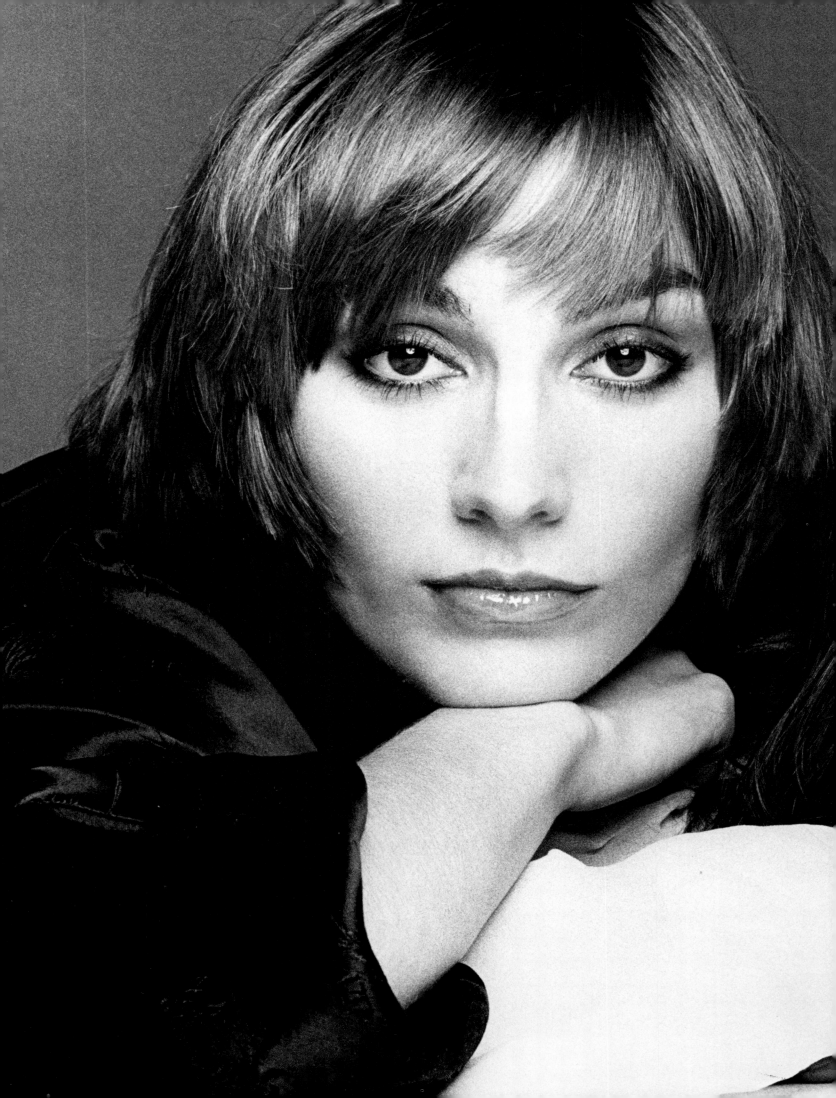

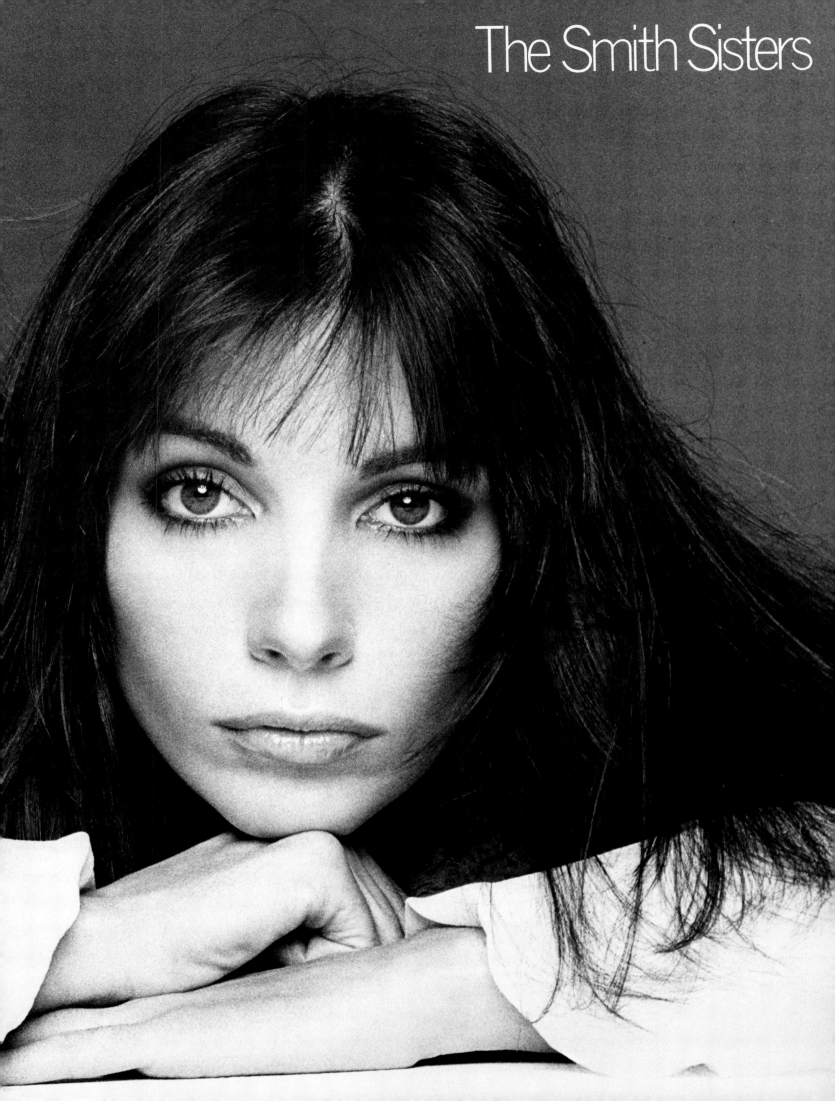

The Smith Sisters

The Smith Sisters: Geraldine and Maria

Geraldine Smith

Scavullo: Do you take care of yourself?
Ms. Smith: I try to go to bed early and get up early. Sometimes, though, I just go crazy and stay up a couple of nights because I want to have fun and stay out all night. I never drink, and the only time I smoke is when I go out socially with a lot of people who are smoking.

Q. Do you enjoy smoking?
A. No, I get sick when I smoke.

Q. Then why do it at all?
A. It's probably an insecurity thing. I don't drink because it makes me sick. Every time I drink, I get instant hangovers. If these things didn't make me sick I'd probably do them. I don't take drugs. I have a very fast metabolism so no matter how much I eat I never gain any weight. I'm very very skinny. I try not to eat junk food like candy, and I'm allergic to chocolate and strawberries—if I eat them I get hives, blotches, rashes.

Q. What is your usual diet?
A. I have juice every morning, grapefruit, yoghurt or health cereal, and I take vitamins every morning. I don't eat meat more than twice a week. I like to eat fish, fresh vegetables—just healthy things. I can go crazy and eat a pizza, but not often. It just makes me sick.

Q. Do you exercise?
A. I take dance lessons twice a week. I find that when I don't take them I feel horrible. It's an addiction. When I first went to dance class I was very thin, and my body became much firmer—I even looked bigger. I'm very small-chested, and dance made my breasts look a little rounder and my bottom a little rounder. Mentally it's great because I get rid of all my tensions. That's how I get out most of my tension, aside from sex. I also walk a lot, and I'm always running.

Q. Do you think sex plays a big part in being beautiful?
A. It really makes you look good and feel better, and it releases tension. I know it puts a smile on my face.

Q. How do you take care of your skin?
A. I put ice cubes on my face when I get puffy. Sometimes in the morning after I've been out late, I put a hot, hot towel on my face, and then I put cold cream all over my face. After that I tissue it off, and then I put the ice cubes on because they really tighten up your pores, wake you up, and make the puffiness go down. I try to get a facial at least once a month, and I really try to cream my face and clean it well with a very strong astringent. I never use soap on my face, and I try to use cream on my body after every bath.

Q. What products do you use?
A. I found out the cheapest things are best. Vaseline is as good as eye cream. My girl friend bought a jar of eye cream for thirteen dollars in a tiny jar. We looked at it, and it contained only Vaseline plus some perfume junk they put in that really makes you break out, especially if you have sensitive skin. What I use for my face is Cetaphil Lotion by Texas Pharmaceutical. It costs two dollars and it lasts so long. It's very natural with no chemicals. It's the most natural thing you can put on your face. I sleep in it and wash it off with cheap, cheap astringent, and it makes my skin look the best. I find Lupiderm is the best thing for my body, it's also about two or three dollars. I think it's silly to spend tons and tons of money on things like cosmetics and clothes.

Q. Where do you find your clothes?
A. They're mostly things people give me or things I find really cheap in thrift shops that I love. Somebody bought me a silk blouse for a hundred ten dollars, and I wore it once. It makes me look very ordinary—I look horrible in it.

Q. Do you read fashion magazines?
A. I just browse through them. I can't stand the way models look; they all look the same to me.

Q. Do you like to use make-up?
A. I used to wear so much make-up—face make-up, eye make-up, lipstick. Now I don't think girls should wear that much. I think they should wear whatever make-up emphasizes whatever beauty they have. Some people should just wear eye make-up, some just lipstick. It depends. But too much make-up simply hides anything that you have.

Q. How do you take care of your hair?
A. I dye my hair because I hate brown. I think red hair suits me. I feel it's my own color because it goes with my personality.

Q. What about cutting your hair?
A. I used to cut my hair myself because I couldn't find a hairdresser who would give me my own individual shape. Then I thought maybe I was cutting against the grain of my hair and should have it done professionally. So Harry King cut it; he just trimmed off the edges and did my hair exactly the way I had done it.

Q. Is your hair easier to take care of now with your new cut?
A. I never use a hair dryer because it's very bad for hair; it dries it out and it burns it. I just put a towel on it and shake it and let it dry.

Q. Do you have any beauty imperfections that you can't change?
A. Well, I always wanted to be around 5'11"

Q. When do you feel you look your best?
A. I think I look my best when I wake up in the morning.

Q. What does beauty mean to you?
A. I look at some people and I think they're physically beautiful, but to me somebody isn't really beautiful unless they have personality or soul or are good or honest. I don't care about looks at all. Even the men I like are not particularly good looking, but they have power and personality.

Q. Are there women that you consider beautiful?
A. I think Ursula Andress and Brigitte Bardot are gorgeous. Ursula Andress has a perfect face. She's beautiful to me physically; I don't know what she's like otherwise. And Bardot is beautiful because she's sexy, she's like a little girl and a woman. I like Charlotte Rampling because she has character. I like people who have character to go with their beauty.

Q. How do you go about analyzing yourself?
A. I like to be alone a lot so I can think and sort things out in my head and ask questions.

Q. What makes you feel good?
A. I guess money would make me feel really good, but many people who have money are miserable. I guess if you were really happy before you had money, then money can only make you happier. I guess what makes me happiest is to be with people I feel comfortable with, people who really have a sense of humor. Then I can have some hearty laughs.

Geraldine is an aspiring young actress. A girl with a lot of feline in her face, she has strong bones with a sleek quality; she's not "bony." Physically small, she's got great power, a hypnotic charm.

If Geraldine wanted to, she could wear just a bright scarlet mouth and nothing else. Her eyes need very little make-up.

Her hair length is right.

A girl who looks fine dressed masculine or feminine. She has the best collection of shoes ever.

154

Maria Smith

Scavullo: What is your personal approach to beauty?

Ms. Smith: I keep my hair clean, and I work on my skin. I have a very thorough facial every three weeks at Marie Gedris. I like my skin to feel really, really clean; when my skin feels clean I feel great. But I do believe in make-up. I think your hair should be cut well, and that your skin should be good and that you should always look nice. I could feel comfortable in a pair of slacks and combat boots, and I also feel fabulous in a chiffon dress. It depends on my mood.

Q. Besides the facial, how do you take care of your skin on a daily basis?
A. I use a cleanser rather than soap, and then I use a camphor astringent on the oily parts of my skin, and I just put some moisturizer on and that's it.

Q. Do you always use eye make-up?
A. Yes, I use Kohl for my eyes. I found it when I was in Marrakesh about eight years ago. It's supposed to be medicinal, and it comes in a powder. When I go out at night I like to wear more make-up.

Q. What is your idea of beauty?
A. It's not just a physical thing, it's something else besides. It's like a friend of mine once said when he was talking about people, "Che non che." In Italian that means, You either have it or you don't. If there were ten girls up against a wall, and they were all equally pretty, there would always be one that would stand out, or one that would be more appealing, and it's usually because of personality or just a certain thing within.

Q. Who are some of the women you admire?
A. Silvana Magnano is a phenomenal beauty; I think her face is incredible. I think Bianca Jagger's face is beautiful—besides being pretty, she's interesting looking. I like Jacqueline Bisset and Charlotte Rampling. Another thing about beautiful women is that I like women that are beautiful who are also intelligent, that also have incredible personalities. I think a lot of women are hung up on always being feminine. I feel my femininity down to my bones, and I'm not the least bit hung up about thinking about being feminine; I never think about it, it just is. A woman who is able to cope with every different kind of situation and still remain a lady, to me, that's being a woman.

" 'Che non che'—you either have it or you don't."

Q. Do you spend a lot of time taking care of yourself?
A. Yes. I don't go to beauty salons and things like that, but I buff my fingernails—I really like old-fashioned kinds of things. For instance, I don't like nail polish, but I love to buff my nails and I love them to be pink. And I love taking a bath in delicious bath oil and having the telephone next to me and having a good record playing—that's ecstasy! And I love getting out and having a really fabulous towel, and then an incredible nightgown. I have a lot of thirties' nightgowns. And I like Kiels Gardenia bath oil. Perfumes usually bother me—I don't like it when I'm near a woman and I smell perfume. When I put perfume on, I put it on in ways that you could only smell if you were really close, like if you're kissing me. And the only perfume I've ever used is called Fracas.

Q. Tell me about the foods you eat.
A. I like really good healthy foods. I like to eat mostly protein and not too many carbohydrates, but there is also a side of me that occasionally likes junk food. I love ice cream sundaes, hot fudge sundaes. I like things like that, and I like places where you go in and press a button and you order, and by the time your car goes to the window it's ready. It's so American. I also love Italian food.

Q. What do you usually eat for breakfast?
A. I always eat breakfast; otherwise, I get very weak. I usually have an egg and bacon and a glass of juice, or I'll have oatmeal.

Q. Do you drink coffee?
A. I never ever ever drink coffee; it makes me very nervous.

"Small women usually have better personalities. If you're small, you're something definite."

Q. What about alcohol?
A. Well, that's very strange because I was a product of the drug generation, so when I was growing up you didn't drink—you just smoked or did whatever you did. And I've only started drinking in the last year, and I didn't like it at the beginning because I couldn't stand the taste. I used to get headachy. It's only been recently that I really started enjoying it, and I do love cognac.

Q. Can you describe your own looks?
A. I think I'm kind of Italian-looking; I'm not American-looking, that's for sure . . . I think I have a look!

Q. What about your height?
A. I'll tell you . . . small women usually have better personalities. I would rather be small the way I am or very, very tall; I wouldn't want to be in-between.

Q. How do you like your hair?
A. I like my hair when I can just shake my head and it looks okay—I don't like hair that you have to worry about.

Q. Why do you have bangs?
A. Because for years I wore my hair back, and I got really tired of it, and I decided that I wanted a different look. To me having good taste is being imaginative and combining lots of things, and having it look good. I would rather have one good pair of shoes than have ten pairs of cheap ones—I like good quality. I don't mean necessarily something that is expensive but I like good quality. I love to wear cotton in the summer, not polyester, but cotton—good cotton skirts and little camisole tops for the evening. I have a lot of things for the summer that are made of gauze. I love to wear clothes that make me feel kind of sexy.

Q. Can you describe something you wear that makes you feel and look sexy?
A. In the summertime I love being on a beach with a piece of fabric wrapped around me.

Q. What do you really like to spend money on?
A. Bath oils, good towels and clothes I really like, like a beautiful dress. Another thing that really relaxes me and makes me feel beautiful is lying on a beautiful beach—it's usually in Italy and I'm lying in the sun and I have Lazlo Bronzing Oil all over my body, and the scent of that with the scent of the beach, the sand and the sea—all that is just something that puts me somewhere.

Q. Do you still wear young and crazy outfits?
A. Yes. You see, that's another thing; there's a side of me that likes to wear a chiffon dress and look very soft and feminine. But on cold days I might wear a pair of blue jeans with leg-warmers over them. And I think that the leg-warmers are really very pretty, with red and yellow and blue stripes, and I think they are kind of sexy at the same time. There are times when I really like to dress with imagination.

Q. When do you think you look your best? Daytime or evening?
A. In the evening. In the daytime you're usually doing something, you're thinking about something, you're working or whatever. But I think I'm best in the evening because it's usually a social situation with friends, and I can be really relaxed, so that makes me feel better.

Q. What are your hang-ups?
A. I think that everyone is insecure, but there are different degrees of insecurity. I guess I feel best when I'm secure in a relationship. I have a problem, and it might sound funny to you, but when I get too thin it's just as much of a problem as being overweight, because I tend to get really drawn. I'm a little underweight right now, so when I'm not hungry I have to force myself to eat. I'm at my best when I'm 96 pounds and I try to maintain it; if I'm 90 pounds, I don't look half as good.

Q. Do you think there are handicaps to being beautiful?
A. I think that maybe people may be drawn to you for the wrong reasons. A man may just like you because he likes the way you look and not because of what's inside—you know, your essence. The difference between Geraldine and me is that I identify completely with the Italian side of the family, and Geraldine identifies with the Irish part.

Maria, also an actress, is funky and outrageous, with great individual style and a catlike feeling in her face too, like her sister.

With her very definite bones, she needs her eyes brought out with feathery lashes, mascaraed and curled, highlighting on the brow bone, plus a dark lid. There's not a lot of differentiation between the color of her skin and the color of the lips, so a pink gloss was used to give her a healthy look.

This is a good hair length. We trimmed it slightly.

Maria has an "Italian" taste in clothes, very colorful, very personal.

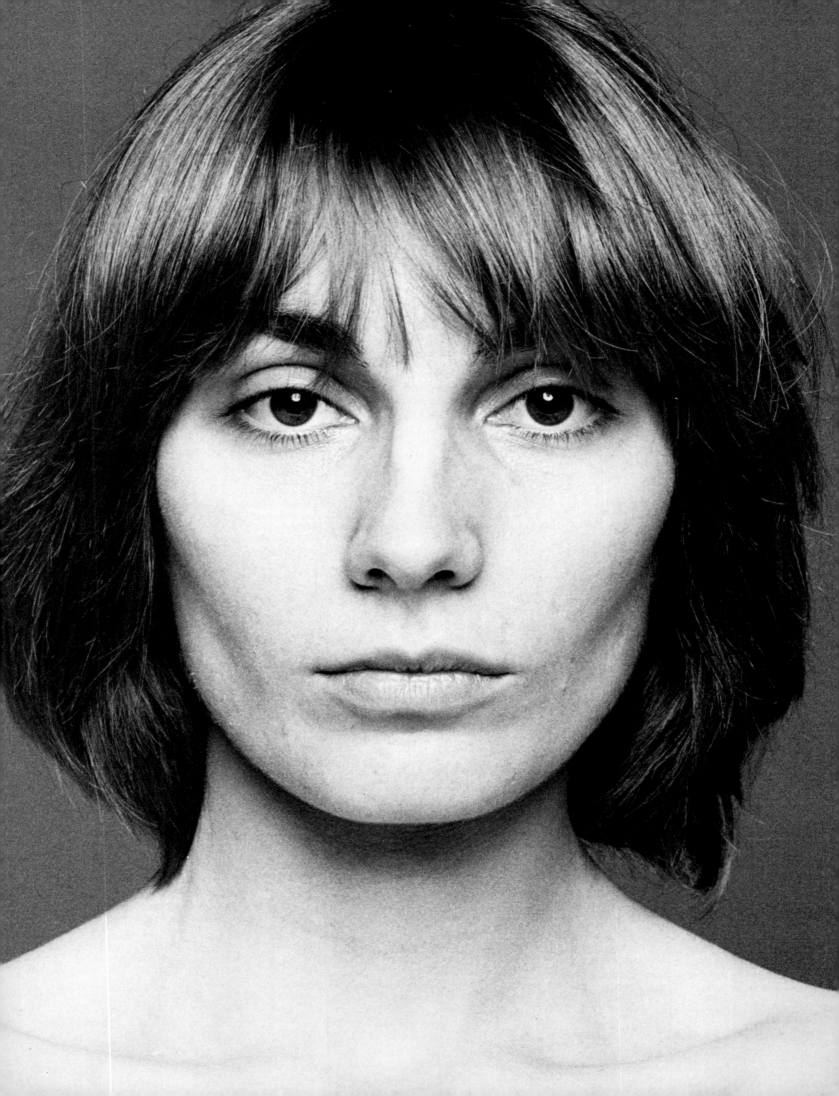

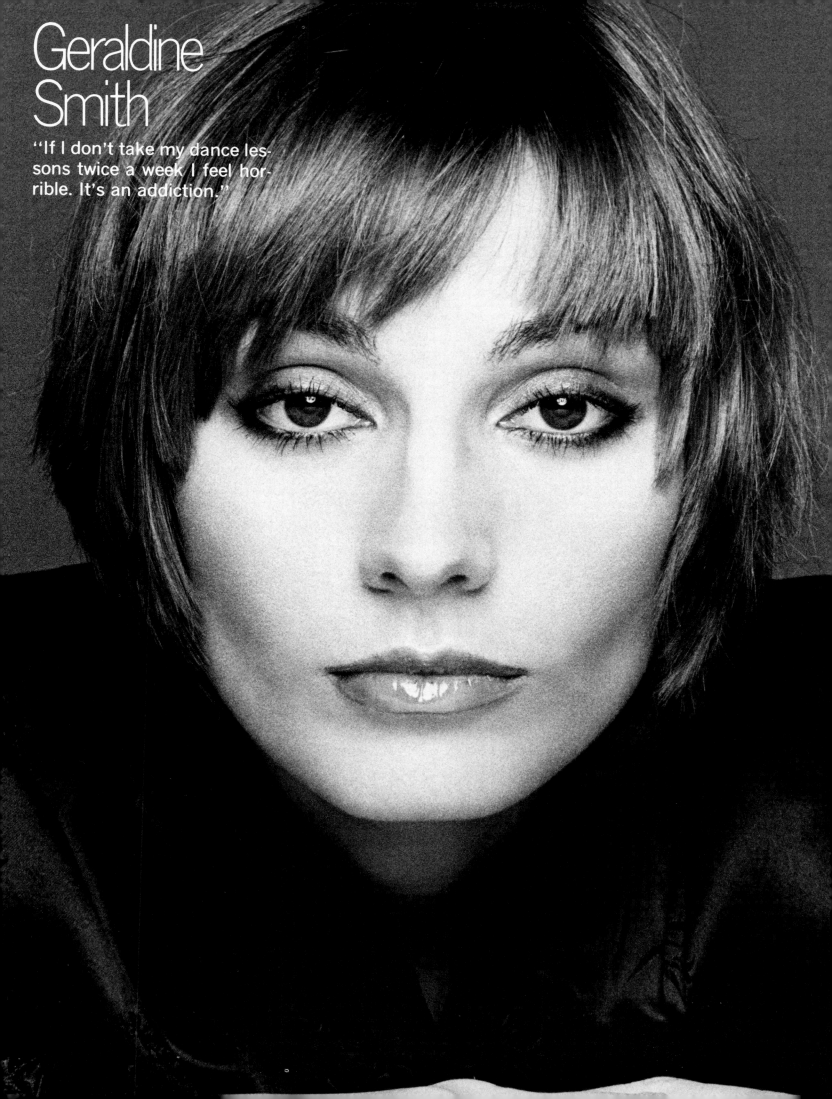

Geraldine Smith

"If I don't take my dance les-
sons twice a week I feel hor-
rible. It's an addiction."

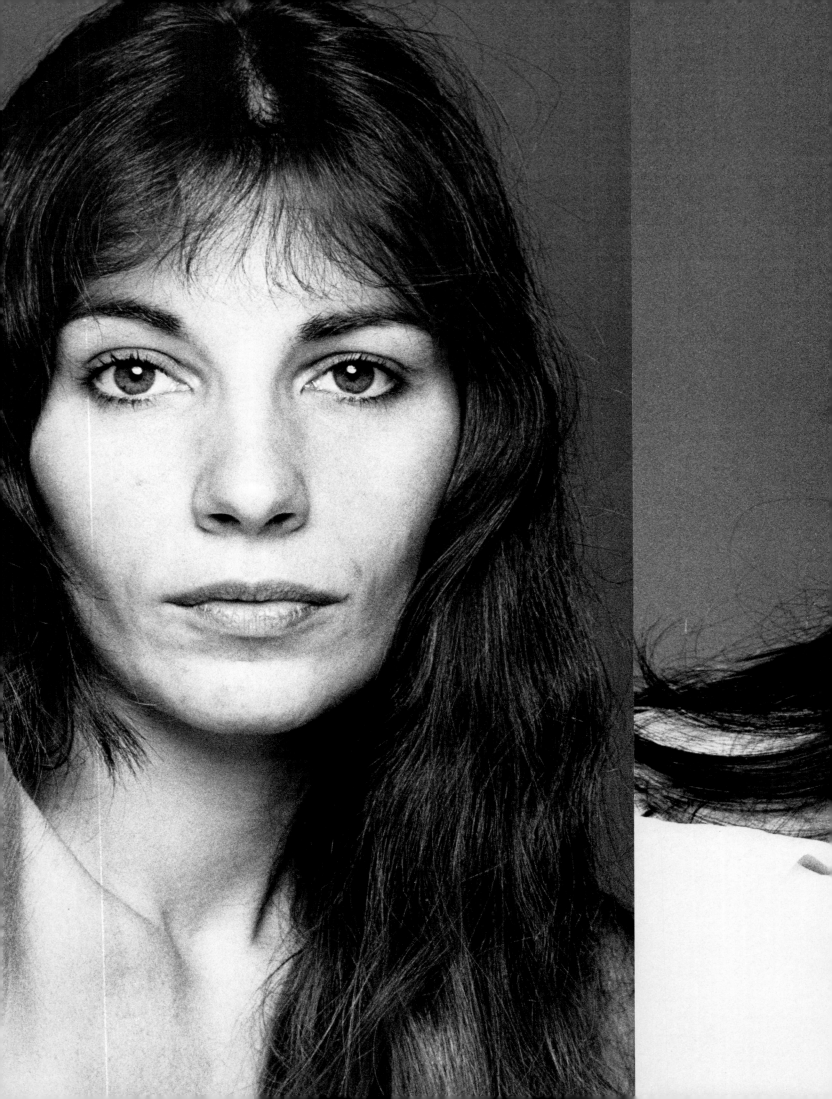

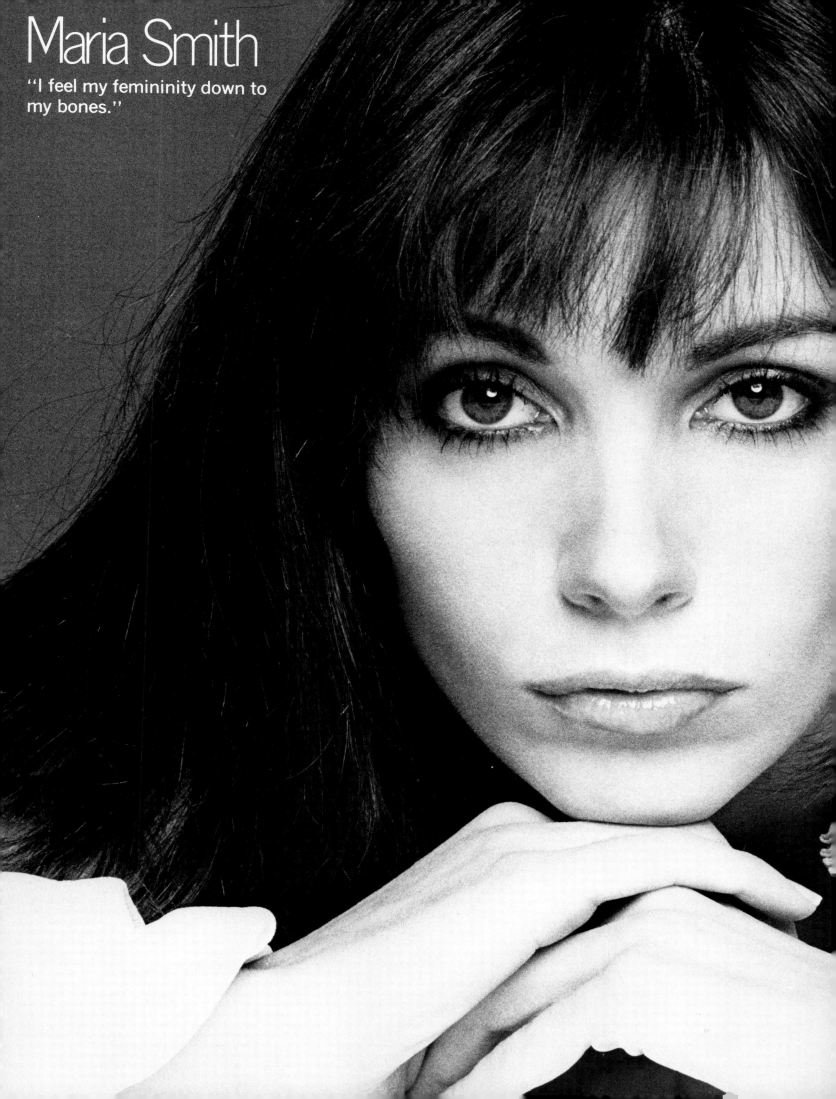

Maria Smith

''I feel my femininity down to my bones.''

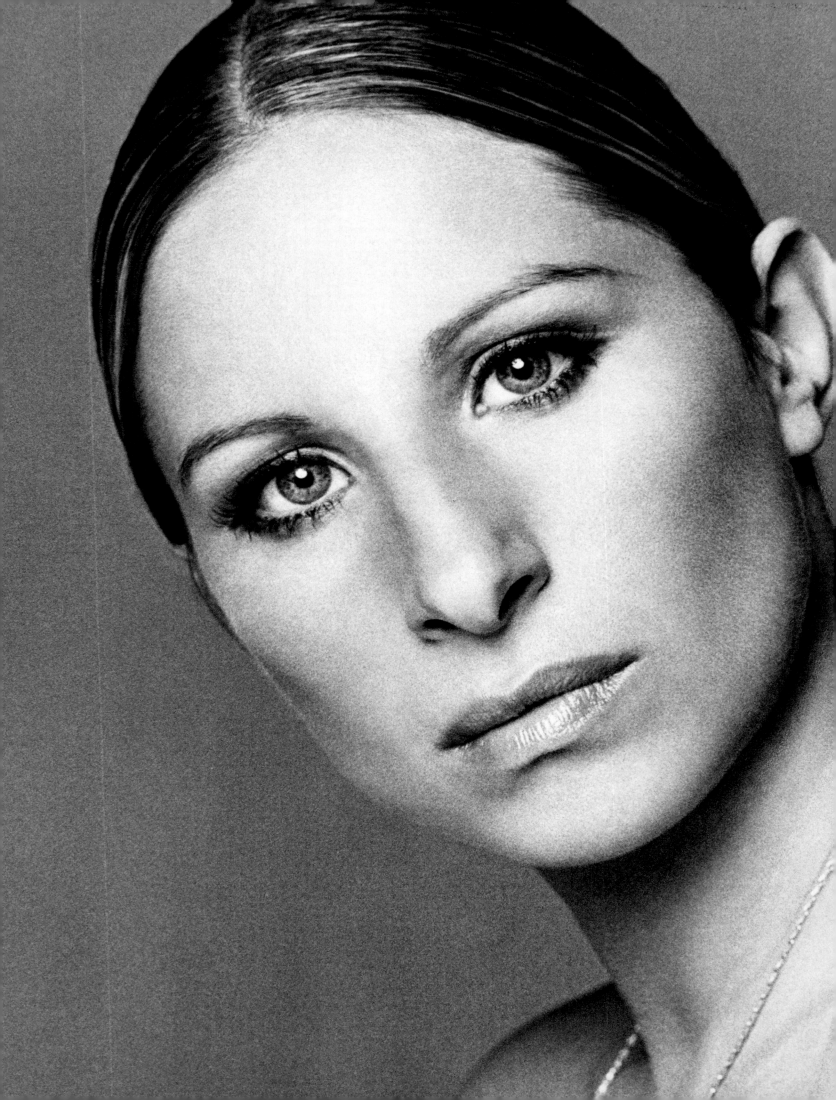

Don't play by the rules; make your own

Barbra Streisand

Scavullo: I want to know if you were born with this beautiful skin and hair. Everything looks so glowy and healthy. Do you have to do anything to your skin?

Ms. Streisand: Keep it clean.

Q. What do you clean it with?

A. I use very unglamorously packaged, unscented dermatological soap, and then I put on the same type of moisturizer. If I have time, I try to steam my face once a week over a tea kettle. And then, if I *really* have the time, I use a very pure, grainy cleanser.

Q. What about your diet?

A. What about it! I think the single most difficult thing to do is to diet. There is nothing I like better than chocolate soufflés, yogurt with honey and crushed almonds, tempura and Chinese dumplings.

Q. Do you exercise?

A. The *second* most difficult thing to do is to exercise! You see, there is also nothing I like better than lying around and just hanging out. Perhaps there's an occasional stroll—to the refrigerator. When I am preparing for a film, I *have* to exercise. In that case, a lot of hard work and worry contribute to keeping my weight down. When I'm not working, I try to go to

> "When I am preparing for a film, a lot of hard work and worry contribute to keeping my weight down."

> "There is nothing I like better than lying around and just hanging out, with perhaps an occasional stroll—to the refrigerator."

The Ashram once a week. It's a very tranquil, spiritual place, where you eat only natural raw foods. They take you walking and hiking through the woods and on the beach, and every night ends with yoga. It's a place where there are no phones, television sets or cars, and above all, it's a place that's run by people who are as lovely as the clear lake we swim in. It's, heaven!

Barbra Streisand is a striking and unusual beauty. She has a strong sense of herself and a good eye for what works for her. I love to work with her because she knows exactly what she wants.

She does a great job with her make-up. Liquid colors, rather than powders, were used because we wanted to bring the warmth of color to her face. She just uses eyeliner and blends it in.

Her hair is pre-Raphaelite.

She loves antique clothes and jewelry and has a very romantic style.

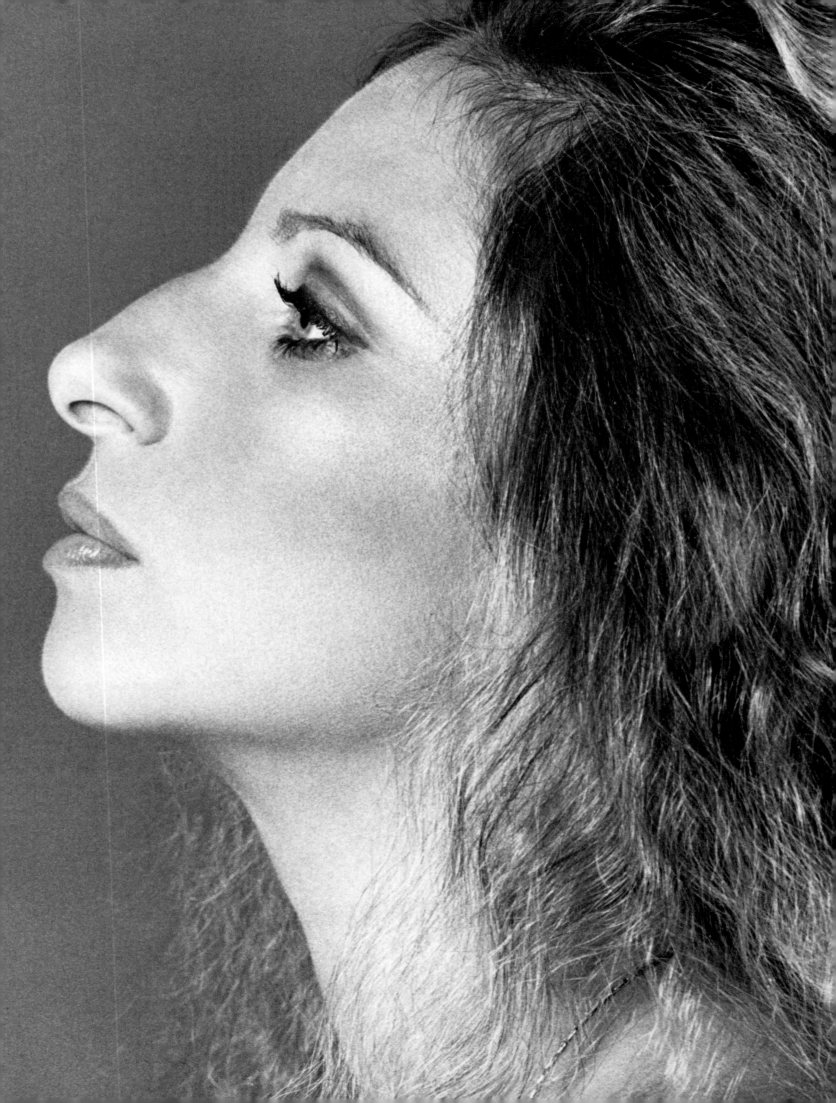

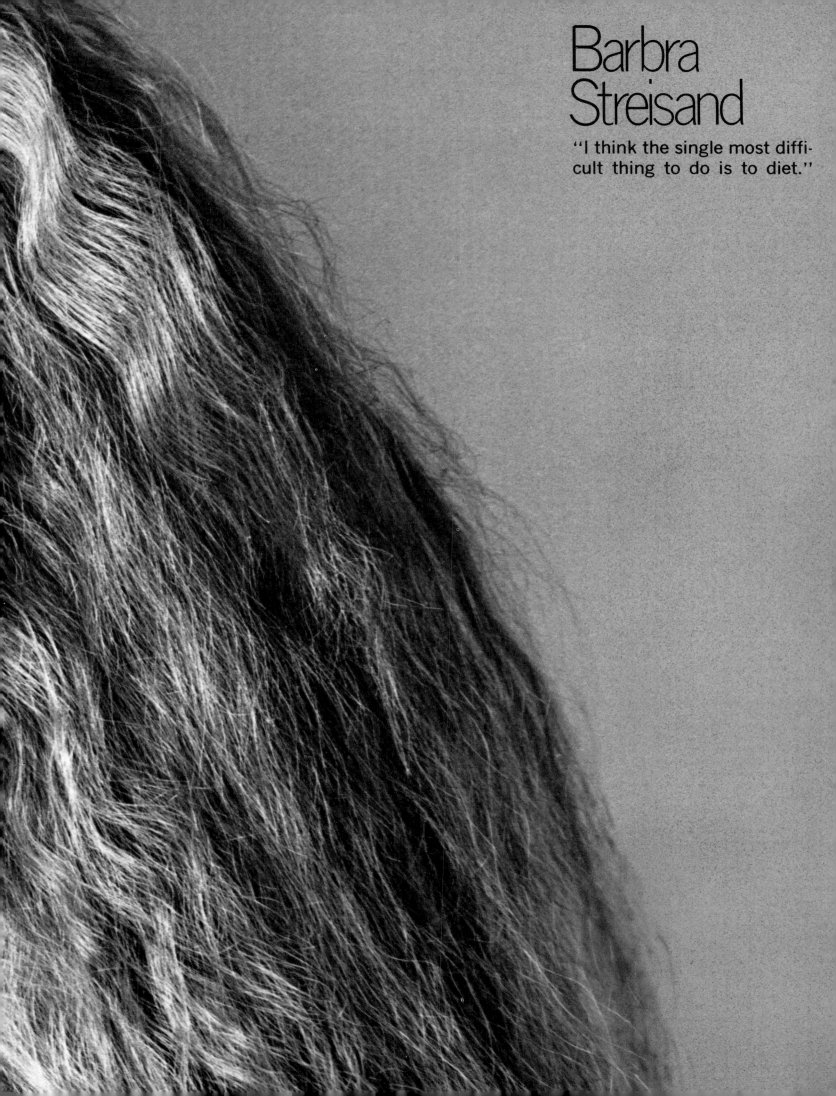

Barbra Streisand

"I think the single most diffi-cult thing to do is to diet."

Barbra Streisand

"The *second* most difficult
thing to do is to exercise!"

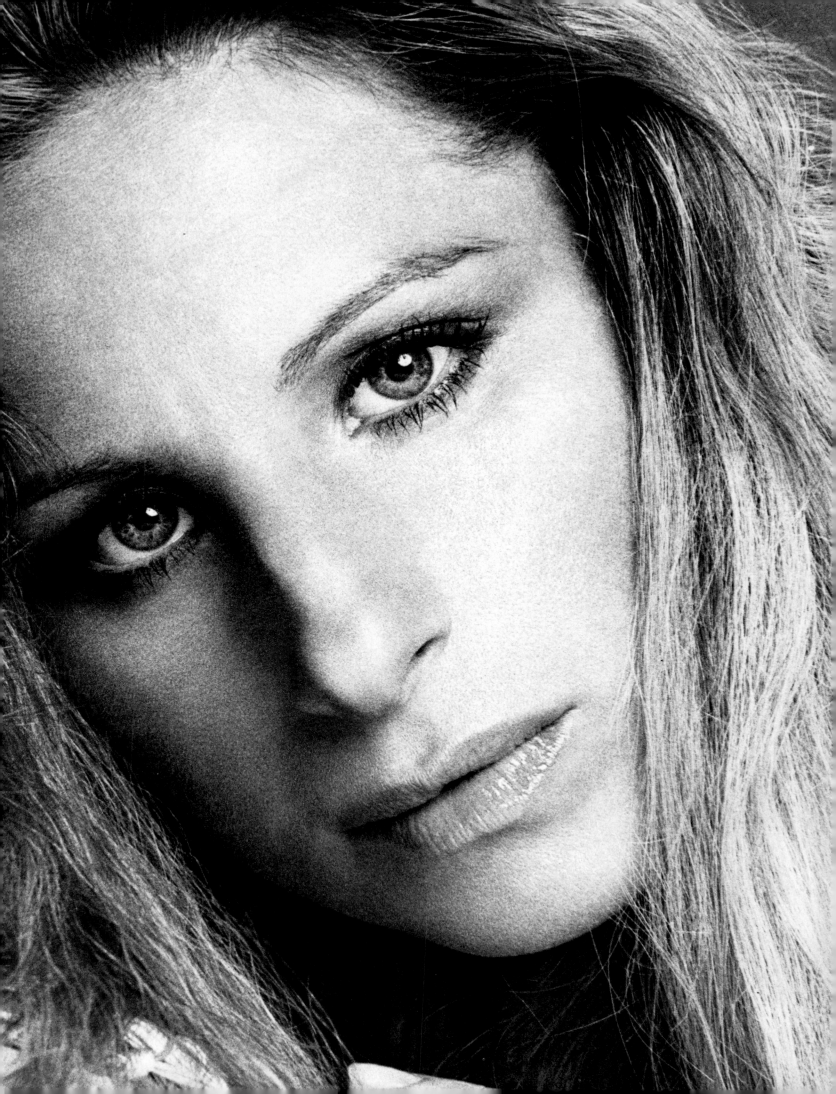

If you live a busy, public life, try to stay yourself

Joan Sutherland

Scavullo: What do you think beauty is?
Ms. Sutherland: Help! I don't think about it that much because I don't think of myself as beautiful. I think I've got a rather funny face. I enjoy a form of real beauty that exudes some feeling of vitality and being alive. I don't like something that's a mask, that is just a beautiful face. I can still look at someone and say, "Isn't she gorgeous, isn't she beautiful?" But then, that's just a passing thing; you don't know what's underneath all that. You can't really get to know anybody by just seeing a face pass by. But I also think that if I feel very down in the dumps, if I feel tired or if I feel worn out, rather than just lie in bed and look like an old hag, I'd rather get up and put on some make-up and make myself feel I look better. I do that purely for my own self, because it just makes me feel better.

Q. Do you use soap on your face?
A. Yes, soap and water—a good soap, though.

Q. How do you take care of your hair?
A. I very often do it myself because I find myself so pressed for time. It takes at least two hours to get into a beauty parlor and sit there and have it done. When you have a busy schedule, it's much easier to get into the shower in the morning, shampoo it and dry it, and put it in some rollers—and be answering mail or telephoning at the same time.

Q. Do you diet?
A. I don't go above a certain level—and I'm not about to say what that level is—but if I see myself getting heavier, I just cut down on the sugar and starches.

Q. What kinds of foods do you eat?
A. I love pastries and I adore dessert. I don't like sweet coffee and tea. I'm really rather overweight—but I'm tall enough to make it look not too bad.

Q. How would you describe your own looks? And how would your friends describe you?
A. Healthy. I think my friends get carried away between the real me and what I do. Most of them tell me I'm mad, actually.

Q. What kinds of clothes make you feel the most comfortable?
A. A simple-line dress with a shirt-type front, with not too much of a cinched-in waist; perhaps more of a princess line.

Q. What kinds of evening clothes do you like?
A. Again, I like comfortable things—not too dressy. I like to wear caftan-type things—straight and rather loose—for dinner in my own home. I like very strong colors—good greens, purples and mauves, blues, turquoises.

Q. Do you use perfume?
A. I've been wearing Ma Griffe for so many years that people can tell when I'm coming. I even use Ma Griffe soap and bath oil.

"My chin is rather jutting, and I try to wear hair styles that help tone it down."

Q. Do you have any specific pointers to help people evaluate their looks?
A. It's very hard to judge it for yourself. I've been very fortunate—my husband has always had to sit out front and see me onstage, and he's said things like, "Sometimes the way you hold your head can accentuate the tilt of your jaw." I have a very strong jaw and really high cheekbones.

It's such a long line from the ear to the tip of the chin, and I must try and alleviate this rather aggressive-looking strength. Also, with my size hips and small bust, I have to dress in a way that helps that situation.

Q. Can you talk about lighting?
A. In the home, we have quite a few dimmers—we subdue the lighting, for the most part, and turn on a brighter light if we really want to see something.

Q. Do you think American women could stand some improvement?
A. There is a big tendency for many American women to dress a bit too young. Some of the aging ladies still seem to think they are eighteen, and that sort of jars a bit. And I wish some of the teen-agers would dress up a bit more.

Joan Sutherland, "La Stupenda," is a statuesque woman with beautiful skin, devilish eyes and a lively sense of humor.

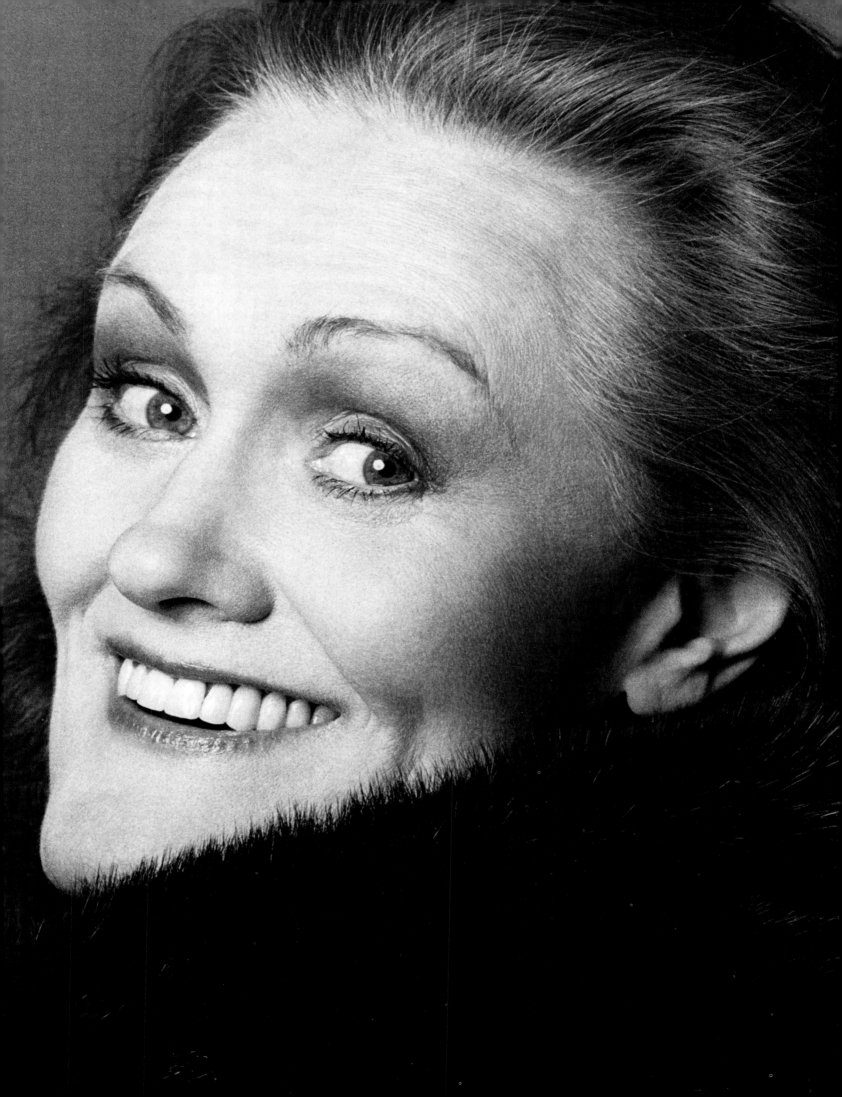

Dare to be yourself

Susan Tyrell

Scavullo: What does beauty mean to you?
Ms. Tyrell: Beauty's pretty weird. Personally, I go through such trips with it. For instance, I sculpt. I had a scholarship to art school, and I was headed for that as a career until acting interrupted my life. I bring up sculpting because there you take a lump of something, and perfect the line—knead and carve until you have the shape you want. I really get off on that, but I do not get off on taking care of myself that way.

Q. I understand you wear a turban most of the time.
A. Yes. I feel like my brains are held in when I've got a turban on, and it frames my whole face and my whole thinking. It frames me. Right now my hair is very, very blond and

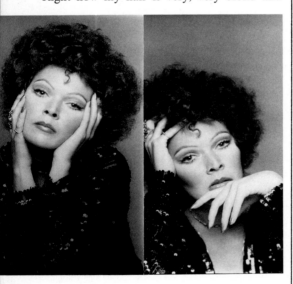

permanented from a film I just finished, so I've got a big Shirley Temple mane. That's nice, but just for my own mental thing I like to wrap the turban around and go to work and not become overly concerned about my looks. But there's no feeling like feeling beautiful, is there, goddamn it. But taking care of yourself is like taking care of your car.

Q. Do you do anything special to keep yourself in shape?
A. I don't keep myself in shape, I never have. I guess the thing about me is that the men I like are kind of primitive, and they'll say, "I just love your body the way it is. I've got something

I can hold on to." But I go through all kinds of feelings. On certain nights I feel wonderful to be so full, and on other nights I feel what fools men must be to like something so revolting. It comes and goes. I get very depressed about taking care of myself. I come from a family that is terribly athletic. My father was on the Davis Cup team, and my sisters were all win-

> **"I feel my brains are held in when I've got a turban on. It frames my whole face, my whole thinking."**

ners in tennis in New England. One of them is a skier in Norway now for six months a year, and teaches gym the other six months in Massachusetts. They're really athletic, and when they were all trying to hit me with tennis balls I just went under a rock. I like riding horses, and I'm a very good swimmer. I like the ocean.

Q. Are there women you think are especially beautiful or glamorous?
A. I love Anna Magnani and, of course, Hepburn. They are exact opposites. I love Hepburn for her extraordinary vitality and the marvelous morality of her thinking—clean, good old Yankee thinking. And Magnani for her torment and her blackness, the poisons in her and the black crow in her.

> **"I love my face, it's so me. I just wouldn't want any other face."**

Q. What are the things that make you look and feel really good?
A. Making love. And to be in top form creatively, that does it for me.

Q. How do you indulge yourself?
A. I eat pans and pans of popcorn. I have to have a few glasses of wine every night.

Q. Are there women you admire?
A. When I was growing up I saw a picture of Grace Metallious, who wrote *Peyton Place*. There she was on the back of the book with this lumber jacket rolled up and these bull-dyke jeans rolled up around her ankles, and her feet propped up on a typewriter desk, leaning over the typewriter . . . That to me was a place I wanted to be, I mean, it was romantic to me—it was an artist who worked. It's a kind of reverie. I've had moments when I've felt like that. When it's late at night and you're writing on something and you're alone and it's very exciting. That to me is it. I also write songs, and the songs that I love the most hit me at four or five in the morning. When I'm sculpting I love

to be covered in plaster, and my hands all cut and scraped and messed up from working with barbed wire.

Q. What is your best feature?
A. I love my face, it is so me, and I just wouldn't want any other face. And I love the part of painting it and putting it together for different characters. That's part of the acting art that I really like to do . . . and the meditation of putting the face on before I go onstage. It's a very beautiful part of acting, the quiet, the deep part. It's very important to me, whether it's a film or the stage. I love putting the paint on.

Q. Does the make-up damage your skin?
A. My skin is messed up all the time, and I'm thirty years old and I behave like a thirteen-year-old.

Q. Talk about food.
A. It's an emotional thing with me, and I get the shakes when I'm eating. I really feel the food making me warm. Most of the time I'm fat, but when I do work, boy, that stuff goes flying off.

Q. Do you like clothes?
A. I love them. I love them my way. I think clothes are very personal. I love Moroccan stuff, and I wear harem pants that I make myself, big balloon pants with elastic at the ankles, and I have about fifteen pairs, all different colors, and my turbans match my pants. When I get myself together I could just live in Chinese pajamas. I love that very, very expensive Chinese silk with the little flowers in a shinier silk. I love very deep blue silk.

Q. Do you like jewelry?
A. I love jewelry. I love symbolic jewelry. I made earrings that are very large crescent moons with a star that dangles in the middle of the moon. There is a turquoise stone in the star. It's the Moroccan symbol.

Q. Do you have any hang-ups?
A. I have one main problem, and that is that I get very down. But I'm sculpting, at least, and that's very good. When I'm up, I'm up—I'm doing everything at once.

Q. What are ten things you hate?
A. The ten things I hate most are unemployment times ten.

Q. What are ten things you love?
A. The ten things I love are to be told by millions "I love you" ten times a minute for the rest of my life.

> *A brilliant actress, an eccentric, a chameleon who changes with her moods. No one should change her, or they'll lose Susan Tyrell.*
>
> *She dresses old, new, wraps her head in turbans—and can look like anything she wants.*

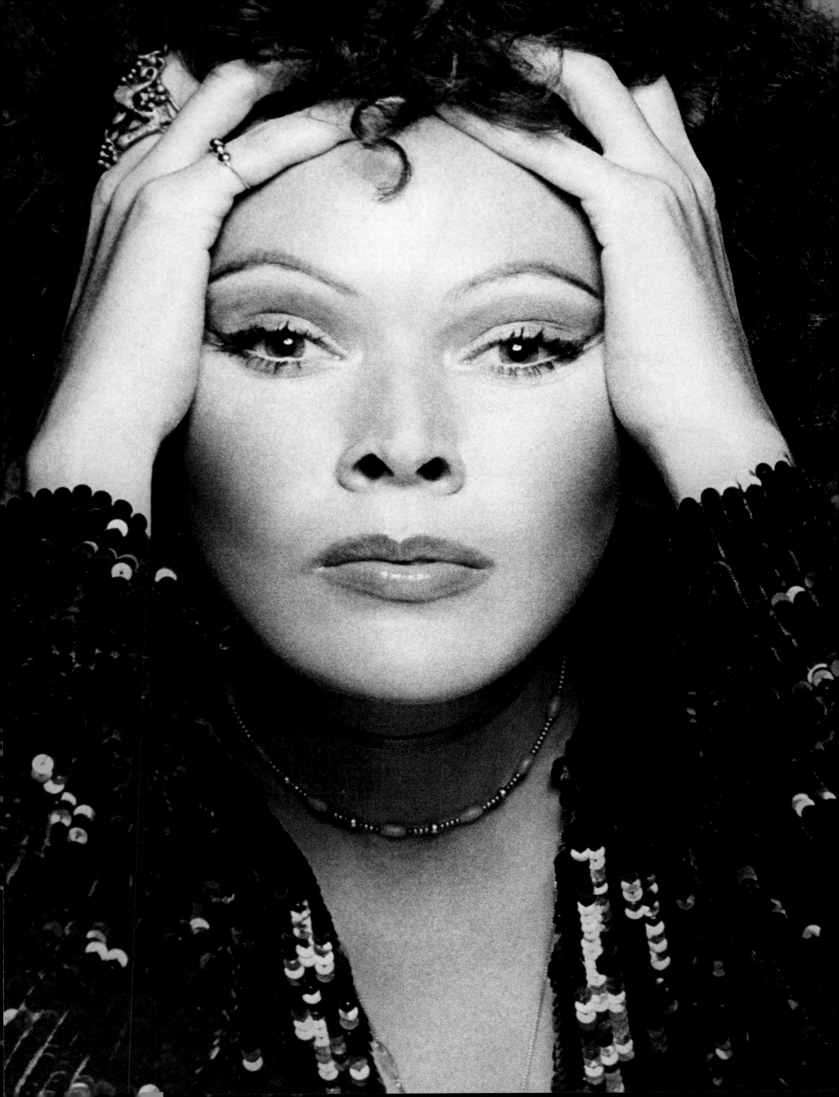

When your body is your most important possession—for your work, for your life, for your looks

Cicely Tyson

Scavullo: Do you associate beauty with physical attractiveness?
Ms. Tyson: I think beauty is an intangible thing. I don't think it's anything that you can put your finger on. I say that because I think the moment I became acutely aware of what beauty actually meant to me was brought about by a woman who lived across the street from me when I was a child. She had eight of the most beautiful children you've ever laid eyes on. One was more gorgeous than the other. But the woman, by all the Western standards we've set for beauty, was no beauty at all. I became very friendly with her because of her children, and as I got to know her I would think "What a nice lady." But it wasn't so much that she was nice, it was that she always made me feel a certain warmth and love, which I recognized, as I grew older, as definite components of beauty.
Q. As a child were you led to believe that your own physical attractiveness was important?
A. Oh, yes. I was conditioned by both parents to always look my best. They were both extremely handsome in the physical sense and terribly clothes-conscious. Daddy was a Beau Brummel, and Momma was the best-dressed woman around. They both had such style. Momma made most of her clothes and ours as well. The Tyson sisters always wore the best clothes. They weren't expensive—we certainly couldn't afford that—but Momma knew exactly what to do with a piece of fabric and a needle and thread. It always amazed me, and it still does. So "people judge you by the way you look" is something I heard almost daily throughout my childhood.

"I was conditioned by my mother and father to always look my best."

Q. Did your mother also teach you how to take care of your skin, etc.?
A. Make-up was a no-no. The closest we ever came to make-up was a little dusting of powder. Keeping clean and brushing one's teeth were just taken for granted. It would never occur to me to go to the breakfast table without doing that first.
Q. What about your hair?
A. The hair situation was a whole other thing because we went through that period when kinky hair was considered unattractive. I had very short kinky hair that was termed "bad hair." And anything anyone ever told my mother would make my hair grow or make my hair better, I was punished with. The worst-smelling shampoo, hair lotion, scalp cream, hair pressing, the tightest braiding, the corn-rows (which came about from someone telling my mother that if she corn-rowed my hair, it would grow—I was corn-rowed until my face was a mask of pain) were my punishment for having had short hair. Coincidentally, it was my hair that got me into modeling.

"I take care of my body because it's the only one I have. It is my instrument, the most important thing for my work."

Q. In the world of modeling and afterwards in the movies, did you become less conscious of the way you looked?
A. Material things became less and less important to me and I began to recognize them as crutches or substitutes for what I felt I lacked as a human being. I began looking more inside—inside my head, my body, my soul.
Q. What else makes you feel good?
A. I try desperately to eat well. Whoever said, "You are what you eat," knew exactly what he was saying. I try not to let a day go by without some form of exercise. I fast periodically and I meditate. I take care of my body because there's nothing more important to take care of. I run, work out at the gym, do deep breathing exercises and, as I said, meditate. As an artist, my body is all I have to work with. It's my instrument—my violin, my piano—and it's the only one I have and I never take it for granted.
I marvel at how people will buy things and take better care of them than of their bodies. If we really became aware of our senses of taste and touch and hearing—and the miracles we are capable of—we would realize that these things are not "forever."

Q. How do you feel about smoking and drinking?
A. I do neither. I tried smoking in high school—I didn't like the taste and I couldn't take the smell. It made me sick to my stomach. Of course today we know it's detrimental to one's health, and that's enough for me. As far as alcohol is concerned, because I was so thin as a child, my father made me drink a shot of sherry with an egg yolk in it every morning. I hated it and I think that killed off any taste for alcohol. Alcohol—I just don't need it. I get high from nature, people, music and love.
Q. What about diet?
A. Basically my diet consists of raw fruits, vegetables, nuts and lots of freshly squeezed juices. And as I said earlier, I fast periodically.
Q. Do you take vitamins?
A. I try to take vitamins when I travel abroad since it is frequently impossible to exercise control over my diet during those periods because of the changes, customs, etc.
Q. What do you think of the women you see on the street in America?
A. I have to deal with Black women first because we have to come a long way in regard to ourselves. For the most part, I feel very proud when I see a Black woman on the street because we have a greater awareness and pride in ourselves that used to be suppressed.
Generally speaking, I think we have a tendency in this country to eat too much of not necessarily the right things and the result is apparent.
Q. What about the make-up you see on the streets?
A. I think there's a much more natural look in make-up today that is more attractive and personal than it was in the past. It's simpler, more basic.
Q. Are there women you admire?
A. My mother—for all she taught me that led to the sum total of what I am today.

Cicely Tyson is an incredibly sensitive actress, one of America's best. Her face shines with youth, intelligence and an understanding of life.

Her eyes were elongated by blending in just a shade darker than her golden-amber coloring, and using eyeliner and mascara. Her bone structure is very important naturally. There's strength in her face, she doesn't need too much make-up.

I think she looks best with her hair pulled back.

She has great flair with clothes, very contemporary and simple but always with dash.

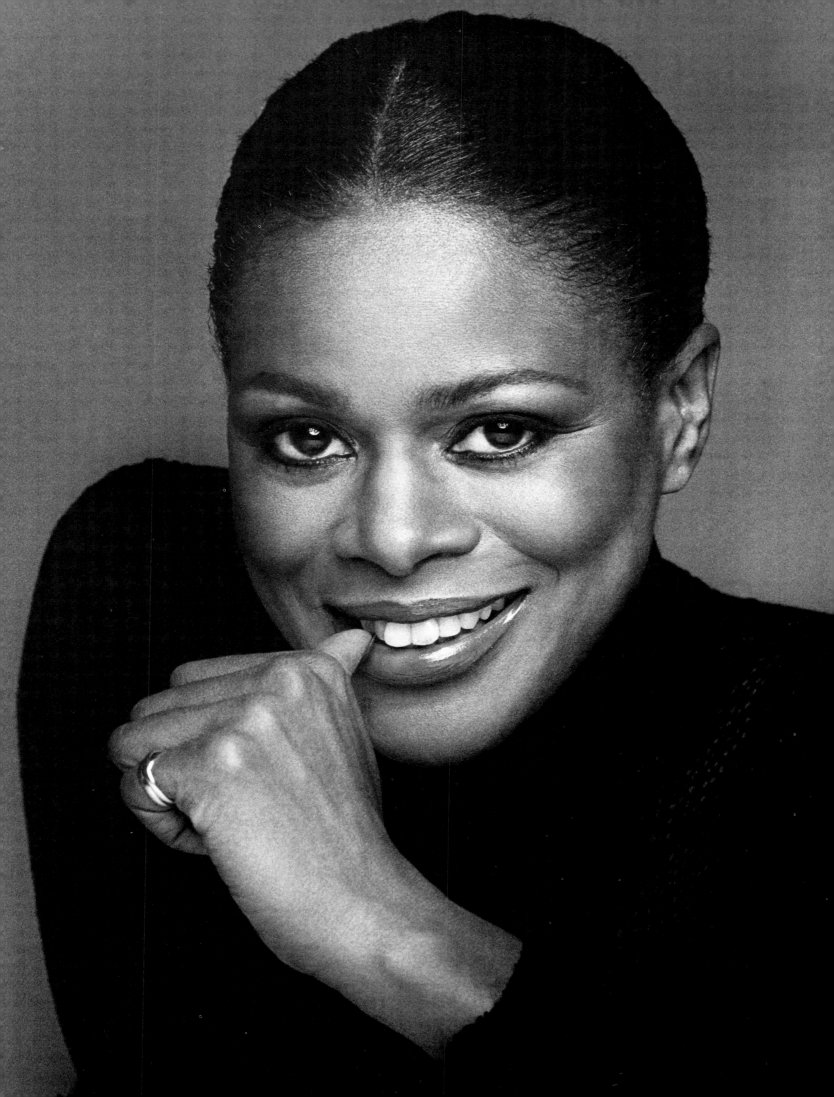

If you find a look that works, stick with it

Gloria Vanderbilt

Scavullo: You've had one look that has lasted you for the twenty years I've known you.
Ms. Vanderbilt: Well, I don't really think about my looks; they really have always worked for me, and I've always had a kind of confidence that's very important to a woman. I just don't stew about it.
Q. Do you find you're spending less time on yourself in terms of personal care, skin care, than you have before?
A. I'm very organized about the way I live because I'm involved in so many things. My painting . . . well, everything stems from that, and it's very important for me to keep the continuity I need to work. My work in designing, although it comes from my painting, is a whole separate mechanism. That's why I'm constantly working to try to organize my time so that I leave space around my life . . . so I don't get into a pressured syndrome. When I'm painting, I don't put on make-up because I don't want to have to think about how I look or what I'm wearing. It detracts from what I'm trying to accomplish. When I have business meetings during the day, then I really enjoy thinking about how I look, what I'm going to wear. I think the whole thing of fashion is that it should be something you enjoy, that makes you feel good about yourself. I think that's very important. I must say, I have fantasies about eventually working out my life so I have a big, enormous white room to work in and never have to worry about the way I look or what I'm going to wear. No mirrors, nothing.
Q. Your life has obviously changed over the last few years because of the growth of your business. Do you find that you are spending less time with hairdressers and skin specialists?
A. Well, I have that absolutely worked out. I have my hair cut once every six weeks, and I have the color done at the same time. My hair

is done so I can just wash it and dry it, and that's the end of it, no setting. I think that it's essential for someone as busy as I am. I can't take the time. For my skin I go to Janet Sartin twice a year, spring and fall, and I use her products.
Q. How would you describe yourself? Your looks seem to be so simple and so extravagant at the same time.
A. Trying to define myself is like trying to bite my own teeth.
Q. Are there women you really admire?
A. I really love women, and I relate to them. I really start out wanting to like every woman. I think another woman's success can only help my own, I never feel threatened or challenged. I admire Anaïs Nin, Carol Matthau . . . and Cher. I think she is absolutely divine. She's my fantasy daughter. I think she's so marvelous, first of all, the way she looks, everything about her. I'm always asking people what she's like. It's probably just as well I don't know her because it's just a fantasy of a marvelous daughter who is simply beautiful.
Q. What kind of time do you spend on exercise and diet planning?
A. Diet is a battle, and traveling so much I find exercise very hard. I'm an absolute walking dictionary of the number of calories in food. I do, from time to time, fast for a whole day. I think the most important thing about weight is to get on the scale every day. I like to stay between 113 and 115. So I get on the scale each day, and if I've gained three pounds, I fast for a day, because it will start to build up . . . five, then ten pounds. I love food.
Q. Are you interested in sports?
A. No, not at all. I walk, I go swimming in the summer. I'd like to have time, really. When I work I automatically do stretch exercises on the floor. I used to do gymnastics and enjoy it.

"The first thing to do is to start liking yourself and having a feeling of self-esteem. If there's something you really want to change, try to change it."

Q. Do you have any beauty problems you'd like to change?

A. I don't think in those terms. I think my best feature is my hands, because they are the tools that do my work.

Q. How would you suggest that someone else do a self-analysis?

A. I think you should do anything that makes you have a better feeling about yourself; things that make you feel good and that are right for you. Fortunately I learned that at a very early age. I didn't get the frame of reference of a supportive self-image from my family, but I got it from other people, from people who touched my life, some only briefly, but still who gave me the kinds of images that helped. I think that's what you're talking about. I think it's very hard when you are in a family that doesn't build you up. That is negative. I think it takes time to evolve personal style. There are models who don't really have a sense of their physical being. We all know people who get upset about their noses or other features, but nothing's going to work. A nose job? They can have a nose job, and it still doesn't get anywhere near the problem.

Q. Do you think that a nice physical appearance is an important thing?

A. It's only as important as you feel. I believe girls and boys growing up, surrounded by an important, positive nurturing from the people around them, get an image of themselves and are able to develop much faster. It really comes down to the self-image you have of yourself. It's a matter of authority. The first thing to do is start liking yourself and start having a feeling of self-esteem. If there is something you really want to change, try to change it. I think it's also important to gravitate toward the people that bring out your best self. The marvelous thing I find in my friendships is that when I'm with these people, I feel they bring out the best in me, and I bring out the best in them. It's mutual.

Q. You must be a great believer in self-expression.

A. Oh, yes! I think it's important for people not to be afraid to express themselves . . . you must trust yourself. Find whatever works for you, put things around you that reflect your feelings.

Q. When you want to indulge yourself, what do you do?

A. I think I'd have a massage. Another thing I find very relaxing is to take a walk along the ocean, the great leveler, putting things in a true perspective. I also like the idea of splurging on a spaghetti dinner.

Gloria Vanderbilt is a great lady. I always think of her as a black swan. She always comes across with amazing vitality, intelligence and talent. She's extremely busy, but takes the best care of herself, always seems to have the energy to tackle anything.

The contrast between her white skin and dark hair and eyes is great, but she needs some color so that she doesn't appear too pale.

She always has the perfect haircut.

She has established her own identity in her clothes and in everything she does. She has an unerring sense of what is right. Gloria Vanderbilt is perfection.

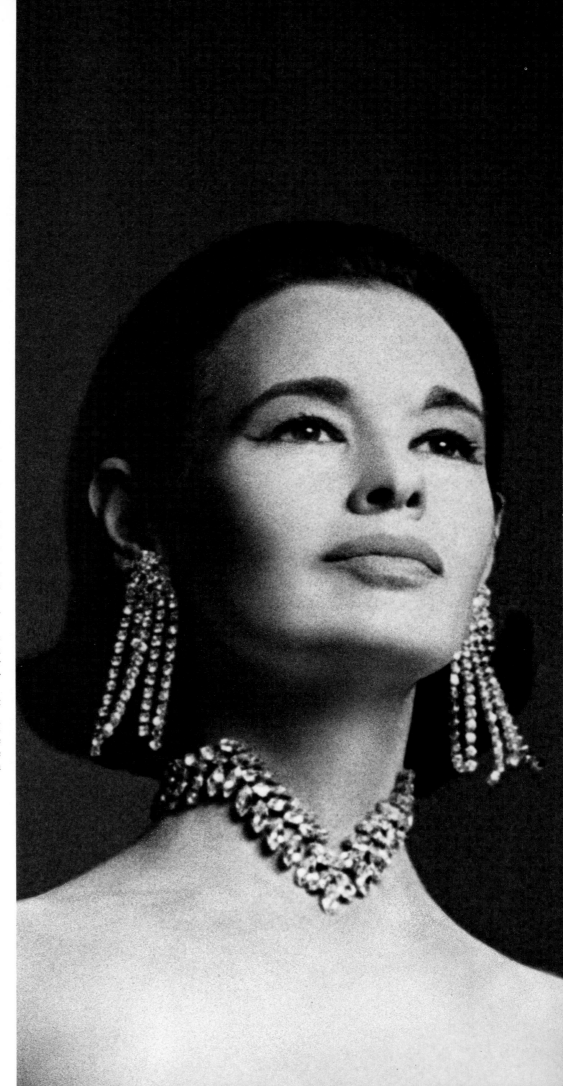

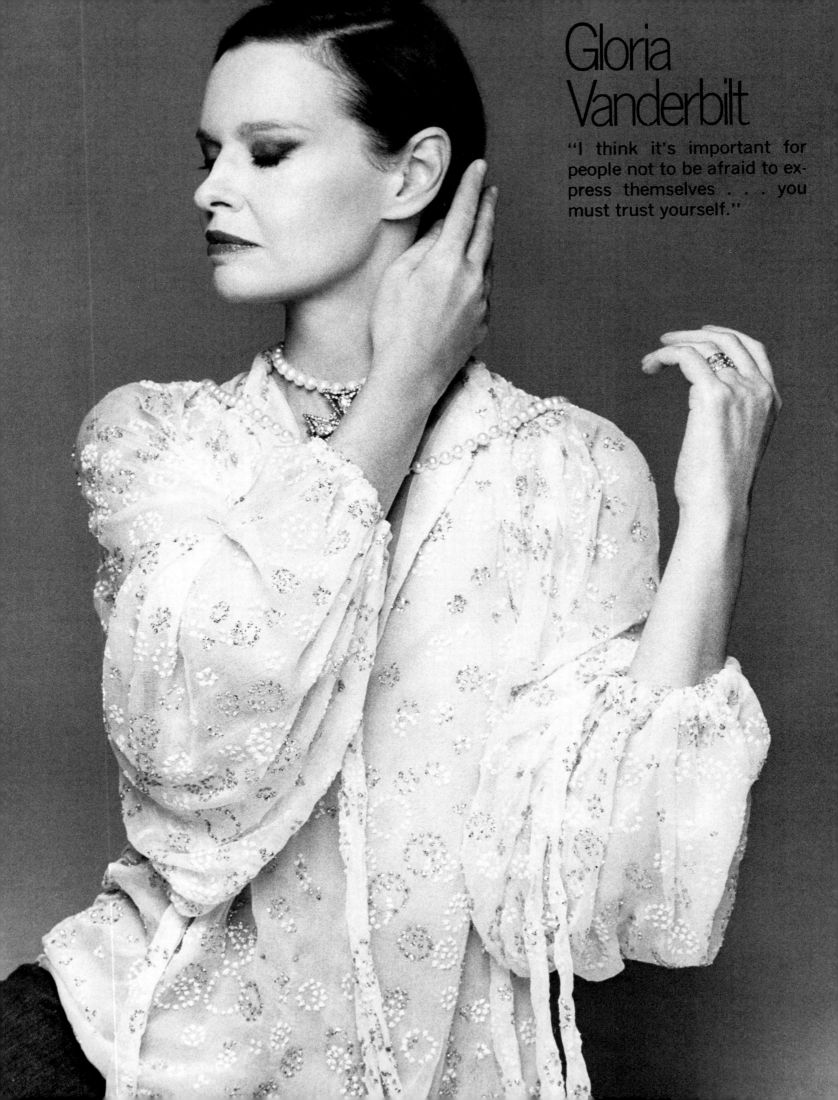

Gloria Vanderbilt

"I think it's important for people not to be afraid to express themselves . . . you must trust yourself."

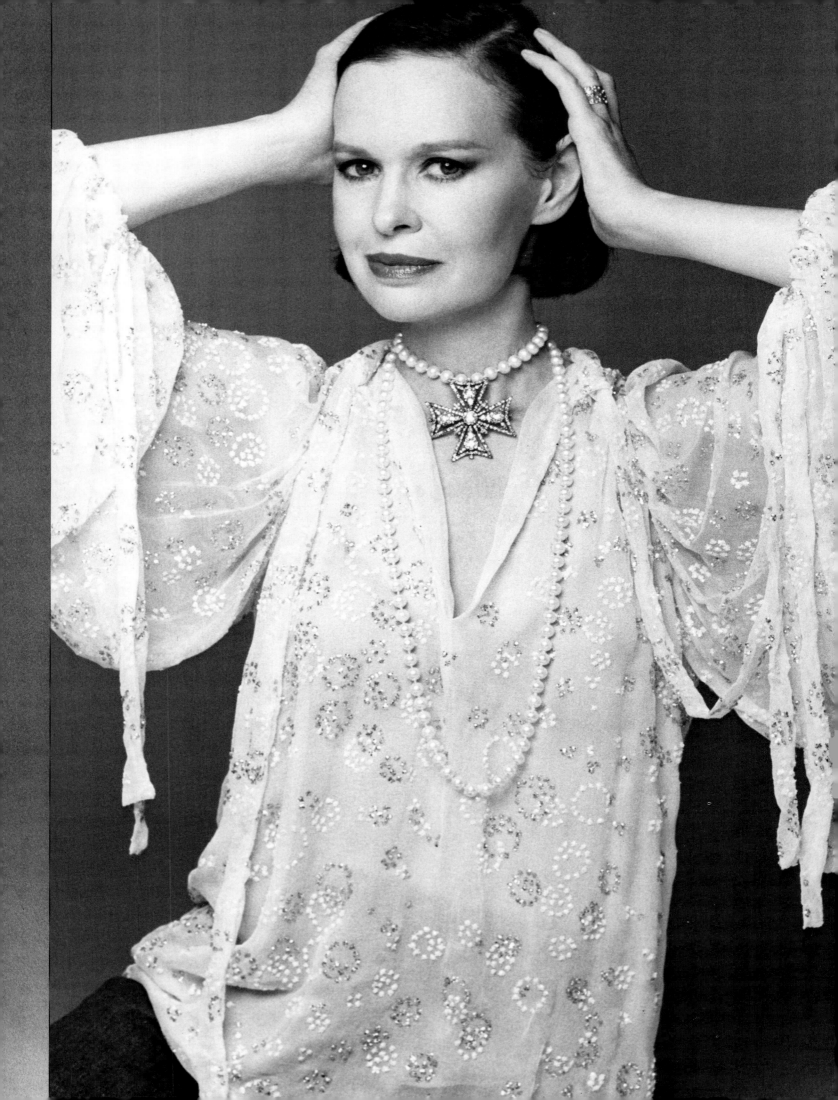

Let yourself go . . .

Viva Auder
and her daughter Alexandra

Scavullo: What is your personal approach to beauty?

Viva: I think no one can be beautiful unless she stops smoking cigarettes! You can't drink alcohol, and meat is bad for your complexion, too. You have to eat lots of vegetables, lots of oil in salad dressing. I eat a lot of fresh garlic every day. Of course, it drives men away—but most of them deserve to be driven away if they don't like garlic. And I have one beer a day. If I really get demented I have a daiquiri maybe once a week.

Q. What else do you eat?

A. I have at least a head of Romaine lettuce a day, or two or three endives, about twelve fresh, cut-up mushrooms, carrots, alfalfa, or regular bean sprouts in the salad and onions. (I love onions.) I used to eat a lot of olive oil, but now I've switched to sesame oil, though I still see nothing wrong with olive oil.

Q. What do you think is bad for beauty?

A. Steam heat is the worst possible thing in the world for beauty. Living in New York in the winter, you might as well add ten years to your life. You need a humidifier going constantly.

Q. What do you think is good for beauty?

A. Real beauty, of course, only comes with love. Otherwise, you just make do for a few hours a day—psych yourself up into looking beautiful. But unless you have a constant love in your life the best you can manage is two hours of beauty a day. If you've got to look well you can take a nice hot bath for about an hour and then hypnotize yourself in the mirror while you're making up to get that look and then hope that you'll be able to stay hypnotized until whatever appointment it is is over.

Q. You really like hot baths, don't you?

A. I find two a day essential to sanity, and I take them for about forty minutes apiece. I'm sure it's bad for the skin. Sometimes if I'm brave I'll take a cold shower after a real hot bath.

Q. How do you take care of your hair?

A. In New York, of course, hair is always dirty, but I only wash mine when I begin to notice the dirt or when I have to have it look especially good. I wash it to get that fluffy look. But I wash it as seldom as possible because I think soap is terrible for the skin and the hair; it robs you of all your natural oils. I usually use baby shampoo. Sometimes I use no shampoo at all, just lots of hot water.

Q. What about cutting your hair?

A. I've had terrible nightmares where my hair has been all cut off. That usually means I'm about to cut my hair and I'm going to regret it. So I'm careful around scissors.

Q. How do you like to wear your hair?

A. I like my hair long because when the man I love rubs the ends of it between his fingers, I can feel it in my throat. Then I use my hair to dry his feet after I've washed them with my tears. In the daytime, I like to just pile it up.

Q. What is that little light brown spot on your forehead?

A. This spot appeared after I took birth control pills for a couple of years. I had a doctor who used to force me to take birth control pills.

body is ever alone. I suppose there is a certain beauty in hyperactivity, but it burns itself out rather quickly. I usually spend every day alone if I can. In fact, I usually spend every night alone, too.

Q. Do you like to wear make-up?

A. I feel it when it's on my skin. I don't like the feeling of it. I like to wear it to look glamorous if I'm in love with someone. Or if I want to seduce someone I'm crazy about, then I'll go to any extreme to look more glamorous, do anything to cast a spell. In reality, though, I think all I do is spend about five minutes slapping on a minimum of color.

Q. When do you think you look most glamorous?

A. When I'm waiting for my one true love to show up. I'm in a nightgown and no make-up. I've just come out of the bath, put on a clean nightgown, pinned my hair up and put on a blue silk kimono, lighted some candles, made a fire, and I'm waiting for the man I love.

Q. What kinds of clothes do you think you look best in?

A. The domineering type—tight pants, high boots, turtleneck sweaters. And I wear capes because I'm so thin. I have a nice back and a long waist, so I can either show off my back, my long waist, my ass or my legs. My shoulders are pretty good. I look O.K. naked.

Q. When you have money, where do you buy your clothes?

A. I never buy clothes. When I have money I spend it on cameras, film, caviar—when I had money I used to spend eighty dollars a day on caviar. If I were buying clothes now I would shop at the new Peruvian and Mexican import stores with all their beautiful handloomed clothes. Having a long waist is a problem too, because when sheath dresses were "in" I had to

"The middle-class woman is now getting to the point where she thinks she has no choice because she thinks she has to do everything herself."

He was Viennese and he would say, "Dahlink, you are so skinny, who would vant to get into bed with you? You've got to take birth control pills." In fact, I had an I.U.D. and he insisted that I take birth control pills on top of it just to gain weight. Now he's saying, "I wouldn't advise birth control pills for anybody. They are zee most dangerous things in the world."

Q. Do you exercise?

A. I do yoga when I'm not near a river, ocean, or swimming pool or a place where I like to walk. If I'm near water, I swim. If I have a bicycle, I bicycle. If I'm in the mountains, I walk. I also ice-skate, but my main form of exercise lately has been yoga, which isn't that much exercise. Yoga is really exercising internal glands to keep them working. I believe that exercise is completely essential for mental as well as physical health. Part of the virtue of exercise is that it causes you to take deep breaths, and it helps oxygen circulate through the blood. In my opinion, however, medicine isn't preventive enough. You watch Marcus Welby, and all they say is "We'll have to operate."

Q. What else do you think is necessary for beauty?

A. I think a lot of solitude every day is necessary for beauty. Do you know why there is such a big deal about meditation now? Because no-

buy them two sizes bigger in order for the waist to hit right; then the dress would have to be totally altered. That's before I realized that I could wear skirts, sweaters, blouses and pants. I like long or mid-calf length, and wraparounds—comfortable things. But I really hate the idea of having to wear clothes, thinking of what to wear. Getting dressed is just traumatic for me.

Q. What do you think is your best feature?

A. My best feature is really my nose. It reminds me that I've come from Scottish aristocracy.

Q. What do you consider your worst feature?

A. I think it's my pointed eye tooth on the left side. Then, of course, I have these deformed murderer's thumbs. I did a movie with Pasolini called *Medea,* where he only showed my thumbs in the movie—close-up. I'm doing these prayer beads with two huge clubbed thumbs and the thumb nails are completely horizontal. The reason they're called murderer's thumbs is because the first time they were discovered, the father of the person who had this kind of thumb had murdered someone just before he conceived his son.

Q. What is your life-style?

A. My life-style is constant contemplation on what I'm going to write tomorrow morning. When people ask me to go out I usually say no

"Steam heat is the worst possible thing in the world for beauty. You need a humidifier going constantly."

because I say, "I've been every place, there's no place to go." I just stay in. I do a lot of reading. I take care of my daughter. If I see people, I see them at home.

Q. Do you think a woman is more beautiful if she has children?

A. Just the act of having a baby is so overwhelming that it's like some huge yoga catharsis that changes you permanently. It makes you more patient and gives you sort of an acceptance of life because once you have children, there are certain things you have to give up.

> "I think that having children adds another dimension to your understanding of life . . . it changes you permanently."

> "I like my hair long because when the man I love rubs the ends of it between his fingers I can feel it in my throat."

But having the joy of the child, the pleasure of this uncontaminated creature—it's like having some beautiful fresh spring garden always there.

Q. How would you describe your own looks?

A. Elegant, I guess, and severe. I wouldn't call myself pretty.

Q. What catches your attention when you first look at someone you think is beautiful?

A. Different things. Skin. I think I'm probably most attracted to skin.

Q. Which women do you think are beautiful?

A. I've always loved Elizabeth Taylor's and Hedy Lamarr's looks.

Q. Do you think they are surface beauties?

A. I don't believe in the thing of surface and non-surface beauty. I think the word surface, like the word spiritual, should be stricken from the vocabulary. When you're young it's pretty hard not to be pretty because you've got that beautiful fresh skin and clear eyes. I think beauty sort of eliminates prettiness. The Indians think that children up to the age of ten have god in them, and they treat them like kings. If people stay beautiful beyond the age of ten they've retained that goodness in them. I think when you get caught up in knowledge and experience, that's when you lose your beauty. You have to transcend your knowledge of corruption.

Q. What are your feelings about lighting?

A. Lighting is a very complicated art, and I've never mastered it. Everything depends on lighting. My room in the daytime is hideous because you can see how dusty and old and really awful it is, but at night with the right lighting, with the fire and candles, with scarves over the lamps, it looks good. The right lighting can change the mood of a room and the mood of a person. The right lighting can make the best business deal possible, the right lighting can write the most beautiful paragraph in the whole book, the right lighting can make you sign the contract, give you the most beautiful orgasm, make you fall in love with someone you've just sent a termination notice to.

Lighting is everything in life. The *Kamasutra* says red light excites a man's passion and a violet light excites a woman's passion. In one of the sexual rites in Tantric Yoga they put a violet light on the woman in order to excite her, because they know that the man rarely needs the added stimulus—at least in those days he didn't. Now that there's this huge problem of impotence, they're getting more into red lighting.

Q. Are beauty considerations an important part of your life?

A. I think the best thing to do with beauty is to sell it as dearly as possible before it fades away. It takes so much time to conserve beauty that if you're into conservation you have no time to actually enjoy it. But after a while, as in all enjoyments, this enjoyment of beauty becomes routine and therefore boring. I think that beauty is on the same level with money, fame, goodness, notoriety, inheritance, talent, genius—they're all commodities you can either exploit or ignore. The only thing that's hard to ignore is money, because if you have it you use it. All these other things can be used, or you can choose to ignore them, including beauty. And I think beautiful girls should be taught to use their beauty as soon as possible before it leaves them and, in fact, all girls should be told they're beautiful from birth, and then they'll become beautiful. Now, I think I was beautiful until I was seven or eight, when the nuns at my school told me vanity was a sin. Then I began to lose my beauty because I remember, at the age of seven, looking into a mirror and actually falling in love with myself. I had platinum ringlets, a violet-colored velvet bonnet and a violet tweed coat and violet-colored velvet leggings, and I actually looked in the floor-length mirror, and I said, "I am the most beautiful thing I've ever seen." I got on my scooter, I went down the driveway, I took a left turn down Ruskin Avenue, where the next-door neighbor, two years older than I, Sharon Flynn, passed me and said "Hi," and I ignored her, stuck my nose in the air and kept going, because I was too beautiful to associate with the neighbors. After that experience of falling in love with myself, the nuns made me feel

came ugly again. I spent six years in ugliness. Then, when I left my husband, I regained my beauty once more. So you could say that, for a woman, beauty is only the mirror of a man's eyes. It's a chronic condition that comes and goes like the sun on a cloudy day. When that cloud goes by it dims the sun; when the sun comes out, it blazes. Also, beauty is dependent on ugliness. If there are no ugly women, there are no beautiful women. If everybody looked like Elizabeth Taylor and Hedy Lamarr, and then there were a few spectacular angels, divine goddesses made manifest on earth, then Elizabeth Taylor and Hedy Lamarr, my idols, would be totally ugly, you see.

Q. Do you like perfume?

A. I love Bal à Versailles; that's the only perfume I like. I think it's the most seductive.

Q. Do you think people are easier to deal with if you've done everything to look your best, to look attractive?

A. Absolutely, no question about it. Except, that's a double-edged sword because when you really look attractive, and most of your dealings are with men, since it's a man's world, the men can get carried away by their sexual attraction to you, and you forget that that's what it is, so you sign your life away in a minute, forgetting that this great bonhomie and comradeship is strictly inspired by the hope of having your body.

Q. Do you think American women could stand some improvement?

A. Well, American women are fools because they try to be everything to everybody. So American women try to look good, be a good wife, be sexually attractive to the husband and in 51 percent of the cases they have outside jobs in addition to having children. This is utter madness. So I think the American woman is really burning herself out rapidly. I don't like the way the average American woman dresses, because all I ever see in the streets is really hideous clothing. Businessmen all dress the same—they always look good.

Q. If you wanted to improve yourself, what's the first step you would take now?

A. Get out of New York and go back to California.

> "I believe that exercise is essential for mental health as well as physical health. Part of its virtue is that it causes you to take deep breaths, which helps oxygen circulate through the blood."

really guilty about my self love, despite Christ's injunction to "Love thy neighbor as thyself." (Of course I loved myself so much I couldn't love my neighbor.) So I began to lose my beauty. Then my father began to criticize my best feature, my nose. In summer he would say, "Stop peeling all the skin off your nose, you're going to draw all the blood to it and your nose is going to get longer." I began to lose my beauty again. I did go through a very ugly period because my father hated my looks and much preferred my sister Mary Beth over me. Then my sister Jeannie got very beautiful. During my period of sibling rivalry, I was quite ugly. Then when I became sexually functioning and men found me beautiful, I once again became beautiful until I got married. When, after the first flush of romance wore off and my husband no longer found me beautiful, I be-

Viva has a face that shows unusual intelligence. It has nothing to do with bone structure; rather, it's the aura of a person who works largely with her own inspirations. She's a haunting beauty. Energetic and somewhat spiritual.

Make-up is used to heighten the shadows she has warming the tone of her skin. It's a softened, smoothed skin. Eye make-up is emphasized.

Her beautiful hair is something out of another time. She just keeps it clean.

Of course Viva has style and is smart about clothes, but she looks great in her uniform, tattered black velvet jeans and an old Air Force jacket. She doesn't spend any time on herself—she's into something else.

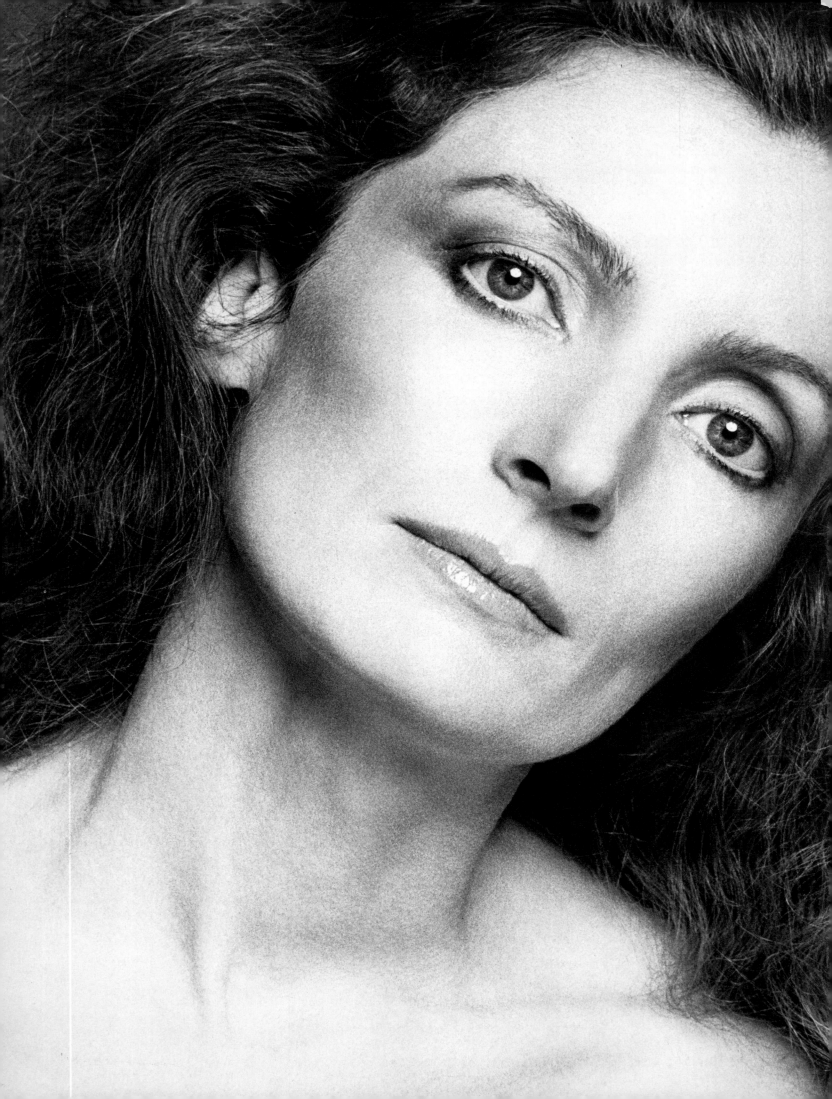

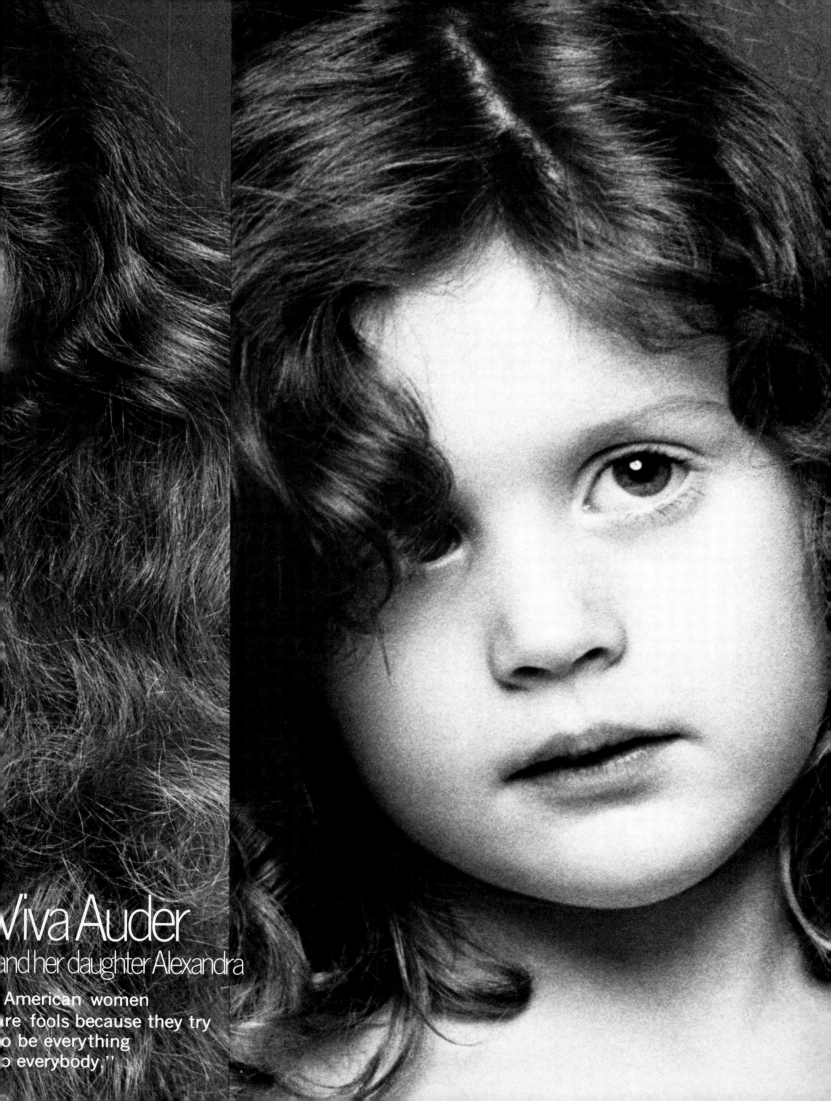

Viva Auder
and her daughter Alexandra

"American women
are fools because they try
to be everything
to everybody,"

The power of personal style

Diana Vreeland

Scavullo: Do you have a system that works for your life?

Ms. Vreeland: Well, fortunately, being at work for the last million years, I've had to have a system. I work five, often six days a week, and then for the seventh day I do something quite marvelous. My whole life hasn't been work, because I have the most wonderful evenings. If one earns one's evening, one has a wonderful evening. You put in a fairly good day, and you've done or accomplished something, and then you enjoy yourself. Pleasure is everything! I believe in pleasure.

Q. What is your philosophy?

A. It's not exactly a philosophy. It's kind of a working schedule ... to use one's self every day in some way.

Q. What is your personal approach to beauty? Is there a certain daily routine you have?

A. First of all, I walk in my sleep into the bathroom and drink a glass of water. Then I get back into bed, where my breakfast tray is plunked down on my lap, and the papers are beside me, and for three quarters of an hour I hope to wake up. I've really never drunk more than one cup of coffee in my life for breakfast until three weeks ago when I decided I should drink two ... they're in the pot anyway. So I did; I think it picked me up a little faster. But it takes years to come around to those conclusions; that's what takes the time. Then I get up and go into the bathroom, which is very cozy and warm, and then I take a nice bath. Then the phone rings and the day begins. About twenty minutes to ten, I talk to my secretary and we dictate and we see whatever is on the calendar for the day. Everything is carried over every day onto the calendar and told to me, whatever it is, sometimes every day for a year and a half or two, every day until it's eliminated. Then there are a lot of phone calls, and I go to my work about half past twelve or a quarter to one, and I'm there until I'm finished for the day.

Q. What kinds of clothes do you wear to work?

A. Always the same things, always the same, just always pants and a sweater, and boots, but always!

Q. Who makes your boots?

A. Roger Vivier and Dal Co. Shoes are a big deal in my life because nothing fits unless it's made to order. I have an extremely high instep.

Q. Where do you like to shop?

A. In Paris and in Rome, because I have the time there.

Q. Do you ever browse through department stores?

A. Oh, I can't stand them, I cannot stand them! I don't see well in them, and I've never seen a saleswoman in one. Anyone I approach is always in the same boat as I am—she's looking for a saleswoman, also. In Japan, where they invented the department store, someone immediately comes up to you—I find it divine; they're not hustling you—and they're yours for the time that you're there.

Q. Do you do your hair yourself?

A. I go once a week to have it shampooed and cut.

Q. How do you get it so smooth?

A. It's dead-straight hair. But it's really shiny, fortunately. I almost went crazy in Japan and Hong Kong—the hair was so beautiful.

Q. How do you take care of your skin?

A. With Formula 405. I think it's the greatest stuff. It's only been in my life a short time, but it's marvelous. It's the most ordinary thing, but my dermatologist gives it to all his patients.

Q. Do you use it at night?

A. No, I never wear anything at night. I just sleep with a clean face. I put 405 on first thing in the morning, and it's on until I make up—which is quite a long time later, the better part of two and a half, three hours.

Q. It doesn't look like you have much make-up on at all.

A. Well, I can't use any make-up on my eyes unfortunately because the lids are so shaped that you can't get those marvelous hollows filled with green and yellow, which I would adore to have.

Q. How do you keep your figure?

A. I take a tremendous amount of vitamins, which includes a giant Swiss pill each morning, and six protein-rich pony pills—what's good for a horse is good for people. Sometimes I eat

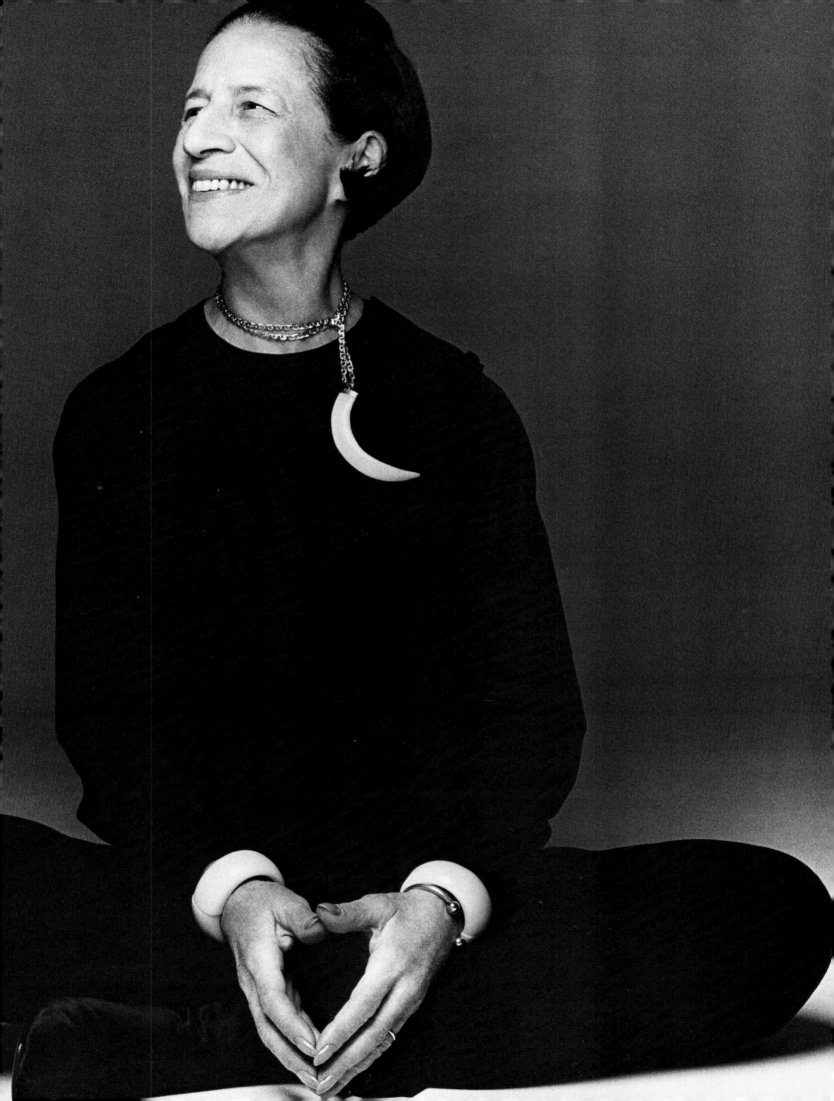

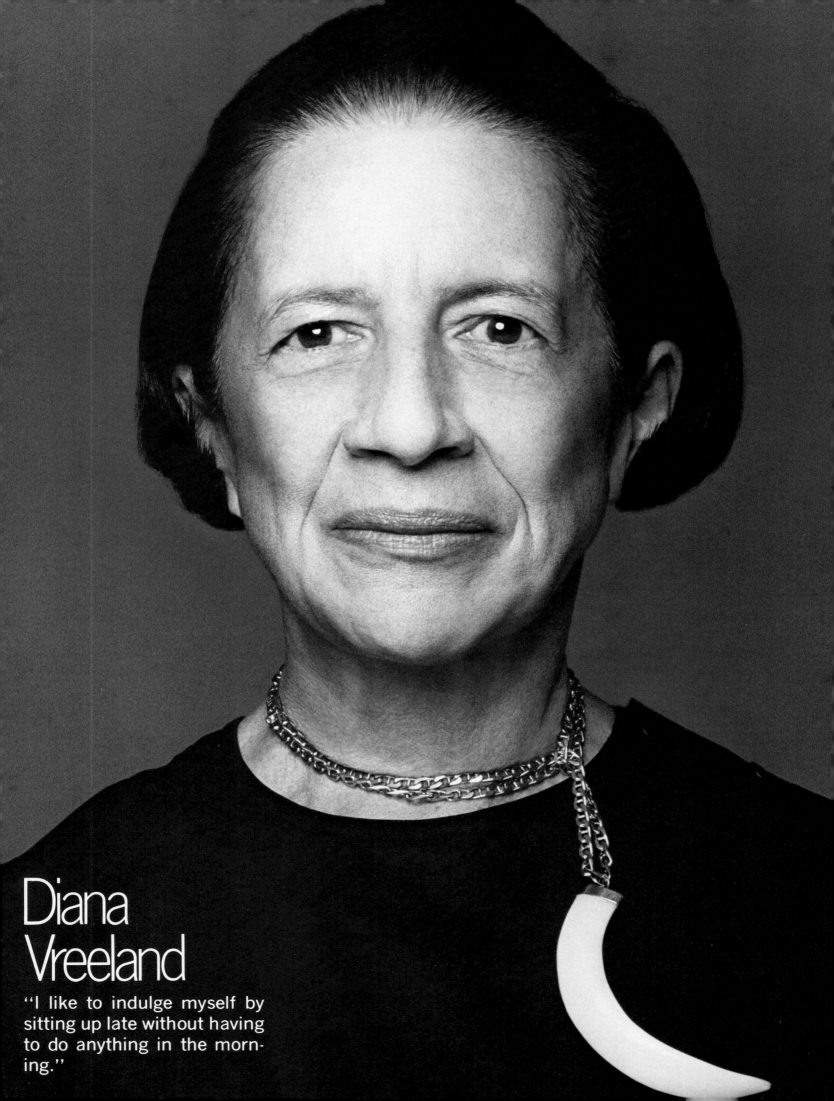

Diana Vreeland

"I like to indulge myself by sitting up late without having to do anything in the morning."

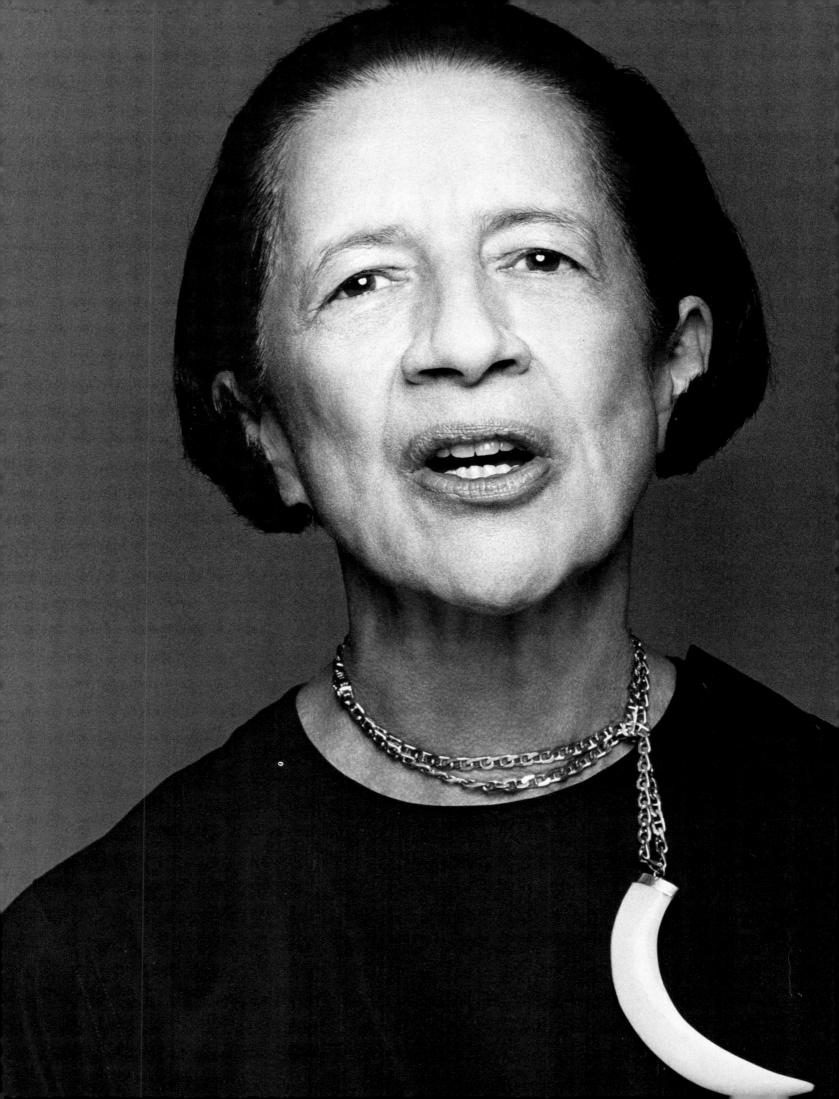

like a truck driver, and then I'm sort of like an animal, like a dog who doesn't eat one day. I haven't got a roaring, everyday insatiable appetite; I think because I take so many vitamins.

Q. Do you watch your weight?
A. I eat only when I'm hungry, and I'm not always hungry. There are days when I don't eat much at all, just a very small lunch. I enjoy breakfast and I have a little bowl of Swiss Bircher Muesli. But I'm sort of in a stupor when I eat breakfast, I'm not myself.

Q. You've worked hard all your life on things like posture, haven't you?
A. I feel very tired if I don't sit up straight; you'll always find me in a straight-backed chair. Otherwise you get tired; the blood doesn't flow up and down where it's supposed to go. I stretch a lot too, and I tell everyone to do it. You can do it while you're on the phone.

Q. What do you consider your best feature?
A. I suppose the proportions across my shoulders, the smallness—very good for clothes.

"I can't stand department stores! I don't see well in them, and I've never seen a saleswoman in one."

Q. What size do you wear?
A. As nothing is ever cut to whatever size it's supposed to be, you have to start at size 10, and then the other day I bought something that was a size 6. Unbelievable! I'm not a 6, and I'm not really an 8, everything varies so. "We make a big 10, so you'd better get an 8. We make a small 8, so you'd better get a 10. We make a small 10, perhaps you'd better take both 10 and 12 and see how they fit you." You see?

Q. Are there any women you consider special?
A. I'd have to think about that for a while; so many people lack splendor. I think a person like Suni Agnelli is marvelous-looking, and so is Marella Agnelli. But I honestly don't know. When you're talking about someone, you might think, "Oh, isn't she beautiful?" but then I forget.

Q. What's the difference between beautiful and pretty?

"You can't get too involved with yourself, or it becomes tedious for other people."

their little white socks and black pants, sitting on the sidewalk, just the way I'm sitting, smoking . . .

Q. Who do you think was the greatest fashion designer of all times?
A. I think Chanel understood the twentieth century completely and put people into the clothes that were totally necessary for them. She turned them out like little Eton boys—sweaters, shirts, marvelous flannels and jerseys, and very racy looks. Now it's all things for all people, so all designers are very good.

Q. What about Vionnet?
A. Vionnet was very great indeed. Superb! She was very, very extraordinary, the poetess of fashion.

Q. What about Zandra Rhodes today?
A. I think Zandra gives color, amusement, and luxury to clothes. People look wonderful in them.

Q. I know you love St. Laurent . . .
A. Love him, love him. The simplicity with which he has arranged things for us in the boutiques at such fair prices is amazing. And he's an adorable, fascinating man. And also, for now, Madame Grès is wonderful, marvelous.

Q. Have you saved your clothes?
A. I saved a lot of clothes of the middle sixties because of the marvelous fabrics. I felt the luxury of those fabrics was going to disappear. And it has. But, you know, I wouldn't want to go back and wear them, not for anything.

much more provocative, much more extraordinary. Everybody is too natural for me. But they're not putting out the magazines for me, God knows.

Q. Do you think American women could do better by themselves?
A. Yes, I do. I don't think they give it enough thought. They all think they mustn't miss anything and must have everything, without considering what they are, who they are. I don't think the American woman has any vestige of originality or any special thing of her own. Nor does she want them. Let's face it, she wants to be popular, that's all. Popularity, that's the goal for everyone in this country. It ruins the men, it ruins the women. It has ruined society. Everybody wants to be in with everybody, whether they like them or not.

Q. Do you like pretty lingerie?
A. No, I rather like nothing. I like stockings and brassieres, and I wear as little as possible. I love Chinese silk nightgowns, little shirts, they're very comfortable, I love the silk.

Q. What do you do to indulge yourself?
A. I like to sit up late without something to do in the morning.

Q. I hear you take these little naps and you need a phone call to wake you up . . .
A. I always say I can never take a nap because there's no one to wake me. All I need is twenty minutes on the bathroom floor with witch-hazel pads on my eyes, and I wake up and I'm ready to go out and conquer the world. Witch-hazel is wonderful for the eyes, it takes all the heat and sting out. I just put it on with a pad and go to sleep there.

"I dream I'm remarkably good-looking while I'm making up."

Q. How much time do you spend in the bathroom?
A. Hours. It's my office, it's my bureau. The only other person I've ever seen who has a bathroom anything like mine is the Duke of Windsor. It's full of newspaper clippings.

Q. Is it true that you drink Scotch before lunch and vodka before dinner?
A. A straight Scotch, no water, nothing is ever diluted. I very rarely drink wine. I do drink vodka before dinner, and sometimes with one piece of ice.

Q. Have your looks and ideas about beauty changed over the years?
A. No, not at all.

Q. What do you think is your best look?
A. I think I look better in the evening because I'm free in the evening.

Q. What is your idea of a smashing evening?
A. It varies. I like dining with friends, I love restaurant life. I like to have friends in, just a special few, for a cozy, easy dinner. At big dinner parties I wish I could leave directly after dinner. I understand people who gamble—at least they can get rid of the rest of the evening after dinner. I love to walk into big parties and see people I haven't seen in a long time.

Q. You love to meet new people, too . . .
A. All the time. I've always adored people who live off-beat lives, free of convention. You become friends very quickly.

"All I need is twenty minutes on the bathroom floor with witch-hazel pads on my eyes, and I can conquer the world."

A. Beauty is something that radiates, it comes from deep within, or out of the sky, or something that's just in the atmosphere. Pretty gives you great pleasure—like fresh flowers, girls are pretty. I think Nefertiti is perhaps the most beautiful woman of all time. The original cast of her in Berlin is too beautiful for any words; it's stupendous. You're never the same after seeing that, because you know you've seen something. It's a woman's face that has the strength of a statesman on one side and a great big dimple and a wonderful eye like a hoola girl on the other.

Q. Do you think bone structure is important?
A. Bones are good things to have. I love the old women of Hong Kong. They are so beautiful because of the bones in their foreheads, which are very high and wide apart, and they're so elegant you can't believe. And in

"Proportion is everything to me."

Q. How do you feel about fashion magazines today?
A. I think too many people with no color in their lives are involved in them; they're run by colorless people. I think the theories are wonderful, but you never put a *face* on a magazine, you never think how marvelous that a certain *person* came to a conclusion. Somehow they don't involve you.

Q. What do you think of the European fashion magazines as opposed to the American ones?
A. I like them much more because the girls look like models. I don't find real-people type of models so interesting. I like something

"My bathroom is my office."

Q. Can you describe your own looks?
A. I really live in a dream when I'm making up. I adore the whole process of dressing and making up, and I dream I'm remarkably good-looking while I'm making up and taking so much trouble with this absolutely beautiful face of mine. And then when I see photographs, of course I almost die. I mean, I'm not really looking for the reality, I'm looking for certain outlines, a silhouette. I suppose I'm so accustomed to my looks that I don't really know what I look like. One has to have one's own sort of romance in order to be at home with one's self. You can't be fighting yourself the entire time. You settle for things. If you know that you're not the most beautiful thing in the world, and it all goes along rather nicely, I don't get too upset. And generally I don't think that one's appearance stops at the neck; if it did, a lot of people would be marvelous-looking, and they're not. The whole thing is line in a body. Proportion is everything to me. It is very delectable to have a very long neck, very long legs, a very high bust, but you've got to get your own proportion within what you've got.

Q. How do you think a woman should evaluate her looks?
A. Well, I think you ought to have a rounded idea of beauty and a sense of selection. You can't just be hungry for yourself; you have to understand the beautiful things in the world. Not everybody can travel everywhere and see everything—that's a great privilege—but I think it's important to learn about the great beauties of the world. Thinking about beautiful things tones you up into a state where you can select beauty very quickly, but I don't think you can just live in a cosmetic world or a world of shiny magazine paper and say "This is beauty" or "She's beautiful." The great thing today is that every girl has the opportunity to look marvelous, no matter what her features are. If it comes to the absolute limit, she can have surgery—she can have her jaw brought forward if it's receding, she can have her nose totally changed if it's impossible, her ears can be flattened, and her hairline can be heightened.

Whatever you do, you have to make a point of keeping your body and your skin and your hair in shape. See the dentist, the oculist, the doctor. You can't get too involved with yourself, though, or it becomes tedious to other people. The light dies out of their eyes as you approach them.

Diana Vreeland is the consultant to the Costume Institute at the New York Metropolitan Museum of Art. She was Editor-in-Chief of Vogue *magazine for ten years, and Fashion Editor at* Harper's Bazaar *for twenty-seven years.*

Diana Vreeland is Empress in the world of beauty. Vreeland's eyes seem to touch everything she sees. Young people love to be with her. If you are lucky enough to spend five minutes in her company, you'll learn something. And she takes and learns from everyone she meets.

She exudes enthusiasm for each new project she attacks. She is always prepared. She arrived at my studio ready to be photographed. "Do I look okay?" she asked. "I don't want to waste your time."

I'd like her to spend the rest of her life "wasting" my time.

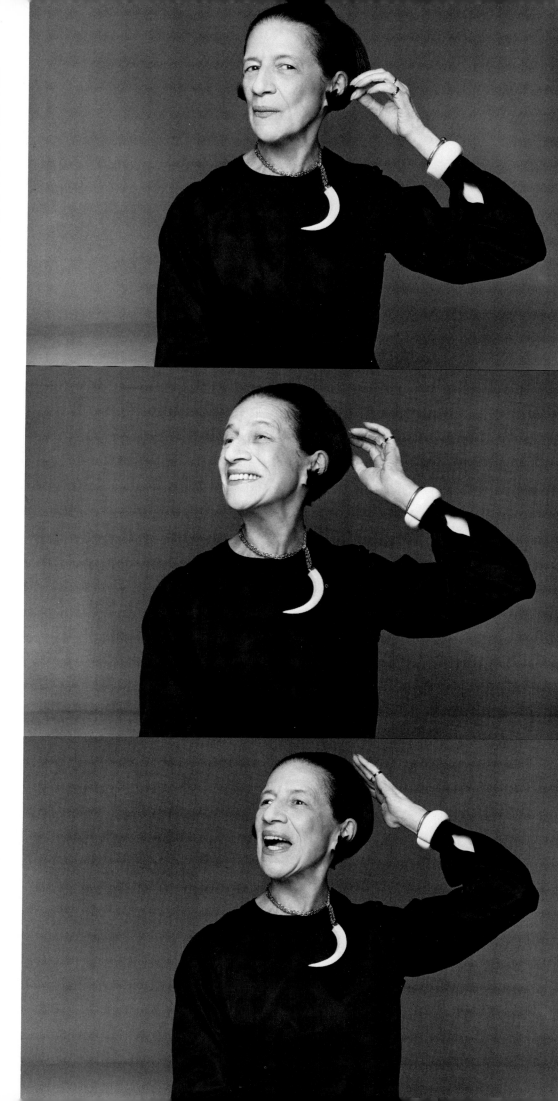

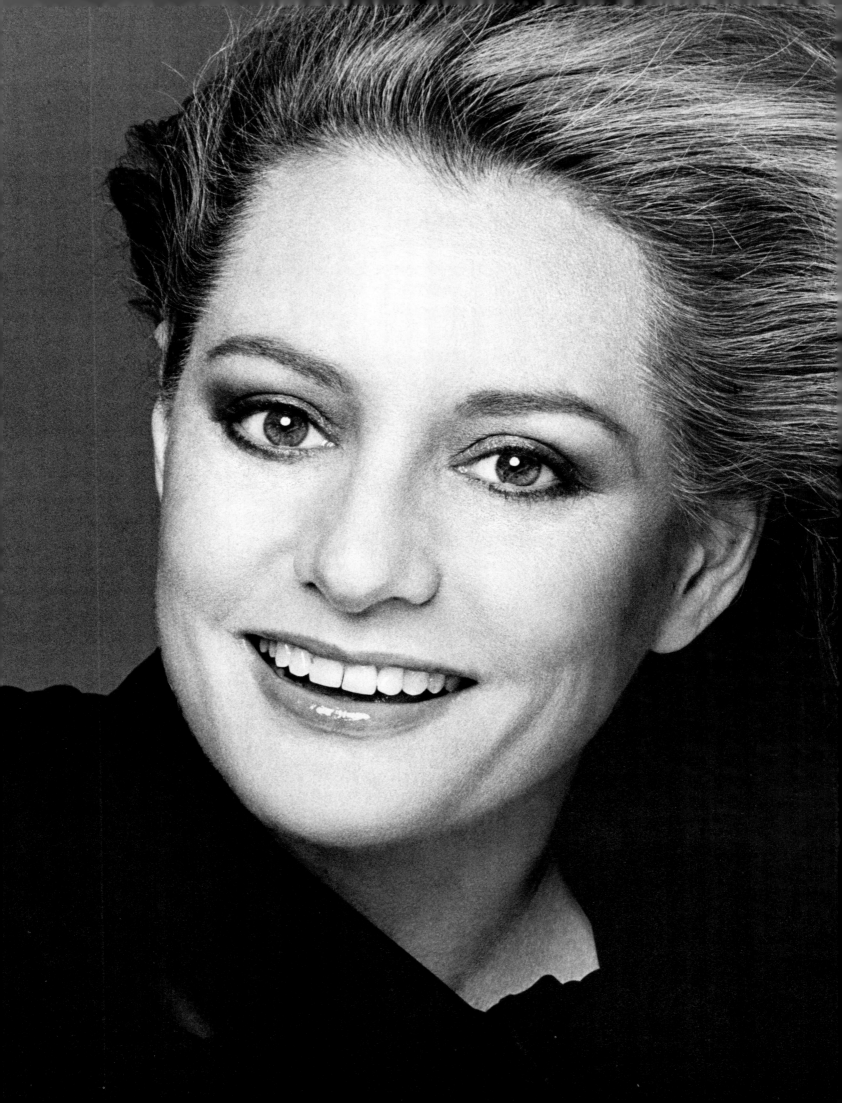

When you have to please a million eyes, find the real you

Barbara Walters

Scavullo: What is your personal approach to beauty?

Ms. Walters: I think that my life is dictated by not having enough time for anything. The make-up that I wear on the air, the products that I use, are the same that I use off the air. I can carry everything in one plastic pouch. I use soap and water on my face and some kind of moisturizer. I use baby oil or my child's baby cream. She uses more of my make-up when she plays than I do. She looks like a seven-year-old mannequin, and she's got the kind of face, beautiful skin and pale hair that should never use any make-up. But she's at the age where she likes to play grown-up, so she puts on the blue eye shadow, the bright red lips.

Q. Do you have facials?

A. No, I always think I should and I don't. I would love it. It would be a great luxury, but a facial takes two or three hours, and I would rather go home and sleep. If I have time in the afternoon I do come home and sleep. I can

> **"If you told me I couldn't eat brownies, I'd be bereft."**

sleep anywhere. I think if I keep my skin clean, which I have to do, having heavy make-up on my face every day—most people, I assume, don't—I find soap and water makes me feel the cleanest. I usually use Ivory soap in the bathtub and Neutrogena as a face soap, and that's almost it.

Q. Do you apply your own make-up for the air?

A. No, I don't, but I can. When I go away I do, and I'm not sure you could tell the difference. You see, for example, if I'm in China, where I'm traipsing around and I'm also doing film stories—I don't want to stand out, I don't want to be the one person in the whole group with a face full of make-up; on the other hand, I have

> **"The perfect evening for me is having dinner on a tray and watching Charlie Brown with my child."**

to be able to go on the air with it. Except for the fact that I may have more blusher on my cheeks, you couldn't tell my make-up from anybody else's on the street. I don't have time for lots of marvelous shading and eighteen different eye shadows. I think it's wonderful to do it, and I love it, but I don't do it to myself.

Q. What about your hair?

A. I have always felt that if your hair looks good, everything looks good. My hair is washed every other day, and I do have good hair. It is set with electric rollers every day that I am on the air. I can come to the studio at six fifteen, have my hair washed, get made up, have my hair dried and set and be finished by ten of seven. My hair photographs much darker than it is, although I lighten it. My hair is never "set." I never sit under a dryer with my hair in rollers—I haven't done that in years, and I wouldn't have the patience for it. On weekends, I either wash it and dry it and stick it in electric curlers if I'm going out, or I just wear it pulled back. But I think the most important thing is for it to be clean.

Q. Do you think hot curlers damage your hair?

A. They probably do, except that every time my hair is washed, a conditioner is used. Every

> **"It took me a long time before I felt so secure that I could really do only what I want to do."**

single time. I have very strong and very good hair. I'm sure electric rollers do damage the hair, but they haven't mine because of the conditioners. I guess you have to know your hair. I can't go for four days without having my hair washed, and really it should be washed every day, but every other day is fine.

Q. In general, what do you feel beauty is?
A. When you feel you look so good that you

don't have to worry about it. And people do respond to someone who is more attractive. I mean, if you can make a little effort and do it, why not? There was a time when no female reporter would do a fashion story. Everybody was going to go out and wear a trench coat and cover the war. Well, I think it's the same way that women, for a long time, thought about beauty. If you used some make-up on your face and you had your hair done, it meant that you were superficial and vain and that you didn't believe in the true, really important things in life. Well, I think you can believe in the true, really important things in life and look attractive, too. I think we went through a phase where everything had to be just so natural that we didn't want to do anything that might be artificial. Even making any effort to look prettier meant that people wouldn't love you for your soul.

Q. Did that have anything to do with the male/female relationship between reporters, too?
A. No, I think it was all part of being true and being yourself and not being superficial and not caring about the plastic things in life.

Q. Do you diet?
A. No, I just talk about it.

Q. What do you eat for breakfast?
A. Brownies, apple pie, whatever was made the night before. From my diet you could get pellagra.

Q. You don't eat health foods at all?
A. I think it's swell to, and I think I ought to but, no, I don't. Again, for me, it's too much effort. And I'm very, very healthy.

Q. Do you exercise?
A. Again, I don't have the time. Do I want to go to a gym for two hours? Yes. I have one of those bicycles in my bedroom that my cousin gave me, which I swear I'm going to use every day, and I should exercise, I think people should. But by the time I've come home, the most important thing to me is whether I can have an hour's nap, and if I have another hour,

"Beauty is when you feel you look so good you don't have to worry about it."

then I want to spend that with my child. I should exercise, I should play tennis, and I should do a lot of things. I also should sleep until nine every morning, but I don't. I think at four thirty in the morning, when I get up, you don't really feel too much like exercising. When I get home, I'm tired.

Q. You said when you first arrived, "I don't want to look chic."
A. Well, I'm not a fashion plate. I don't want people to get so busy looking at me that they don't listen to what the person I'm interviewing is saying. I don't want people to get hung up on my looks or my clothes—I like to look a particular way and I like to look comfortable. I like to look attractive, but I don't want people to say, "What is Barbara wearing today?" I find that people even notice haircombs. If I change my hair I get more mail on that than on the interview, so I don't like to change my hair that often. When everybody else cuts her hair short, I don't care whether my hair is short. I like to keep fairly much the same look. If I'm doing a show at night, then I try to look different. Then I will wear a low-cut dress. I'll try to wear something that's very feminine, and my hair will be much fuller. But on the air, I

in quite simple things, not terribly, terribly sporty. I don't like myself that much in slacks and blazers and things. I'd rather wear a sweater and skirt or a dress on the air. I like clothes and materials that don't wrinkle, because I travel so much.

Q. Do you like polyester?
A. No. I like soft wools, I love cotton in the summer. I think nothing is as fresh as cotton, or certain knits.

Q. Who are your favorite designers?
A. I probably wear mostly Adolfo and Halston at night.

Q. And in the daytime?
A. I wear a lot of sweaters and a lot of separates.

Q. You've said that you don't really shop a lot yourself.
A. Very little. I will go to one designer because it's so easy for me, or someone will send up some things for me to look at. That's why you see me wearing a lot of the same clothes on the air.

would rather people just felt comfortable with me. I want the interview to carry, not my clothes. I don't want to come out with something that is so highly styled or so "done."

Q. You looked lovely in the St. Laurent dress you wore on your show about European royalty.
A. Well, that was different. In "European Royalty," the show was geared to a daytime audience, it was not a news special. It was an entertainment special. Part of that was having marvelous clothes and having a particular kind of look, although on many of those things I did my own make-up and hair, as a matter of fact. But the kinds of clothes I wore were important. I went to Adolfo, and I chose special clothes for that program (which I've been wearing all year long). I buy certain clothes for the program, but rarely is it something that, if I wanted to, I couldn't wear off the air.

Q. What kind of clothes do you feel you look best in?
A. Well, for the air I would wear pastels or bright colors. In my own life, I might wear more beige and white, but they don't look good on our set and on the air. I think I'm best

Q. You like your work, don't you?
A. I love my work.

Q. As a little girl did you dream about being a commentator?
A. No. First of all, they didn't have any television when I was little. And certainly when I began, there were no jobs like this for a woman—the jobs didn't exist. I think I've worked very hard, and I think I've changed the job from what it was to what it is today, but I didn't do it because I was trying to blaze trails. I did it because it was the only way I knew how to work.

Q. Why does the news particularly interest you?
A. I think news is where everything is today. I think it's why people are reading more nonfiction than fiction. I find that the life is so full and exciting—to find out the whys and wherefores behind it and to talk to the most important and stimulating people. What could be more wonderful? I wouldn't want to be an actress, I wouldn't want to be a model—I'd go crazy.

Q. Who are some of the women you think are beautiful, and whom do you admire?
A. It sounds so funny . . . I think one of the things you have to do in my business is not to get hooked on anybody. You see all sides of them so, yes, you admire but you never have any kind of hero worship. I could give you the usual trite names, but I think there are so many women today who are admirable. I think any-

> **"I have always felt that if your hair looks good, everything looks good."**

one who works with the handicapped is admirable. Or women who have changed our lives: Margaret Mead, Lillian Hellman, Beverly Sills, Betty Friedan, Clare Boothe Luce—the legendary ones. Just to hear their thoughts, and to have fun talking with them and to see the vulnerability and to see how much these women are, in their way, individuals. That's so exciting. I don't think of men and women in terms of whom I admire or whom I think is beautiful.
Q. Did you enjoy talking to Diana Vreeland?
A. Yes, I did. I had met Diana Vreeland, and she is such an original in her own world, but I never knew what all that smoke was about, really. I felt that she was rather snobbish and lived very much in a very kind of "in" social, fashion New York world which I have never found that appealing. Then she came on the program, and the humor came out and the sense of herself and the lack of artificiality. She is, of course, enormously chic, and that can be off-putting, but there is great humor, a kind of self-deprecating humor. I enjoyed her. She was also totally professional. She knew what it was that we were trying to do, and she appreciated that. She trusted us and we trusted her. But the world that she represents is not the world I'm either comfortable in or find attractive. The Beautiful People, The Get-Ups and the opening-night museum parties are just not my life at all. I like interesting people, and I like to go to pretty things, but that whole world just isn't mine and never will be.
Q. What is your idea of a perfect evening?
A. Having dinner on a tray and watching Charlie Brown with my child. I know it sounds phony, but that's what I like. I enjoy much more now being with close friends. Maybe we don't all go through stages, but there was a point where it was very important to be "there." People have said that you sort out your cards, but it took me a long time until I

> **"I think you can believe in the true, real important things in life and look attractive, too."**

felt so secure that I could really do only what I want to do. I'm lucky because I can move in different circles. I find the political world fascinating. I find Washington a marvelously interesting fishbowl kind of world. There's too little privacy there, and it would bother me to live there. In New York you can live any kind of life you want, but I find the world of politics far more interesting than I find the world of show business or fashion. Journalists are always interesting, probing, and I like my own very comfortable friends. I never go to cocktail parties, never. That's the time I spend at home with my child or with myself.
Q. Do you drink at all?
A. Very rarely.
Q. Do you like wine?
A. Yes, but if you told me that I couldn't drink it—it wouldn't be something I'd have to struggle with. If you told me I couldn't eat brownies, I'd be bereft. And I'm a cookie freak, I

> **"The make-up I wear on the air is the same that I use off the air. I can carry everything in one plastic pouch."**

could live on cookies—so we never have them in the house.
Q. Do you get more women listening to your programs about women, fashion and beauty?
A. They are very good programs. Also, there was a time when, if you were beautiful, you couldn't be smart. Then we talked about Ali McGraw or Candy Bergen, and their minds are so good it's exciting. People like things that are either very glamorous or that can help them live better. We did a week of programs called "Help, I'm Losing My Mind" . . . because everyone, at one time or another, has

that feeling. I did myself. My secretary once brought in a sampler to me which she was going to do in needlepoint. It said, "As soon as things get quiet I'm going to have a nervous breakdown. I've worked very hard for this. I deserve it, and nobody is going to take it away from me." I put it on my wall and I said that I felt that way, too. We all do.
Q. What do you do when you're under stress and tension?
A. I have never taken a pill. With all the stress and tension, nothing could make me go out of my mind. I'd never smoke marijuana; I'm not even aware of ever being around it. I wouldn't know it if I smelled it.
Q. But you don't even take a tranquilizer for your stress?
A. Never. My only problem is that I'll go some

> **"I can't understand walking into some people's rooms that are too brightly lit. I think, 'Don't they see?' 'Don't they know?'"**

days with three hours' sleep a night, and then it gets to me.
Q. What kind of lighting do you like?
A. We have the world's worst lighting on television. That's why everybody thinks we look so much better in person. In the living room at night I usually have lots of candles. I like soft lights; I love candlelight. I can't understand walking into some people's rooms now that are too brightly lit. I think, "Don't they see? Don't they know?"
Q. Lighting is very important to the mood.
A. Except bedrooms—they should be bright and sunny and well lit. I like them that way because I read so much in bed. I can't describe anyone else's apartment because I have no visual sense. I can write, I can talk, but I have no visual sense. I can't draw at all; my penmanship is awful. I'm very unhandy; I can't gift-wrap a package prettily. But as far as my own apartment is concerned, I like it to be very comfortable, I like people to be able to sit—I hate to keep things under glass. I like prints in a bedroom—white and yellow, and that kind of grassy-green and pinks. I like it to look like a garden, and to be very fresh and very pretty. But I don't like terribly feminine, feminine rooms. I love red—any color as long as it's red. I used to wear a great deal of red, but the last few years the designers have been using much more of those murky colors, and I find it harder to get red to wear. I have a lot of red in my living room.

> **"I think if I keep my skin clean, which I have to do, having make-up on my face every day, I find soap and water makes me feel the cleanest."**

Barbara's work is far more important to her than her beauty, yet she always looks attractive, neat, and pulled together. She's a strong woman whom people respect.

Her face was made up to achieve a soft effect, so it looks natural.

Her hair is kept at a good length.

The strong solid colors that Barbara Walters wears—particularly her favorite, red—suit her perfectly. She never wears too many accessories and sticks to simple clothes.

189

Coming into your own means back to basics

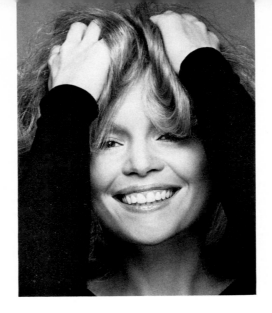

Tuesday Weld

Scavullo: What does beauty mean to you?
Ms. Weld: Beauty is something that could evoke pain but does not.

Q. What is your personal approach to beauty?
A. Don't think about yourself too much. Do everything in extremes, but with great lapses of nothingness.

Q. What women do you admire?
A. I admire any woman who has sane, healthy children, no live-in help, and makes her own living.

Q. Who is beautiful? Glamorous? Why?
A. Buster Keaton is beautiful. Mystery is glamorous. Because.

Q. What does it take to make you look and feel good?
A. Not much. Just someone's total love, attention, respect and devotion.

Q. What are your hang-ups?
A. I don't have any hang-ups. (That, many people feel, is my greatest hang-up.)

Q. Where is life the most beautiful?
A. Life is usually the most beautiful when you're in a car or a plane going to the place where you *think* life is the most beautiful.

Q. In what way do American women differ from European women?
A. They have different-colored passports.

Q. What do you cook?
A. Tunafish salads, tunafish sandwiches and tunafish casseroles.

Q. How do you feel about fashion and buying clothes?
A. I feel the best way to solve those horrendous "what to wear" fashion problems is to find something you're really comfortable in and *feel* most yourself in; then wear it into the ground.

Q. Are there things you hate?
A. I hate to be rejected.

Q. What things do you love?
A. I love thinking I'm lonely and knowing I'm not. I love to see love in the eyes of my little girl. I love to win. Chinese food, American food, French food and most of all—junk food.

"Fashion is finding something you're comfortable in and wearing it into the ground."

Tuesday Weld is a great example of the beauty of vulnerability. I first photographed her when she was eight, and I remember looking through the camera and thinking, "This is the sexiest child I've ever seen." She looked frankly into the camera, not at all hesitant, but she had a touching quality. She still does. I love to see her with just a glow on her face, and lips that are moist. She's a woman-child who's always threatening to blossom.

Tuesday Weld has it all—bones, structure, nice bright eyes, a lovely mouth. You don't need to use any tricks on her; there was no special emphasis on any feature. She just glows and looks beautiful.

Her hair is perfect for her.

Her dress is clean-cut, pure. Usually in a black leotard under dungarees or a skirt, she's totally unaffected.

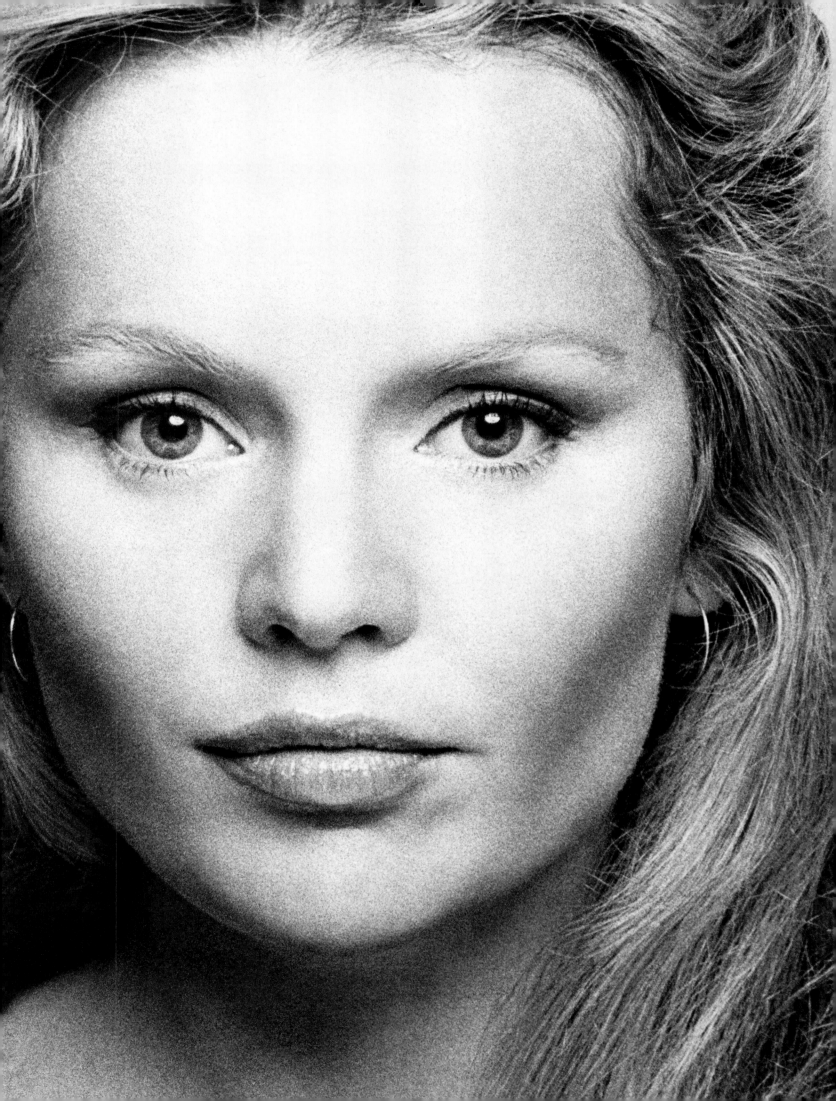

Francesco Scavullo was born in Staten Island, raised and educated in New York City. He began his career as assistant to the photographer Horst. In 1948 he photographed his first cover for *Seventeen* magazine and opened his own studio in 1950. Mr. Scavullo has done covers for every major magazine in America: *Women's Home Companion, Ladies' Home Journal, Redbook, Charm, Today's Woman, Glamour, Life, Newsweek, Harper's Bazaar, Town & Country, Vogue, Playboy, People,* in addition to *Seventeen.* He has been taking photographs for the cover of *Cosmopolitan* magazine for the past ten years. He also does commissioned portraits, and photographs celebrities and artists for record-album covers and book jackets.

Francesco Scavullo uses a Hasselblad camera with a 150-millimeter Sonar lens and an electronic flash. He shoots with Tri-X film and develops with Acufine. The printing is done on Kodak polycontrast F paper. All photo printing for this book was done by Robert James Cass, Jr.

The text of this book was set in film in a face called TIMES ROMAN, designed by Stanley Morison for the Times (London), and first introduced by that newspaper in 1932.

Among typographers and designers of the twentieth century, Stanley Morison has been a strong forming influence, as typographical advisor to the English Monotype Corporation, as a director of two distinguished English publishing houses, and as a writer of sensibility, erudition, and keen practical sense.

The book was composed by New England Typographic Service, Bloomfield, Connecticut. It was printed on 70 pound Casco gloss by the Murray Printing Company, Forge Village, Massachusetts, and bound by American Book-Stratford Press, Saddlebrook, New Jersey.